'A therapy that promotes interactive attunement between adults and children is taking the world of therapy by surprise. With the help of a simple video camera focusing on the good moments of human interaction, however limited these may be, its practitioners empower their clients, bring a smile to their wary faces and achieve real positive changes in the attachment of their children. Not only is it accessible to all who wish to train under supervision, it is also cost effective and cross-culturally applicable. If you are now curious to know more don't hesitate to buy this exciting new book on Video Interaction Guidance written by eminent practitioners and researchers in what is a promising new development in the therapeutic field of change through mentalisation.'

— Dr Felicity de Zulueta, Emeritus Consultant Psychiatrist in
Psychotherapy at the SLaM NHS Foundation Trust and Honorary
Senior Lecturer in Traumatic Studies at King's College London, UK

'This excellent book on Video Interaction Guidance, edited by leading experts, should be read by everyone interested in promoting sensitive parent-infant interaction in infancy and supporting vulnerable families. It provides highly accessible descriptions of the approach, its application across a range of settings, and the evidence about its effectiveness. Video Interaction Guidance is undoubtedly an intervention whose time has arrived, and we need wide-ranging groups of practitioners including midwives, health visitors and social workers, to develop the necessary knowledge and skills to intervene with families using this highly effective method of working to bring about change. This book will be an important first step in achieving that.'

— Professor Jane Barlow, Professor of Public Health in the Early
Years, Warwick Medical School, University of Warwick, UK

'This book is the first to offer a comprehensive introduction to Video Interaction Guidance (VIG), together with an accessible account of the strands of theory and research underpinning the approach. It provides a much needed resource for both practitioners and trainers in the fields of psychology, social work and education. Particular strengths are the wide range of applications that are described in detail and the illustration provided throughout the book by case studies and session transcript material. Connections with other perspectives and approaches are explored and encouraged in a book that is likely to inspire further development and research in VIG, as well as stimulating interest and engagement more broadly among practitioners.'

— Professor Norah Frederickson, Director, Educational Psychology Group, Department of Clinical, Educational and Health Psychology, University College London, UK

'This is a book of hope. It shows us a way out of the despair of social dysfunction, a way out of continuing with relationship patterns that have become jagged and draining. The contributors to this volume show us repeatedly that, when we are supported to look anew at the way we relate to others, then we come to see both ourselves and our partners in a new light. Joy and growth can be restored to relationships from this reflexive stance. The range of evidence that Kennedy, Landor and Todd have been able to gather together provides a convincing case for Video Interaction Guidance as a therapeutic approach that nurtures lasting behavioural change. It also becomes clear that VIG requires only a modest investment of time or money. The reader begins to feel that VIG is best described not as a method for nurturing behavioural change, but as a method for nurturing compassion.'

— Dr M. Suzanne Zeedyk, Senior Lecturer in Developmental Psychology, University of Dundee, UK

Video Interaction Guidance

of related interest

Video Modelling and Behaviour Analysis
A Guide for Teaching Social Skills to Children with Autism
Christos Nikopoulos and Mickey Keenan
Foreword by Sandy Hobbs
ISBN 978 1 84310 338 7

How to Help Children and Young People with Complex Behavioural Difficulties
A Guide for Practitioners Working in Educational Settings
Ted Cole and Barbara Knowles
Foreword by Joan Pritchard
ISBN 978 1 84905 049 4

Creating Change for Complex Children and their Families
A Multi-Disciplinary Approach to Multi-Family Work
Jo Holmes, Amelia Oldfield and Marion Polichroniadis
Foreword by Professor Ian Goodyer
ISBN 978 1 84310 965 5

Reflective Practice in Mental Health
Advanced Psychosocial Practice with Children, Adolescents and Adults
Edited by Martin Webber and Jack Nathan
Foreword by Alan Rushton
ISBN 978 1 84905 029 6
Part of the Reflective Practice in Social Care series

Picking up the Pieces After Domestic Violence
A Practical Resource for Supporting Parenting Skills
Kate Iwi and Chris Newman
ISBN 978 1 84905 021 0

A Non-Violent Resistance Approach with Children in Distress
A Guide for Parents and Professionals
Carmelite Avraham-Krehwinkel and David Aldridge
ISBN 978 1 84310 484 1

Video Interaction Guidance

A Relationship-Based Intervention
to Promote Attunement,
Empathy and Wellbeing

EDITED BY HILARY KENNEDY, MIRIAM LANDOR
AND LIZ TODD

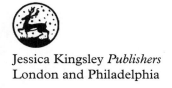

Jessica Kingsley *Publishers*
London and Philadelphia

Cover photograph of the man and the boy from iStock. All other
photographs by Lisa Madden and Hilary Kennedy.

First published in 2011
by Jessica Kingsley Publishers
116 Pentonville Road
London N1 9JB, UK
and
400 Market Street, Suite 400
Philadelphia, PA 19106, USA

www.jkp.com

Copyright © Jessica Kingsley Publishers 2011

Library of Congress Cataloging in Publication Data
Video interaction guidance : a relationship-based intervention to promote
attunement, empathy, and wellbeing / edited by Hilary Kennedy, Miriam Landor,
and Liz Todd.
 p. cm.
Includes bibliographical references.
ISBN 978-1-84905-180-4 (alk. paper)
1. Counseling. 2. Video recording. 3. Interpersonal relations. I.
Kennedy, Hilary. II. Landor, Miriam. III. Todd, Liz.
 BF636.6.V53 2011
 158'.30284--dc22
 2011007707
British Library Cataloguing in Publication Data
A CIP catalogue record for this book is available from the British Library

ISBN 978 1 84905 180 4

Printed and bound in Great Britain

This Book is dedicated to Harrie Biemans and Claske Houwing. In gratitude for their generosity in sharing the development of VIG in the Netherlands with us in the UK

Contents

TABLES

FIGURES

Preface

HILARY KENNEDY

The idea of writing a book on Video Interaction Guidance (VIG) has been proposed by many of us involved in VIG work since the first national conference in Scotland in 1997. From that time, VIG development was demonstrated at annual conferences in Scotland and at International Research conferences based at the University of Dundee in 2001, 2006 and 2009 each attended by around 250 people from over 12 countries.

There is an overdue need for a book on VIG that puts together a clear explanation of the method with a few of the many applications, and some ideas for taking VIG forward.

The time now feels right to confirm VIG as an evidenced-based method that works to enhance or rekindle communication within important relationships. As you will read in the first four chapters, VIG has a strong theoretical core which can be used to adapt and accommodate the existing skills of a wide range of professionals. This book will be of interest to anyone who is thinking about ways to enhance the quality of relationships experienced by themselves and others around them. The focus of your interest could be as teachers, psychologists, psychiatrists, psychotherapists, social workers, doctors (e.g. consultants for diabetes and other life-long conditions that require patient-centred care), nurses (from special baby units to care of the elderly with dementia), health visitors, police in child protection work, support staff working with families, young people and whole communities who would like to improve interactions and relationships on a day-to-day basis.

Practitioners using VIG in many countries and contexts have experienced the effectiveness of this way of working. As practitioners they have seen the video evidence of the change in their clients' communications with others, like parents and children or teachers and pupils, alongside their own

changes in effective communication with their clients, so their energy and enthusiasm for VIG rises.

The narrative of the development of VIG in the UK is a story of connections and generosity between people across the North Sea. In 1992, Colwyn Trevarthen from Edinburgh University brought a group of Dutch psychologists, film makers and social workers to Scotland to let us know how families can change using Video Home Training (VHT). This conference inspired Hilary Kennedy to find out more and soon Hilary with Raymond Simpson from Scotland were offered a study week and then two years VIG training in the Netherlands through the generosity of the SPIN organization headed by Harrie Biemans. Hilary and Raymond were supervised by Claske Houwing (who was centrally involved in early VIG courses and conferences in the UK). At the same time, Andy Sluckin from Norwich was supervised in the Netherlands by Henk Vermeulen (an author in this book with strong connections over the years to VIG in the UK).

Hilary, Raymond and Andy had all been connected with the Psychology Department at Edinburgh University in the early 1980s, where Colwyn Trevarthen was developing his micro-analytical approach to understanding the rhythms and subtle turn-taking of mother–baby interactions. At the same time Harrie Biemans came across Colwyn's work and invited him to the Netherlands to work out how his ideas could be developed into a practical intervention to improve communication in troubled situations. Details of this interesting synergy of theory and practice across countries are described in Chapters 1, 3 and 12. We would like to thank Harrie Biemans first for having the vision, second for putting it into action and third, for sharing it so generously with so many. His dedication to and skill in the development of VHT / VIG in the 1980s and 90s is the foundation of many effective video feedback interventions being offered in Europe and the USA.

The period of initial development in the UK was backed by the Scottish Education Department Professional Development Initiative (for educational psychologists) and through their support the UK project began with the training of eight educational psychologists across Scotland. From this small start, VIG has grown in the UK with 60 fully trained supervisors, 800 trained practitioners and approximately 200 at various stages of full VIG training as this book is written. There are also firm contracts for new large projects (with research built in from the start) for 2011–2014 across the UK (in health, education, social work and charities) and in Mexico. The new Neglect Theme of The National Society for the Prevention of Cruelty to Children (NSPCC) has decided to introduce and research the

implementation of VIG to eight NSPCC projects over the UK. The Juconi Foundation, based in Mexico, which aims to develop effective solutions for socially excluded children, young people and families affected by violence, is starting a VIG training programme. VIG will be implemented throughout the organizations from leadership to those working directly with youngsters on the streets.

It has been a challenge to write this book – VIG can and has been successful in so many diverse situations that it was sometimes hard to know how to write for such a variety of readers. We, the editors, had a totally absorbing task for a few months of encouraging, reading and suggesting revisions for chapters but we did receive considerable help. Every chapter was read and developed in light of comments from our non-VIG internal editors, Alice Curteis, Carrie Cocke and Helen Irwin. Their thorough reading for meaning and detailed feedback was invaluable. Finally, each chapter went out to two external reviewers, who had expertise in the appropriate field and then adjusted again. We will not list these reviewers individually but thank them all for their careful reading and helpful feedback. We would also like to thank all the VIG practitioners and the families, teachers and others who were involved in VIG with them over the last 15 years for enriching this method.

We are writing this book in a climate where strengths-based interventions that focus on interaction and sensitivity are recognized. This was not the case 20 years ago, when many interventions focused on either the child or the parent / teacher with the aim of giving them the skills to overcome their difficulties. However, it is still common practice in child protection investigations to assess the parents' capabilities and to examine the child for evidence of abuse. In our opinion, this investigation should always look at the parent–child interactions and also at the parent's ability to reflect on their role in providing a nurturing relationship for their child. VIG can provide a skilled assessment of the parent's current interactions, their reflections on these and their potential and desire to change.

The importance of actively involving people – families, patients, young people and so on – in their own change/learning is now well understood. VIG is a very effective way of putting these aspirations into practice. It gives professionals a way to move from either pole on the helping continuum of 'advice giving' to 'therapeutic listening' to finding a balance with each client where leading and following becomes a carefully crafted dance. We believe that people in troubled situations can find considerable inner strength once they see themselves in a different light.

The 26 authors of this book were selected for the depth of their knowledge of VIG in different contexts and countries. Individual details of their experience and expertise are in the contributor section so will not be repeated here. However, current collective experience in delivering, developing, evaluating and training in VIG totals a combined VIG delivery of over 200 years.

Unlike many evidence-based interventions which are initially launched with clear guidelines and tested in experimental conditions before being rolled out, VIG has been delivered, evaluated and developed in the wide range of messy situations where people were asking for help. Through this process VIG has now arrived at a point where the method, its training and accreditation procedures, theoretical background and research evidence can be clearly described.

The book is divided into three sections. The first section (Chapters 1 to 4) describes what VIG is and how it is delivered, the supervision process, how and why it works, and research evidence on its effectiveness. The second section (Chapters 5 to 11) concentrates on the applications of VIG in with range of clients and contexts, including infants, vulnerable families, schools, children and adults on the autistic continuum and children with hearing impairment. This section ends with two chapters on the way VIG can be adapted for professionals to develop their own communication using Video Enhanced Reflective Practice (VERP) focusing on the diverse contexts of staff in residential care and university lecturers. The third section (Chapters 12 to 17) celebrates the connections of VIG to other theoretical frameworks, starting with companionship through intersubjectivity, then attachment, Feedforward, relational systemic perspective, narrative therapy and mindfulness. The book concludes with Chapter 18 taking the impact of VIG beyond therapy and into a political context of a culture of relational democracy.

Writing this book has been a rich, collaborative process that has mirrored VIG principles of attuned interactions between people and the belief that everyone is doing the best they can in the circumstances in which they find themselves! It was completed in six months with the delivery of the manuscript to Jessica Kingsley Publishers on time following a weekend when the editors worked round the clock with co-authors in the UK, the Netherlands and the Czech Republic. Most of the chapters have been co-authored, with some requiring co-writing where English was a second language for one of the authors. This open collaborative process has benefited from an intranet platform (SPINLINK – developed and supported by Kateřina Šilhánová and Mirek Burkon from Prague). Consultation took

place throughout the first three months starting with the first chapter, which although written by a single author is the result of at least 20 contributers. There were online and Skype discussions with many different opinions voiced and agreements gradually reached on the new diagrams and principles. Interestingly, as we were finalizing the core communication principles, we realized that we had gone full circle and were almost back to the 'characteristics of successful interactions and guidance' as described by Harrie Biemans at an international seminar for innovators in the field of youth care in the Netherlands (Biemans 1990).

We know of several video feedback interventions across the world and there will be others that we have not yet come across and more still to be created. We are very aware that we cannot and do not want to restrict the use of ideas in this book to those who register for certified VIG training in the UK. However we would encourage an interested reader to find out about the unique features about Video Interaction Guidance in the UK (VIGuk) – this information is available on our website www.videointeractionguidance.net. This will lead you to the Association of Video Interaction Guidance (VIGuk) supervisors and practitioners where you will find details of the 'certificated' training, supervision and accreditation system. The training starts with information but is primarily developed through 'learning by doing' (taking videos and reviewing them with clients), reflecting on what you have done with them (preparation of your videos of the clients, such as parents and their children, and your shared reviews of these films for supervision), dialogue in supervision where you can reflect on your strengths and areas for development and then back to learning by doing. Accreditation at three points throughout the process requires you to demonstrate your emerging new skills and explain them in dialogue. Clients and VIG trainees address the question 'What is it that you are doing that is making a difference?' and this discussion raises further ideas for future change. It is a personal, supported journey of about two years with at least monthly supervision and additional group sharing of work. The VIG trainee is actively developing themself, fine-tuning their own unique style when engaging clients in the change process.

Standards are maintained and developed by the regular and frequent process of exchange and collaborative working between supervisors over the UK and beyond. It would be much simpler to have developed a prescriptive manual and accreditation process and then trained the trainers to maintain fidelity of the model. However, the lack of regular supervision and dialogue would in the end have made a more prescriptive method less effective. Moreover we have chosen a model that places the development of

emotional connections within attuned dialogue at the heart of our training standards.

There has never been a greater need for people to relate more effectively as it is only in this way that we are going to be able to address the considerable problems of the world. The use of VIG in many different kinds of situations in this book is a reminder of its potential for many more.

Video Interaction Guidance

CHAPTER 1

What is Video Interaction Guidance (VIG)?

HILARY KENNEDY

Introduction

> ...That (VIG) has been such an eye opener for me. Watching them all today and seeing where we were and where we are today is amazing in a relatively short space of time really. How all this has come together and is helping him so much, and me; I have had to change my whole way of parenting; like with the eye contact, waiting for him to answer me and trying to get conversations going again. Sometimes now he will start them and want to talk to me about something which is great! Not that I always want to know how fast a car can go! But I have to sit there and look really interested, he goes on and on! It's not often that he walks out of the room now... We'll sit together for ages... I felt that I was drowning, really felt that I was drowning, and it is not that anymore; we're actually swimming together, yeh! It is brilliant, I have got my little boy back. This works, it really does work. I just don't want it to stop... (Rautenbach 2010, p.82)

This quote is from a parent with a five-year-old son whose behaviour at home and school was causing concern. They took part in a short Video Interaction Guidance (VIG) intervention, delivered by a trainee guider while studying for her doctorate in educational psychology. It speaks for the experience of many parents who are receiving VIG as an intervention in the UK. This is the sort of feedback that energizes guiders to meet what seem like entrenched situations with a sense of hope.

So what is this method that is able to move parents and children from seeming trapped in a 'no-cycle' of communication to enjoying being together again?

VIG is an intervention where the clients are guided to reflect on video clips of their own successful interactions. The person who engages with the client and leads the process is called the Video Interaction Guider (shortened throughout this book to 'guider'). VIG works by actively engaging clients in a process of change towards better relationships with others who are important to them. Guiders are themselves guided by the values and beliefs of respect and empowerment. These include a hope that people in troubled situations do want to change, a respect for what they are managing to achieve in their current difficulties and a conviction that the power for change resides within clients and their situations.

The process starts with the guider meeting the family, usually at home, listening carefully to their worries and concerns and exploring and joining in their hopes for a better future. The VIG intervention can then be explained, as how VIG could link with the family's goals for change, and an invitation is given to take part in the VIG process. The guider might say: 'Next week I will come back to your home and I shall take a very short film of you and David doing something together. You can choose what you would like to do, or I could make some suggestions. Usually, videos are most helpful if the activity is relaxed and allows you to follow each other and maybe also enjoy being together. I realize that this may seem strange to you, as I will not be seeing all the problems that you are experiencing. What I will be seeing are some of your natural skills in communicating with David that you are not often experiencing at the moment. What we are going to try to do is to build a future moving away from your current difficulties. In order to do this, the first step is to focus on you and David interacting together when you are getting along. So, when I come back the week after, I will have had time to look at this video very closely and select tiny successful moments for us to discuss. From this discussion we shall build up an understanding of how you and David can enjoy being together, how you follow him and how perhaps he can start to follow you.'

It is hoped that this starting script will introduce the reader to the spirit and practicalities of starting a VIG intervention. The next section describes VIG in a professional context.

How does VIG work?

VIG works by reviewing micro-moments of video clips of clients' own successful communication, based on the premise that attuned responses to the initiatives of others are the building blocks of an attuned interaction pattern. Clients are supported to review these moments in conversation with guiders and to reflect actively on the nature and details of what they are doing that makes the interactions work better than usual. At the end of review sessions, clients summarize newly observed strengths in themselves and their interactions. Then thoughts about what they would like to change in their interactions before the next filming session are discussed. This pattern of video recording and shared review of micro-moments continues. Many clients make very good progress in three or four videos and reviews, although the length of each intervention is tailored to the nature of the difficulties experienced and the wishes of individual clients.

Once a pattern of attuned interactions is established or re-established, an attuned relationship develops which reaches well beyond simple interaction patterns to form new emotions and identities. For example, in the opening quotation of this chapter, by seeing herself on video watching and responding to her child's lead, the client was able to gain confidence in herself as a mother. Once she could see that her child enjoyed being with her, their relationship could develop naturally. She went from feeling she was 'drowning' to 'swimming' and her child's behaviour with his mother went from 'walking out the room' to 'staying for ages'.

VIG is an intervention that aims to improve effective communication where it occurs naturally, building on each individual's unique and effective style. The video is usually taken in the natural situation (e.g. for parents interacting with their children, in the home environment) but this is not essential. Some clients prefer to be filmed outside their normal context and some guiders prefer to work in their own settings.

Origins of VIG

The decision to focus in this chapter on the use of VIG in families reflects both the history of the development of VIG from 'Video Home Training' (VHT) in the Netherlands, and the theoretical underpinnings of VIG. The study of what happens in 'moments of vitality' between people (Stern 2010) is at the core of VIG. Professor Colwyn Trevarthen has spent the last 40 years studying and enjoying these 'moments of vitality' between parents and their infants. He became very interested in the 'communicative dance'

he saw happening between a parent and an infant. Trevarthen studied the subtlety of the way the parent follows the child and the child follows the parent, looking at the rhythm, the tone and the 'pauses' that help the communication work. These pauses occur naturally in the vocalization patterns of infants, even those born prematurely, and give each partner, the parent and the child, 'space in their mind' for the other.

The origins of the VIG 'principles for attuned interactions and guidance' were created by Harrie Biemans in the early 1980s (Biemans 1990). Biemans was inspired by Colwyn Trevarthen's BBC films on the subject of parent–baby interaction, and by discussions with him on the theories of primary and secondary intersubjectivity and on mediated learning. These will be discussed in more depth (see Chapter 3) but are introduced here so that the reader can make the link between the theories behind the principles for attuned interaction.

Primary intersubjectivity is the process of communication that takes place between two people (e.g., a mother and a very young infant), in which emotions are actively expressed and perceived in a two-way dialogue (Murray and Trevarthen 1985). *Secondary intersubjectivity* is characterized by an increasingly sophisticated communication, involving a joint focus on something external. For example, during the second half of the first year an infant is able to share a focus on a third subject, such as food or a toy, with an adult (Hubley and Trevarthen 1979). *Primary and secondary intersubjectivity* not only express the aim of VIG, i.e. greater attunement, but also explain why the process of shared review of video clips helps to bring about the process of change. 'Attunement', from intersubjectivity literature, refers to a harmonious and responsive relationship where both partners (for instance, parent and baby) play an active role.

Mediated learning experiences refer to the important role of the adult as mediator to the child's intentions. Wood, Bruner and Ross coined the term 'scaffolding' to describe this tutorial interaction between an adult and a child (Wood, Bruner and Ross 1976). The metaphor was used to explore the nature of the aid provided by an adult for children learning how to carry out a task they could not perform alone. 'Scaffolding' builds on the notion of *secondary intersubjectivity* where the adult, by an attuned response, gives meaning to the child's cognitions and emotions at a level that the child can understand.

Hundeide (1991) acknowledges the influence of these principles when he writes:

Identification, confirmation and following the initiative of the child is the key to the healing process…turn-taking and reciprocal confirmation of positive expressive feelings adjusted to each other, may be described as a 'yes-cycle'. This is always associated with the sharing of joy…this positive confirmatory cycle has a very strong therapeutic effect. In a situation of family stress and disturbance, however, this positive cycle is one of the first things to disappear. Instead a 'no-cycle' starts…with metacommunicative signals that are detrimental for the child's self worth and exploration. (Hundeide 1991, p.61)

Aim of VIG

The aim of VIG is to support the move from no- to yes-cycle interaction patterns as illustrated in Figure 1.1. This is something that troubled families find easy to grasp and it helps them to think about plans for change.

When communication has broken down, parents and their children sometimes give up making initiatives, as there is either little contact, or one or both are making strong discordant initiatives that are either ignored or responded to in the 'no-cycle'. The healing process in VIG therefore involves the selection of video clips that show the parent involved in an intersubjective communication where they are meeting their child in the 'yes-cycle' at an emotional and cognitive level.

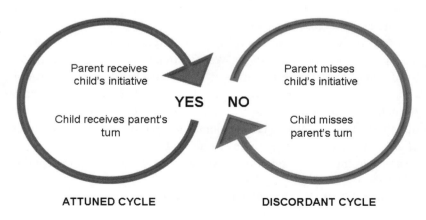

DOES PARENT RECEIVE CHILD'S INITIATIVE?

Parent receives child's initiative

Child receives parent's turn

YES NO

Parent misses child's initiative

Child misses parent's turn

ATTUNED CYCLE **DISCORDANT CYCLE**

Figure 1.1: VIG supports changes from the no- to the yes-cycle

Clients are not taught how to interact better, but rather to learn through experience how they can actively develop more joyful relationships. For example, David's mother quickly started feeling much more warmly towards him when she experienced and 'saw' his pleasure when they were playing together on the video. These changes in emotions from feeling 'rejected' to 'appreciated' by David prompted an 'intuitive' change in behaviour from no- to yes-cycle responses.

The core principles of VIG

The principles for moving from discordant to attuned communication are more complex than a simple reception of initiatives. First, how is it possible to encourage initiatives in the 'yes-cycle' from the child? Second, once 'attuned interactions' have been achieved, how can the child be helped to learn and be protected from difficulties?

Through the core principles the adult is enabled to respond in an attuned way to the child's initiative and then to develop this 'response to initiative' into the pattern of an attuned interaction, as shown in Figure 1.2. Effective reception simultaneously involves an emotional response (often non-verbal) as well as a more cognitive (verbal) response.

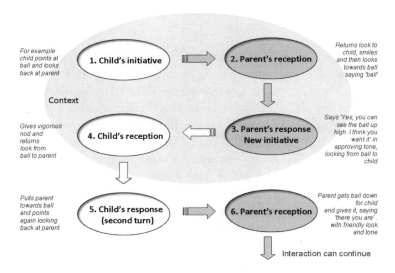

Figure 1.2: The core principle of an attuned interaction: attuned reception by parent of child's initiative

The building blocks in Figure 1.3 illustrate how, by starting from the bottom step, a parent can build the fundamentals of an attuned relationship. These 'principles for attunement' (applicable in any situation involving interaction between people) are described in the text; the key principles are on steps.

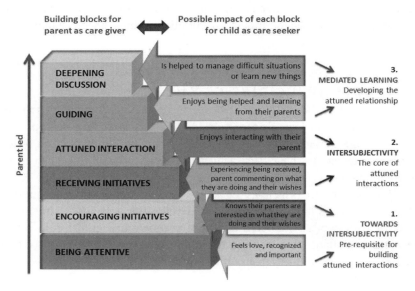

Figure 1.3: Building attuned relationships

The important foundation for attuned communication, and the way to support parents to re-make contact, is to guide them to be *attentive* to their child. The next step is to *encourage* the child to make *initiatives*, often by leaving space for the child to make the attempt at contact by naming what they are doing, or naming possible thoughts or feelings. Waiting and watching the child very carefully and thinking about what the child might be thinking or feeling is very important. Once the child makes an attempt to communicate with their parent, this *initiative* can then be *received* in an attuned manner. The parents can then respond with their own ideas and help the child to receive them. In this way an *attuned interaction* pattern can be constructed. Once this is in place, the parent can carefully *guide* the child by extending the child's idea; this can be done by making new suggestions that the child can follow, sensitively judging the amount of support that is required. In education this has been referred to as 'scaffolding' (Wood, Bruner and Ross 1976) and is introduced in the previous section under mediated learning. It refers to the adult's contribution as building carefully

on the child's response, so that the child is slightly extended but not by so much that they cannot understand where the adult is leading them. The highest step of these principles for attunement is in place when the adult is able to *deepen the discussion* by taking the initiative and giving explanations and opinions, and passing on knowledge in all sorts of ways. These elements of communication are very important in *managing conflict* (potential or actual). In essence, attuned contact is built on the adult following and understanding the child so the child can then give the parent a turn. The child is then ready to learn actively from the adult and to accept the adult's skilled *guidance* whenever they require help. The steps of Figure 1.3, building up from fundamental principles, are elaborated in Table 1.1, which can be characterized as a progression, with the same starting point of 'being attentive'. Table 1.1 should be read from the top down while the steps in Figure 1.3 start at the bottom.

The VIG process explained

Continuing to use the example of parents and children, the process begins by helping the parents to think about how they might like things to change. Initially parents often want their child to stop crying, to eat their food, to smile at them more or perhaps to do what they say. In other words, the goals are focused on specific behaviours; it is these aspects of the child that the parent wants to change. These concerns are carefully received. After discussion, new shared goals are co-constructed by introducing the parents to the importance of the impact that they have on their child and vice versa. These new goals are more focused on interaction than on particular behaviours.

A filming session is carefully set up to show the best possible interactions achievable at the time. Although people can at first be very self-conscious at being filmed, the way that filming is done can be an important intervention in itself. The guider might, for example, ask a parent to look at a magazine with their child, to play a more open-ended game, to do an activity together or simply to have a conversation on a topic likely to generate positive interaction. The reviewing together of the clips of positive interaction is an important part of the intervention.

The guider then edits the film, selecting a few very short clips of the most successful interactions. These are very likely to be exceptions to the usual pattern. The clips selected exemplify various principles of attuned contact, especially parent reception of child initiatives.

Table 1.1: Principles of attuned interactions and guidance

Being attentive	• Looking interested with friendly posture • Giving time and space for the other • Wondering about what the other is doing, thinking or feeling • Enjoying watching the other
Encouraging initiatives	• Waiting • Listening actively • Showing emotional warmth through intonation • Naming positively what you see, think or feel • Using friendly and/or playful intonation as appropriate • Saying what you are doing • Looking for initiatives
Receiving initiatives	• Showing you have heard, noticed the other's initiative • Receiving with body language • Being friendly and/or playful as appropriate • Returning eye contact, smiling, nodding in response • Receiving what the other is saying or doing with words • Repeating/using the other's words or phrases
Developing attuned interactions	• Receiving and then responding • Checking the other is understanding you • Waiting attentively for your turn • Having fun • Giving a second (and further) turn on the same topic • Giving and taking short turns • Contributing to interaction/activity equally • Cooperating – helping each other
Guiding	• Scaffolding • Extending, building on the other's response • Judging the amount of support required and adjusting • Giving information when needed • Providing help when needed • Offering choices that the other can understand • Making suggestions that the other can follow
Deepening discussion	• Supporting goal-setting • Sharing viewpoints • Collaborative discussion and problem-solving • Naming difference of opinion • Investigating the intentions behind words • Naming contradictions/conflicts (real or potential) • Reaching new shared understandings • Managing conflict (back to being attentive and receiving initiatives with the aim of restoring attuned interactions)

In the shared video review session that follows the selection of clips, the parent and guider look together at these selected micro-moments and then reflect on what the parent is doing that makes this particular interaction go well. These moments will often be times when the adult has responded in an attuned way to the child's action or initiative using a combination of non-verbal and verbal responses. VIG is not an approach where guiders find 'good' video clips and then 'praise' the parents. Parents can enjoy getting things right, but they can so easily become passive or only make progress to please the professional. Guider 'praise' confirms the guider in the role of evaluator of interactions. Whilst there are inevitably some elements of this, the aim of VIG is to involve the parent as a collaborator in reflecting together on clips of interaction. Therefore, less 'praise' and more focus on the naming of what is actually in the clips and the effects of what is named, enables a cumulative collaboration between guider and parent. Parents are not being taught how they should interact with their children but are learning how they can actively develop a joyful relationship.

The skilled use of the video clips and still images is part of the 'art' of using VIG. There are few definite rules, but one is that the guider and parent stop the film when they want to have a discussion. The guider clearly models giving short turns to the parent and receiving short turns from the parent where possible, looking attentively for the parent's initiatives to discuss certain moments on the film or to rewind and study a sequence again.

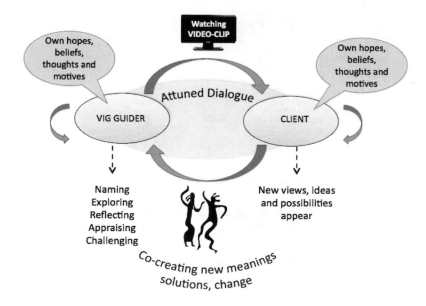

Figure 1.4: The shared review of the video

Whilst reviewing the video, the guider is aware of the therapeutic relationship they are building with the parent. The guider is doing this by exemplifying the same 'principles of attuned interactions' to the parents, by receiving their initiatives and responses and exploring their thoughts, feelings and intentions, while also being mindful of their own thoughts and sharing these whenever possible (Figure 1.4).

Figure 1.4 shows how the guider uses the film as an object of shared interest (secondary intersubjectivity) while building a strong attuned interaction with the parent directly (primary intersubjectivity). The guider pays attention to the rhythm of the interaction, leaving 'spaces' for the parent to think. This enables the parent to develop new thoughts, feelings and intentions that can trigger new narratives about themselves as parents and about their parenting. The guider's role in developing attunement during the shared review is summarized in Figure 1.5.

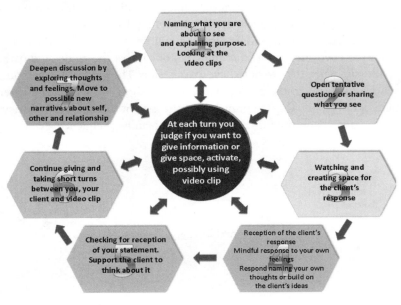

Figure 1.5: The seven steps to attuned interaction and guidance in the shared review

These seven steps to developing attunement form the backbone of the training of guiders as they reflect on their interactions in the shared review process. The centre of the circle describes the important decisions the guider has to make from moment to moment. First, should the guider try to activate the client (encourage them to say what they see, express their own

ideas or thoughts) or compensate (give their knowledge and thoughts to the client)? Second, should the guider use statements or questions, or use the video? The video clips are central to providing an alternative way for the parents to conduct themselves and are used and replayed during the review sessions. They provide the evidence on which discussions are based. A skilled guider uses them almost as a third party in the interaction. In VIG, there is no prescribed balance of 'activation' and 'compensation' during the shared review. The aim is to support the client to become as active as possible in experiencing and thinking about their own change. The client's response to the guider's initiatives is more important than whether the guider's initiatives were activating or compensating. This balance is often a subject for discussion in supervision (see Chapter 2).

The complete VIG process

So far, the process of meeting with the parent and engaging in the process of change and the first video and shared review have been described and the theory behind them has been discussed. Now the process of a complete VIG intervention for a guider in training will be described.

There is no prescribed number of VIG sessions as this may depend on the nature and complexity of the problem, any other help complementing the VIG work and, of course, the wishes of the family and time constraints of the guider.

However, research supports the contention that shorter interventions are at least as effective as longer ones, and that often the greatest progress seems to be made in the first two shared reviews. This method aims to activate the parent to rediscover their own natural successful style. Once this has been re-established and the parent understands the reasons why it works, progress can often continue without VIG.

Good practice at the time of writing is moving to offering families three or four films and three or four reviews as an initial intervention, then evaluating progress at this point. Re-engagement in a second cycle is then discussed with families who wish more support either immediately or after a break to allow them to consolidate what they have discovered so far.

Methods of evaluation will depend on the profession and/or wishes of the guider and the organization in which they work. However, a basic level of evaluation involves setting and reviewing negotiated goals. This can be done by asking parents to say on a scale of 0 to 10 where they would estimate they are now regarding an individual goal and where they would hope to be after the planned intervention period. Aims are recorded at the

start and re-evaluated at the end. New goals emerge throughout the process and these can be added.

Feedback is encouraged from the parents throughout the intervention and at the end a more formal reflective feedback is sought, often using a Traject Plan format which is described after the following case study,

What does VIG look like from a family's perspective?

This case study has been written by a trainee guider with the mother who was involved in the VIG intervention.

> Rebecca is a young woman in her mid-twenties; she is a single parent and has one son, Joe, who has just turned six. One of the great features of VIG is that we didn't need to talk about any of their underlying difficulties; we just got on with working together and talked about whatever came up. However, it might be helpful for the reader to know from the beginning what I came to know over the weeks of work. Rebecca had experienced neglect and abuse as a child and had eventually been taken into care. As an adult, she was in a state of perpetual homelessness and was battling to stop history repeating itself: her own child, Joe, was subject to safeguarding procedures on the grounds of suspected neglect. When we first met, Joe was struggling at school and he had the involvement of the speech and language therapist, the behavioural support services and the educational psychologist. Rebecca was also clearly struggling: she was pale, withdrawn and often looked ill. She seemed downhearted to the point of depression and sorely lacking in both hope and confidence. Yet she was willing to give VIG a go – I'd admired her for that and wondered where she found the courage to do so. I think the answer is simple – she loved her son and wanted to do anything to help him.
>
> The films and shared reviews all took place at school, which was Rebecca's choice. Her initial targets revolved mainly around the changes she wanted to see in her son: for him to express himself more easily without getting so frustrated; and for him to be able to take turns more easily. For herself she chose the target of being able to communicate more about the good things. VIG aims to help people see what part they play in interaction and targets are usually expressed in terms of what change that person hopes to bring about: I could have reframed Rebecca's targets, but

I knew this would come through the work and something told me she needed a gentle approach. A key point of VIG is that it's important to have faith in the client's ability to change. The guider needs to have hope for the client when they may have none for themselves. Also, it's a process – it doesn't have to be perfect from the beginning, and that goes for the guider as much as for the client. We added two targets for Rebecca during the work: for her to have more confidence and specifically to feel more confident about being a playful mum.

In the first film, Rebecca was withdrawn and uncertain with her son, taking the lead in play and quite subdued in her responses. When choosing the clips for review, I looked for examples where Joe took the initiative and Rebecca followed his lead and instances where Rebecca could see how much Joe loved her attention. I could see there was lots of potential that Rebecca wasn't even aware of and it was these moments of potential I selected to show her. In the review, her very first comments were critical of herself: to my question 'What can you see?' she responded, 'I can see all the things I'm doing wrong.' But she tentatively suggested that she could also see Joe 'seems to do alright being with me'. It was this comment I gave a strong reception to, repeating it back to her and commenting that it was a powerful statement. Her expression perked up. These moments laid the foundation of her gaining trust in herself as a parent and in me as a guider – in VIG there is always a parallel process going on.

In the second film, there was a noticeable difference in the quality of their interaction. Rebecca already seemed more confident – most of the play took place with Joe on her lap, her following Joe's lead and the pair of them taking short turns with talking. It was heartening to see Joe making many more initiatives and his mum consistently being able to respond to them with interest. There were also several moments of shared smiles, as well as a consistent emotional warmth between them. The second review was a delight to do: Rebecca could already see more clearly how she was responding to Joe, what messages this was sending to him and what this meant for them both.

It was heartening for us both to see her become more aware of her skills in interacting with Joe. Note the use of 'we': VIG is truly a joint project. I sign up to Rebecca's goals as much as she does – we take joint pleasure in her progress. We continued working in this way over another two films and reviews. I think what she found

helpful was being able to analyze the films in detail and name the different ways in which she was enabling Joe to feel heard, valued, respected and loved. The parallel emotional processes were around her feeling that she could be a good parent, because she could see how happy she was making Joe; and, I hope, around her feeling heard, valued, respected and appreciated by me. There was a lovely example of this in the fourth review, when Rebecca talked about how she had put so many of Joe's drawings on the wall that there was no space left. We discussed what would be in Joe's mind seeing them and how she felt about that. I ended up summarizing it as: 'You take delight in seeing Joe's work and he takes delight in you delighting in him' – there is another level, as I take delight in seeing their mutual delight. Awareness of shared joy is a powerful experience and is fundamental to VIG.

When reviewing her targets, Rebecca felt Joe was at a 10 in all areas. She commented: 'He's been coming along really well since we've been doing all of this. I'm really proud of him – I'm also really proud of myself, actually, because I've moved along with all of it as well. I've become a stronger person, the same as him.'

She says about her growing confidence: 'In the beginning, I was...at a 1 [on the scale], I didn't feel confident with him and everyone else felt more confident with him... I just couldn't join in [activities] with him and that was extremely hard for me. But since all this, I'd put myself at a 9.5. Over the holidays, me and Joe have been painting, we've been going down the common, going to town together, down the beach, really interacting with each other, holding hands, talking about everything we see, playing and just general kids' stuff really.' What a wonderful spontaneous description of a mum and son having fun together and delighting in each other's company.

As I write this, there has just been a review meeting at school for Joe: he is doing extremely well, to the extent that both behaviour and speech and language therapy services will be withdrawing, and he has almost caught up with his peers. He has gone from being hesitant to speak to actively enjoying talking to the whole class; and he has lots of friends. Rebecca is looking much better – her face has begun to take on a quiet radiance and she smiles so much more. She is sorting out her housing situation and her health. I am hopeful that the safeguarding procedures will all come to an end.

What you need to know is that this was only my second case, in Phase 1 of my training. What does this say about VIG? I had to

put into practice what I was asking Rebecca to do: I had to notice her emotional reactions to seeing the clips, be in attunement with her and think together with her. I also experienced in supervision the same principles in action. Above all, I had to have an open mind and heart, and a willingness to learn from Rebecca and Joe as well as from my supervisor.

On reading this together, Rebecca commented that the process of VIG had been 'a very good learning curve for me and Joe'; she said it had given her 'the satisfaction of knowing that I've got a stronger bond with Joe...and it's been challenging but rewarding'. As for my description of the work, she commented: 'Feeling myself praised was something that I never really had as a child, so reading this and seeing your praise makes me feel warm.'

This case study demonstrates both the power of VIG to enhance Rebecca's key relationship with her son and the spin-offs it has in other areas of her life. In the Netherlands, this systemic dimension of VIG has been labelled the Traject Plan.

> Although Traject plan roughly translates as 'Treatment plan', we have retained the original Dutch term because in our experience, it conveys a more flexible, subtle relationship with attuned communication than the word Treatment suggests. It may be useful to think of the progress of the work as a trajectory, the speed and direction of which is controlled by the client's concerns and their ability to attune to them. (Simpson 1999, p.3)

VIG in the UK does not often use the Traject Plan as a planning device; instead, it more frequently uses it as a celebration of progress and a discussion of 'working points' which can be constructed by guider and client at a mid-point or at the end of a series. The example below (Table 1.2) shows the main sections of attuned communication, daily life, development of child, development of parent and the family functioning in society. It is related to the case study above and again was created by the guider and parent together. Parents can use the Traject Plan as a summary of their VIG work that they can present at a review meeting for their child or can show to other professionals involved.

Table 1.2: Traject Plan for Rebecca and Joe: summary of impact of VIG intervention on different areas

Traject Plan areas	Current achievements/ strengths	Working points/ challenges
Basic communication	Joe doesn't get so frustrated when he speaks, he is easier to understand, he asks other children to join in games, he will say what he wants and he doesn't interrupt Rebecca now but waits his turn; Rebecca helps him to take turns. She's good at showing interest in him. She gives Joe lots of praise and he laps it up; he comes to her for help and with problems, and she knows how to help him; she can talk through concerns. Rebecca also feels she can communicate better about the good things,	For Rebecca to keep the good communication going by continuing to meet Joe in his world and enable him to feel listened to. Also, for her not to give herself a hard time about this, but to keep recognizing that she does it well and can tell by Joe's response.
Daily life	Enjoying doing things together, e.g. painting, outings. Able to take delight in daily life.	For Rebecca to keep noticing how she makes Joe feel heard, valued, respected and loved by what she does. Again, to keep noticing how much Joe responds to her and basks in the delight of it!
Development of child	Joe has gone from being hesitant to speak to actively enjoying talking to the whole class at school, and he has lots of friends. His imaginative play is much more developed and he happily involves everyone else in this play.	Enable Joe to continue this progress, so that both the behaviour support service and the speech and language therapy service will recognize the progress.

Development of parent	Increase in confidence, playfulness and strength as a parent: 'I've become a stronger person, the same as him.'	For Rebecca to maintain and continue to develop her levels of confidence in being a good parent, and ask for 'top up' VIG sessions if she feels her confidence go down. Also, for her to look after her health and general wellbeing, and to be viewed by social services as a parent who is coping well.
Neighbour-hood /Com-munity	Rebecca was able to walk away from sharing a house with a friend who also hurt her, and was able to ask for help from social care.	For Rebecca and Joe to find permanent accommodation and for Rebecca to keep using a wide support network.

Examples of shared review conversations

The transcript below has been selected to illustrate a typical conversation that takes place during a shared review of the video. The conversation was transcribed by a trainee guider (TG) as part of her own self-reflection during Phase 2 of training, where she was focusing on the impact of using questions and statements that encourage her client to take an active part in the conversation. The scenario consists of a learning support assistant (SA) who is working with a young pre-school boy (K) diagnosed with autism. The SA wants to discover how to make any sort of contact with him. This is her first review and her response to the first clip. It is a 15-second sequence (which is an exception to the general pattern of very little contact with K) of SA paying close attention to everything that K is doing and carefully offering him a few spoons to extend his play.

You can see from the transcript that TG is not telling SA what she is doing well in the clip but is activating her to discover this for herself. The TG uses a mixture of open questions, open statements and using the film together with a strong reception of what SA says. This strong reception is a very important component of VIG as it encourages SA to feel that her opinions are important and therefore supports deeper reflection.

TG: What do you see that's working really well there? *(activating supportive question)*

SA: He doesn't have eye contact there but he's definitely drawn to sounds that I made with the materials I used. I think following his interest as well because I know he likes to stir. That's why I was keen to offer him the spoons and I wanted to offer him choices as well.

TG: Yes, I can see that you are anticipating what he wants *(affirmative reception)*. Also, you're paying close attention to him. At one point you lean in and offer him the rice. *(responding by naming 'being attentive' behaviour)*

SA: Because I could see he was looking at it and I thought by bringing it forward it might prompt him to reach out and touch it. It's funny looking at it like this because at the time I didn't feel that confident in how it was going and I thought oh it's going to be dreadful but it's not too bad actually. I can see my awareness of K and his behaviour and what he was doing and how he was reacting so that makes me feel a little bit better.

TG: So you can see that you were following his interests and then that he seemed to notice you *(reception summarizing points made)*. Let's enjoy this again and carefully study how you are watching him and see if he is watching you *(using the video as evidence)*.

SA: Yes, he does follow what I am doing. But you're not aware of that at the time so I'm quite surprised myself really.

TG: I am wondering how you are feeling about that now? *(exploring changes in feelings)*

SA: That makes me feel better, actually. I feel that I was paying attention to his needs and following him and observing his facial expressions as well and he is beginning to notice me.

The above example shows that a short attuned conversation about an attuned interaction on the video can boost the support assistant's confidence as she can actually see how she is already helping the child. This is the first building block to her developing an enhanced learning environment for the child and this is the process that the guider 'guides' her through in the next clips and future videos.

How do people train in VIG?

VIG is not a skills-based training that can be learnt by following a manual. There are strong principles, guidelines and training standards which are evidenced throughout by video clips. However, the delivery of VIG is an art and as such it requires skilled 'coaching' but cannot be easily 'taught'. The training process for professionals provides an in-depth focus on the developing relationship between professional and client. The supervision sessions on the video shared review give space for self-reflection and reflection with the supervisor, suggest plans for improvement and use the evidence of change on the video. This cyclical process has all the elements of effective adult learning. Supervisors see their VIG trainees becoming more animated and effective with their clients as they progress through the training.

VIG training in the UK recognizes that this depth of discussion with vulnerable parents, or indeed with any clients, requires regular supervision. All shared review sessions are filmed during the training and these films (or edited clips) provide the focus of supervision sessions. VIG supervisors (those supervising guiders in training) follow the same 'intersubjectivity' principles, aiming to activate the trainee guider to reflect and develop their skills with attuned delivery of 'support and challenge'. Such a 'supervision process in training' supports the professional to have the 'space to reflect' on their attunement to the parent. This in turn gives the parent 'space in their mind' (Trevarthen 1998) to be able to respond to their child's signals while also reflecting on themselves as parents.

On the one hand, the guider is warm, responsive and genuine in believing that the parent is doing the best they can in the circumstances. On the other hand, the guider may also need to say 'difficult things' to help move a situation which has come to an impasse. Guiders are encouraged to find ways to say to parents what they really think will help them, at a time when the parents are ready to receive these comments.

Turning points for parents and professionals seem to take place around moments of joy which can be observed on the video and celebrated by both the professionals and the families and then again with the supervisor. The quality of the supervision process is central to the quality of the VIG method and Chapter 2 will develop the importance of supervision in VIG training.

VIG training in the UK usually takes the form of an initial two-day training course followed by three phases of training. These consist of 25 hours of individual supervision spread over at least 18 months plus 3

accreditation days. A fourth phase is added if a trainee wishes to go on to train as a supervisor. The supervisor 'guides' the trainee through the phases of training on a one-to-one (or one-to-two) basis, paying close attention to the balance of support and challenge for maximal growth.

Reflections on the VIG training process

To end this chapter, extracts from two VIG trainees' reflections are included below which allow us glimpses into the learning journey of a trainee guider. The first are 'verbatim' reflections offered during VIG supervision in Phase 1 by three VIG trainees from a range of caring professions and a VIG supervisor. The second is an extract from a written reflection presented as part of the Phase 3 final accreditation by a Portage (home-visiting educational service for pre-school children with additional support needs and their families) practitioner. These have been included to bring to life the VIG training process that has been and is being experienced by over 1000 practitioners in the UK.

REFLECTIONS IN SUPERVISION – PHASE I TRAINEES

I am used to reflecting on process because I use transcriptions of my work with individual families in my work on my masters degree... But VIG training is one step beyond, it has a rewind button. I think 'I could have done better' or 'I did better than I thought'. For instance with [family A], before I watched the film of the shared review I had remembered the silence before the mother started to cry when she saw the baby developing independence from her...it [the silence] seemed to go on forever and I felt really uncomfortable, yet looking at it with you and talking about it, I saw that the silence was necessary to help her express her feelings, and therefore completely appropriate. I came out [of supervision] feeling that I actually did some things well, as well as being able to look at difficult moments and re-evaluate them. *(Re-evaluating competence and improving confidence)*

I am aware of so many more of...the communication outlets, the little blips, the tiny movements but subliminal messages that she and I are giving, that you can pause and check out. It makes the simple message twice its own volume. You can take my camcorder away but you won't remove the VIG in me...it makes me feel

humble and more in touch with people at every level, not just people I am working with, but my own family... I used to think VIG was a technique I could get right, now I know it's at the core of my being. I used to think I listened to people, but really I wasn't listening very well. I can see why families might have disengaged. *(Increased awareness)*

...You have seen an emotional response, and you can be in tune with your own emotional response because you have had time to reflect before the situation. On a normal home visit, you never know where it's going, with VIG you can focus on what we have been called in to help with, rather than the most recent crisis. It is safer to explore the crisis within the VIG framework, and put some boundaries around it because you can focus back onto the film and talk about how that might be related to the current crisis situation. *(Emotional regulation and focus)*

REFLECTIONS ON VIG TRAINING FOR ACCREDITATION – PHASE 3 TRAINEE

I continue to find VIG tremendously satisfying both professionally and personally... This year something has 'clicked' with regard to my understanding and practice of the method and I have found the visual representation of the seven steps to a learning conversation very helpful in identifying and bringing clips to supervision. The fluency of the collaborative review has improved as a consequence.

I have moved on from being over-concerned about activating my client. I understand the need for balanced activation and compensation (see text describing 'attunement in the shared review' Figure 1.5) and I feel I have achieved this more over the past few months... My present practice, in which I feel the shared review leads to a deepening of the discussion and the development of new theories or thinking (a bit like grounded theory), has made me realize that in the past I had not facilitated this so effectively. I feel that I have become more confident so that I can enable the deepening of a discussion and exploration of thought with my client without fearing how that discussion may conclude – something I was subconsciously avoiding this time last year. The process of VIG focuses on the successful responses of clients to another's initiative that we hope they will identify and celebrate with our guidance. However, it is also based on a helping question derived from a problem area for them. The shared review

is therefore likely to take the client to an area of discomfort or pain at some point – the fact that the process is positive in its ethos then enables them to come out of the review safely and one would hope, more confident in what is really possible for them.

Using VIG is a way of practising mindfulness for me. I find that I am generally more mindful in my daily life – it can feel like VIG without the camera. I have been able to share with some families the skill of naming each other's actions and possible feelings as a non-directive method which has, at times, had a significant effect on communication and behaviour. This, I feel, has come from my VIG practice.

I thoroughly enjoy the beauty of a positive interaction between an adult and child – to see how a child can 'grow' when their initiative is responded to through attunement. To see an improvement in this relationship with parents and the young age group I work with is vital and can be life changing.

The spin off for me as the adoptive mum of a son with an attachment disorder is that I remain hopeful.

VIG and the Supervision Process

KATEŘINA ŠILHÁNOVÁ AND MICHELLE SANCHO

Introduction

Supervision is acknowledged as essential for the continued professional development of practitioners within a range of professions (Carrington 2004). It is seen as important for maintaining high-quality practice as well as the wellbeing of clients (Nolan 1999). Supervision has a number of functions which include educative, supportive and managerial (Hawkins and Shohet 2000). A variety of models exist which are employed by different supervisors and therapies. Well-established models of clinical supervision include developmental (Carrington 2004; Falender and Shafranske 2004; Powell, Leyden and Osborne 1990; Stoltenberg and Delworth 1987), process (Hawkins and Shohet 2000) and orientation-specific (Leddick and Bernard 1980; McDaniel, Weber and McKeever 1983). Page and Wosket (2001) consider supervision as 'primarily a containing and enabling process, rather than an educational or therapeutic process' (p.41) and Fruggeri (2005) sees supervision as a generative and transformative process, through which people develop abilities and skills (p.3).

VIG supervision is mentioned in the new guidelines produced by the British Psychological Society (Dunsmuir and Leadbetter 2010) as an example of specialist/therapeutic competence supervision, which is built on 'the core competence skills, which should be expected in any supervisory relationship, including respect, listening skills, understanding of professional and ethical issues and confidentiality' (Dunsmuir and Leadbetter 2010, p.8). This model fits well with VIG where the ethical values and core principles for attuned interaction and guidance underpin the supervision process.

VIG supervision can be viewed as an example of orientation- or therapy-specific supervision. In this model the processes and techniques used in supervision parallel those of a session with a client and are guided by the theory underpinning the approach (Russell-Chapin 2007). Supervision becomes a reflexive process where much learning and self-reflection takes place. Supervision in VIG was developed primarily as a training tool for individuals developing skills as a VIG guider or VIG supervisor and so was based on the principles and values of the VIG approach: principles of attuned interaction, intersubjectivity, empowerment, reflection and self-modelling. Joyce Scaife, in her book *Supervision in Clinical Practice: A Practitioner's Guide* (2009) also highlights the relationship between values and beliefs and the kind of supervision offered. Scaife encourages the clinician to consider what beliefs they hold about the supervision process and how it supports growth and change. She offers a few of her own beliefs, including: 'learners need to feel safe within the supervisory relationship to acknowledge their vulnerabilities and anxieties'; 'supervisors can have greater confidence in their own (supervision) work if it has been seen'; and 'the tasks of supervision are best accomplished when both/all parties take responsibility for the outcomes' (Scaife 2009, p.xi). The quality of the supervision process is central to the quality of the VIG approach employed by the trainee guider or trainee VIG supervisor (Findlay 2006). This supports Milne's (2007) proposal that supervision in evidence-based practice needs to be consensually defined and operationalized to achieve 'treatment fidelity'; that is, the careful definition of and faithful implementation of a specific therapy or intervention by providing consistency in training practitioners in that method, making comparative evaluations possible. The rigorous video-evidenced method of training through supervision and the thorough accreditation process using video exemplars that VIG guiders and supervisors experience goes a long way to explaining why VIG meets or exceeds the standards of consistency and fidelity that 'manualized' intervention aspires to achieve.

This chapter will primarily focus on an evolving model of supervision for the supervisors of trainee VIG guiders and supervisors and for continued professional development. It is acknowledged that there is much literature surrounding professional supervision. It is not the intention of the authors to review the general literature on supervision within this chapter, but rather to attempt to describe the distinctive aspects of supervision in VIG and the specific theoretical elements that underpin it.

Both authors of this article are experienced supervisors from different countries and different professional backgrounds with different histories

prior to becoming supervisors. Together with Hewson (see quote below) we also believe that supervision is a 'dance between two arenas' (Hewson 2001, p.65). On the one hand it entails the establishment and development of the supervisory relationship where people feel valued and can learn. This is constantly being balanced with the 'arena of science' (Hewson 2001, p.69), which can be described as the ability to name, classify, cluster and discover parallel processes within the supervisory process. For both arenas we need clear theoretical frameworks against which we can test our observation and develop our understanding of why this gently coordinated activity, which the supervisory relationship is, works.

> Supervision is an art and a science, a relationship and a knowledge base, an encouraging and supportive process as well as a monitoring one. The art of supervision is the ability to create a safe space, a relationship where the re-creation of natural curiosity and observation can be validated and enhanced. Supervision is the development of trust and respect, and the willingness to meet in an encounter of mutuality and mentorship. It requires sensitivity to the potential emergence of shame, needing an eye and an expertise not only to the subject matter but also in how to enhance the learning environment. (Hewson 2001, p.65)

From our experience as both supervisee and supervisor, key questions about supervision have arisen. These include:

- Which theoretical concepts help us understand good supervision practice?
- What are the different contexts for the use of VIG supervision?
- Is it possible to design a model for use in VIG supervision and is it possible to 'teach' supervision?

These questions form the basis of the remainder of the chapter.

Theoretical frameworks that conceptualize VIG supervision

In common with VIG, many (if not all) therapeutic and counselling approaches to supervision have taken their theory and practice from original therapeutic models and later applied these principles and processes

to supervision practice. As VIG supervisors we often ask whether these theories can explain our entire experience as supervisors and, even more, whether there are other theoretical concepts that can help us to understand and develop the whole complexity of an effective supervision.

There is no doubt that the main focus of the VIG approach is the relationship between two people, in which one side of this interactional process could be characterized as a person seeking help (care seeker) and the other side as a person willing to provide help (care giver).[1] As professionals we have increasingly recognized that the dynamics of care giving and care seeking are highly complex and have their roots in early infancy. This framework helps us to think about the ways in which people interact with one another, particularly in situations that bring them together to fulfil their goals (as in many therapeutic or supervision situations) (McCluskey 2005). What we, as helping professionals, expect from the theory and research are answers to basic but frequently asked questions, such as 'How does it work?'; 'Why does it work?'; 'How can clients best benefit from the process?'; 'What are we doing when helping?' The answers to these questions can help us maintain the delicate balance in this dance between sensitivity to how people ask for help and the awareness of how people learn and change.

It is generally agreed that:

> VIG is a sensitivity-focused intervention, where the underlying theory of intersubjectivity permeates the method at every level, from selection of clips of attuned interaction, and the therapeutic learning process in shared review, to the supervision of guiders delivering the intervention. (Kennedy, Landor and Todd 2010)

The theory of intersubjectivity is an important concept in understanding the interaction between two people, where 'the internal and the social worlds are not distinct or separable aspects, rather they are inextricably interwoven' (Dallos 2010, p.5).

The idea of the self as part of a system of social processes is also central to social constructionism, which arose from an explosion of ideas in communication and social sciences that questioned the possibility of objectivity, knowledge, reason, authority and progress in our social worlds

1 The care seeking/care giving concept was explored and researched in great depth by Una McCluskey and presented in her book *To Be Met as a Person* (2005). We borrowed this description of the specific role positions from this article as we think it could be applied universally to the relationship of mother and baby as well as to the relationship between two professionals (e.g. supervisee and supervisor). This explains the dynamic of interactions we are concerned with as well as the different motives that bring people together.

(Gergen 2001). Social constructionism claims that there is no pre-verbal, objective reality that we can know and that we co-construct the world through language (verbal and non-verbal) (Burr 1995). In this way therapist and client co-create 'reality' through conversation, where instruction is replaced by construction as a key element of therapeutic work. These ideas have radically altered the 'expert' position of any professional helper (therapist or supervisor); this helper becomes a 'collaborative explorer' co-creating meanings with the client. This new position allows us to appreciate that as soon as we meet a person we inevitably affect and are affected by them. However, there is also a new responsibility as we no longer remain outside the system we meet. We should be aware that we inevitably influence the system through the language we use, our verbal and non-verbal responses, our gestures and facial expressions, the way we 'see' and 'hear', what we are able or not able to notice and the way we ask questions or make comments. What we see and hear is also determined by our structure, by our past and present, by what we expect and want to hear, by our relationship with the client and also by the context and our understanding of the context (Watzlawick 1964).

Contexts of VIG supervision

There is no doubt that there are two main overarching goals of supervision in the helping professions which are traditionally recognized as:

- the welfare of the client

- the development of the supervisee.

This is, in fact, only the beginning of the story and the focus on these goals (and the contexts where these goals are defined) does not allow us to explore and understand fully what really happens during the supervision process.

VIG supervision is commonly used in two main areas:

1. VIG supervision as a training tool for individuals developing skills to become VIG practitioners. This context could be described as 'supervision as a practice of teaching'.

2. VIG supervision as a support for professional development – for those who have completed their formal training and are already accredited as VIG practitioners. This context could be described as 'supervision

as a practice of reflection on someone's therapeutic practice' (Fruggeri 2005, p.13) and is akin to Video Enhanced Reflective Practice (VERP).

We consider it important to make a distinction between these two contexts as they influence very different factors of successful supervision. In the first context, both supervisor and supervisee focus on a VIG model/approach that should be implemented by supervisees in their practice. We can speak about training in terms of 'teaching', where the main aim is building the competences and skills of the trainee in this specific approach to become a VIG practitioner. Fruggeri (2005) notes that in this context the supervisory process 'may – but we could say it should – address especially the individual level of construction' (p.18). Hence the educative function of supervision (Hawkins and Sohet 2000; Kadushin 1976) is to the fore, where one person is defined as the 'one who does not yet know' and asks to be trained in the approach and the other one is defined as 'one who knows more' about the model and agrees to transmit this knowledge (Fruggeri 2005). The contract that defines the relationship between trainee practitioner and trainer/ supervisor is centred on learning the VIG approach and includes training in the following:

- forming effective (therapeutic) relationships

- understanding (and actively using) the principles of attuned interaction

- training in the 'positive' eye, i.e. looking at things that work (well enough) instead of focusing on dysfunctions and problems

- analyzing videotapes (at a micro-level of interaction)

- developing the skills of editing video and selecting meaningful clips (as well as using the camera in a helpful way, e.g. focusing on positive moments of interaction)

- having effective conversations including the use of video clips and providing positive feedback

- dealing with boundaries and ethical issues as well as with the supervisee's own feelings, for example, fear and inadequacy.

The instructional content of VIG practice and the close monitoring of individual learning towards acquiring the key knowledge and skills is encapsulated in the VIG criteria for accreditation competence at four levels of practice, and trainees are coached and supervised to give evidence in micro-clips of interaction on video of: where they are meeting the

competencies; their strengths to date; and their current gaps or working points. The learning is scaffolded towards eventual mastery by visiting and re-visiting these at each supervision.

In the second context of supporting professional development, VIG supervision is centred primarily on the interaction of the supervisee (VIG practitioner) in supporting their work with a client. The main focus is on what they do together and how they move from individual construction to co-construction as a higher level of learning. The supervisees' requests to their supervisor gradually move to questions like 'Help me in reflecting on my work with my client'; 'Help me to understand better what is happening between the client and myself when we are working together'; 'How do my interventions meet my client's needs?' (this could also happen in the later stages of the first context). The experienced supervisee is likely to be concerned with deepening relationship dynamics, parallel processes, exploring different intervention options and resources in wider contexts.

The 'contract' that defines the relationship between supervisor and supervisee in this second context is no longer centred on the VIG approach itself but on reflection on how and to what extent it is manifested in the supervisee's practice. In this case the supervisor's role is to facilitate the supervisee to reflect on what people do together and how this affects their learning and all the relationships they are involved in. The VIG approach becomes shared and developed through supervision on a collaborative level and supervisees themselves can generate new ways of thinking and acting. For comparison this could be related to supportive aspects of supervision (Hawkins and Sohet 2000; Kadushin 1976).

A cyclical framework for a VIG supervision model

We have deliberately used the metaphor of the dance previously and we would like to continue to do so as this appropriately describes the processes involved in successful supervision. The skilled supervisor will draw on many skills and techniques to choreograph the supervision. However, in order to describe the success of this process, and indeed to answer our question 'Can we design a training model?', we propose a model that is divided into seven stages. It is important not to see these in consequential steps but more as integral parts that create a dynamic cycle which is under 'the control' of the supervisor. The linear limitations of our language are not sufficient to express the richness and complexity of a more cyclical process,

but describing these discrete stages offers us as supervisors and supervisees guidance and reflection in our work. This model can rather be viewed as a map that draws our attention to certain features that might otherwise be overlooked. It can help us to establish the boundaries and direction but this does not mean that supervisors have to follow this structure rigidly. The supervisor who uses this model effectively needs to have the ability to let go of the model or jump between stages when this is required. It should always be adapted to the needs, possibilities and preferences of the supervisee (Page and Wosket 2001; Šilhánová 2008).

Adopting a non-blaming approach, widening the focus on competencies and being willing to understand things from new perspectives is central to VIG. In the relationship arena both supervisee and supervisor when working together are trying to achieve mutual understanding. This mutual understanding (from individual construction to co-construction) is activated through dialogue, which is the main tool to support learning, reflecting and scaffolding new meanings. A successful result is a co-created 'working alliance' (Carroll 1996; Hewson 2001; Inskipp and Proctor 2001) which is a major aspect of the supervisory relationship. This intersubjective experience can be observed and explored deeply during the supervision session. From the point of view of the educative/supportive activity that supervision is intended to be, there is always

> one person (client) who seeks to engage the other person (the therapist) in attending to their emotional and practical concerns in such a way that they understand themselves better and manage their interactions with others more effectively... The therapist needs to respond with attunement and empathy, plus ideas and concepts which are held together within a theoretical framework that add a dimension that the client can use to gain another perspective on themselves and what they have brought. (McCluskey 2005, p.78)

It is acknowledged that attunement is a key element in developing the whole supervision relationship. Successful attunement constantly supports effective interaction on all levels. In supervision we need to recognize the level of attunement evidenced through the video clips and discuss this through a moment by moment analysis of those discrete levels of interaction barely perceived in live interaction by the human eye. We should always be aware how attunement or misattunement influences interaction at other levels.

If such attuned interaction takes place we can first witness emotional vitality between people which is linked to significant cognitive development where new ideas, possibilities and meanings on both sides can be explored. Even more importantly, renewed energy for activity towards change can occur (McCluskey 2005).

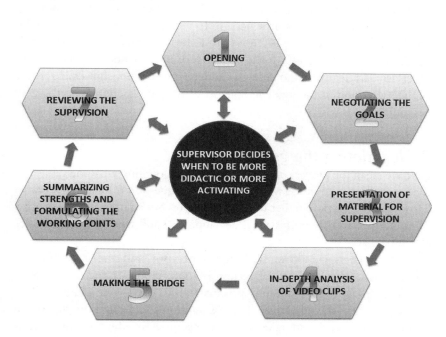

Figure 2.1: A cycle of VIG supervision model

1. Opening

Building relationships is central to the VIG approach. The opening is a moment of encounter, where the supervisor and supervisee meet. It is an important moment for making contact and for attuning to each other. At the very opening moments of the session supervisors should aim to create a safe space and conditions for the success of the whole supervision.

In fact the process of attunement starts even before the session, when supervisors should spend some time paying attention to themselves and their own state of mind. This moment of self-awareness (we cannot be aware of others when we are not aware of ourselves) enables supervisors to be connected with themselves. Supervisors might ask themselves: 'How

do I feel in this moment?'; 'What is my experience with the supervisee up to now?'; 'Am I confident of the way I am working with this person?' Supervisors should give free rein to their thoughts about what they need for the following session: 'What did we do last time and what was successful?'; 'Where should/could we go with respect to our trajectory?'; 'What were my working points from the last supervision?' It is important to point out that 'both supervisee and supervisor need to feel safe, to feel contained or held' (Wosket and Page 2001, p.24). It is hard to be a reflective learner when this condition is not achieved. In the supervisory process both supervisee and supervisor are learners and thus the supervisory relationship calls for our explicit attention to the key components of their interaction from the very beginning.

2. Negotiating the goals

Here we mean the process of contracting and negotiating what the subject of the supervision is to be, or what is the helping question from the supervisee: 'How shall we work together to meet the supervisee's targets (in the context of training or further professional development) and what more can I offer as a supervisor?'

A clear contract allows both the supervisor and the supervisee to acknowledge when their collaboration is approaching its goal. Supervisors should be aware that the training process with its clear goals and guidelines could 'prescribe' the objectives. This assumption could cause the supervisee to lose their way or to take less responsibility for their learning. It is therefore important not to underestimate the process of contracting goals for each supervision session. The supervisor needs to exceed the seemingly obvious goals set down by the training manual or training guidelines. The supervisor's role is to help in clarifying and formulating these objectives and then to transform them into collaborative and achievable goals in the context of the supervisee's situation.

Supervisors stimulate the active role of supervisees in supervision as supervisees often approach supervision without any clear objectives. It means that during such negotiating we should also establish the rules concerning time and the role of supervisor (on the continuum of 'teach me – support me'). It is very important to clarify what supervisees want to 'take away' as this increases their responsibility for the usefulness of supervision and their ability to reflect and learn.

Examples of a supervisor's stimulation could be through reflective questions such as: 'If we imagine that this supervision will be useful what

is most important for us to do together today?'; 'What will give you a more confident feeling?'; 'How will your clients recognize that you had supervision today?' All of these questions can help the supervisee to participate actively from the very beginning of the supervision session. The supervisor should pay attention to this stage, listen carefully and follow and respect the supervisee's wishes and their tempo of learning. This will help the supervisee to monitor the learning process and to reflect on how it fits with their overall goals and the trajectory of change/learning (client's and guider's).

3. Presentation of material for supervision

Supervisees are expected to prepare video material for supervision, including a video from the 'client's system'. This should include a video that focuses on the client's change and a second one of the shared review with this client focusing on the supervisee's trajectory of change and possible parallel processes. There could also be narrative material concerning the case or the supervisee's role as guider. The language of the narrative in addition to the video material may reveal important clues about the supervisee's attitude and whole approach. The supervisor's more objective stance and curiosity help examine the different contexts of the material brought to the supervision. Very often this curiosity allows 'hidden agendas' to reach the surface and become part of the main agenda.

At this stage, the supervisee's ability to recognize the importance and validity of the material in terms of usefulness for the client's or the supervisee's desirable change is activated by the supervisor. Choosing the material is in fact an important step in deconstructing the received narrative to allow a change in the professional's perception.

Acquiring the openness and trust to discuss and therefore select the relevant video clips that capture the trajectory of change will save valuable supervision time, which can be released to look in more depth at the analysis of that material.

4. In-depth analysis of video clips

It seems to be crucial to reserve relevant space for in-depth analysis of video material that the supervisee has agreed to work on within stage three. It is important to distinguish the chronology of the client recordings now under review. Normally the supervisee as a practitioner will, when meeting their client, first make a video of their shared review of the client tape from the

previous meeting; after this the practitioner will make a new video of the client's interaction which should reflect the learning from this shared review. Usually the videos are then edited and clips selected that evidence the client's and the supervisee's progress. The supervisor supports the supervisee to choose clips that show important moments that speak for themselves. These moments provide the evidence for discussion, especially evidence of positive moments as 'exceptions' from ineffective communication (this could be recognized on both levels of interaction as a chance to explore and understand parallel processes). The main line of the supervisor's questions is to support the supervisee to move away from describing actions (i.e., the behaviour of one person) in favour of exploring the interaction.

The depth of video analysis supported by video technology which allows us to freeze moments of interaction frame by frame and the supervisor's support facilitates the supervisee to discover 'magic moments of attunement'. The analysis uses as a map the 'principles of attuned interactions and guidance' to orientate the landscape of human interaction. As supervisor and supervisee view the clips they often have the map in front of them to assist recognition, and supervisors help supervisees to turn the language of their early observations into the precise terms of the principles that then allow them to communicate about what they see with families and with colleagues. Enabling the supervisee to see differently and label those observations facilitates different feelings and thinking, which leads to new meanings. Such analysis and discussion is the catalyst for change.

During this exploratory process the supervisor follows the same 'intersubjectivity principles' that the supervisor uses with the client. The supervisor's responsive repertoire creates the pre-conditions for effective dialogue, which is universally recognized as the most important part of supervision.

Figure 2.1 shows the supervisor in the centre of this cyclical process dancing to the tempo of the 'activation – compensation' continuum (see Glossary). The supervisor should be very conscious of this role as this will become the model for the supervisees in their own work with clients.

5. Making the bridge

We call this stage 'the bridge' (Wosket and Page 2001) as this indicates the transfer of what was explored in the supervision to the next consultation with the client. Not only the agreed clips, but all the ideas, meanings and decisions that came out of discussions concerning the interaction and their implication for the 'client's system' should be refined and decisions reached

about how, and to what extent and in what order, this will be shared with the clients.

The supervisor's skills in operating within the 'activation – compensation' continuum will be exercised to their limit in this part of the supervision. Supervisors need to work in the most flexible way possible: they can be more didactic (giving more information or suggesting the means of intervention) or very supportive, but they always should ensure that their supervisee is able to share the 'material' with the client in a sensitive and thoughtful way.

This stage requires a change of perspective as the analysis and reflection within the previous stage is brought to an end and all attention is now turned to its implementation. The supervisor can indicate this shift by suggesting: 'I think it is time to consider how to apply all that we have been doing (or analyzing, reflecting, discussing).' This could be further drawn out by reflective questions such as: 'I wonder what you want to do with all this material we have been analyzing (or discussing)?'; 'What would you like to take from our discussion to your next meeting with your client?'; 'What was most important for you from what we have been doing (or discussing) today?'; 'What do you think your client would like most from…?'

It is also very important to provide enough time for the supervisee to make this shift. There could be strong feelings about what was discussed in the previous stage or possibly some feelings of discomfort about how to bring all this back to work with the client. For many supervisees this could be quite intuitive, whereas for some this will need more exploration and support from the supervisor. For example, the supervisee might be invited to role-play with the supervisor, playing either the guider or the client. This experience can offer powerful and immediate feedback which bridges the gap of confidence between knowing and doing.

6. Summarizing strengths and formulating the working points

In this concluding stage supervisors invite supervisees to reflect on their strengths or things that they have done well in this work with the family so far, considering the potential barriers that they may have faced in getting to this point. These could be challenging aspects of the work itself and/ or technical challenges of learning how to make and edit good film. It is common for new supervisees to experience this part of the supervision as slightly uncomfortable and challenging as trainees are often more familiar with focusing on their working points or deficits. Supervisees' difficulties in recognizing their strengths and saying them out loud to another person

are accepted and supported and supervisees are encouraged to remember this discomfort when they first ask parents or clients to name their strengths so that they can help them learn to do it. During the recall of strengths supervisors often scaffold perceptions and memories by using prompts such as 'What about when the family cancelled but here you are with a film for supervision? – is there a strength in you that you made this happen?' Supervisors also name what they see as strengths and ask the supervisee if these seem reasonable. Once a good amount of time has been spent eliciting and exploring strengths supervisees are then encouraged to design individual working steps (both in their own trajectory and in the trajectory of the client). Those working points are small, realistic steps with the potential to be mastered in the time between supervision sessions. For example, the supervisee might be asked: 'What stood out for you as surprising or interesting in the session today?'; 'What would you like to develop further in the light of our discussions today?'; 'What do you plan to achieve before our next session?'; 'What will you do differently in your next meeting with the client?'; 'How will you get the client to use their strengths more often?'; 'What do you see as your working points?'

In this important stage the supervisor has to give the supervisee the opportunity to reflect on what they have learnt about themselves in the supervision, in light of both discussions and of the analyzed videotapes. The supervisee will begin to create a new reality of themselves and their clients. In order to promote change and development, the supervisor will need to help the supervisee crystallize in their mind how they need to develop and change with simultaneous awareness of their newly identified strengths. It is important that this stage is revisited at the start and end of the following supervision session in order to have continuity and consolidation.

7. Reviewing the supervision

The supervision process concludes with a summary and an evaluation connected to its beginning: the agreed goals for the supervisor and supervisee to work on together, and what they wanted to achieve in the supervision. The conclusion should also include a review of how they worked together.

The supervisor now has the opportunity to summarize their feedback and at the same time ask for feedback from the supervisee. Checking the usefulness of the process for the supervisee should be continuous. Finalizing the supervision with this conversation completes the cycle in both the supervisee's work with their clients and the supervisee's work with the supervisor. Each end becomes at the same time a new beginning.

At periodic intervals in addition to the regular end of supervision review it is beneficial to step back and take a look at the work done together from a longer-term vantage point and assess the supervisee's progress as well as the condition of the supervisory relationship. Such reflection on their work together, if it is a natural part of the process, helps all participants to consider the professionalism and quality of their work.

Conclusion

In this chapter we have raised certain fundamental questions about the process we call VIG supervision and have discussed these in depth, considering the process, its conceptual setting and its practical implementation.

Developing the relationship on all levels that are present in supervision is the cornerstone of the VIG approach. Successful supervision is creative work. Becoming a good supervisor requires personal attributes and skills that cannot just be learned from a book. A good supervisor will be a committed and lifelong learner who has achieved this through refining the process of self-reflection. This experience brings increasing self-knowledge and sensitivity to the supervision, so that the process utilizes all of the 'principles of attuned interaction and guidance' on which this methodology is founded. The supervisor becomes the model of effective communication for supervisees and provides them with new energy and inspiration through attuned interaction.

Hewson (2001) highlights that supervision has to be more than a model or method and even more than creating supportive relationships where people can learn: 'It is the combination of strategic thinking and sensitive enabling/mentoring relationship that will make the balance of art and science, one that will be in the service of supervisees and clients' (Hewson 2001, p.74).

Readers of this chapter also need to bear in mind the historical and cultural differences in the various countries where VIG is practised. VIG supervision is a dynamic system which is constantly influenced by practice, research and new theoretical discoveries. We consider that the exchange of ideas is vital for the continuing development of the approach and the constant improvement of the quality of our work with our clients.

How and Why does VIG Work?

JENNY CROSS AND HILARY KENNEDY

Introduction

The first paper on Video Interaction Guidance (VIG) in the UK, written a year after starting the training (Simpson, Forsyth and Kennedy 1995), acknowledged three discrete theoretical standpoints relating to the three core elements of the approach:

- *Video* – theories of change that use self-modelling and video feedback.

- *Interaction and Guidance* – theories of intersubjectivity and mediated learning.

- *Empowerment* – theories of change that emphasize respect, empowerment and collaboration with families.

These three related bodies of theory were used to explain why the earliest VIG work with families and teachers in Scotland appeared to the authors to be working so well.

Throughout the development of VIG in the UK over the last 16 years, these three sets of theory still stand as the strong backbone of VIG practice. These and many other theories have been discussed, debated and developed by VIG practitioners, supervisors (Simpson 2003) and researchers from a variety of professional backgrounds and cultures. In 2008 Hilary Kennedy created a snapshot of these theory-in-progress conversations and compiled a series of mind-maps with 20 VIG practitioners from the UK, asking them to discuss in groups 'Why VIG works when it does' (Kennedy 2008). This rich data was thematically analyzed, and the most commonly mentioned explanation was the quality of the 'relationships'. This theme included the

relationship between the guider and client, the relationship between the supervisor and the trainee guider and the relationship between the parent and child (or teacher and class). With a primary emphasis on sensitive communication between the parent and child or teacher and child some guiders spoke of the importance of 'parallel processes' operating between the guider and the parent and between the supervisor and the guider. Other key themes to emerge were around the value of the video as a visual addition to solution-focused support, the empowering effects of the method and themes relating to social constructivism.

This chapter is structured around the original three theoretical themes, which were echoed in the 2008 research, starting with an exploration of theories relating to the use of the *video* as a medium for change. This is followed by the theory of *interaction and guidance*, which ends with further discussion of the importance of relationships and communication in any successful intervention. Finally, we discuss how VIG actualizes the *empowerment* principles, values and beliefs that create the foundation on which VIG stands (see Chapter 1).

Video

The importance of the video as a powerful medium for change is described by Andy Sluckin, a clinical psychologist trained in VIG, in his paper 'Bonding failure; I don't know this baby: she is nothing to do with me' (Sluckin 1998). Sluckin discusses the impact of VIG, art and systemic therapy on two mothers with severe post-natal depression who were struggling to feel a connection with their infants. Both mothers were described as 'particularly enthusiastic about the therapeutic use of video'; in the words of one mother, 'It's mind blowing in changing my perception of myself... What I'm thinking and reacting inside is so different from what I see...' (Sluckin 1998, p.19). This reported experience of seeing and discussing positive video clips with the guider which are incongruent with the parents' negative views of themselves is fundamental to VIG and will now be considered in terms of explanatory theory.

How can working with video effect positive change?

In his book *Helping with a Camera*, Paul Wels (2004) gives extensive consideration to the theory and practice of using video for family interventions. He begins with the observation that photographs and video are not objective representations of reality but are deliberate constructions

which convey messages to and about the family by what is included and left out and what elements are given perceptual salience. This is not always understood by other agencies first hearing about VIG who might wish to look at video taken as part of a VIG intervention to provide an objective assessment of parenting quality to inform decisions about care. Not only are videos in VIG deliberately subjective (positively skewed) but they are intervention tools and not assessments in and of themselves.

Theories of why the visual medium of video is so effective in promoting change are summarized by Wels as those relating to concepts of 'self-confrontation', 'self-awareness' and 'self-modelling'. Within the concept of 'self-confrontation' Festinger's (1957) theory of cognitive dissonance suggests how viewing positive exceptions in video clips might lead to change in beliefs. In relation to this, Bandura's theory of the importance of self-efficacy (Bandura 1977) and Carol Dweck's work on attributional styles and 'learned helplessness' (Dweck 2000) are both useful in considering the process of cognitive changes occurring over time when people see themselves on video repeatedly achieving their goals. We will consider each of these in turn. The final section on the contribution of the video element of VIG will consider theories derived from studies of how the brain processes visual information about emotion from faces. It will describe the neurological processes that are triggered when we watch other people performing actions and when we watch ourselves performing actions on video.

VIG and video-confrontation or self-confrontation

Berger (1978), in reviewing the use of video-confrontation in psychiatric training and treatment, concludes that there is strong evidence for its potential to have positive effects on the patient. The theory of video-confrontation or self-confrontation in VIG is that the person who is depressed or lacking confidence in their abilities is 'confronted' with evidence in the video that challenges their own negative self-evaluation. They then experience cognitive dissonance, for example a discrepancy between what they see themselves doing in interaction with their child and what they believe about their capabilities as parents. Festinger (1957) first theorized the construct of cognitive dissonance as an uncomfortable (temporary) mental state arising when people find there is a gap between what they do and what they think they should do, suggesting that they have a basic need to avoid dissonance and to reduce inconsistency by changing either their thoughts or their behaviour so that they are congruent. Often the cognitive dissonance examples given in the literature involve situations in which people view their

behaviour as problematic compared to their positive beliefs or intentions. By contrast, in VIG it is evidence of positive behaviour in themselves and their children that the parent views on the video which is incompatible with prior negative self-beliefs such as: 'My children never listen to me and we are always arguing.' In this situation, with enough support from the guider and a number of sessions to repeat this challenge to negative self-belief, the negative self-beliefs gradually shift to fit with the positive self-behaviours and self–child interactions observed. Significantly, given the literature on relationship-based interventions, Bandura emphasizes that warm personal relationships are the best environment for supporting people to consider discrepant views. In our experience, what is special about VIG – and is a central part of its ability to improve outcomes for families who have been previously labelled by professionals as 'resistant to change' – are the two elements of attuned and supportive relationships with the guider and an emphasis on the parents' 'exceptionally' good interaction in video clips. If cognitive dissonance theory is right, adjustment between beliefs and behaviour could work in an unhelpful direction. Deficit-focused approaches by professionals highlighting the inconsistency between parents' desire to be deemed 'good enough' and confrontation with their actual behaviour which is judged 'not good enough' – without a supportive context to learn the necessary skills – may lead to parents having to forfeit positive intentions and hopes of being a good parent simply to achieve internal congruence. Maria V. Doria in Doria *et al.* (2009, 2011) was the first researcher in the UK to propose cognitive dissonance theory as a useful explanatory theory for how VIG might work at a social cognitive level.

Neilson (1962) considers what happens to an individual in video confrontation of themselves in a good light, using the term 'emergent phenomena' as follows:

> What people can do, and what things they see they can do…all of this we can become aware of either because we voluntarily set ourselves to look for them *or because the whole perceptual situation causes us to look for them.* (Neilson 1962, p.62)

By setting the expectancy frame for parents to view positives – 'I have some lovely film clips to show you of the activity we filmed last week' – and by excluding any clips of 'failure', VIG explicitly causes parents to look for and perceive 'what they can do' even in challenging times. When guiders ask them, 'How did you manage to respond with such sensitivity to your two-year-old when you had been up half the night with the baby?' it causes

the parent to recognize their own strengths in adversity that they may have been too tired even to register at the time.

VIG and self-awareness

When a person's attention is directed towards themselves and they are in a state of self-awareness, an automatic comparison is made between the perceived self and the standards associated with the ideal self. Wels (2004) notes that in these circumstances it is natural to try to close the gap between the two and this provides a motivation towards positive change. This theory can explain the common phenomenon reported by teachers that when psychologists come into class to observe 'problem' pupils, *unfortunately* the pupils behave much better than usual, thus failing to demonstrate to the visiting professional how difficult they can be. This is because the presence and interest in us of another person prompts us to think about our ideal self and to try to move closer towards it. In this example the teacher who is waiting for the visit of the educational psychologist might visualize their own 'ideal teacher' as someone who: plans the lesson so that it is interesting to the pupils; speaks kindly to the 'problem' pupil; smiles at and uses humour with the whole class; is able to stay calm but pleasantly firm about boundaries as the children get excited. This cognitive rehearsal of 'ideal self' and self-monitoring of actual self during the observation means that being observed in these situations helps the teacher *be as good as they sometimes are* with the class, and this reciprocally affects the mood and the behaviour of all the pupils. Our experience is that a similar process is involved when we set up a filming session with VIG interventions, but that we intensify the positive potential of the adult being filmed by asking them to think of doing something that the child and the parent will enjoy doing together. It is a conscious device to plan, where possible, for the creation and exchange of shared positive emotion.

VIG and self-modelling

Social learning theory (Bandura 1977) emphasizes the importance of people around us who function as role models for learning social behaviours; for example, the young or novices in an activity watch and attempt to copy how others perform an action. This natural tendency to learn by watching others has been harnessed by teachers and carers working with children and adults with learning disabilities, and modelling has become a research-validated technique in this field. Figueira (2007) notes that over time, researchers such

as Lantz (2005) have discovered that observational learning or modelling for students with learning disabilities works best when the model closely resembles the student in appearance (height, hair colour, ethnicity, etc.) and when the model has equal or higher perceived status in the student's eyes. The availability of affordable video cameras and improvements in editing technology then led to the next logical step, which was for teachers and researchers to try to teach students social and behavioural skills *using the student as their own model*. Figueira refers to this as video self-modelling, or VSM. Typically in this field sequences of skills are broken down into step-by-step components and various helps and prompts are provided to assist learning. By editing out evidence of the help and joining together all the parts of the sequence students can then watch themselves on video apparently performing the entire skill sequence without difficulty or mistakes. This method of using video of the self 'as-if-successful' to support change has been labelled Video Feedforward (Dowrick 1999; see also Chapter 14).

VIG and self-efficacy

Bandura has argued that a key concept in predicting whether an individual will engage in any action is the individual's beliefs about whether the action will lead to a successful outcome; that is their perceived self-efficacy (Bandura 2000). When parents have been referred to a professional for help in managing their child they have typically lost self-efficacy and self-confidence. VIG deliberately sets out to increase parents' self-efficacy, first by reminding them through the visual images in the video clips of their residual good interactions with others and the positive effects that they can create in interaction, and second by creating a supportive space in which to reflect together on the reasons for various successes in the clips.

In relation to this, Dweck's work on individual differences in attributions for success and failure and the concept of 'learned helplessness' (Dweck 2000) are helpful in understanding change in VIG interventions. These will be considered in the final section of this chapter on empowerment and social constructionism.

Neuroscience and the power of the visual image

The 'mirror neuron system' was discovered less than two decades ago (Gallese *et al.* 1996; Rizzolatti *et al.* 1996), well after the development of VIG in the Netherlands. It was a major discovery and is beginning to build biological evidence for what so many VIG practitioners and recipients were

seeing and feeling on an intuitive level. In the UK Terri Pease was the first person to present a paper on the neurological basis of VIG (Pease 2006). The next section will explain what mirror neurons are and how they were discovered and will then consider the importance of these findings in the search for an explanation as to why VIG works.

THE DISCOVERY OF MIRROR NEURONS

Neuroscientists working in Parma, Italy initially discovered mirror neurons almost by chance when a research assistant started eating an ice cream in the laboratory and the scientists were surprised to see a sensory-motor cell in a macaque monkey's brain activate as if the monkey were eating an ice cream itself (Rizzolatti *et al.* 1996). After many experiments Rizzolatti and his colleagues concluded that a class of visual-motor neurons in the premotor cortex, which are active when the monkey produces a specific action like eating an ice cream, are also active when the monkey simply *observes* a human performing that action (Rizzolatti and Craighero 2004).

Once these revolutionary findings were scientifically established for monkeys (Rizzolatti *et al.* 1996), the next step was to explore the possibility that humans could also have a similar system. Marco Iacoboni, a neuroscientist from the University of California at Los Angeles, has been exploring this hypothesis (Iacoboni *et al.* 1999) along with many others and has published a book, *Mirroring people: The New Science of How we Connect with Each Other* (Iacoboni 2008). This book presents strong evidence that mirror neurons exist in humans and that they seem to be the *only* cells that specialize in coding the actions of other people as well as our own actions. Mirror neurons could therefore be the 'biological correlate' (Wolf *et al.* 2001) of intersubjectivity. Wolf's proposal is extended by Stephen Seligman: 'The emerging model of mirror neuron functioning corresponds to the second feature of the intersubjective core experience: that as others are encountered they are simultaneously taken as similar and different from oneself' (Seligman 2009, p.504).

SO WHAT DO 'MIRROR NEURON' FINDINGS MEAN FOR VIG?

The parent's mirror neurons connected with 'smiling' fire when they see their child smiling in response to them in real life and again when they review the video. They also fire when they see the guider smiling; the guider's mirror neurons are also firing. This describes the neurological response to experiencing and seeing attunement. These facts help to explain why both parents and guiders can look and feel happier as the shared review

progresses. Mirror neurons explain the fact that the use of negative video clips (even when the discussion is focusing on preferred behaviour) does not promote the desired change. This is because we process images through direct feeling before we engage in thinking. When a parent sees an image of themselves responding with anger to their child, their mirror neurons will react to that image before the rational discussion about that image can be processed. It proves that babies' brains are programmed to learn with and from others. The strongest research on human mirror neurons is in adult–adult interaction, and these findings explain the importance of the intersubjective dialogue (or the therapeutic relationship) when the video clips are reviewed, either by the parent with the guider or by a trainee guider with the supervisor during supervision. It explains the unconscious mirroring of non-verbal behaviour so often seen when two adults are reviewing a video and the strong emotional connection observed in 'moments of change'.

HOW DOES VISUAL PROCESSING OF EMOTION THROUGH FACIAL EXPRESSION FIRST DEVELOP?

In this section we will consider how primed humans are to process emotional signals from facial expressions and look at the neurological and physiological correlates of positive and negative facial affect in communication.

Developmentally it is the visual channel that takes primacy – 'The child looks and recognizes before it can speak' (Berger 2008) – and as adults we process vision before words. In infant development vision is closely linked with social development and it is normally close face-to-face contact and positive facial expression from the carer that triggers the development of first smiling in babies. This is confirmed by the late development of smiling in infants who are blind (Fraiberg 1977).

Allan Schore suggests that it is positive looks that are the most vital stimulus to the growth of the socially and emotionally intelligent brain (Schore 1994). When a baby sees their mother smiling at them this stimulates the release of beta-endorphin and dopamine – feel-good biochemicals – which then travel to the social (orbito-frontal) region of the brain and cause it to grow. Conversely, negative facial expressions and negative communication to babies trigger the stress hormone cortisol, which stops both the circulation of endorphins and dopamine and the pleasurable feelings they generate. Disapproving or rejecting looks to young children cause a change from sympathetic arousal to para-sympathetic arousal and can trigger a sense of shame, associated with a sudden lurch into low blood pressure and shallow breathing. Peter Fonagy's work explores the neurology

of attachment and maltreatment, and he presents the findings of Cicchetti and Curtis (2005) on the effects of angry faces on maltreated and non-maltreated child populations, showing that when maltreated children are faced with an angry adult's face their EEG monitors show high levels of arousal compared with non-maltreated children, suggesting their physiology and learned responses to maltreatment make them vulnerable to future stress (Fonagy 2009).

Although the research and theory that we include relates mostly to children processing emotion from their parents' facial expressions our experience is also that parents sometimes talk of disliking professionals who are judged as 'cold' or 'stony faced', and we intuitively theorize that the friendly and sympathetic face and the emotional reception of parents through face-to-face communication are key elements of why VIG works. To conclude:

> Brains are built relational – for example they automatically prime themselves to copy what respected others are doing and they automatically build models of how those around look, sound and react. This capacity for intersubjectivity may well be crucial for consciousness of all kinds including mindfulness. (Claxton 2006, p.303)

This now leads us to the core of VIG: the principles of attuned 'interaction and guidance'. These have been developed from the micro-analysis of Trevarthen's videos of optimal interactions in parents and their babies (Trevarthen 1979a) and are connected to the theories of intersubjectivity and mediated learning.

Interaction and guidance
Theories of intersubjectivity
This section will introduce the reader to the history of the establishment of 'intersubjectivity' as a core psychological theory. This is important for VIG because the central 'principles of attuned interaction and guidance' are directly related to Trevarthen's view of intersubjectivity (Trevarthen 2009).

When VIG in the UK was developing in the 1990s, there were very few interventions that focused on the relationship *between* parent and child or teachers and their class. VIG's focus on the 'interaction' and the emotional expressions around this interaction was unusual. Similarly, Trevarthen's propositions that 'in any interaction there are two equally important people'

and that emotions are of central importance were still not generally accepted in mainstream psychology. These times have changed, and intersubjectivity is now 'anchored' in developmental psychology. In a recent article by Stephen Seligman (2009) called 'Anchoring intersubjective models in recent advances in developmental psychology, cognitive neuroscience and parenting studies' he introduces Trevarthen's article (2009) with:

> He [Trevarthen] has distinguished himself for more than four decades as one of the most inventive and rigorous explorers of infant development and its implications. Among the infant research *cognoscenti*, he ranks with Bowlby (1969), Sander (2008), Stern (1985) and Emde (1983) in breaking misleading assumptions of the varied disciplines to see what mothers and babies really do. (Seligman 2009, p.504)

HISTORY OF THE TERM 'INTERSUBJECTIVITY'

The concept of intersubjectivity in developmental psychology is not new. Stout (1903/1915, p.170) states that 'from the start there is a marked difference between the child's relations to persons and his relations to inanimate things'; he goes on to say that 'intersubjective discourse can only exist in a rudimentary stage before the growth of imitation and language as the vehicle of ideal construction and ideal communication' (Stout 1903/1915, pp.172–3).

However, the concept seemed to be forgotten in the development of psychology as a science, with behaviourism (Skinner), cognitive psychology (Piaget), psychodynamic theories (Freud) and linguistics (Chomsky) taking centre stage. Even as late as 1971 Rudolf Schaffer stated that 'at birth, an infant is essentially an asocial being' at the start of his book *The Origins of Human Social Relations* (Schaffer 1971). In the late 1960s there was an attack on this perspective. John Bowlby published the first of his trilogy on attachment separation and loss in 1969, proposing that the mother–infant interaction was enormously subtle and based on an observable process of smiling, crying, babbling, looking and listening and on the mother's responsiveness to these messages. Bowlby is describing the two-way relationship between mothers and their babies, and his proposal that a baby was 'born social' reworked psychoanalytic ideas.

In 1967 and 1968, there was an influential group of researchers working at the Centre for Cognitive Studies at Harvard University, including Martin Richards, an ethologist from Cambridge, Berry Brazelton, a paediatrician, Jerome Bruner, Professor of Psychology, and Colwyn Trevarthen, Professor

of Child Psychology and Psychobiology. They were involved in an ambitious project analyzing the behaviours of 16 infants from birth to 3 months in relation to the two modes 'doing with objects' and 'communicating with persons'. They saw differences and decided to study this more closely using the new, relatively cheap video cameras which had a great impact on the possibilities for scientific rigour and for reflection. They looked very closely at five babies from shortly after birth to 6 months using the mirror-behind-the-infant technique so that full-face pictures of the mother and infant at the same time could be obtained. In this way they could see frame-by-frame and hear (although the sound had to be recorded separately) exactly how the interactions progressed. They could rewind and review and they could develop reliable coding; through this they discovered that from the very beginning babies were different in their interactions with people from their interactions with objects. Bruner first reported this finding in 1968 as 'the innate predisposition to expect reciprocity in specific gestures' of eye contact, smiling, crying and vocalization (Bruner 1968, pp.56–7).

During the 1970s exciting, often unrelated, studies in parent–child interaction were carried out, often using video as data. Margaret Bullowa, from the Massachusetts Institute of Technology, edited a book, *Before Speech: The Beginning of Interpersonal Communication* (Bullowa 1979). In the introduction, she states: 'It came as a surprise to me to discover the extent to which we are in basic agreement…that meaning and intent are fundamental… Timing and sequencing are acknowledged aspects to investigate. These ideas must be "in the air".' One of Trevarthen's seminal papers 'Communication and cooperation in early infancy: a description of primary intersubjectivity' appeared in this book. The chapter is key reading for those involved in VIG who want to study its origins.

> For infants to share mental control with other persons they must have two skills. First they must be able to exhibit to others at least the rudiments of individual consciousness and intentionality. This attribute of acting agents I call subjectivity. In order to communicate, infants must also be able to adapt or fit this subjective control to the subjectivity of others; they must also demonstrate 'intersubjectivity'. (Trevarthen 1979a, p.322)

Discussion of intersubjectivity

At this point, it is important to clarify the current thinking about the use of the term 'intersubjectivity'. Some psychoanalysts have been interested in the

'intersubjectivity' in their patient's relationships and in their own therapeutic relationship with the patient. Benjamin (1988) wrote an important feminist critique of psychoanalysis challenging psychodynamic thinking and re-examining the nature of interaction. Her premise is that there are always two subjects negotiating each other's personhood, and she proposes looking at a therapeutic relationship from an intersubjective standpoint. Beebe (2005) have written a fascinating book in which they have extended their studies of caretaker–infant interaction to the broad field of intersubjectivity in adult psychoanalytic treatment. The details and arguments regarding the complexities of the use of the term 'intersubjectivity' are beyond the scope of this chapter, but the interested reader is encouraged to study their three theories of intersubjectivity for infant research (Meltzoff and Gopnick 1993, Stern 1997 and Trevarthen 1998) and five theories in adult treatment including Benjamin (1988). In VIG theory the concepts of primary and secondary intersubjectivity following Trevarthen are central to the method and are now discussed.

PRIMARY INTERSUBJECTIVITY

Primary intersubjectivity in developmental psychology from the 1960s Harvard studies described earlier can be defined as the innate capacity for early subject–subject engagements.

> Emotional expressions of newborns – smiles and coos of recognition, frowns of annoyance, and hand movements that signal changing states of alertness, distress or interest, and readiness for making communication – announce, for a sympathetic other person, the infant's state of openness to the world. (Trevarthen 2004, p.10)

Mother–baby interaction has often been likened to a dance, in which the two partners intuitively read and anticipate the rhythmic movements of one another (Stern 1997; Trevarthen 1979a). Hanus and Mechthild Papoušek, were part of the early group exploring the importance of emotionality in young children (Papoušek and Papoušek 1997). They gradually found evidence that the vocalizations of babies in different cultures have a universal core that they explained by the term 'intuitive parenting' which provides the support for cognitive development (Papoušek and Papoušek 1997). Harrie Biemans, the Dutch psychologist who developed Video Home Training (VHT), was interested in the Papoušeks' work and their belief in the natural ability of all parents to rediscover their own 'intuitive parenting' once they

have been supported to respond within the attuned cycle. This means that they do not need to be taught how to parent but can learn from their own child.

Emese Nagy has demonstrated the remarkable ability of newborns to imitate attitudes, expressions and gestures. She tested the infant's ability to make an initiative by withholding her presentations of expression after she had successfully encouraged the baby to imitate her, tempting the baby to 'propose' behaviours which she, the adult, might then imitate. This was successful and was extraordinary to observe in frame-by-frame video footage (Nagy and Molnár 2004). This discovery is very important as often imitation experiments present babies as passive objects who are being trained to imitate others.

Zeedyk (2006) provides an important paper on the move from subjectivity to intersubjectivity in which she draws attention to the central role of emotional intimacy in the process of imitation. She proposes that 'developmental research needs to be re-orientated from the baby as imitator to the baby as imitatee'. This is exactly the focus of VIG when the adult follows the child's initiative in an attuned way and is its core principle. Zeedyk recognizes the central role of emotional intimacy within 'imitation': 'Imitation as an inherently intersubjective phenomenon, in which both infant and adult are actively involved in an emotionally endowed communicative exchange' (Zeedyk 2006, p.336).

The following experiment and later verifications are of central importance to the core principle of attuned interaction in VIG, as they highlight the primacy of responses to others' initiatives, not simply the behaviour. The experiment was created by Lynne Murray (Murray 1998; Murray and Trevarthen 1985) while she was studying the differential responses of babies to depressed mothers. She looked closely at a variety of disruptions of maternal behaviour with 6- to 12-week-old infants (such as interruptions or a still face), but it is the final condition of the study when the mothers and infants were presented with normal communication *but losing its relationship in time*, that is, not in real time, that is of crucial importance to VIG. A double TV apparatus, invented by Lynne Murray, in which a young baby and the mother (not depressed) are communicating via a video and sound link while in separate rooms, seeing and hearing each other face to face and life size on two monitors, allows a critical experiment to be performed. A lively, positive portion of the recording from the mother is relayed to the infant with a few minutes' delay. The distress this produces shows that a two-month-old is extremely sensitive to the responsiveness of the live mother's expressions, which is lost when a physical recording is offered of what was a cheerful

live conversation. The mother's behaviour also changes from the 'live' to the 'replay' condition, causing the usual characteristics of 'motherese' in the speech to become more complex and more directive, controlling and critical (Murray 1998).

Trevarthen (2004) draws the following conclusion: 'Live communication has to be just that, a real time engagement of feelings and impulses to communicate. A delay or an inappropriate response proves that the other is "out of touch"' (Trevarthen 2004, p.10).

The concept of contingency is also expressed in the assessment of parenting and attachment provided by Patricia Crittenden (2009) in the development of the CARE Index, in its coding of parenting as sensitive (sensitive and contingent to the infant's communication) vs. unresponsive or controlling (contingent but not sensitive).

The scientific reaction in the early 1980s to Murray and Trevarthen's work was initially critical, finding fault with the scientific design within a positivist tradition. Nadel *et al.* (1999) repeated this experiment using a tightly structured research design and consequently refuting previous objections (e.g. the babies were more tired in the non-contingent condition; blind rating by researchers). They confirmed the findings of the earlier study that, without doubt, babies react differently when their mothers' actions are non-contingent to their own.

This is important evidence to validate the key VIG premise that in an interaction, it is not what a person does that is important but what that person does in response to another, and that both partners are equally affected by disruptions in communication.

SECONDARY INTERSUBJECTIVITY

Returning to the study of the development of parent–infant interaction, it is during the period of birth to three months that primary intersubjectivity in its purest form can be observed:

> After 3 months, the baby will develop increasingly adventurous plans, making more vigorous use of their senses and limbs, seeking to explore and to form concepts of objects, negotiating purposes and the tempo of experience more vigorously with others. (Trevarthen 2004, p.10)

From three to nine months is the age for development of games, jokes and tricks, starting with person–person games and moving to person–person–object games. The baby leads the parent's attention to explore the shared

world and begins to share affective experiences of people and things, 'combining communication about action on objects with direct dyadic interaction' (Trevarthen and Hubley 1978). This is how the development of 'co-operative awareness', 'proto-language' (Halliday 1975) or 'secondary intersubjectivity' becomes established.

Penelope Hubley describes her discovery of the emergence of secondary intersubjectivity in the important paper 'Sharing a task in infancy', for which she intensively studied the development of cooperative understanding in five girls from the ages of eight to twelve months (Hubley and Trevarthen 1979). Peter Hobson (2002) is cautious about talking about the infant understanding that the other person has a mind but asks us to focus on what we see, which is the infant reacting in a new kind of emotional engagement to the attitudes of others to objects and people. He highlights two distinct classes of communication in this stage: one when the infant requests that an adult *does* something and the other when the infant *shows* the adult something. It is this 'showing' communication that is an invitation for social engagement and that has a livelier dance.

What is important for VIG is that secondary intersubjectivity is about developing a two-way cooperative understanding, with the face-to-face attuned interactions around the new focus being as exciting, complex and melodic as in the primary intersubjectivity phase. It is hard to capture in either words or still pictures the excitement of a playful, joyful interaction when a new understanding is reached. These are the video clips that energize researchers and VIG guiders and their clients when they explore these 'moments of vitality' (Stern 2010).

Relationships

Relationships are built from patterns of interactions (attuned or discordant) over time and are of key importance to our health and happiness. VIG focuses on improving attunement in 'interactions', aiming to establish a more attuned interaction pattern and hence improve the quality of the relationship. This idea relates to the literature on attachment difficulties which holds that improving maternal sensitivity could move children into a more secure attachment classification.

Bakermans-Kranenburg, Van IJzendoorn and Juffer (2003) produced an important paper in which they aimed to provide evidence for the best intervention practices for babies experiencing attachment difficulties. A meta-analysis of 51 interventions, all RCT (randomized controlled trial), on more than 6000 mothers, that aimed to promote attachment, found that

interventions using video feedback (ES = 0.44) were more effective than those without and that short interventions that focused on sensitivity alone were the most effective (ES = 0.47) (Bakermans-Kranenburg *et al.* 2003). As the reader will see, VIG has a high probability of working as it is a short, sensitivity-focused intervention using video feedback.

VIG is also effective because of the attuned interactions between the guider and parent. 'Among the most consistent findings of psychotherapy outcome research is that the therapeutic relationship is vital in contributing to client progress' (Lambert and Ogles 2004, p.19). This proposition is not recent. Freud (1940) wrote about the profound importance of the therapeutic alliance within psychoanalysis. Rogers (1979) moved the concept to a wider 'counselling' context and stressed values such as empathetic understanding, non-possessive warmth and positive regard.

Michael Lambert and colleagues (Lambert 1992; Lambert and Ogles 2004) have investigated the common factors that lead to successful outcomes using multiple analyses of research in counselling and psychotherapy and have proposed four factors that contribute to change. They are

> *Client factors* (accounting for 40% of change): Everything that the client brings to counselling – strengths, interests, perceptions, values, social supports, resilience and other resources
>
> *Relationship factors* (accounting for 30% of change): The client's experience of respect, collaboration, acceptance and validation from the counsellor
>
> *Hope factors* (accounting for 15% of change): The client's positive expectancy and anticipation of change
>
> *Model/technique factors* (accounting for 15% of change): The counsellor's theoretical model and intervention techniques (Murphy 2008).

VIG has every chance to be effective as it aims to support the client to be actively involved in their own change; it provides 'video reflective' supervision aiming to optimize the guider–client relationship while hope is maintained as it is a method based on strengths and optimism. On the foundation of this strong relationship, effective 'guidance' can be offered and received. Children can learn how to manage volatile emotions with support and their parents can learn from the guider's and theri own experience.

Mediated learning

'Secondary intersubjectivity' is an important stepping stone to 'mediated learning' (Feuerstein and Feuerstein 1991) and the dividing line between them is unclear. In mediated learning, the more knowledgeable adult 'mediates' between the child and the task, breaking the task down and using strategies to keep the child interested. Reuven Feuerstein uses a Vygotskian view of learning in which social interaction with a more capable other is the way in which learning and the assimilation of culture take place (Vygotsky 1962). It could be argued that once a baby is in any stage of intersubjectivity with an adult, they are in a sense 'learning' from that interaction: 'In humans intersubjective awareness motivates cultural learning – the intergenerational transmission of knowledge and skills with all the conceptual and material consequences' (Trevarthen and Aitken 2001).

In the VIG 'principles for attuned interaction and guidance', mediated learning is the core theory for the 'attuned guidance'. For the guidance to be attuned, it has to be in the learner's 'zone of proximal development' (Vygotsky 1962). If the adult's contribution is either too advanced for the child or delivered in such a way that the child cannot grasp it, then the interaction ceases to be attuned. This process was first described as 'scaffolding' by Wood, Bruner and Ross (1976) in the context of mother–child interaction and is now a term firmly established in early education literature; it is also an important component of attuned guiding in VIG. VIG provides mastery experiences for the parent by working at the right difficulty level and with sufficient support to enable success. 'Successful efficacy builders do more than convey positive appraisals of capabilities. They structure situations in ways that bring success and avoid placing people in situations prematurely where they are likely to fail often' (Bandura 2000, p.302).

Barbara Rogoff's work provides further theoretical ideas important for the cultural learning both of children of school age and of adults. She contrasts 'adult-run' and 'child-run' ways of teaching and develops her interest in a 'community of learners' (Rogoff 1990; Rogoff et al. 2003). She bases her writings on observations of how children learn as apprentices the skills and values of their family and community. She proposes that children learn naturally from observing more skilled others (adults or often other children) and then trying to join in. Jerome Bruner (1996) emphasized the difference between 'teaching' and 'learning', proposing that children learn best in a community of learners in which teachers are aiming both to support the learning and to be 'guided, directed and inspired' by the pupils. Bruner

described this type of education as 'a subcommunity of mutual learners with the teacher orchestrating the proceedings' (Bruner 1996).

When dealing with conflict or exploring different opinions, the 'principles of attuned interaction and guidance' are informed by Argyris and Schön's (1974) theory of action and double loop learning for reflection and the importance of the dialogic processes (Alexander 2004; Barrow 2010).

THEORY OF ACTION AND SINGLE/DOUBLE LOOP LEARNING

> When someone is asked how he would behave under certain circumstances, the answer he usually gives is his espoused theory of action for that situation. This is the theory of action to which he gives allegiance, and which, upon request, he communicates to others. However, the theory that actually governs his actions is this theory-in-use (Argyris and Schön 1974, pp.6–7).

Argyris and Schön further developed the concept of two types of strategies, single loop and double loop, which support people to actualize their 'espoused theory' instead of responding with their 'theory in use' (that is, to do what they would want to do instead of their automatic reaction).

In single loop learning, the guiding values are 'win, don't lose' and 'avoid unpleasantness', while keeping unilateral control. In this way, underlying assumptions or beliefs are not challenged. In contrast, in double loop learning, underlying assumptions are shared and explored, increasing valid information for all, enhancing freedom through informed choice and developing commitment and responsibility through bilateral control.

The reader will see that this is important for the exchange of ideas beyond what is seen in the video during the shared review. The guider will be given a chance to reflect in supervision on their theory in action and espoused theory and to think what conversation could bring them closer to their (related to VIG's) espoused theory. Guiders can then reflect on whether they were acting within a single or double loop model and explore how to move towards a strong double loop model. Often supervisors ask guiders about their thoughts when their client is speaking. A guider might say, for example, 'I am thinking that we are stuck in an old story that I keep hearing and am not sure how to move on without seeming rude.' The supervisor can then say, 'Well, how can you let them know what you are thinking, because this is important?' The reply could be, 'I could say: "Hold on a minute, I am not wanting to cut in but I am wondering how this story is helping us. We

discussed it last week. It is important to you, I hear, but how can I support you to move away from this story to the way you would like things to be?"'

Using the concept of 'increasing valid information' and encouraging 'bilateral control', the guider can enhance their skills in moving from 'difficult conversations' to 'learning conversations' (Stone, Patton and Heen 1999). The book *Difficult Conversations: How to Discuss what Matters Most* by Douglas Stone and colleagues (from the Harvard negotiating project) fits very well with the VIG and 'theory in action' model.

Learning conversations are, of course, important at all times, not just when conflict arises. They allow a range of possible attributions to be explored for success with support for the parent to look at the video for evidence of where their attunement and receptivity to the child impacted on the child's wellbeing.

DIALOGIC PROCESSES

Teachers can reflect on their interactional styles within the moment of teaching and discuss with the guider ways to explore and extend classroom dialogue. This is a method where 'reflection on action' does not rely on memory because the video provides evidence.

The aim of classroom talk, according to Robin Alexander, is to focus on promoting the types of interactions that probe and extend children's thinking and understanding. His concept of 'dialogic teaching' places talk as the key driver in the processes of thinking and learning. He considers that 'talk vitally mediates the cognitive and cultural spaces between adult and child, between teacher and learner, between society and the individual, between what the child knows and understands and what he or she has yet to know and understand' (Alexander 2004, p.2).

Wilma Barrow (2010) takes the dialogic process further.

> The role of dialogue in such processes has been recognized in the literature on children's participation rights. Fattore and Turnbull (2005) argue that as children are able to engage in intersubjective understandings with others, they can enter into inter-generational communication and that dialogue is therefore vital to their participation. (Barrow 2010, p.9)

These important issues show the power of attuned dialogue to reach the very heart of empowerment democracy (see Chapter 18).

Empowerment

Social constructionism and constructivism

VIG is informed by the perspectives of social constructionism and social constructivism. Social constructionism is the idea that our experience is given meaning by culture – by people around us, the structures and institutions we inhabit and the discourses that inform these. This is the idea that experience and identity are not just internal but are collective and distributed, meaning that reality is created in a social context.

We are, however, active in the construction of our experience and identity; we are not just determined by culture and context but are constantly making meaning from our experiences. Such ideas come from a social constructivist perspective – that reality is constructed. VIG uses such ideas along with those of social constructionism since the perspectives we hold about ourselves that provide the frame for giving meaning to our lives are often strongly influenced by the discourses and normalizing ideas of society and culture.

What are the implications of this for how VIG works? We understand people who consult with us as the primary authors of their own life; it is they who are making the meaning. They have a lived experience that gives them perspectives not available to those outside that experience. VIG works as a process as it has the guider standing alongside the guidee, attuned to and receiving the perspectives, ideas and meanings of the guide. It works because it is not an approach in which the guider is the expert in the person's life; rather, the guider recognizes the person as knowledged. The ability of the guider to co-construct meaning with the guide is one of the central aspects of their relationship that empowers the guidee. Whilst the guider focuses in the early stages on the immediate micro details of the principles of attunement, this leads to a deepening discussion that recognizes the guide as existing in a sociocultural world. One of VIG's strengths in terms of how it works is that it is an approach that recognizes experience as constructed and not just as internal, and as constructed in the social context.

Active engagement in change

COLLABORATIVE FEEDBACK

The concept of 'feedback' is fundamental to systemic thinking. Recognition of its importance prompted therapists to move from 'an intrapsychic view of the person to an interpersonal one and helped therapists to make sense of puzzling and repetitive communication patterns' (Hedges 2005, p.10). George Kelly (cited in Ravenette 1999) suggests that if you want to know

what someone means, then ask, and emphasises the process of open questioning and exploring. This reflects Wittgenstein's (1953) proposition that it is impossible for a therapist to be an expert on what a client *really* means as we cannot see into others' minds. Likewise, personal construct theory argues that individuals are constantly engaged in making meaning of their world (the construct system) and, in relation to this, behaviour is viewed as an experiment (Ravenette 1999).

John Hattie has been exploring the power of feedback in classroom situations through large-scale meta-analyses. Hattie's (1999) database included information about feedback (across more than 7000 studies) that demonstrated that the most effective forms of feedback provide cues or reinforcement to learners; are in the form of video-, audio- or computer-assisted instructional feedback; and/or relate to goals. Programmed instruction, praise, punishment and extrinsic rewards were the least effective for enhancing achievement.

Hattie has continued to explore the type of feedback that is effective and proposes that effective feedback is part of the whole climate of teaching and learning and is not just stimulus and response:

> Feedback needs to be clear, purposeful, meaningful, and compatible with students' prior knowledge and to provide logical connections. It also needs to prompt active information processing on the part of learners, have low task complexity, relate to specific and clear goals, and provide little threat to the person at the self level. (Hattie and Timperley 2007, p.105)

What Hattie has found is congruent with VIG principles for attuned interaction and guidance which support the guider to give 'collaborative feedback'.

EMPOWERMENT

The concepts of empowerment – starting with Carl Rogers' (1979) humanist theories where listening, empathy, respect and genuineness by the therapist are essential, moving on to partnership models (Davis 2009) and then even the more radical 'parent as co-worker' as proposed by Deborah James – are actualized in VIG's values and beliefs and in its delivery. Her discussion of change through analysis of discourse in a VIG shared review (James *et al.* 2011) bases empowerment in three domains: the personal, the interpersonal and the social/political. This important research paper explores changes in empowerment at these three levels by using discourse analysis and proposes that:

this change in language can be mapped onto our understanding of the Self in terms of self-efficacy, transitivity and empowerment. The constructs of the participant's verbalizations – how they identify themselves in grammatical proximity to others in the clause structure, the organization of ideas and sources for information – is analogous with such relationships in actuality. (James *et al.* 2011, section 4.1)

Optimistic and future-orientated

Although VIG is not a 'positive' approach in which behaviour is shaped by praise for 'good behaviour', it is closely resonant with the basic definition of positive psychology, which 'is a scientific study of optimal human functioning [that] aims to discover and promote the factors that allow individuals and communities to thrive' (Seligman 2002). VIG shares this emphasis on increasing wellbeing. Within this paradigm, Carol Dweck's work (2006) on Mindsets which develops her important earlier work on adult learning (Dweck 2000) supports VIG ideas that abilities are not fixed but that change can always take place, though rarely without the active effort of those involved.

VIG is often described as solution-orientated (De Jong and Kimberg 2002) and, indeed, guiders do look for 'exceptions' and even 'miracles' on the video clips. However, the dialogue about these clips is co-constructed, with 'one foot in pain and one foot in possibility' and may become an exploration of past narratives in a similar way to narrative approaches (White 2007). There is something about the energy in appreciative inquiry of reliving 'vital moments' of success that also mirrors the VIG process. Appreciative inquiry is generally applied at an organizational level, with the assumption that 'whatever you want more [of], already exists in all organizations' (Hammond 1996).

What all these approaches have in common is 'hope' for a better future. Unless people believe they can achieve a good outcome they have little motivation to try. If their attributional style is also to blame themselves for failure ('That was a bad outing because I'm a bad parent') but to attribute success to factors outside them and their control ('Today was better because my child woke up in a good mood this morning') they remain trapped in a belief that they are not in a position to improve their relationships. Feeling that there is no point in trying since the situation is hopeless is an illustration of Dweck's concept of 'learned helplessness'. In contrast, a parent who develops feelings of self-efficacy is motivated to 'engage in

actions that might seem initially hard, sets themselves goals, persists in the face of challenge and experiences less stress' in the process (Bandura 2000). The experiences most likely to create strong feelings of self-efficacy are identified by Bandura as those that give a sense of mastery; progressive experiences of moderate success build a stronger belief that success can and will happen again. VIG deliberately creates these conditions by 'confronting' parents with visual images of their good interactions with others and by creating a supportive space in which to reflect on the reasons for their various successes in the clips viewed together with the guider. It also helps parents to set goals for how they want their lives to be and to identify and work towards these goals, using achievable steps and watching their own progress on video along the way.

Conclusion

'I hear and I forget, I see and I remember, I do and I understand' (attributed to Confucius 479BC–221BC)

In VIG the picture is the video, and the parents' intuitive emotional reaction to seeing themselves and their children communicating on it, is the trigger for deep reflective dialogue in which the theories of intersubjectivity and mediated learning and the values of empowerment can be actualized. Supervisors see on the videos of shared reviews with parents brought to supervision their VIG trainee guiders becoming more animated and effective with their clients as they progress through the training. Working in VIG is about working with the heart as well as with the head. Guiders often speak to others, including their managers, about how much they enjoy doing work with VIG and that 'it's nice to feel successful for a change' and 'to feel like you are actually helping people', thus reporting an increase in their own feelings of self-efficacy. Many guiders will state that this way of working has fundamentally changed their levels of hope and feelings of self-efficacy when working with seemingly intractable situations and has also transformed the way they interact on a day-to-day basis and when dealing with stress and conflict. We believe that VIG training and shorter courses such as VERP (see Chapter 10) offer the potential to increase satisfaction, decrease feelings of stress and improve staff retention in professions and working contexts where burnout and rapid staff turnover are common. This needs to be researched in action not only for the avoidance of suffering in the helping professions but also to allow children and young people more continuity in their relationships with their carers and advocates. Many supervisors report an increase in energy and enthusiasm after VIG supervision sessions. Many

welcome being given the task of VIG supervision as part of their work even when it is an extra role on top of many others. Supervisors and guiders report that working this way feels like 'proper psychology' or 'proper supervision' or 'the reason I came into this job – to make a difference'. This may explain why there is such a high level of enthusiasm and dedication to this way of working expressed by those involved, and why the feedback from clients who have taken part in VIG sessions remains so consistently positive.

Our final thoughts on why VIG is effective relate to the role of optimism and to the importance of capturing or noticing our strengths and our blessings particularly when we face personal difficulties. When Martin Seligman began to write in 2002 about the need for psychology to focus less on how to reduce human misery and more on how to nurture wellbeing by studying the state and pre-conditions of 'authentic happiness', many ridiculed the idea of a science of happiness. The VIG idea of working to improve poor parenting by filming only exceptions to problems and working respectfully with strengths sometimes still generates scepticism, but perhaps culturally we have more potential space in our minds to believe that it might just work. As we were finishing this chapter, the BBC's *Breakfast* programme (2011) had a week-long feature on happiness, in which the charity Action for Happiness invited the nation to try a number of activities to enhance emotional wellbeing and (like VIG) showed on film the outcome of these activities and the reported impact on participants. Activities such as mindful meditation, noticing and writing down three good things a day and writing a letter of appreciation to a significant person and reading it to them slowly with expression and pausing to make eye contact, were all filmed by the BBC as were the participants reporting on the positive effects, with the last activity promoting deep emotional connectedness and wellbeing in both the letter writer and the recipient. Perhaps, like intersubjectivity and the scientific study of wellbeing, Video Interaction Guidance is now of our time.

CHAPTER 4

What is the Evidence that VIG is Effective?

RUBEN FUKKINK, HILARY KENNEDY AND LIZ TODD

Introduction

There is convincing experimental and small-scale qualitative evidence that Video Interaction Guidance (VIG), the review of micro-moments of video clips of clients' own successful communication, affects maternal sensitivity, enhances interaction in the classroom, assists professionals in the development of their practice and, indeed, improves relationships in many different contexts. Indeed, VIG is one of the two main EU-recommended parenting support programmes (DataPrev 2011). This chapter summarizes and discusses current research evidence for the effectiveness of VIG and draws research understandings from this on what it is about VIG that is effective.

The nature of evidence available in VIG research reflects its development. VIG, as practised in the UK (Kennedy, Landor and Todd 2010; see also Chapter 1), is a dynamic and versatile approach and has been expanded and developed over the last 15 years in collaboration with a variety of multidisciplinary practitioners, nationally and internationally. The UK originators (Hilary Kennedy, Raymond Simpson and Andy Sluckin) trained in 1993 in the Netherlands in the model created by Harrie Biemans and colleagues. This model is called Video Home Training (VHT) when delivered in homes, and Video Interaction Guidance (VIG) when used in any other situation including with families, such as in clinics, hospitals, kindergarten/ nursery settings and schools (Biemans 1990; Dekker and Biemans 1994; Dekker *et al.* 2004; Eliëns 2010).

Much of the evidence on the outcomes of VIG is experimental research from the Netherlands. This literature includes a large number of quantitative

intervention studies including randomized controlled trials (RCTs) (e.g. Juffer *et al.* 1997) and meta-analyses (e.g. Fukkink 2008) looking at effects of VIG-related interventions on the relationship between infants and care givers. Large-scale experimental research on VIG in mother–infant relationships is ongoing in the Netherlands. Research into the efficacy and effectiveness of VIG in the UK has been supported by yearly national conferences from 1995 to 2000 and, more recently, international conferences held in 2001, 2005, 2006 and 2009 (VEROC Conferences 2011). Adding to this research base are small-scale outcome evaluations (e.g. Robertson and Kennedy 2009) and around 20 masters and doctoral theses. The smaller-scale research looks at the impact of VIG on the enhancement of relationships in a wide range of contexts, including families, schools and the varied agencies of health and social care. It also focuses on the professional development of, for example, teachers, teaching assistants, psychologists, care workers and social workers.

This chapter is inevitably a summary, since a full review of all literature is beyond its scope. First, it reviews the effectiveness of VIG as an intervention to improve the relationship between carers and children, drawing on a large body of experimental evidence and a smaller number of qualitative studies. Second, the chapter considers the literature on the effectiveness of VIG as a tool of professional development and learning that helps to support change and demonstrate outcomes (e.g., for children and parents) in a range of contexts.

Evidence for VIG: Effectiveness with families

There is persuasive and growing evidence of the effectiveness of VIG as an approach for change with families and more particularly the relationship between carers and young children. Much of this is evidence for the effectiveness of VIG on parent–child relationships and interaction, including enhancing maternal sensitivity, reducing parental stress and improving the child's behaviour and cognitive functioning (e.g. Fukkink 2008; Robertson and Kennedy 2009).

The growing evidence base for VIG, including its versatility as a training model that requires regular and skilled supervision over time and the growing use by many different practitioners, has meant that VIG is increasingly the approach recommended by agencies. VIG was one of two recommended programmes in the NSPCC's evidence to England's review of the delivery of early interventions (NSPCC 2010). It is also a mental health prevention

intervention that is recommended by the EU to provide parenting support in infancy and early years (DataPrev 2011; Stewart-Brown and Schrader McMillan 2010) with a focus on maternal sensitivity and attunement. This recommendation has been the result of an EU-wide search for evidence of interventions (Stewart-Brown and Schrader McMillan 2010). Barlow and Schrader McMillan (2010), in their review and discussion of what works in preventing emotional maltreatment from occurring and reoccurring, provides a strong endorsement of the use of VIG. VIG is seen as an intervention that is focused on changing parental behaviours. It is seen as an approach that involves 'observation of both parent and infant with a view to providing supportive feedback aimed at helping parents to attend better to infant cues' (Barlow and Schrader McMillan 2010, p.54) in order to support more positive interactions.

VIG and other similar video feedback approaches

Most of the experimental evidence for VIG comes from research into VIG/VHT (Video Home Training, i.e. VIG delivered in the home; see Eliëns 2010), Basic Trust (see Polderman 2007), Video Feedback Intervention to promote Positive Parenting (VIPP: see Juffer, Bakermans-Kranenburg and Van Ijzendoorn 2008) or Interaction Guidance (IG: see McDonough 2000). The approaches all review micro-moments of video clips of clients' own successful communication yet vary in some aspects of delivery, training or focus. The VHT/VIG method and training in the Netherlands is clearly described in Eliëns book, *Babies in the Picture* (Eliëns 2010). Basic Trust, also from the Netherlands, is where VIG is used as an attachment-based intervention. VIPP, similarly, has an attachment focus, was developed in the University of Leiden for research purposes and is therefore manualized for high fidelity to the method. IG, which was developed in the USA, uses the same theoretical basis as VIG and aims to develop change in families with a focus on carer–infant relationship difficulties. Unlike VIG (in the Netherlands), IG comes from a therapeutic (rather than a behavioural) stance. Orion is very similar to VHT/VIG and was developed in the Netherlands and used in Israel. What is common to all approaches (VIG, VHT/VIG in the home, Orion, Basic Trust, VIPP, IG) is the use of video feedback (VF) to review video clips of the parent and child's own successful interaction to promote change in relationships. The approaches vary according to the different client groups, the problem in question, or whether the intervention emphasizes parent–child interaction (i.e. parent behaviour or interaction with their child) or parent representation (how they think of themselves as

a parent). While these different approaches arose as distinctive models, their similarities mean that studies into the effectiveness of VHT/VIG, Orion, Basic Trust, VIPP and IG and other similar VF programmes provide evidence for the effectiveness of VIG as practised in the UK. VIG (as practised in the UK) focuses on the interaction between parent representations and behaviour following parents' interest and initiatives to their children in the shared review. The evidence of studies is discussed in the following sections.

Video feedback in parent and family interventions
META-ANALYSIS OF VIG COMPARED TO OTHER VIDEO FEEDBACK INTERVENTIONS

The most extensive and recent research on the effects of VIG on interactions between carers and children is Fukkink's (2008) meta-analysis of 29 VF intervention studies in 1844 families. Many of the studies reviewed used video home training (VHT/VIG) or related interventions, and some used VF approaches that were not related to VIG. Figure 4.1 compares the effectiveness of 2 subsets of the 29 VF interventions (from Fukkink's 2008 review). It compares the effectiveness of VIG, as delivered as VHT in the Netherlands, the latter taking as a comparison the effect sizes of 8 VHT studies (the VIG columns in Figure 4.1) with the effectiveness of 21 studies, in other words of all 29 studies but without the VHT studies (the VF column in Figure 4.1). Effect sizes play a central role in meta-analytic reviews of individual experiments by allowing a precise quantification of the size of effects. Following the statistical rules of thumb of Cohen (1988) the effect sizes in studies reviewed in this chapter can be categorized as small (between 0.20 and 0.50), medium (between 0.50 and 0.80) and large (0.80 and above).

First, Fukkink's (2008) review (referring to all 29 studies) found that VF intervention studies in families were not only influential in increasing parental sensitivity, but also resulted in behavioural and attitudinal changes of parents towards their role of carer to their children. The review showed that VF, usually as part of a wider family programme, is an effective method to stimulate parents' positive care-giving behaviour: parents not only become more skilled in interacting with their children, but they also have a more positive perception of their own parenting. They derive more pleasure from and experience fewer problems with parenting on completion of the programme. The programmes were also found to have a positive effect on the development of the children in the families being treated. The positive result is encouraging because it shows that family programmes that include

video feedback achieve the intended dual-level effect: parents improve their interaction skills, which in turn helps in the development of their children.

From the meta-analysis of all 29 studies, the aggregate effect size was 0.49, a medium effect, for the parental behaviour domain (the effect on parent skills), 0.37 for the parent attitude domain and 0.33 for the effect on the child. The specific gains were in reducing parental stress and increasing self-confidence in parenting. Children varied in age from 0 to 8 years old. In these studies, risk factors at the parent level (e.g. poverty, mental health and addiction issues) were often present.

Second, we will now look more closely at VIG effects. In Figure 4.1, in a number of studies the effects of VIG were studied in different family contexts (represented as the VIG column), mostly using VHT interventions (Eliëns 2005; Jansen and Wels 1998; Janssens and Kemper 1996; Kemper 2004; Sibbing *et al.* 2005; Vogelvang 1993; Weiner, Kuppermintz and Guttman 1994; Wels, Jansen and Pelders 1994; see also Häggman-Laitila *et al.* 2003, 2010). These studies are a subset of the 29 families in the video feedback meta-analysis. They are all family interventions, focused on a range of difficulties (hyperactivity, crying babies, family difficulties, etc.), and the ages of the children in the interventions ranged from 0.2 years to 8 years. These studies suggest positive effects and are represented as VIG in Figure 4.1. The aggregated effect sizes for these studies were 0.76 (i.e. medium to large effect) for the behavioural domain (the effect on parent skills) and 0.56 (i.e. medium effect) for the attitude domain (the effects on parent attitudes) in the meta-analysis. The effect size was 0.42 (i.e. small to medium effect) for the development of children in this study (see Figure 4.1). These studies provide empirical evidence that VIG enhances positive parenting skills, decreases or alleviates parental stress and, finally, is related to a more positive development of the children. However, given that many of the studies referred to have used a pre-test/post-test model and that many of the VIPP studies used randomized controlled research designs, more research is needed to understand more about the causal effect(s) of VIG.

To summarize, there is convincing evidence from quantitative research of the effectiveness of VIG. Some of this evidence is from a meta-analysis of video feedback studies, many of them approaches that are similar to VIG as used in the UK, and when studies that used only VHT were selected out, the effect sizes increased. This research suggests that VIG has produced larger gains in experimental research than other video feedback approaches.

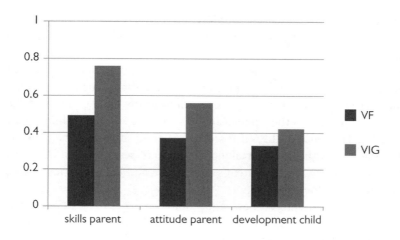

Figure 4.1: Effect sizes for experimental outcomes of VF and VIG studies

VIDEO FEEDBACK INTERVENTION RELATED TO VIG

Evidence from another group of VIG evaluations contained within the meta-analysis of Fukkink's (2008) 29 studies, experimental evaluations of VIPP from the Netherlands, merit closer attention because of their contribution to an understanding of the effects of VIG. There is a sizable body of evidence for VIPP (Juffer, Bakermans-Kranenburg and Van IJzendoorn 2005b; Juffer *et al.* 2008; Van IJzendoorn, Juffer and Duyvesteyn 1995; Klein Velderman *et al.* 2006).

The development of VIPP as a short intervention focusing on sensitivity and using video feedback was built on a 'search for evidence-based conclusions about what are the best intervention practices' (Bakermans-Kranenburg, Van IJzendoorn and Juffer 2003, p.196). Bakermans-Kranenburg et al. (2003)'s meta-analysis of 51 attention-focused RCT interventions on more than 6000 mothers, found that interventions using video feedback (effect size of 0.44) were more effective than those without. They also found that short interventions that focused on sensitivity alone were the most effective (effect size of 0.47).

VIPP, a manualized research intervention, uses positive clips and is delivered in the home over four sessions that have standardized activities, each starting with making the videotape that will be used in the next session. VIPP highlights 'chains' of interaction with at least three turns, and here

can be seen particular similarity with VIG's principles of attunement: signal from the baby, mother's sensitive response and baby's positive reaction to this response. Each session has a theme: the first shows the difference between the child's play/exploration and attachment behaviour; the second promotes the perception of the child's signals; the third aims to enable the parent to perceive the relevance of responding to the child's cues; and the final session encourages the parent's affective attunement to the child (Juffer et al. 2008). The focus of the VIPP sessions is more structured than VIG as used in the UK, with the latter taking the focus of sessions from the goals of the parent, following the parent's ideas more and conversations arising when initiated by the parents.

In a randomized intervention study, Juffer et al. (1997) showed that VIPP significantly lowers the rate of disorganized attachment. Ninety families with adopted babies aged six months were randomly assigned to two attachment-based programmes. The first group were given a personal book (written information focused on the encouragement of sensitive parenting), the second received the personal book and three video feedback sessions in their homes, while the third group (the control group) received no intervention. The mothers who received video feedback and the book showed enhanced maternal sensitivity (effect size 0.65) and received lower scores on the rating scale of disorganization than the mothers of the children in the control group (effect size 0.62). The less intensive programme, using only the personal book, did not bring about change in mothers or infants.

Long-lasting evidence of the impact of parent sensitivity on child behaviour was shown by Klein Velderman (2005; see also Juffer et al. 2008), comparing VIPP with an additional representational focus (i.e. VIPP-R, intervening in how the mother saw her understanding of her own attachment) with a group of 81 first-time mothers. The mothers were selected on the basis of insecure attachment representation and were randomly assigned to VIPP, VIPP-R or a control group. In the short-term (T1 = 6 months; T2 = 11–13 months) the mothers in both intervention groups were significantly higher in maternal sensitivity than in the control group. The rate of disorganized attachment was significantly reduced. At three years the children in both intervention groups exhibited fewer externalizing behaviour difficulties. Interestingly the group who received VIPP plus discussions of past attachments showed significantly fewer gains than those receiving VIPP alone. This suggests that VIG methodology can be very effective on its own.

Other experimental research not only contributes to outcome evidence for the effectiveness of VIG, but also suggests what should be the focus

of interventions. Benoit *et al.* (2001) found that IG interventions in which the videoed interactions involved play were more effective in eliminating specific feeding behaviours than training on behavioural techniques. This study, conducted on 28 parents with infants who had feeding difficulties, found a significant decrease (73%) in the level of disrupted communication from pre- to post-intervention sessions in the IG play-focused group but not in the behavioural feeding-focused group (the latter showed a decrease in feeding problems of 17%). This suggests that a focus on interaction and relationship seems more likely to impact on the problem than a focus on the problem itself, which is a central tenet of how and why VIG is understood to work (see Chapter 3).

Hedwig Van Bakel and colleagues started the Project 'Baby Extra' in Eindhoven, a city in the southern part of the Netherlands. Baby Extra functions as an intermediary between at-risk parents and health care providers and closely cooperates with several mental health care organizations, hospitals and youth health care centres. Baby Extra also offers a short-term prevention programme with two VIG cycles. A pilot study of 11 mothers with psychological/psychiatric and/or addiction problems receiving VIG and care as usual, compared with 15 mothers with no such problems from the same geographical area, were assessed until their infants were one month old. Sensitivity, infant responsiveness and involvement significantly increased from the time of referral to 15 months and intrusiveness significantly decreased. The first preliminary data of the pilot study showed Baby Extra to be a successful and promising low-cost preventive intervention programme for vulnerable families with young infants.

Evidence of the effectiveness of VIG also comes from other approaches that are similar but have some important differences. The Sunderland infant screening programme, developed by P.O. Svanberg (2009), built on Pat Crittenden's work using video feedback to promote secure attachment through early screening (Crittenden 2000). The key difference of this approach from VIG is that a three-minute video was taken as part of an assessment. In other words, the video was not taken once a family were engaged in change and was not taken to reflect positive moments. Svanberg (2009) discussed how video has become more widely used as part of intervention work with parents and families (e.g. Tucker 2006). He trained health visitors to deliver reflective video feedback on four visits. The video feedback involved: a strengths-based approach aiming to develop mindfulness; the acknowledgement of ambivalence; links to the mother's own childhood and her emotional roots; and dealing with separation.

His results showed an effect size of 0.73 (i.e. a medium to large effect) for changes in maternal sensitivity and 0.59 (a medium effect) for changes in child co-cooperativeness as measured with the CARE index (Crittenden 2000).

CONCLUDING COMMENTS

There is important evidence for the impact of VIG on families, in particular on the relationship between parents and children, and on the impact that this has on child behaviour, from experimental studies. This evidence will be summarized at the end of the chapter. We now turn to the number of small-scale research projects with families looking at many outcomes of VIG.

Change in families: Small-scale studies

There are numerous case study research reports from practitioners on the effectiveness of VIG as an attachment intervention although methodological limitations of these studies should be acknowledged. These studies give an account of noteworthy change for the better in seemingly intractable situations where families have already had significant input from health and social care but have been reported as resistant to change. Psychiatrists and psychologists are observing the power of VIG to move families from a reactive attachment disorder to secure attachment and have found this improvement is sustained in long-term follow-up (Helen Minnis (2010), personal communication).

Small-scale UK evidence that shows that VIG affects families and has associated effects on child outcomes has come from several sources, including Ofsted, postgraduate research and research carried out by particular agencies. In a few authorities VIG has been delivered as specialist input to a number of families receiving support through Sure Start, for example in children's centres in South Lowestoft. One of the South Lowestoft children's centres had a recent inspection and received an 'outstanding' evaluation. Interestingly, VIG was mentioned in the evaluation report: 'The use of VIG has resulted in improved outcomes for parents and their children' (Ofsted 2010).

There are many case studies and other small-scale outcome research on the use of VIG in the UK that have recorded impressive change in vulnerable families, in some of which changes in behaviour were measured and then triangulated with interview data (Robertson and Kennedy 2009; Savage

2005; Simpson, Forsyth and Kennedy 1995); others took a qualitative approach to the parents' experience of VIG (e.g. Hynd and Kahn 2004; Rautenbach 2010; Sluckin 1995; Strathie and Kennedy 2008; see also Chapter 6). Loughran (2010) is one of the few studies to look at the impact of VIG on siblings, and in particular on sibling relationships where one child has a disability (in this case the sibling is on the autistic continuum). Some of these are explored in more detail in the following paragraphs.

Examples of studies showing measurable changes in behaviour

Simpson *et al.* (1995) analyzed the change in the videos of the first five families who received VIG in the UK. Their central hypothesis was that VIG increases the frequency of positive or attuned responses by parents to their children's initiatives. The results of detailed micro-analysis of before and after videos supported this hypothesis. There were significantly more positive responses to their children's initiatives after intervention. Parents also spent significantly less time in 'discordant' interactions and if they had been disengaged at the start they became more actively involved. They also significantly increased the proportion of time they spent turn-taking. The two families who did not turn-take in the 'yes-cycle' (see Chapter 1) before intervention both became able to sustain attuned turn-taking sequences. These changes in behaviour showed an increase in reported positive shared experiences, improvements in communication and more effective management strategies (Simpson *et al.* 1995).

Later studies have built on this research, developing micro-analytic techniques for video interaction analysis (VIA), triangulated with qualitative data connecting meaning to the changes in the behaviour observed. For example, Savage's (2005) dissertation showed changes in the families' interaction patterns pre- and post- VIG intervention. Detailed micro-analysis of pre- and post-videos were carried out and showed a change in parents' responses to children's initiatives (Savage 2005). Figure 4.2 shows an increase in attuned responses and initiatives from the parent, and in the initiatives from the child. It also shows a decrease in discordant responses and initiatives. More detail of the ways these categories were defined can be found in Savage (2005).

Figure 4.2: Overall percentage change in the frequency of behaviours per category following VIG

Before the intervention, the percentage of children's initiatives responded to in an 'attuned' way ranged from 27 per cent to 75 per cent with the mean around 35 per cent. After the intervention, the same measure ranged from 83 per cent to 100 per cent with the mean around 94 per cent. This increase in 'attuned' responses is statistically significant.

The first study in the UK to measure the effect of VIG on an aspect of attachment, using a before and after measurement of attachment (the CARE index), shows promising results. Robertson and Kennedy (2009) looked at the effect of VIG as an intervention in a residential treatment centre where parents are placed with their children for three months as a result of court orders due to child protection concerns. Results from naturally occurring data suggest that VIG is effective in families where there are severe attachment needs such that there is a danger of family breakdown and child care placement. In this study, VIG was offered to all parents and delivered to those families who wished to take up this offer. Parents in these circumstances are traditionally thought of as being very hard to engage, often coming from abusive backgrounds themselves or having lost older children within the care system. Pre- and post-intervention data was collected on 15 parent–child dyads that received 'treatment as usual' and

8 parent–child dyads that received VIG as an intervention alongside the standard treatment. The VIG intervention took the form of three to five films and shared review sessions for each parent. For the 'pre-score' a brief film was taken of three to four minutes of parent and baby interacting 'as they would normally do'.

Data was collected using the CARE index to provide a reliable score for seven aspects of behaviour for both care giver and infant (Crittenden 2000). For this research, the score of maternal sensitivity was used. Scores are calibrated as follows: 8–14 indicates the interaction between the infant and the parent is 'good enough'; 4–7 indicates that it is 'of concern'; and 0–3 indicates that it is 'seriously compromised'. Results showed that the mean pre-CARE Index score was very similar for each group. This score went down slightly for the control group but increased by 3.13 for the VIG intervention group. This result is equivalent to a reasonable and statistically significant effect size (ES = 0.5). Before the intervention only 25 per cent of the VIG intervention group, were scoring in the 'good enough' range whereas afterwards 87.5 per cent were now considered 'good enough' and all families who were 'of concern' had improved by at least 2 points. This is in stark contrast to the control group, who started the intervention with 46 per cent in the 'good enough' category and ended it with 27 per cent in the same category. The tentative conclusion that can be drawn from this pilot study is that VIG has been successful in increasing parental sensitivity as measured by the CARE Index and that a more substantial study is justified. This pilot data is very encouraging; however, a much stronger research design is required as a next stage. Further research with the possibility of using randomized allocation with the VIG treatment group or carefully 'matched' pairs is in discussion. Other measures of change should be triangulated with the CARE Index. Post-intervention interviews with parents and professionals involved could throw light on how VIG is promoting change. The data in films and shared review tapes could also be examined to look at how VIG is promoting change. Long-term follow-up data on whether the parents manage to sustain the progress in the community is of prime importance.

One of the few studies into the effect of VIG on parent stress and child behaviour to be carried out in the UK and also showing long-term gains was carried out by Sharry et al. (2005). They used VIG (but named this Parents Plus Early Years Programme: PPEY) over 12 sessions with 30 parents of pre-school children and observed a significant drop in behaviour problems and parental stress. Gains were being maintained at the five-month follow-up. Parents were interviewed and spoke of the influence of the programme.

Their responses suggested the importance of the support of other parents in the group, the idea of 'stop, wait, listen' had been remembered by many parents, and one said that the video had stayed with her.

NARRATIVE DATA

Sluckin (1998) wrote the first 'narrative' study of the process of VIG and changes he observed in two parents who received an intervention that combined VIG with art therapy. They wanted help with their experience of 'bonding failure' and post-natal depression. Readers are encouraged to read this thoughtful account of the impact on the parents of seeing themselves with their baby on video and of the changes in their behaviour and feelings. This is a quote from a follow-up interview with a mother who at the start 'felt repulsed by the baby and was distressed by her own lack of affection' (Sluckin 1998, p.16). This shows the impact of VIG at a personal level:

> I continually tell people about the videoing we did with you and how much easier it made my understanding of my own importance as a mother... I have a very clear picture in my head of one of the first video sessions when Elizabeth literally lit up as I turned my attention to her and we simply said, 'Hello'... I have (now) started to let Elizabeth touch me and through seeing her enjoy squeezing and tickling me, I have begun to do the same to her... I'm allowing her to lead our play and learning to recognise her signals... We often read, sing and cuddle together, talking and giggling; this is something I could not have imagined doing last year... I've taken what I've learnt (from you) and moved it up a year... In new situations, I look at Elizabeth and think, 'What would you be suggesting now?'... If it's something that I really don't want to do, I think, 'Let's pretend I'm being videoed!' (Sluckin 1998, p.19)

Hynd and Khan (2004) explored women's changing identities in the context of their experiences of post-natal depression which suggested the gains that are likely for infant–parent interaction from the use of VIG in such circumstances. They were working at Edinburgh University under Colwyn Trevarthen who has had a long-term interest in using video to study the interactions of depressed mothers (Trevarthen 1998, see also Chapter 3).

> Guider: Do you appreciate all the skills you use there? Have you been aware of that?

Mother: No – I haven't. No – no-aha-yeah…but I mean I've always been – I've always been a chatty person – I've been a bubbly person – always – so maybe that's rubbed off on my child…

The most important part of this interaction occurs at lines 5 and 6 where the participant makes a series of stable and internal attributions as regards her self-identity, that is, 'I've always been [chatty]'; 'always [bubbly]'. (Hynd and Khan 2004, p.740)

Another UK study of partly naturally occurring data, supplemented by interviews (Doria *et al.* 2009, 2011), suggests theoretical explanations for the success of VIG as a therapeutic tool with vulnerable families. This work suggests not only that VIG aids the development of secure attachment but also that there is evidence that parents become more active in a shared review process, one of the aims of the VIG guider, and that parents therefore become their own agents of change. The five parents in Doria *et al.*'s (2009, 2011) project sample had received a VIG intervention and this had promoted positive change for them and their relationship with their children. These parents were viewed as having difficulties in attachment and mental health, and (in the case of most) with drug or alcohol dependence. Detailed qualitative analysis of the shared review sessions over time showed that parents became much more active and all categories of interaction increased in frequency, suggesting that VIG succeeded in activating parents' cognitive ability and reflective processes (e.g. showing constructive self-criticism or insight). Detailed explanations of the categories used can be found in Doria *et al.* (2011). It seemed that parents were seeing more positive and negative aspects of the video. They made more spontaneous positive remarks about their interaction with their child, their child's behaviour and their thoughts about themselves. They also made more spontaneous comments about 'ideas for change' or things they did not like about themselves, their child's behaviour and their relationship with their child. It is suggested that this is evidence that the VIG process, through support, enables parents to challenge themselves. By the third feedback session, each parent was making a metacognitive statement almost every minute. Looking at the evolution of the metacognitive responses both spontaneous and reactive, results indicate a clear increase in the *metacognitive emotional* responses, meaning that the client mothers start spontaneously thinking more often about how the other person is feeling (Doria *et al.* 2011). The authors suggest this is impressive for parents who have been considered to have difficulties expressing themselves

in the past. Parents spoke of the importance of setting aims and of receiving positive and negative information, and of being able to see positive change and positive futures (Doria *et al.* 2009, 2011).

SUMMARY

In summary, there is evidence that parental sensitivity can be enhanced through VIG intervention, that video feedback is effective as a component of learning and that VIG has the added advantage of promoting the emotional wellbeing of vulnerable parents and of activating them to solve their own problems. This area of research is in its early stages and merits more systematic investigation.

The effectiveness of VIG on practitioner learning and action

One of the most common ways of using VIG to create change in families, classrooms and other situations is by making the focus of the VIG intervention the professional who is working directly with, for example, the parents, children or teachers. VIG can enhance reflective practitioner learning in a wide range of settings and professions (e.g. Early Years settings, schools, universities, health, psychology, social care and the police).

There is less experimental research in this area than in direct interventions with families. However, practitioner action research is growing, as evidenced by masters theses and doctoral dissertations in the UK and other countries (e.g. Forsythe 2010; Hewitt 2009). See also den Otter (2009) on doctoral and other studies of SVIB (School Video Interactie Begeleider – Schools Video Interaction Guidance). At Fontys University in the Netherlands, for the last 10 years teachers have been able to implement SVIB in their own setting and then write an action research study as part of a masters programme. Ruben Fukkink and Hilary Kennedy have contributed to training events relating to this exciting course.

A meta-analysis by Fukkink, Trienekens and Kramer (2011) of 33 experimental VF studies involving 1058 people shows an aggregate effect size of 0.40 for the growth of professional skills (a medium effect). The effects of VF were found to be more favourable if a structured observation chart was used which listed the specific target behaviours.

There are a number of small-scale and qualitative investigations into the use of VIG to enhance professional skills but these are reported in more detail elsewhere, particularly those of teachers (see Chapter 7), social workers (see

Chapter 10) and higher education teachers (see Chapter 11). Fukkink and Tavecchio (2010) reported promising results for the application of VIG in the training of professional care givers.

VIG has been shown to have an impact on relationships, behaviour, cognitive skills and partnership working in the context of schools – and change has been recorded in the actions, feelings and views of parents, teachers, teaching assistants and children. Although the research into the interventions in this area has predominantly comprised small-scale qualitative studies, the quality of the methodology suggests these approaches are promising. Much of this research is reported in an exploration of the use of VIG in schools (see Chapter 7). Some of this research is reviewed here, starting with studies of interventions in response to concerns about child behaviour.

There are two studies where VIG with staff was used to bring about changes in classroom interaction. Brown and Kennedy (2011) carried out a VIG intervention with five primary teachers in a school for young people with emotional and behavioural difficulties, giving them three sessions each. This study used sophisticated computer video interaction analysis of the classroom, recording teacher–pupil interaction at the start and end of the project. In an initial session the teachers set their own goals which centred on encouraging more dialogue between the children, spending less time using 'controlling talk' and allowing the children to spend more time developing their ideas. There were significant positive changes in the nature of teacher–pupil interaction with a greater focus on children's input, and an increase in the children's ability to use linking statement to connect their ideas. Children engaged more in the learning process and showed evidence of extending their ideas with the teacher and other children; there was also a considerable decrease in negative/off-task interactions.

McMillan (2004) used VIG with eight nursery staff over three sessions with a whole class. As a result of these sessions she found that staff were more in tune with the children and had changed their working practices, in particular their style of interaction, in order to achieve this goal. Staff members increased their ability to allow the child to lead the interactions and activities and had developed skills in adult guiding that they utilized more frequently. Staff also reported an increase in skill level and self-confidence which was also noted by the senior management team (McMillan 2004). The head teacher of the nursery took this further by training as a VIG guider and using this method to support quality in children's centres throughout the authority.

VIG supporting collaboration between teachers and parents
BEHAVIOURAL/EMOTIONAL FOCUS

Several of the small-scale research projects not only report outcomes but also show the creative application of VIG and its positive impact on the ways in which professionals can work together. This is a key finding given the attention needed to improve integrated working in services (Cummings, Dyson and Todd 2011; Todd 2007). Roosje Rautenbach (2010) showed that VIG can help with the development of consistent nurturing principles between home and school in her evaluation of a small-scale intervention delivering three to five cycles of VIG to five parents of children attending a primary school nurture group. The teacher of one child was also involved in the VIG cycle. Data was collected on children in the intervention and on a control group and included interviews with parents and the teacher, systematic observation of the children in the class and two measures of social, emotional and behavioural development. The experimental group showed greater improvement than the control group on all measures, and interviews demonstrated greater partnership working. Children cooperated more with adults and were better at listening and engaging with learning. The thesis shows how VIG was used with adults in different situations.

McCartan (2009) conducted a VIG intervention over four months with the aim of tackling a situation of concern about behaviour in school; the intervention comprised two cycles of VIG with the parent and with the teacher. The study showed that VIG promoted the development of a collaborative relationship between parent and teacher, led to more positive parent–pupil and teacher–pupil interactions and increased self-efficacy and self-awareness of parent, teacher and pupil. The following quotes from the child, parent and teacher suggest the change to a sense of collaborative working that was not present prior to the intervention:

> Parent: ...It made me think of her differently you know... (Interview 3, p.22, line 12)...[teacher] really helped me throughout this, she's really helped me...like in the sense that I know she knows [child] now, you know. She was...she didn't just have it in for him, all the time...she knew what I knew about him...because she was going through exactly the same...(p.23, line 20).

> Teacher: Relief that what I was trying to say you know was... was finally being understood and was finally being witnessed (Interview 4, p.4, line 1).

Child: That's what my teacher does every time we're like naughty, she just makes it out as a laugh…it makes it better cos we don't have a big row (p.10, line 15).

LEARNING/COGNITIVE FOCUS

There is also evidence, albeit a small scale, that VIG interventions lead to both emotional and cognitive gains. Meadows (1996) has asserted the importance of the parent–child relationship for children's cognitive development. It is a reasonable hypothesis that as VIG enhances interaction experiences, children will be more able to learn given that learning takes place within an interaction.

In another example of VIG-facilitated partnership working, an evaluation of VIG (Kennedy 2001) looked at evidence for the effects of VIG on children in an intervention that took place in a Sure Start nursery. The effects were assessed on eight children aged from 3.3 to 4.9 years at the start. All the children were enrolled at a pre-school centre and were allocated places in August 2001 because of significant additional support needs. At this centre a teacher and nursery nurse enhanced staffing from a Sure Start initiative and flexible arrangements were made for the children between the Child and Family Centre (Social Work) and Nursery School (Education). The Sure Start intervention team aimed to give the children an optimal learning and nurturing environment by providing all the children, staff and parents with good communication opportunities on a moment-by-moment basis. This was based on VIG principles and used VIG feedback with staff and some parents to activate them to enhance their own communication patterns. Pre- and post-test measures showed educationally significant outcomes.

The children were assessed before and after the intervention (seven-month interval) with standardized assessments such as the British Picture Vocabulary Scale (Dunn *et al.* 2005); the Derbyshire Language Scales (Knowles and Masidlover 1982); and Teaching Talking developmental profiles (Locke and Beech 1991). The gains on the standardized assessments and developmental scales were very similar. Overall the children made more than predicted progress with the average standard score moving from around 70 to 80 (on average eight months' gain over four months' predicted gain). The biggest changes overall were in 'verbal comprehension'. This is interesting because the staff and parents were being encouraged to follow the child's initiative and this seemed to result in the child being more able to follow the adult's.

Results of a video micro-analysis of six children playing with their key worker at the water tray showed that, on average, the children took twice the number of verbal turns and contributed more in each turn. This represents a considerable improvement in verbal interaction.

To summarize, VIG was used in interesting ways to facilitate partnership working between children, teachers, parents and the educational psychologist where all the adults around the children aimed to enhance their interactions on a day-to-day basis. A strong link between these impressive cognitive gains and the improvements in relationships and the skills of intercommunication may be proposed. Perhaps the VIG intervention with the increase in verbal comprehension (so essential for a primary classroom) gave the children this educational opportunity. Seven of the eight children were able to transfer to a mainstream, rather than special, primary. These mainstream placements were maintained three years after the intervention period.

Conclusion

VIG is an effective intervention with families – but more experimental evidence is needed, especially in the UK

Reviews of quantitative studies and individual, small-scale studies of VIG and other related interventions have made clear that VIG is an effective method for fostering change in families and for improving professionals' interaction skills, leading to change in learning, behaviour and collaboration in a range of contexts. There are two meta-analyses that have merited attention. One was Fukkink's (2008) meta-analysis of 29 video feedback interventions. Analysis of a subset of eight VIG interventions showed medium to large effect sizes on parent skills in comparison with other video feedback approaches. The other, Bakermans-Kranenburg et al. (2003), a meta-analysis of 51 interventions focusing on maternal sensitivity found medium effect sizes from those that used VF. Interventions on maternal sensitivity using VF were found to be more effective than those without VF. Most studies are from outside the UK, particularly from the Netherlands, an exception being Crittenden (2000), which evaluated an approach related to VIG and showed a medium to large effect size. In particular there needs to be an increase in research that experimentally investigates the effect of VIG on attachment.

Further experimental research is needed, particularly in the UK, focusing on RCT studies and those with mixed methodology

The limitations of experimental studies in this field should be acknowledged, however, such as the small-scale nature of many study designs. Further research is therefore needed to strengthen the knowledge base related to VIG. An interesting line of study is to combine relatively large-scale experimental studies with a fine-grained analysis for a (random) selection of participants. These studies may demonstrate the general effect of VIG on standardized, validated measures, while in-depth analysis of the communication may shed further light on the actual change in communication patterns in various contexts before and after the programme.

A focus on parent sensitivity seems likely to be more effective than a focus on the presenting problem

A number of experimental studies have suggested that the focus of VIG on the relationship and on maternal sensitivity, may be more effective in solving a problem than a focus on the problem itself (e.g. Benoit *et al.* 2001, on feeding problems). There is of course a need for more research into this possibility.

There is some evidence that VIG interventions are long-lasting

Long-lasting impact has been shown on the importance of parent sensitivity, with a reduction of child behaviour problems three years after the intervention (Klein Velderman 2005). Sharry *et al.* (2005) in a small-scale impact study found parental gains maintained at a five-month follow-up. Impact is an area that has rarely been considered in experimental research and merits attention.

There is an impressive range of case studies and small-scale studies of the effects of VIG in families, but more such studies are needed

Because of the lack of published literature from small- and large-scale studies summarizing the effects of VIG we have taken the opportunity to

report the research in some detail. We have reported the results of relatively numerous case-study, small-scale experimental outcome research and small-scale analysis of naturally occurring data. There has been promising research of this type on the impact of VIG on vulnerable families. One such study has used the CARE index and has shown highly promising pilot results with vulnerable families.

VIG can be effective delivered in short interventions, but long-term support of some families is likely

Different studies suggest that the effects of interventions are related to the number of sessions given. On a number of occasions a short intervention of three to five sessions has seemed to be the recommended finding of much of the experimental evidence (Bakermans-Kranenburg *et al.* 2003) and of the small-scale studies (Robertson and Kennedy 2009; Savage 2005). The effect on parenting behaviour in the VIG studies appeared to be moderated by the programme duration: programmes of a shorter duration are more effective (Fukkink 2008; see also the 'less is more' hypothesis in Bakermans-Kranenburg *et al.* 2003). However, it would, we suggest, be premature and probably incorrect to conclude from this that short-term VIG interventions are more effective with families. We suggest that there is no sound experimental basis for drawing this conclusion. The experimental data on short-term interventions such as VIPP, on which much of the strong evidence for VIG is based, is almost always carried out in a smaller number of sessions (i.e. four to six). The small-scale studies are often masters dissertations which rarely present the opportunity for longer-term work. It is our experience as practitioners that whilst short-term interventions can be very effective with families, longer-term work is needed for some families in order for the intervention to be effective. Clearly there is also a need for research into longer-term interventions.

Similarly, data from small-scale outcome studies has shown that the greatest impact on the actions of classroom assistants occurred between the first and third VIG cycle (Hewitt 2009), and between the first and second cycle (Forsythe 2010). More research is needed in this area in schools in the UK. However, this finding may prove encouraging to those who perceive this as a time-consuming intervention. The evidence from these two doctoral theses suggests that brief interventions can have an effect on the relationships between staff (in this case teaching assistants) and pupils.

A range of outcomes

The body of research on VIG has shown a wide range of outcomes, including positive changes to parent stress; sensitivity and skills; child behaviour and cognitive skills; and sibling relationships. VIG has also had an effect on the professional skills of a range of practitioners that has led to a consequent effect on teaching, on children in school and on families. There needs to be more research that seeks to widen the impact beyond these areas and to research evidence for the impact on other people, situations and areas of functioning.

How VIG works

Both experimental and small-scale research has provided an insight into why and how VIG works. One example of this is the focus on maternal sensitivity already mentioned (Benoit *et al.* 2001). Another is Doria *et al.*'s (2009, 2011) research that looked in detail at the process of change in VIG cycles. More research is needed that sets out to investigate the process by which VIG is effective.

VIG as a creative response to partnership working and as an addition to other interventions and approaches: VIG enhancing multi-agency working

What has been clear from reading much of the research into VIG, particularly small-scale dissertations and doctoral theses, has been the versatility of VIG in contributing to a range of interventions and practices in schools and other agencies. We have examples, some from our own practice, of VIG being used to enhance the effectiveness of interventions in areas such as informal parent groups, parent consultation meetings with educational psychologists, restorative practice, etc. In particular VIG has enhanced multi-agency working (see Kennedy 2001). This – an exploration of the creative use of VIG and the likely impacts of such use – is a particularly under-researched area which merits more attention.

Researching practice

Evaluating VIG does not necessarily require large-scale or controlled experimental evidence. It is possible to reflect on one's own practice (see Chapter 15) and to involve clients in feedback in a way that enables practice to change by routinely asking the person one is working with for

feedback (How is this going? Are these questions/ways of looking at what is happening useful to you?). There are systems to help measure a change in practice using Target Monitoring Evaluation (Dunsmuir *et al.* 2009) and also to observe change even within one VIG cycle. Todd (unpublished, personal communication) gives an account of a mother and a four-year-old child where improvements in the child's speech were sought by the family. The speech therapist hoped that a VIG intervention would focus the parent's concern away from the child's speech and onto communication more broadly. 'Intervention' happened in the taking of the video, before the full VIG cycle could take place. This came about since the guider spoke over the video to suggest that the parent might see what happened if play was led by the child, and the parent did indeed let the child take the lead. In a comparison of the interaction in a 60-second clip before this change and another 60-second clip after, the child not only made more initiatives but also increased the frequency of voiced communication after the change. When the time came a few days later for the VIG feedback, the parent had observed the video, which had been left on the day that it was recorded, and had noticed this change and pointed it out to guider. This enabled further conversations to take place about communication that related to the video.

Applications of VIG

CHAPTER 5

VIG as a Method to Promote Sensitive Parent–Child Interaction in Infancy

MARISKA KLEIN VELDERMAN

Introduction

Sensitive parental responsiveness is one of the important determinants of secure attachment. As John Bowlby (1971) emphasized: 'The young child's hunger for his mother's love and presence is as great as his hunger for food' (p.13). However meta-analytic results of attachment studies reveal that parents who have not received sensitive parenting themselves as a child (Van IJzendoorn 1995). Likewise, literature shows that parents who are in stressful parenting situations (Degroat 2003; Kang 2006) can display less sensitive behaviours in interaction with their child. Infant crying is an example of one of the first stressors in parenting. The stress it causes can impact strongly on parent–child interaction and on the future relationship between parent and child.

This chapter examines Video Interaction Guidance (VIG) as a method to promote sensitive, responsive parent–child interaction in infancy. VIG is an intervention that is ideally suited to supporting joyful contact between parents and their babies. The theory underlying the method of intersubjectivity, which recognizes that in every interaction there are two equally important subjects, fits like a glove when applied to promoting sensitive parent–infant attunement.

This was recognized in the early days of the development of VIG/ VHT (Video Home Training) in the Netherlands when Marij Eliëns and

others developed this as a method to support parents and babies directly and to train health professionals who were supporting parents around the time of the birth. Eliëns led the way, training many professionals in the Netherlands and speaking at conferences all over Europe. She first started to train primary health care workers, nurses and doctors in clinical care. Next she continued to coordinate the implementation of the method in the neonatal, obstetric and paediatric wards, currently reaching many of the hospitals in the Netherlands.

Following research on the effects of VIG, especially in the support of parents who have an excessively crying or restless baby (Eliëns 2005), Eliëns together with Cecilia Van der Zeeuw is currently leading a new experimental and innovative project to help parents or future parents with post-natal or other forms of depression or other psychiatric problems, and who have a complicated background (e.g. with a history of abuse, violence or childhood neglect) (Van der Zeeuw and Eliëns 2009). The aim of the project is to support secure attachment and prevent developmental problems in babies from these families, by reinforcing the parents' positive feelings about their parenting and simultaneously improving the preventive care and reinforcing the consistency of total care. Eliëns also started a new, ongoing, multi-centred randomized controlled study, looking at the effectiveness of VIG for the parents of premature infants.

The pioneering work of Eliëns and her colleagues (such as Kateřina Šilhánová, VIG leader and supervisor in the Czech Republic) has inspired many guiders in Europe and the US to use VIG with parents and their infants where there are difficulties with feeding, attachment, or crying. This has met with considerable success. As an example, VIG training is currently being introduced in the UK in several parent–infant projects led by health professionals. Small-scale research projects specifically focusing on parents and infants are also being set up in the UK with doctoral dissertations in progress.

In the remainder of this chapter, the use of VIG is considered as a method to promote sensitive mother–child interaction in families where there are parental worries about infant crying, starting with a case study (Klein Velderman *et al.* 2011). Next, the importance of supporting sensitive parenting in general is discussed, followed by a review of the literature on the effectiveness of VIG in infancy. This chapter ends with a general conclusion and discussion about how VIG could further develop as a promising method to promote sensitive parenting in infancy.

CASE STUDY

Jason and his mother are participants in the current study in the Netherlands (Klein Velderman *et al.* 2011) on the use of VIG in families with worries about infant crying. This entails the short version of VIG, consisting of six home visits and possible follow-up, as currently implemented in preventive child health care in the Netherlands (Eliëns and Prinsen 2008). Participating families in our study have babies aged from one to five months of age. They worry about their infant's crying and continue to do so after at least two weeks of regular care, that is, the standardized approach of regularity and stimulus reduction as studied by Bregje van Sleuwen and colleagues (van Sleuwen *et al.* 2006). This standardized behavioural intervention consists of a recurrent pattern of baby care, which provides structure and regularity without being rigid or inflexible. Parents apply a sequence of sleeping, feeding, positive interaction with baby and time the baby spends awake and alone in a playpen. Parents are instructed to recognize signs of tiredness in the baby when the baby is on its own. When tired, the baby is put to bed and tucked in tightly with a sheet and blanket. Subsequently, a new cycle starts. 'Essential is the repetitiveness of the elements, feeding the infant directly after waking (with an assumption that a well-rested baby is able to drink effectively) and not feeding to stop crying, and after playing alone putting the child to bed sleepy but awake' (van Sleuwen *et al.* 2006, p.513).

If parental worries continue after two weeks of regular care, parents are randomly assigned to the regular care plus VIG intervention group or to the regular care control group. Jason and his mother were assigned to the VIG group. He is a first-born child, born at 41 weeks and with a birth weight of 3.7 kg. His mother has a medium level of education and his father a low one. The mother was internationally adopted and has received treatment for attachment disorder.

Pre-test

Before the intervention started, we conducted a pre-test using a questionnaire. At the time of this questionnaire, Jason was three months old. Amongst other things, his mother reported that Jason cried for an average of three to four hours per day. Perception of crying was measured using the Lester Cry Perception Scale (Lester *et al.* 1992). This scale consists of 12 7-point Likert-type rating items. Mothers, for instance, rated whether they perceived their

infant's crying as sounding (1) not worrisome to (7) worrisome, or whether crying made them feel (1) not irritated/angry at all to (7) extremely irritated/angry. On a 1 to 7 scale, crying was rated a 7 on several items. For example Jason's crying was perceived by the mother as sounding very urgent, very irritable and piercing. This mother felt depressed: she scored a 27 on the Center for Epidemiological Studies Depression Scale (Bouma et al. 1995), where scores of 16 or higher are seen as possible cases of depression. A few weeks later, the VIG trainer reported a diagnosis of post-natal depression, for which the mother received medication.

Prior to the start of the intervention, Jason's mother was observed bathing him in the home setting. On the video made by the VIG trainer, she appeared to be a caring and loving mother. However, she was primarily focusing on her care giving tasks. For instance, Jason looked at the VIG trainer holding the camera several times. He turned his head to be able to see this new lady in the room. However, his mother did not respond to Jason's attempts to see who was standing there; instead she continued undressing him. Overall, there was little to no eye contact between mother and son. His mother frequently had no contact with Jason at all and did not seem to be attuned in her communication with him. When she did talk, it was rarely in response to Jason's initiatives.

Intervention process
After each home visit, the VIG trainer noted her impression in a semi-structured logbook (Klein Velderman et al. 2008). She rated how much she liked working with the mother involved; whether she thought it was possible to change the mother's behaviour; how the VIG intervention was received; how she perceived the mother–child interaction; and any additional points she thought were worth mentioning. From the logbook information, we know that both the father and the mother were present during almost all the visits (the father missed only the fifth home visit). The trainer wrote that she enjoyed her visits and had the feeling that it would be possible for the mother and the father to change. She felt that both parents were very cooperative and were open in their conversation. The father seemed to feel more secure than the mother and appeared to be very proud of his son. The mother said she sometimes felt rejected by Jason. She perceived his crying as anger and frustration, which corresponds to the results we found on the Cry Perception Scale (Lester et al. 1992).

The trainer reported that during the second home visit the mother noticed some of Jason's signals. From the third visit onwards Jason's mother started to feel less guilty and enjoyed the interaction with her son more. During visit four, the trainer wrote down that mother was more and more capable of naming Jason's initiatives and her own actions. At the last visit she looked more at what Jason needed and did. The father consistently supported his wife.

Post-test

At the end of the intervention, Jason was four and a half months old. His mother reported that he now cried for an average of one and a half (instead of three to four) hours per day. Her perceptions of his crying (Lester et al. 1992) were clearly less negative. She perceived it as sounding less urgent, less grating and less worrisome.

The trainer again made a video for our observations. In the post-test video analysis, there appeared to be far more communication between mother and child. The mother noticed Jason's signals more, and although responses were not always prompt, she did respond adequately more often. Several times, she named the signals she received from Jason. For instance, she would say 'Pete Pirate' when Jason looked at a little pirate puppet hanging on the wall. When he later looked at the pirate puppet again, although her response was somewhat delayed, she showed him how to pull the puppet string and moved him closer so that he could try to pull the string as well. This task was too difficult for him, but she confirmed that he would be able to do this himself when he was 'a little bit older'. This time, when Jason turned his head to take a closer look at the VIG trainer, his mother did respond to him, saying: 'Yes, she is still here!' Finally, as Jason made a noise, she confirmed: 'Yes, you can tell me!'

Conclusion

This case of Jason constitutes some promising first results in our study, showing that, despite the significant risk of infant crying in early life, it is possible to improve the parenting situation using VIG. Future analyses of the video observations in our study, using the Emotional Availability Scales (Biringen, Robinson and Emde 2000) or similar observational measures can provide us with more information about the possibility of making a significant impact on the sensitive responsiveness of participating mothers.

The importance of sensitive parenting

Since John Bowlby formulated the fundamentals of attachment theory (Bowlby 1971), many studies have confirmed the beneficial effects of secure attachment. Secure attachment was found to be associated with children's competency in regulating their negative emotions, their development of more satisfactory parent and peer relationships, and their optimal cognitive abilities (Cassidy 1999), which are capacities linked to some of children's main developmental tasks. On the other hand, insecure attachment is found to be predictive of less optimal socio-emotional functioning. Based on his overview of studies, Mark Greenberg concludes that insecurity of attachment may therefore be regarded as a risk factor in development (Greenberg 1999).

Bowlby emphasized sensitive care giving as a determinant of secure attachment. Maternal sensitive responsiveness can be defined as the mother's ability to perceive her child's signals accurately, and to respond to them promptly and appropriately (Ainsworth, Bell and Stayton 1974). A meta-analysis (Van IJzendoorn 1995) has indeed revealed that the transmission of adult to child attachment security occurs in part through the adult's sensitive responsiveness.

In stressful parenting situations, parents can display less sensitive behaviours in interaction with their child (Degroat 2003; Kang 2006).

The risks of infant crying

Infant crying is regarded as child attachment behaviour and is an important way for the child to communicate with their parent. On the other hand excessive crying in young infants is a common and often serious problem for parents, as was seen in the case study of Jason. Infant crying is one of the first stressors in parenting, causing a loss of confidence in parents. The stress it causes can impact strongly on parent–child interaction and the future relationship between parent and child (Raiha *et al.* 2002).

Reijneveld and colleagues (Reijneveld *et al.* 2004) studied infant crying and the associated risk. They reported on a sample of over 3000 Dutch infants, aged from one to six months. Nearly 8 per cent of the parents in this sample worried about their infants' crying. Parents may undertake all kinds of actions to stop infants crying, some of which may be harmful to the infant's health, such as slapping or shaking the child. In an anonymous questionnaire, the researchers asked about actions that had been taken to stop the infant crying (Reijneveld *et al.* 2004). Parents were asked about whether they had smothered, shaken or slapped their infant to stop it crying. These three actions were incorporated in a list of 20 others, such as

using a baby's dummy or carrying the infant. The striking result was that nearly 6 per cent of parents reported taking at least one action (smothering, slapping or shaking) that can be considered child abuse to stop the infant from crying. One in five of these parents had taken more than one of these three actions. Rates were significantly higher for infants with parents who worried about the crying, or had at any time judged it to be excessive (Reijneveld *et al.* 2004). The results of Reijneveld and colleagues (2004) emphasize the necessity to intervene in two areas: 1) interventions should aim to reduce infant crying, or at least the parental perception of their infants' crying as excessive or problematic; and 2) parental stress should be reduced and positive parent–infant interaction promoted.

With regard to the first target of intervention concerned with reducing infant crying, van Sleuwen and colleagues (2006) compared the effects of a standardized approach of regularity and stimulus reduction (see the Case Study) with the same approach supplemented with swaddling, in a sample of Dutch infants up to three months of age. Results showed that crying decreased by 42 per cent in both groups after the first intervention week. Swaddling was a beneficial supplement in excessively crying infants aged less than eight weeks. In response to this study, a guideline was developed for Dutch Preventive Child Healthcare. In the Netherlands, child health professionals (i.e. physicians and nurses) working in Preventive Child Healthcare offer routine well-child care, including the early detection of psychosocial problems, to the entire Dutch population. This entails at least 12 contacts (at home and at well-baby clinics) with child health professionals in the first two years after birth. Therewith, Preventive Child Healthcare in the Netherlands reaches almost all children from birth to four years of age. Access is independent of insurance status, but, in contrast to the US system, the services do not provide treatment services. The recurrent pattern of baby care, which provides structure and regularity, is now part of standard advice given to parents by Preventive Child Healthcare professionals in the Netherlands.

This chapter has so far focused on the second target of intervention: reducing parental stress and promoting positive parent–child interaction. The case study of Jason has provided us with some promising first results on the possible effectiveness of VIG as a method to promote sensitive mother–child interaction in families with worries about infant crying. After the VIG intervention, Jason's mother perceived her infant's crying as less excessive and less worrisome; also, interacting with Jason was more enjoyable to her. On video, the mother appeared to communicate more, perceive Jason's initiatives more accurately and respond more adequately than before the intervention. The following section focuses on what else is known about the effectiveness of VIG as a preventive intervention in infancy.

The effectiveness of VIG in infancy

Many intervention studies have been undertaken to enhance parents' sensitive responsiveness (Juffer, Bakermans-Kranenburg and Van IJzendoorn 2005a). Meta-analytic results have shown that interventions with a focus on sensitivity successfully enhance maternal sensitivity in families both with and without multiple problems (Bakermans-Kranenburg, Van IJzendoorn and Juffer 2003; Juffer *et al.* 2005a). Moreover, interventions on sensitivity and/or attachment were found to be more effective if they involved only a moderate number of sessions and a definite focus.

More recently, Fukkink (2008) conducted a meta-analysis of 29 studies specifically on the effect of video feedback intervention on parenting behaviour and parental attitude, and on the development of the child. Statistically significant evidence was found that parents 1) become more skilled in interacting with their young child; 2) experience fewer problems; and 3) gain more pleasure from their role as a parent ($d = 0.47$ = average effect). As in the meta-analysis of Bakermans-Kranenburg *et al.* (2003), shorter programmes appeared to be more effective in improving parenting skills. Intervention effects were smaller for the attitude domain both at parent and at child level. However, effect sizes still pointed to effects between small and average.

In Fukkink's meta-analysis, results were included of 15 experiments (12 studies) focusing on families with children up to one year of age (Fukkink 2008). These studies were published in or before 2006. For the current chapter, an additional literature study was carried out to search for relevant publications in the last five years (2006–2010). The PsychINFO electronic database was searched using the same terms as Fukkink used (p.906): 'terms for relevant intervention [self-model*, self-confrontation, self-observation, feedback, playback, parental training, intervention, treatment *and* video*] were combined in the search profile with terms for particular family populations [parent*, family*, child*, marital, mother*, and father*]'. Selection was restricted to those studies focusing on families with children in their first year of life.

Four additional relevant publications were found. Table 5.1 summarizes several programme and research characteristics of all experiments (including the experiments described in Fukkink's study). In the following paragraphs, some of these characteristics are reviewed in a qualitative, narrative manner. For a quantitative review and description, we refer to the primary studies and to Fukkink's meta-analysis (Fukkink 2008).

Table 5.1: Summary of programme and research characteristics of VIG interventions in infancy

Study	Sample	Intervention approach	Duration	No of sessions	Nexp+ Ncon	Start intervention	Positive intervention outcomes
Bakermans-Kranenburg et al. (1998): I*	Low-SES, insecure mothers	Brochures/video feedback (VIPP) in home visits	14	4	10+10	7 months	Maternal sensitivity
Bakermans-Kranenburg et al. (1998): II*	Low-SES, insecure mothers	I plus discussions (VIPP-R)	14	4	10+10	7 months	Maternal sensitivity
Cassibba et al. (2008)	Premature children and children with atopic dermatitis	Video feedback in home visits plus discussions (VIPP-R)	-	4	20+20	6 months	Maternal sensitivity and infant–mother attachment in insecure mothers and their children
Egeland et al. (2000)*	Low-SES, multiproblem mothers; firstborns	Support, video feedback, mother–child psychotherapy (STEEP)	65	65	74+80	Pregnancy	Maternal sensitivity; understanding of infant development; (less) maternal depression and anxiety scores; competence in managing daily life
Eliëns (2005)*	Maternal concerns about infant crying	Video feedback (VIG) in home visits or in hospital	8	-	33+49	2 months	Maternal conception of contact; perception of infant crying
Juffer et al. (2005b): I*	Internationally adopted infants; first children; with birth children	Personal book/video feedback in home visits	12	3	30+30	6 months	Maternal sensitivity; (less) disorganized infant–mother attachment

Study	Sample	Intervention approach	Duration	No of sessions	Nexp+ Ncon	Start intervention	Positive intervention outcomes
Juffer et al. (2005b): II*	Internationally adopted infants; first children; with no biological children	Personal book/video feedback in home visits	12	3	20+20	6 months	Maternal sensitivity; (less) disorganized infant–mother attachment
Kalinausk-iene et al. (2009)	Low maternal sensitivity; firstborns	Video feedback in home visits (VIPP)	20	5	26+28	6 months	Maternal sensitivity
Klein Velderman (2005): I*	Insecure mothers; firstborns	Brochures/video feedback (VIPP) in home visits	16	4	28+27	7 months	Maternal sensitivity; (less) externalizing and total problems in clinical range at pre-school age
Klein Velderman (2005): II*	Insecure mothers; firstborns	I plus discussions (VIPP-R)	16	4	26+27	7 months	Maternal sensitivity
Landry et al. (2006)*	Children born at term (n = 120) or at very low birth weight (n = 144)	Video taped examples, problem-solving activities, video feedback in home visits (PALS)	10	10	133+ 131	6 months	Maternal responsiveness; infants' social, communication and cognitive competence (facilitated by increases in maternal responsiveness)
Magill-Evans et al. (2007)	Fathers; firstborns	Video feedback; handout	4	2	81+81	5 months	Paternal sensitivity; cognitive growth fostering
Mendelsohn et al. (2005)*	Low-SES; Latino children	Video feedback integrated in pediatric primary care (VIP)	154	12	42+51	2 weeks	Child cognitive and language development; (fewer) developmental delays

Table 5.1: Summary of programme and research characteristics of VIG interventions in infancy *cont.*

Study	Sample	Intervention approach	Duration	No of sessions	Nexp+ Ncon	Start intervention	Positive intervention outcomes
Moran *et al.* (2005)*	Adolescent mothers	Video feedback in home visits	5	8	49+50	6 months	Maternal sensitivity; infant–mother attachment
Seifer *et al.* (1991)*	Infants with developmental disabilities	Video feedback; interaction coaching	40	40	23+17	8 months	Maternal sensitivity; (decreased) overstimulation; infants less fussy; more optimal child development
Stein *et al.* (2006)*	Mothers with eating disorder	Video feedback in home visits; guided cognitive behaviour self-help for eating disorder	28	12	38+39	4 months	Maternal facilitation and appropriate non-verbal responses; (fewer) mealtime conflicts; infant autonomy
Wijnroks (1994)*	Preterm infants	Video feedback in home visits; booklet on sensitivity	26	4	25+25	6 months	Maternal sensitivity; non-intrusiveness; infant responsiveness
Woolley *et al.* (2008)	Mothers with post-natal eating disorder	Video feedback in home visits (VIPP) particularly during feeds; individualized child development album; cognitive behavioural therapy	24–27	13	38+39	4–6 months	Maternal facilitation and (less) mother–infant conflict, intrusive behaviour, inappropriate attributions during family meals; infant autonomy
Ziegenhain *et al.* (2004)*	Adolescent multiproblem mothers	Video feedback	12	7	5+10	Birth	Maternal sensitivity

Note: * = Experiment also depicted in Fukkink (2008); Duration = programme duration in weeks; Nexp + Ncon = number of participants in experimental group + control group; Start intervention = age of child at programme start. Information missing reported using '-'. For more information on design, random assignment of condition or not, use of alternative programme for control group, age of parents and session length, see also Fukkink (2008).

Sample characteristics

Traditionally, intervention studies aimed at parenting competencies and engagement have primarily focused on mothers, or to a lesser extent on both parents. This is reflected in the experiments summarized in Table 5.1. All but one study (Magill-Evans *et al.* 2007) focused primarily on mothers. Magill-Evans and colleagues conducted a randomized controlled study with first-time fathers. They evaluated the effects of video feedback delivered during two home visits when the infants were five months old. Fathers in both the intervention group and the control group reported increased competence in parenting over time. However, fathers in the intervention group were significantly more skilled than control group fathers in fostering cognitive growth and maintained their sensitivity to the infant when the infant was eight months old.

Except for the study by Magill-Evans and colleagues (2007), all studies were directed towards high-risk families, with the risk either at parent or at child level. Risks at parent level included low socioeconomic (low-SES) background (Bakermans-Kranenburg, Juffer and Van IJzendoorn 1998; Egeland *et al.* 2000; Mendelsohn *et al.* 2005); insensitive parenting (Kalinauskiene *et al.* 2009); insecure attachment representation (Bakermans-Kranenburg *et al.* 1998; Klein Velderman 2005); eating disorders (Stein *et al.* 2006; Woolley, Hertzmann and Stein 2008); teenage parenthood (Moran, Pederson and Krupka 2005; Ziegenhain, Derksen and Dreisörner 2004); or multiproblems (Egeland *et al.* 2000; Ziegenhain *et al.* 2004). For example, Klein Velderman (2005) studied the effects of video feedback in a sample of mothers with an insecure attachment representation. Mothers were randomly assigned either to an intervention group (I) with brochures (on, for example, crying and comforting; baby's need to feel understood and secure; and play with young children) and video feedback in home visits ($N = 28$); an intervention group (II) with additional discussions in the home setting ($N = 26$); or the control group ($N = 27$). Intervention mothers showed statistically significant increases in sensitive responsive parenting behaviour. Further, the first intervention resulted in a reduction of clinical externalizing and total problems at pre-school age.

Experiments focusing on high-risk samples with risk at child level involved samples with premature children (Cassibba *et al.* 2008; Wijnroks 1994); concerns about infant crying (Eliëns 2005); internationally adopted infants (Juffer, Bakermans-Kranenburg and Van IJzendoorn 2005b); or children with developmental disabilities (Seifer, Clark and Sameroff 1991). For example, Cassibba *et al.* found that in an Italian sample of premature

children and children with atopic dermatitis and their mothers, video feedback resulted in an enhancement of maternal sensitivity and increased attachment security of their children (Cassibba *et al.* 2008). This was only true for mothers with an insecure attachment representation. Results were not replicated for secure mothers and their children.

Intervention programme characteristics

The intervention programmes being reviewed in this chapter differed in number of sessions, ranging from two (Magill-Evans *et al.* 2007) to sixty-five sessions (Egeland *et al.* 2000), and in duration, ranging from four to sixty-five weeks (see Table 5.1). Some interventions started during pregnancy (Egeland *et al.* 2000) and some at birth (Ziegenhain *et al.* 2004). Two interventions started in the first three months after birth (Eliëns 2005; Mendelsohn *et al.* 2005). Three others began in the third to fifth month after birth (Magill-Evans *et al.* 2007; Stein *et al.* 2006; Woolley *et al.* 2008). The majority, that is twelve interventions, started from six to eight months after birth.

From this list, one cannot deduce the best time for intervention. However, a clear association can be found between the age at the start and the focus of the intervention. Interventions starting before, at or shortly before birth were primarily aimed at low-SES, high-risk, first-time parents. An example is the STEEP programme provided to low-SES, high-risk, first-time mothers, studied by Egeland and colleagues (2000). This intervention, starting at pregnancy, is based on attachment theory and research, as well as on research on child abuse and neglect. Participating mothers were offered an intensive intervention consisting of support, video feedback and mother–child psychotherapy, resulting in a better understanding of infant development and an improvement in the mothers' relationship with their infant, as well as lower depression and anxiety scores, more competency in managing daily lives and improvement in areas of sensitivity, responsiveness and availability (Egeland *et al.* 2000).

Eliëns' intervention (2005) started at two months of age. This intervention was aimed at maternal concerns about infant crying. This adheres to research evidence that the risk of crying arises from one to six months after birth (Reijneveld *et al.* 2004). The two studies in this review focusing on mothers with eating disorders started at four to six months after birth (Stein *et al.* 2006; Woolley *et al.* 2008). The twelve studies starting in the second half of the first year of life (see Table 5.1) have one thing in common: these were primarily attachment-based, focusing on the increase

of maternal sensitive responsiveness, reduction of maternal intrusiveness and support of secure child–mother attachment. We know from research that the child–mother attachment relationship is thought to emerge and become more firmly established during the second half-year after birth (Marvin and Britner 1999). This information about normative development of attachment clarifies the start of these interventions with their specific focus on maternal sensitivity and attachment.

An example of an attachment-based video feedback intervention is the Leiden video feedback intervention VIPP (Video Intervention to promote Positive Parenting). A total of seven research projects in this chapter's review (Bakermans-Kranenburg et al. 1998; Cassibba et al. 2008; Kalinauskiene et al. 2009; Klein Velderman 2005; Woolley et al. 2008) examined the effects of this intervention. VIPP is a brief and focused, evidence-based parenting intervention programme consisting of a short number of video feedback sessions in the home setting. It was developed from a background of decades of experimenting and research. An overview of research on this intervention is summarized in a recently published book (Juffer, Bakermans-Kranenburg and Van IJzendoorn 2008).

Study outcomes

Most studies chose to measure parental sensitive responsiveness. All those that chose this as a measure reported an increase in parental sensitive responsiveness. This reflects the positive trend of the success in increases in parental sensitive responsiveness, as found in previous meta-analytic research (Bakermans-Kranenburg et al. 2003; Fukkink 2008). Some of the studies also reported positive effects on child behaviour and development (Klein Velderman 2005; Landry, Smith and Swank 2006; Mendelsohn et al. 2005; Seifer et al. 1991; Stein et al. 2006; Wijnroks 1994; Woolley et al. 2008), parental wellbeing (Egeland et al. 2000; Eliëns 2005) or child–mother attachment (Cassibba et al. 2008; Juffer et al. 2005b), albeit to a lesser extent. This is in line with previous meta-analytic results that show the strongest effect of VIG on changes in parental behaviour (such as enhanced interaction with their children) and less strong effects on parental stress and on changes in the child's behaviour (Fukkink 2008). However, it is important to consider the focus of the studies involved and the outcome measures selected before making quantitative interpretations.

General conclusion and discussion

The aim of this chapter was to illustrate the possible effectiveness of VIG as a method to promote sensitive parent–child interaction in infancy through a case study and narrative review of VIG interventions implemented at this age. To start with, a case study showed how Jason and his mother successfully participated in VIG as provided in the preventive child health care settings in the Netherlands. Jason's mother increased her levels of communication, trust and sensitive parenting. To gain more insight into the overall possible success of VIG in infancy, a narrative review followed, elaborating on the recent meta-analytic work of Fukkink (2008). This narrative review allowed for the description of some general trends and overall impressions about positive outcomes of different applications of video feedback interventions in infancy. It showed that only one intervention was offered to fathers; all others were directed primarily at mothers. Future research should acknowledge the important role fathers play in parenting. It would be interesting to compare process and effect evaluations of participating fathers and mothers. Further, except for the one intervention offered to first-time fathers, all interventions were offered to and tested in at-risk groups. It is important to test the use of video feedback interventions in non-risk, healthy families as well.

Limitations of case studies and narrative review are generally the omission of quantitative comparisons and summaries. Meta-analyses can offer that information. The timeliness of information is another limitation of narrative reviews. In this chapter a snapshot was offered of a moving field of practice and research. There is a current flow of research, with a certain delay between the end of research and publication of results. We presented the Dutch case study as an example of ongoing research – that is, we focused on studies archived in the PsychINFO database – but other ongoing studies were not included. Moreover, intervention studies published in languages other than English, German or Dutch, or presented in research reports instead of peer-reviewed articles were omitted (e.g. Van der Zeeuw and Eliëns 2009).

Despite the abovementioned limitations, this chapter offers an important overview of the current knowledge on VIG in infancy. 'Promising' was a key word in this chapter. Promising examples were presented of the powerful effectiveness of VIG as implemented in infancy. The present overview can be regarded as a first stepping stone for future research on effectiveness, mediating elements or principles, cost-effectiveness, long-term effects and research in different samples and other age groups.

Supporting Vulnerable Families to Change through VIG

MARIA V. DORIA, CALUM STRATHIE AND SANDRA STRATHIE

Practitioners and researchers are finding that Video Interaction Guidance (VIG) is an effective method for improving family relationships (Fukkink 2008). This chapter explores the potential of VIG for working with vulnerable families who are not engaging with the services offered, where factors such as domestic violence, adult mental health problems and parental substance misuse are an issue. In the first part, the way VIG is introduced and implemented with families is described from the first-hand experience of VIG professionals working with families. In the second part, detailed analysis of the use of VIG is presented through a case study of one of these vulnerable families, in order to demonstrate how change came about.

Working with families

Many theories and hypotheses seek to explain why children are abused, neglected or rejected by their parents. In particular, poverty, ill health, substance misuse and environmental factors seem to influence the parents' sensitivity and ability to respond appropriately to the child's needs (Hoskins 1999). These are reflected in the referrals that are made to VIG guiders by, for example, health professionals, psychologists or social workers. While valuing the referrer's professional hypotheses, the main question for the guider to start the work is, 'What does the family want to change?' We have found that, even in the most complex situations, most families want their relationships to be better and/or want their children's behaviour to improve.

Our experience is that children from very difficult backgrounds often wish to have loving and emotionally responsive relationships with those who care for them. Even when family relationships have nearly broken down, 'a desire for intimacy' often remains (Howe 2005, p.103). Where there are child and adult protection concerns these should be openly discussed with the parents and in collaboration with all other professionals involved with the family. Jane Barlow recommends that key groups of practitioners working in the area of 'safeguarding children from Emotional Maltreatment' should be required to 'work in partnership/therapeutically with families to bring about change'; she suggests that relationship interventions such as VIG might be helpful in supporting this process (Barlow and Schrader-McMillan 2010).

The first step for the guider is to engage with the family in a meaningful way, establishing trust and listening to the meaning of the family's request for help, in particular what they want or need to change (Beaufortová 2001). Engagement can be particularly difficult to establish with families who are in crisis but who refuse offers of support that are perceived as prescriptive rather than helping. In this context, the communication between the professionals and the family becomes a crucial factor for the success of the work. It requires 'listening more to meanings than to words', and understanding the family's perspective (Covey 1999, p.224). VIG is an intervention agreed by mutual contract with the family; it therefore cannot be imposed against families' wills or made compulsory. Families are usually offered an initial session, so that they can decide whether or not they wish to continue with the intervention. Therefore, there is an opportunity for the family to opt out without feeling a sense of failure or being concerned about how they might be perceived by other workers involved with the family. Rather than focusing on what is not working, the guider will compliment the family on what they see as exceptions to the presenting 'problem'. This assures the families that professionals can recognize their strengths and that there are signs of hope and possibilities for change. For example, the mother featured in the case study presented in this chapter reported to the researcher the following reaction when the guider, on his first home visit, had told her he could see good things already: 'Good things? What good things? But obviously they had been there all along – it was just that I didn't see them.'

From the start, the guider is looking for strengths and exceptions to the family's normal patterns of communication and interactions. The aim is to 'reframe the perceptions of the family' (Satir, Stachowiak and Taschman 1989), helping them to form a richer understanding of themselves, their interactions and their relationships. The identification of strengths may also

help the family to relax in front of the camera and to trust the guider to record and capture the sense of the family interacting together in a normal daily activity. The guider needs to be close enough to the family to capture on video the eye contact between them, to see facial expressions, to record words and, most importantly, to capture how the parent attunes to the child. From initial engagement guiders are seeking to build a 'helping relationship' with the family (Rogers 1990) which is crucial if any meaningful recording of interactions is to take place.

At the very first meeting with the family, the guider begins to discuss the family's own goals. For example, using carefully chosen clips of attuned interactions and a broad goal, such as 'to have a good time together' or 'for the child to behave', the guider can begin to explore with the family what might help them reach that goal. The family is engaged in a collaborative reflective process whereby they are setting the goals for change. It may seem very clear to the guider that an obvious solution to their difficulties is within the family's power. However, solutions posed by others are not always perceived as helpful, empowering or acceptable to the family. The VIG approach integrates the principles of empowerment theory, facilitating the family 'to take control of their circumstances and achieve their own goals' (Adams, Dominelli and Payne 2002, p.201).

Through focusing on successful interactions in the parent–child relationship, both the guider and the parents have the opportunity to discuss strengths and possibilities for change. The partnership of guider and parents can help in exploring ideas, thoughts and feelings, with parents choosing what is useful or not useful for themselves and their families. We have found that mobilizing the parents to find and test their own solutions is motivating for them and crucial for a successful outcome. Success rarely appears in the early stages, but it emerges as a developmental process. However, small signs of change may encourage families to continue and what may seem a small change to the guider can feel much bigger to the family. Parents may need to refine their approaches and discuss challenges or negative experiences that impact on their ability to achieve the desired change. They also need to be supported in exploring how they have overcome or might overcome these challenges (e.g. how their understanding of their own childhood traumatic experiences helps them to relate better to the feelings of their children). There are also times when the guider needs to give more support, offer opinions or challenge perceptions. Overall it is a co-exploration between the family and the guider (i.e. how the family see things and how the guider sees things).

It is important that there is 'a firm focus on the child' while working with families where there are concerns about the parent–child relationship (Lishman 2007, p.120). Video recording of a child's interaction with a parent is a first important step in assessing the underlying attachment patterns while looking for moments of hope. Seeing the child at home, without the compensation or structure of an assessment centre or other external environment, can provide an indication of how the parent and child interact in normal daily activities. This can provide vital information about the parent's ability to care for the child and to meet the child's developmental needs, and also how attuned, warm and receptive they are to the child's initiatives. From the initial session of VIG, the guider can assess the parent's motivation to work towards change and identify where the risks are for the child and the family.

Child protection research consistently stresses the importance of direct communication with and involvement of the child (Lishman 2007). To produce a useful video recording, the guider has to keep a sensitive presence that is not distracting for the child or disempowering for the parent. To help build rapport and relationship, the guider should use developmentally appropriate ways of interacting with the child. The guider should seek to model sensitive attuned communication with the child through the use of the VIG principles for attuned interaction. We take a socially constructed view that children are active participants in the world (Lishman 2007) who can make valuable contributions to the shared review when appropriate. Research shows that by getting close to the family, professionals can understand the dynamics of family life and provide better protection for the child. It is also strongly acknowledged in social work literature and practice that the strength of the relationship with the family brings change and ensures greater safety for the child (Department of Health 1995).

In our experience many professionals have expressed two worries that they have about filming families. One is that the families act in an unnatural way in front of the camera. Second, they worry what will happen if the parent becomes abusive to the child when the camera is recording. We acknowledge that people do become very self-aware when they are being filmed and that they will try to show themselves acting and communicating in the best way they can. This provides useful material for the shared review as the child will respond positively to this happy time with the parent, which gives a basis for discussion with the parent about why things are different or better than they normally are. In our experience no parent has ever acted abusively towards a child while being filmed and if such an

incident arose we would turn off the camera and deal with the matter in the same manner as we would in any other aspect of our work.

When families are referred for support, the referrer should be immediately involved, as the guider needs to know what it is that the referrer wants or needs to change in the family. However this must not override the goals of the family, who must be empowered to take an active role in the VIG work. Often the referrer will have one or more concerns about the parent's capacity to care for the child – for instance, their relationship with the child or how the child is cared for on a daily basis or behaviour management. There may be other factors involved, such as substance misuse or anti-social behaviour. The referrer and the family need to be clear at the time of contract exactly what information will be shared and when. It should be made clear to the family that any concerns about the wellbeing of the child will be dealt with through the usual child protection practices of the agency. After consulting with the family, the referrer and other professionals involved with the family may be invited to contribute to an assessment of the family's progress. This takes place during normal meetings between professionals and the family. Here the family, supported by the guider, can speak about the progress they have experienced with the VIG sessions, show evidence of this progress through the video clips and explain what steps they are taking towards change and the desired goals. In our experience the family often feels empowered and other professionals feel involved in the VIG process of change. Lack of progress can also be discussed with parents, who are encouraged to state their perspective on what they feel is hindering progress, or what further support they feel is required. Regular sharing of information and discussion among the family and professionals can be very helpful for the success of the intervention. The VIG professional always has to bear in mind who is commissioning the intervention, and work with the referrer and their agency is crucial to build cooperation and strong communication links between involved agencies. Likewise, clear consent must be established in the initial contract before any showing of video clips to other professionals is undertaken. The confidence and motivation of the family can benefit from their being supported to take the lead in the meeting. When parents present the video clips showing their family's progress, they very often receive positive feedback from the workers involved and can gain encouraging recognition for their attempts to improve. As Calder and Hackett (2003) suggested, motivation is a product of the interaction of the client, the professional and the environment, and is not an isolated product of the client. The VIG shared review sessions

ensure direct observation of the parents and children interacting together and support ongoing assessment of the family's progress.

Researching the impact of VIG with vulnerable families

The second part of this chapter reports research findings from a single-case investigation of a series of VIG sessions with a vulnerable family who was receiving a school-based social work service and support from a community mental health team. This case is part of a larger qualitative study conducted by the authors (Doria *et al.* 2009, 2011) which aims to explore the theoretical explanations for the success of VIG as a therapeutic tool in family work. In this project, the authors had an 'opportunistic' sample of all the families for whom VIG work had been completed and the recordings of the first three shared reviews were available at the onset of the investigation (January 2008). Data was gathered through multiple methods (video recordings of VIG sessions, content analysis, interviews and focus group). In this chapter, the case of a particularly vulnerable family is presented and analyzed in greater depth.

Previous research has suggested the contribution VIG can make in promoting positive change with families. A meta-analytic study reported that video feedback in general (including some VIG studies) was effective in promoting positive change with families and that VIG (in the Netherlands) was more effective than other video feedback methods. As with most interventions, video feedback methods in general were less effective when used with more vulnerable families (Fukkink 2008). There are many individual case studies using VIG in the UK that have recorded impressive change in families with whom professionals have traditionally found it hard to engage (Rautenbach 2010; Savage 2005; Simpson, Forsyth and Kennedy 1995; Strathie and Kennedy 2008). The research reported in this chapter aims to contribute to further understanding of how the process of VIG is effective in working with vulnerable families.

The family of our case study had participated in a VIG intervention and this had promoted positive change for them and their relationship with their children. All the content produced by the mother and the guider within the three initial shared review sessions was transcribed from the video recordings and submitted to a content analysis with the support of NVivo software. The content analysis generated 50 different categories of meaning regarding the parent's contributions and 60 categories of meaning

for the professional's contributions. These parent and professional categories were grouped further to reflect selected aspects of VIG (i.e. VIG principles of attunement and the cycles of the shared review). Moreover, to investigate further the evolution of the parent's thinking in the case study, the parent's response to the edited clips as she watched them for the first time was analyzed for the three review sessions. The case study analysis also included self-reported data of a semi-structured interview with the mother. The interviews explored the mother's personal view of the VIG method and its outcomes. She was also asked how VIG compared with other intervention methods in order to seek data that might generate an understanding of the success of VIG for vulnerable families.

The case study

Yes because nine times out of ten when I am trying to tell him something I am screaming at him, so he is probably like: 'Oh she is screaming again!'

(*start of intervention*)

Whereas he sat and listened and I looked at him and explained it and this time I didn't (scream) so he understood and he didn't get himself all worked up because I was calm.

(*mid-point of intervention*)

Mary (mother)

A mother and her 14-year-old son, presented in this case study under the pseudonyms of Mary and Matt, were referred to the social work based guiders by the local community mental health team. Matt was the youngest of three sons and was living with Mary and his middle brother.

The relationship between Mary and Matt was described by referrers as one of frequent conflict: mostly verbal conflict but with some instances of physical damage to the home. Much of the conflict appeared, according to referrers, to stem from Matt's refusal to attend school and Mary's concerns that this was going to lead him into more troublesome behaviour in the community. This conflict seemed to be having an impact on the mental wellbeing of both Mary and Matt. Mary described the experience of depression and anxiety for which she was prescribed various medications. It appeared from what Mary said that she blamed the current situation

totally on Matt and she spoke very negatively to him and about him. From Mary's perspective, as expressed to the guider, it seemed it was Matt who needed to change. Matt, on the other hand, had started to show signs of extreme emotional distress by leaving written messages about his suicidal thoughts and intentions to self-harm. These messages seemed to give a clear indication of his feelings and appeared to suggest he was accepting blame for the impact of his behaviour on his mother. Both Mary and Matt appeared to be locked into a downward spiral of blame and guilt and did not seem to know how to reverse it.

> Mary: I had social workers, even educational social workers to drop him off to school and he would still plunk (stay off school).

At the initial meeting between Mary and the guider a lot of her negativity and blaming was expressed. However after the initial conversation it emerged that she wanted her relationship with Matt to be restored and was willing to engage with VIG.

The frequencies of the coding categories across the three initial shared review sessions were analyzed in order to explore the effect of the VIG intervention on the professional and client responses (see Figure 6.1 and Table 6.1). In this particular case, the mother increased her negative information statements from the first to the second shared reviews and then showed a big drop from the second to the third. Once these changes occurred, the son's response to his mother seemed to improve, and the relationship continued to improve as evidenced in the evaluation interview with her; Matt was involved in the shared reviews. We think this must be significant. It was not just Mary who made changes in her thinking and attitude. Changes also occurred in the intersubjectivity and attunement between mother and teenage son.

> Matt has started to listen to what I say.

> Now, I feel better with myself, like I took this heavy weight from my shoulders.

> I have learned that if you have something to say, say it at the time and don't keep it in.

> Now, he is respecting my wishes and I respect his wishes.

> I've stopped anti-depressants.

The way the guider brought about this change is explored by looking at the change in mother and guider contributions over the three shared review

sessions (Figure 6.1 and Table 6.1) analysis of the mother's first response in seeing each of the clips (Table 6.2) and the interview responses (Doria *et al.* 2009, 2011).

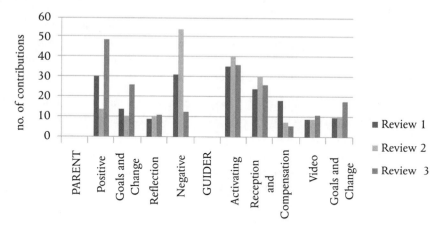

Figure 6.1: Comparison of one parent's and guider's contributions

Table 6.1: Key for Figure 6.1 combined coding categories

Parent	
Positive	parent's contributions contained positive talk
Goals and change	parent referred to aims, goals or change
Reflection	parent reflected on thinking or feeling
Negative	parent's contributions contained negative talk
Guider	
Activating	as a result of verbal or non-verbal response of the guider, parent made an initiative or gave her opinion
Reception and exploration	guider received parent, verbally or non-verbally and/or explored parent's meanings
Compensation	guider compensated, for example by giving his opinion or information about what helps attuned communication
Video	guider referred to or suggested further observation of the video
Goals and change	guider referred to change or goals

Mary did not seem to find the first or second sessions easy; her contribution seemed to have a high proportion of negatives (see Figure 6.1) and the video filming was not a particularly comfortable experience for her. Yet on the seventh minute of the first session (see Table 6.2) she made an initiative, a spontaneous positive response, noting she was observing a 'conversation', i.e. a proper dialogue. This can be considered a significant achievement in the context of her family situation at the time. She later referred to this initial session, reporting even here an effect on her relationship with her son:

> At first, when VIG started it was alienating for me, it was not natural at first. When X [the guider] first came up he said, 'Pretend I am not here and do what you normally do' but what I normally did was not what we were doing… It was backward at first because it was not natural behaviour, but that started off us interacting even when X was not there.

Analysis of what the guider was doing from session to session suggested he was activating at least a third of contributions throughout all sessions (see Figure 6.1). Reception and exploration of what Mary said seemed to occur a quarter of the time overall (see Figure 6.1). He was compensating more (offering Mary his knowledge and thoughts) in the first session than in other sessions, as would be expected given that VIG was new to her and, perhaps, in response to some of her negative contributions.

Mary's first spontaneous response to the edited clip in the second session (see Table 6.2) was positive, and she used the term 'we' (referring to her and her son), which was a relevant concept for interpersonal closeness (Karremans and Van Lange 2008) and suggested an improvement in their relationship when compared with the pre-intervention situation. However, overall it was in the second session that Mary seemed to be most negative in her response (see Figure 6.1) Interestingly, this negative response suggested that she had learned from the previous session to look in the clips for what was working towards the stated goals, but what she saw seemed to fall short of the goals. Even after only one session she was indeed responding to the video, and goals seemed important. Her response to the second clip in session two was negative towards herself: 'This is me negative negative' (Table 6.2). Maybe this was a consequence of Mary's own process of self-reflection, which seems to have been activated within this second review session. She also continued to refer to the unfamiliarity of being filmed (Table 6.2).

Table 6.2: Mary's response after seeing edited clips for the first time

Review Session (paragraph; time)		Parent first response	Parent categorized response
1	43; 02:02 168; 06:56	'We never sound the same' 'Trying to…it was a conversation'	Not familiar with video positive behaviour
2	66; 03:38 179; 10:25 316; 17:55	'Well we are sitting together and it looks like...the first time we were (...)' 'It does yeah, but then this is me negative negative...' 'I mean I think he is sitting there awful stiff kind of like it is not natural and he is not relaxed he looked like he was stiff'	'We' positive Positive agreement; self-negative focus Spontaneous Not familiar with video
3	67; 05:26	'Well he was looking at us and he was listening to us and he was taking it in, because there has been a few times when he has tried to speak to us and he has been glued to the telly and I am like "look at me when I am talking to you", how many times have I screamed at you look at me when I am talking to you? because he is looking around and I am like "what did I just say to you?" and he is like "uh, uh" and I am like "see what I mean?"'	Other person positive spontaneous; positive change; usual negative behaviour
	259; 15:22	'What I was saying is that what I want doesn't cost nothing and what I want from you, you will not give, but I ken (know) that what I want you could give I want you to start...(giving respect)'	Means to desired behaviour spontaneous

It was notable that the strongest reception of the guider to Mary seemed to happen in the second sessions, which coincided with the time when Mary was most negative (see Figure 6.1). A less skilled professional might have been tempted to try to persuade Mary to think 'more positively' rather than to focus on becoming attuned with her by demonstrating that she was being heard. By focusing on attunement rather than persuasion, the guider was enabling Mary to be more in a position that she could see for herself the changes that were visible in the selected video clips. Interestingly the guider showed more or less the same use of the video throughout the three sessions, reinforcing the evidence in the video of a positive moment of interaction between Mary and Matt.

In the third and last review session, for the first time Mary's response about her son was a positive and spontaneous one and she acknowledged the positive change that was occurring within their relationship. It therefore seemed to be from the second review session to the third that the qualitative change in Mary's use of positive terms seemed to happen. Also, for the first time she spontaneously referred to the specific attitude or behaviour she aspired to achieve in the future. There was, in other words, the appearance of self-reflective discourse, i.e. reflection on how Mary herself felt, thought or acted in the face of a particular situation. The guider's level of compensation or giving information perhaps predictably decreased as the sessions proceeded, and thoughts about the changes seen by both Mary and guider were highlighted. This matched the increase in Mary's own initiative-taking (the positive statements and self-reflective discourse).

From Mary's point of view, things improved dramatically with the help of VIG. The guidance of the professional, in particular the reinforcement of the 'good points' (i.e. the evidence of positive behaviour), was referred to by Mary as one of the main factors that had contributed to the success of VIG:

> Maybe we were doing it before but having someone to point out that there were good points... I was not able to see the good points without the help of X [the guider]...it was all negative in my head at that time.

It was interesting that this parent, who often tried to avoid professional intervention, thought a main success factor in VIG was the guidance of the professional.

Results indicated that Mary was happy with the outcomes of VIG and regarded it as more effective than other approaches she had experienced. VIG was particularly successful in this case as it restored the relationship

between mother and son with an increase in interpersonal closeness, communication, respect and trust. As a result of VIG, Matt's attitude and behaviour changed considerably, with the main distressed behaviour being eliminated with his return to school. In the third shared review with Mary, in which Matt participated for a while, one of his quotes illustrates his process of change: 'She was opening up...not an easy life but it is harder when I am not going to school and messing things up...and it is like me that is making it harder and really if I went to school it would be a lot easier' (paragraph 53). Moreover, Mary also noted that life, including her health, had improved for her personally.

The only negative aspect of VIG for Mary was seeing herself on video. Such a reaction is not uncommon and is perhaps due to a mistrust of the system and possible use of the videos. However, our experience tells us that with the appropriate engagement and informed consent procedures clients very easily become familiarized with the methodology.

Further research is needed into how VIG intervention supports change in vulnerable families through enhancing their capacity for self-reflection.

Acknowledgement

Maria V. Doria's research has been partly supported by the Fundação para a Ciência e Tecnologia (FCT) Portugal.

CHAPTER 7

Use of VIG in Schools

DAVID GAVINE AND PENNY FORSYTH

Introduction

The importance of the quality of relationships in schools is increasingly being recognized as fundamental not only to the development of wellbeing and resilience but also to the effectiveness of the learning environment (Hattie 2009; Roffey, Tew and Dunsmuir 2010). This quality is built and sustained through mutually satisfying interactions in which staff and pupils recognize each other's emotions and intentions and actively adapt their responses accordingly. Since Video Interaction Guidance (VIG) is a method based on intersubjective experience and the mediation of learning (Wels 2004), it provides a potentially important tool with which to address the relationship issues that underpin the goals of education.

Studies based on VIG indicate that professionals tend to overestimate their communication skills by underestimating the importance of elements that achieve shared understanding and cooperation (Forrester *et al.* 2008; Forsyth and Thurston 2007; Thomson *et al.* 2005). When these are in place, however, classroom relationships go well (Robb Simpson and Forsyth 2003). In addition, when teachers are supported with VIG, the indications are that they become more aware of the value of interpersonal skills and teacher and pupil perceptions become more positive and empowered (Kaye, Forsyth and Simpson 2000).

When asked to reflect on their experience of VIG, teachers have consistently identified the video as the most useful part, closely followed by the shared review, and they have described the following benefits: increased self-awareness and enjoyment with children; acquisition of skills; opportunity for reflection; team building; and feeling valued by the process (Forsyth, Kennedy and Simpson 1996).

VIG with adults who work directly with children

Schools are highly complex systems where adults with a wide variety of roles interact with children in an equally wide variety of settings. The basic VIG paradigm which was established in a context of one adult with one or two children does exist in schools, but teaching staff have various other goals to pursue simultaneously: delivering a curriculum; forming a cohesive group from a large number of children; engaging every child at their individual level; and managing problems of behaviour and learning. In this context, the goals of VIG have to be adapted to identify and address the particular aims that are relevant to the staff members' needs. The consistent reception of child initiatives remains the key focus but the question is how this can be achieved within the much more complex situation of a class.

An example of the approach in school is for a guider, who may typically be an educational psychologist or advisory teacher, to carry out filming in class and subsequently review the film with a teacher or classroom assistant, or with both together. As in work with families, it is generally thought that around three films and shared reviews are needed to produce worthwhile change. The shared review focuses on clips of good communication between adult and pupils at an individual level and at class level as well as good communication between pupils. Films in classrooms produce so much data that it is essential that the guider keeps a clear focus on the purpose of the intervention and on the particular outcomes sought.

In the current atmosphere of intense scrutiny of teacher performance, it takes courage for a teacher to agree to be filmed and it can be difficult to gain this permission if the intervention seems to focus principally on the action of the teacher. However, if the focus is altered so that pupil-to-teacher and pupil–pupil interaction becomes the initial focus, then the process can make more sense for the teacher. After experiencing a review, staff will often admit to initial anxiety about taking part and express astonishment at how positive an experience it is. By taking this approach, the teacher may gain sufficient confidence to review the clips with the pupils, often with support from the guider. Alternatively, the teacher may be willing to involve the pupils from the start so that an improvement of the classroom climate becomes an explicit task for teacher and pupils together.

In the following sections, examples have been selected to illustrate the considerable diversity in the application of the approach. They vary in scale and in the educational issues they address.

Early Years education

The context of early education arguably provides the optimal setting for VIG. Children at this stage of education are expected to develop autonomy in their choice of activity. Conversational skills are encouraged and social development is considered a major developmental task.

The use of VIG with children who have additional support needs has featured in much of the work carried out in schools. In such cases, classroom assistants may be the recipients of VIG since they frequently have more one-to-one contact with the children than do teachers. As a group, they have been shown to benefit by becoming more aware of attuned communication which then has a positive impact on the behaviour and focus of the children (Forsythe 2010). A good example of this work is the case of a severely visually impaired six-year-old boy who was required to make a deferred transition from nursery (Lennon 2003). It was reported that the nursery staff felt he would struggle to adjust to primary school unless he developed better peer relationships and independent mobility. The intervention involved carrying out VIG with the boy's teaching assistant over four cycles of filming and shared review. Pre- and post-intervention data was obtained on the assistant's behaviour and on the child's peer interaction and mobility. Over the course of the intervention a significant shift occurred in the assistant's behaviour. She used fewer 'compensating' moves (doing things for him) and more 'scaffolding' moves (supporting him in doing them himself). Peer interaction increased from 0 pre-intervention to 20 instances in the post-intervention film and there was also a 39 per cent increase in mobility behaviours. Senior nursery staff reported that these changes were generally observable in the nursery.

The credibility of any educational intervention is enhanced by the inclusion of long-term follow-up of any changes observed following the immediate post-intervention phase. A substantial project carried out in the Netherlands has included this requirement in a rigorous methodology (Fukkink and Tavecchio 2010). This project was based around a VIG training programme for experienced Early Years teachers and consisted of, on average, four cycles of filming and shared review. The researchers used an experimental paradigm with pre- and post-intervention and follow-up data, experimental and control groups with substantial numbers (n = 52 and 43 respectively), independent assessors to analyze the data and a rigorous process for ensuring the reliability of the data. The measures included not only micro-analysis of the content of the films but also the results of independent assessors' ratings of the teachers in terms of their sensitivity towards and stimulation of their children.

The results showed a large range of effects which cannot be discussed fully here. However, the key targeted measures of 'verbal stimulation' and 'sensitive responsivity' produced significant improvement at post-intervention and at three-month follow-up.

Emotional and behavioural difficulties

Managers of residential special schools for children with emotional and behavioural difficulties have been quick to see how VIG can help them achieve their aims. In one school, a project was commissioned from two educational psychologists (Brown and Kennedy 2011). Six of the teachers agreed to take part. The project started with two workshop sessions in which the use of language in the classroom was discussed and the teachers had the opportunity to view films of classroom interaction. Three cycles of filming and shared review then took place with each teacher on an individual basis. The teachers were in control of the timing and taking of the film and the preparation for the shared review. Initially, the teachers were looking at a range of possible outcomes but during the course of the intervention a consensus emerged to focus more closely on how they enhanced children's participation in classroom conversations by building on children's ideas and supporting cooperation.

The outcome of the project was that, in general, the teachers talked less and the children talked more. However, there were considerable differences in the nature of both teacher and child talk. Teachers spent less time giving information and making requests and more time extending children's ideas, linking children's ideas and talking about the process of cooperation itself. Children spent less time making new initiatives and more time extending the ideas of the teacher or other children. There was also a decrease in negative interactions across the board.

Formative assessment

A project which also aimed to enhance teachers' use of communication styles focused on the strategy which is variously referred to as 'formative assessment' or 'assessment for learning' (Gavine and Simpson 2006). This is the process that teachers can use to engage students in setting learning intentions and reviewing progress and outcomes (Black and Wiliam 1998). In this project, the principles of attuned communication were aligned with the concepts being utilized in the literature on formative assessment. In particular, earlier work (Torrance and Pryor 1998) had identified two

distinct styles of teacher communication: the convergent style, which is teacher-led and has predetermined answers; and the divergent style, in which the teacher is open to a diversity of possible outcomes and a fluid exchange of views among students.

Twelve volunteer teachers from the Early Years, Primary, Secondary and Special sectors took part. The structure of the intervention was very similar to that described in the previous example (Brown and Kennedy 2011). An important difference was that the shared reviews were also filmed. One set of research questions examined whether the project changed the teachers' implementation of formative assessment. The evaluation involved the micro-analysis of films of classroom interaction pre- and post-intervention. A second set of research questions explored the relationship between the reflections of the teachers during review and their subsequent teaching behaviour. To address these questions the shared reviews were also subject to micro-analysis. Complete sets were obtained for five of the original volunteers and this data set became the focus of analysis by an independent researcher.

Rich and varied individual profiles were obtained for each of the teachers. The numerical data was aggregated and showed that there had been a general increase in the use of formative assessment strategies and more divergent patterns of discourse. The shared review discussions were found to be closely related to the specific observable changes in the post-intervention tapes. (Gavine and Simpson 2006).

Outside the classroom

Many of the issues facing schools occur outside classrooms. VIG has been deployed to assist staff who work in playgrounds, dining halls and other public areas. The usefulness of VIG in this area was highlighted in an intervention at a large primary school in which seven support staff with varying school responsibilities were deployed to monitor and support playground behaviour (Lennon and Philp 2003). Two educational psychologists acted as guiders and they evaluated the project by collecting pre- and post-intervention films of the individual assistants as they carried out their work. The films were analyzed to determine the proportion of adult behaviour that could be categorized as 'scaffolding' pupil behaviour. Pre- and post-intervention questionnaires were completed in order to establish change in participants' understanding of the principles of attuned interaction.

The intervention comprised two group sessions in which the principles of communication were discussed and this was followed by two cycles

of individual filming of practice and shared review. Following the post-intervention filming, a final group session enabled the participants to share clips of good practice. The attitudes of the participants expressed in the questionnaire changed over the course of the intervention. They had started out highly apprehensive but agreed at the end that it had been both worthwhile and enjoyable. Micro-analysis of the pre-intervention films showed that four of the seven participants were already operating almost entirely in a scaffolding style with pupils, so there was little scope for observing any increase. The remaining three participants substantially increased their proportion of scaffolding behaviours. The post-intervention questionnaire indicated an improved understanding of the importance of attuned interaction and its power in shaping pupil behaviour.

This intervention has some features worthy of note. In a school situation where there are large numbers of staff working together to manage a very diverse population of pupils, inconsistencies between staff can be a source of friction within the team and with school management. Conventional training that relies only on imparting information is unlikely to open up for discussion the patterns of professional behaviour that underlie this issue. However, VIG has the capacity to examine practice in its context and provide coaching as needed to create change. In this particular intervention, it appears that not all of the participants actually needed the training; nevertheless, it is arguable that the already skilled staff could feel validated by the intervention, the less skilled staff helped to improve, the range of practice become less wide and a sense of common purpose enhanced.

VIG with children

The conventional VIG method, applied in school settings and exemplified above, comprises a guider working with an adult who has a key role with a target child, group or class of children. The role of the guider is consequently an indirect one, so that it is common for the guider to have no direct dealings with the children. However, an alternative approach is for the guider to use VIG directly with young people. The guider takes a film in class or other agreed setting and carries out a shared review with the child or children. Good practice requires the children to be as fully involved as possible in the preparation, analysis and sharing of outcomes. The degree to which key adults in the school are involved can vary but it would be normal for the child's class teacher to be included in the review discussions so that working points can be agreed and acted upon. Working with a whole class presents particular challenges for a guider and for the method. The children

are usually fascinated to see themselves on screen but attention can flag when the focus shifts to other children. The guider requires considerable skill to keep the tenor of the discussion sufficiently positive.

One practitioner (Walmsley 2010) has reported promising results, described below, working with individual children, groups of various sizes and whole classes. In the following examples, Walmsley took the role of guider.

She worked with an individual Year 5 pupil who, despite being of high ability, could disrupt lessons and be challenging to his teacher if a topic was not of interest to him. He lost his temper easily if he thought he was being treated unfairly or was being teased. At an initial meeting with the guider, he agreed to take part in VIG to help him make friends and stop getting into trouble. The first film taken was of interaction with the guider and the second and third were taken in class during paired activities. Following the intervention, his teacher reported noticing a positive change in how he interacted with her and his classmates and the child himself said he was feeling calmer. While there was no immediate improvement in friendships, the other children were becoming more willing to work with him.

A separate intervention targeted an entire Year 7 primary class in which the teacher was finding that her attempts to introduce a cooperative learning approach was not successful because many of the pupils struggled to work well together. Common difficulties included pupils talking over each other or disengaging, ignoring the ideas of others, struggling to reach consensus and having limited discussion. Each of the six cooperative learning groups experienced three cycles of film and review. The shared review groups focused on the interactions between pupils and minimized any focus on the behaviours of individual pupils. The class teacher was released from teaching responsibilities to allow her to join the shared review sessions with each group, and this facilitated a systematic generalization to the classroom. The pupils wrote their targets on their group display area and the class teacher tried to notice them working on a target and provide feedback to them. Observations by the guider and class teacher and pupil self-report all indicated a degree of positive change.

VIG within organizations

The quality of relationships is fundamental to any learning environment, so VIG is important not only to pedagogy but also to school processes and ethos. How VIG has been used to influence such processes will be illustrated

by looking at the development of the use of VIG within a whole school and then within a local authority.

A special school

The secondary department of a special school for children and young people with a range of significant additional support needs wished to enhance further the working relationships among their staff group, reduce conflict situations with pupils and in so doing enhance the learning and teaching taking place. With the support of the school's educational psychologist, this was carried out in three year-long stages. The stages were direct casework, staff training and systemic development. Following each stage, a qualitative evaluation was undertaken by staff questionnaire which sought reflections on strengths, areas for change and next steps.

At the first level, the psychologist supported a staff member and a family in their communication with their autistic son. As a result of this experience, the participants felt they had achieved a far closer working relationship between them, and the principal teacher of the department decided to train as a guider. The educational psychologist's role in the school therefore changed from guider to that of supervisor of the principal teacher's guider training. The principal teacher used VIG to coach staff, pupils and parents in communication skills. To improve the level of trust among staff, their shared reviews initially took place with each teacher individually. Each teacher then passed on their insights to their classroom assistants. Parents also received individual support whilst the young people received suitable input within their class groupings. This took the form of a customized series of lessons and shared review based on the principles of communication. This was followed by a shared review on their contribution to a role play in a 'stranger danger' programme jointly delivered by the principal teacher and the department's speech and language therapist.

Shared understanding and common language between selected school staff and parents was again enhanced by the process. For example, the department staff agreed they now spent time discussing interaction and could view 'difficult' behaviour as a form of communication. The principal teacher also reported that discussions with staff members were becoming more cooperative and deeper, particularly when the staff members were anxious. The young people were seen to become more active by making more initiatives towards each other and staff, and by taking longer turns. Staff began to reflect on the level of scaffolding required by each young person and the danger of creating over-dependency. At the conclusion of

this phase of the work, the identified area for development was the need to extend the approach to all staff.

In Year 3, the educational psychologist's role to the department was delivered at a systemic level as part of a multi-agency team. The school's speech and language therapist, who had taken part in the 'stranger danger' programme, began to train as a guider and the department head undertook a VIG-based course, 'Communication for Management'. This course uses an adaptation of the VIG method called Video Enhanced Reflective Practice (VERP). The model requires that participants receive an introduction to VIG, collect video footage and carry out video analysis. This is followed by staff taking and preparing video for shared review with a guider.

As a consequence of this considerably enhanced capacity in the school, the head of department, principal teacher, speech and language therapist and educational psychologist were able to deliver a training day to the whole staff based on the VERP model. This was followed by three shared reviews facilitated by those trained or training in VIG. It was carried out in class teams (class teacher plus classroom assistants), each taking and analyzing their own videos with shared reviews involving one VIG practitioner to three class teams. By the end of the school session the whole of the department had shared their practice with each other and had focused on incorporating VIG into everyday practice by assessing individual pupils' interaction skills, identifying targets for pupils' individual educational plans and identifying the scaffolding required from staff. Following these developments, the staff reported an increased awareness and level of skill (including scaffolding), enhanced pupil progress and improved teamwork (Learning and Teaching Scotland 2005a).

A local authority

After 20 years of development, Dundee City has more than 50 VIG practitioners across three services: education, social work and health. VIG is embedded within the local education authority's Continuing Professional Development programme, educational psychology service, pre-school home visiting service, individual schools, the speech and language therapy service and the social work department's staff development team (HMIe 2009). It has also enjoyed a close association with the local university, co-founding the Centre for Video Enhanced Reflection on Communication, and delivers the principles of communication and self-modelling creatively through three approaches: VIG, VERP and Video Feedforward (Dowrick 1999). Training delivered by a multidisciplinary team is the norm and covers guider and supervisor training, maintaining the VIG network of trained and training

practitioners and short courses tailored to a particular need, for example communication with children or supervision skills.

The factors that help and hinder the development of such a multi-agency authority wide initiative can be seen to cluster under the following headings: leadership and governance; strategy and planning; making the changes; and sustaining progress. The details of what helps and what hinders a project under these headings are clearly described elsewhere and will therefore not be covered here (DCSF 2008). However, a glimpse at Dundee City Council's journey can illustrate key features.

The current network began with a single individual. One of the authors, Penny Forsyth, linked the approach with specific service priorities and engaged the full support of her direct line management. The importance of the commitment of trainees' line managers and the long-term sustainability of their ability to deliver VIG cannot be overestimated. With this platform, Forsyth then repeated this pattern by further engaging highly motivated individuals and line management. In this way VIG, in an ever-widening circle, was linked with a range of service, school, centre and authority priorities.

Other interventions that develop interaction, such as counselling and solution-focused conversations, were already well established in the area. Communicating the quality of the VIG work undertaken and its achievements to key others in the authority was found to be a crucial factor in the development of an authority's ability to embrace the approach. Presentations to line managers of work by practitioners with their clients and of guider accreditation videos have proved very powerful vehicles to convey the benefits and richness of VIG to an organization.

Because of the investment in time required to train staff, it has been important to have a robust trainee selection process. Trainees must be open to reflective practice and subscribe to the core beliefs of the method. This level of commitment and quality has helped maintain and develop a system that is able to create and take advantage of opportunities as they arise.

Conclusion

There is encouraging evidence to suggest that VIG can make a significant contribution to professional development in a diverse range of educational contexts. It has been demonstrated that VIG is able to raise awareness, develop and nurture constructive relationships, and enhance children's learning. It could be said that VIG demonstrates that good relationships really do deliver.

VIG when Working with Children and Adults on the Autistic Continuum

PENNY FORSYTH AND HEATHER SKED

Introduction

Living and working with children and adults on the autistic continuum demands that we understand and see life from their perspective. Vermeulen (2001) calls this seeing the world through the 'autistic lens'. In this way we enlarge the world in which both we and those on the autistic continuum feel a sense of belonging. Participants remain engaged and resourceful when engaged in satisfying care giving and care seeking experiences (McCluskey 2005).

Video Interaction Guidance (VIG) uses the camera lens to increase our understanding of the experiences of children and adults on the autistic continuum. A central aspect of VIG is the micro-analysis of communication, and being able therefore to observe the smallest components of interactions. This has been found to be extremely beneficial in helping parents and professionals to notice emerging initiatives of autistic children, to facilitate engagement and to realize small changes.

Child development and autism
Neurodevelopmental perspective

Impairments in the areas of social communication, social interaction and social imagination are currently seen as a triad of impairments that underlie autism (Wing 1996; Wing and Gould 1979). From a neurodevelopmental perspective these same areas are seen to drive child development. We have

all observed that mutually pleasurable interplay of emotion, gestures and melodic vocalizations between the smallest infants and their mothers. This is called primary intersubjectivity. Towards the end of the first year of life this mutuality is extended by the development of the infant's ability to hold joint attention and a shared focus with another. This is secondary intersubjectivity. The mutually enjoyable sharing of turns and creation of a shared understanding is the bedrock of communication and social interaction (Trevarthen et al. 1998). It is this interaction with others that generates cooperation, a sense of self, mentalization (the mind reading of oneself and others) and the transference of a culture (Bruner 1996; Fonagy, Gergely and Target 2007).

Hobson (2002) highlights this link between intersubjective experience and the characteristics of autism. He noted the prevalence of autism and autistic-like behaviours amongst congenitally blind children, who experienced an additional level of difficulty in making contact with others, and also in Romanian orphans, who had experienced a severe lack of stimulation by others in infancy. Whilst stressing that there may be several routes to the development of autism and also that there may be several reasons why children with autism experience difficulty in developing intersubjectivity, he states that: 'The intersubjectivity theory that I espouse… locates the unique and characteristic deficit between the affected individual and others' (Hobson 2002, pp.202–204).

It is suggested that how others' interactions are perceived is the underlying factor that affects not only the motivation to interact but also the ability to learn from others. Imagination or a degree of cognitive flexibility is required for another's point of view to be considered and absorbed.

Sensory sensitivities
Bogdashina (2005) describes how perception, the process by which we collect, interpret and comprehend information via the senses, can be different for those on the autistic continuum. Examples of the qualitative differences experienced are hypersensitivity, hyposensitivity and a vulnerability to sensory overload. This raises the importance of 'creating an umbrella' by taking into account each individual's sensory–perceptual profile, and so enhancing their ability to communicate and function (Bogdashina 2005). However, although sensory differences appear to be more frequent and prominent in children with autism, currently there is not enough empirical evidence that these symptoms differentiate autism from other developmental disorders, for example, fragile-X syndrome or deaf-blind children (Rogers

and Ozonoff 2005). One tentative hypothesis suggests that sensory under- or over-stimulation might interfere with an autistic child's ability to achieve joint attention (Talay-Ongan and Wood 2000).

Imitation

In summarizing the usual development of intersubjectivity, Trevarthen *et al.* (1998) also raise the role of imitation in the early proto-conversations of infants, in the subsequent cognitive development and processing of experience and in the development of cooperative skills between toddlers. Wing (1996) also notes that imitation of actions and expressions should begin during a child's first year and is an important aspect in the development of social behaviour. She notes that imitation may be delayed in children with autism or may not happen at all. When a child with autism does imitate, it may be apparently meaningless echolalia or echopraxia. She describes the impairment of imitation as 'a significant part of the autistic picture' (Wing 1996, p.50).

Mirror neurones

Recent research into mirror neurones has been able to shed light on how we are able to understand another's emotions, thoughts and actions through observation. Through the mirror neurone system (MNS) for action, and the viscera motor centres for affect, the same neurones are activated in the observer as for the actor. It could be said that the observer experiences the event, including communication and actions as if it were their own (Gallese, Keysers and Rizzolatti 2004; Rizzolatti and Craighero 2004). However, whilst the same neurones are activated it appears that the action system is facilitated when one is the observer and suppressed when one is the actor. We represent the other as different from ourselves (Shutz-Bozbach *et al.* 2006). Research with a small sample of autistic subjects has found significant thinning of the cortical mantle in areas belonging to the MNS as well as in other areas associated with emotion production and recognition (Hadjikhani *et al.* 2006).

Cognitive models

Cognitive models of autism argue that three theories contribute to our understanding of this triad (Frith 2003). The weak central coherence theory suggests people with autism prefer to process information by focusing on

detail rather than on the whole. The theory of impaired executive function suggests a lack of top-down control in the brain for unfamiliar activities. The mind-blindness theory, or lack of theory of mind (Baron-Cohen 1995), suggests that people with autism cannot fully understand that others may think differently from themselves. Rogers and Pennington (1991, cited in Nadel and Camaioni 1993) link the lack of development of a theory of mind to the impairment in imitative capacity in movements, expressions and symbolic actions, consistently seen in people with autism. Uta Frith suggests that the factor that unifies these three theories is a deficit in self-awareness, specifically regarding the interpersonal self.

The development of interventions

Trevarthen *et al.* (1998) have summarized the interventions currently being used with those on the autistic continuum in line with our developing understanding of its causes. They began with behaviour modification techniques and the use of reinforcements, followed by interventions that provide structure and predictability and finally approaches that emphasize the social environment and motives for communication. Trevarthen *et al.* therefore document a gradual departure from approaches that focus on the experiences and behaviours of the child towards those that focus on relationships, communication and the motivation to develop these.

Short (2010) recently reviewed the use of video in interaction-focused interventions for adults and children with autism spectrum disorder (ASD) and their parents. Positive outcomes were found in all studies with the majority focused on outcomes relating to the child (such as communication or behaviour) or the parent (efficacy and reduced stress). Two VIG studies, however, looked at the quality of the interaction between the dyad, i.e. intersubjectivity. They found that adult initiatives decreased, child initiatives increased and at the same time interactions that demonstrated intersubjectivity or attunement increased. It seems that VIG shows promise when its aim is to enhance the quality of the interaction. Research evidence is, however, currently limited in this area because of small sample sizes and because video was used as part of a larger programme (Short 2010).

Intensive Interaction

Hewett and Nind (1992) found that behavioural approaches in teaching were not addressing the communicative needs of their students, including adults, with very severe learning difficulties. They developed the approach known

as 'Intensive Interaction'. This uses techniques based on developing pre-verbal communication, including pleasure in physical contact and proximity, turn-taking, making meaningful eye contact and using meaningful facial expressions. Imitation is a significant part of this approach. Adults are encouraged to see the student's actions as a starting point from which to move forward by adding new elements. The theoretical base they cite for this approach is knowledge of infant interaction (e.g. Brazelton *et al.* 1974; Bruner 1983; Kaye 1977; Trevarthen 1974; all cited in Hewett and Nind 1992). Caldwell, who has had considerable success in using this approach with people with autism, equates the use of imitation in her interventions to that which happens in intersubjective exchanges between mother and baby (Caldwell 2006a).

Video Interaction Guidance

Video has been used over the years for data collection and analysis in studies relating both to intersubjectivity and to autism (Kugiumutzakis 1993; Nadel *et al.* 1999; Nadel and Pezé 1993; O'Neill 2007; Trevarthen 1979). In studies of interventions with Video Interaction Analysis (VIA) and Video Home Training (VHT) video has made it possible to analyze aspects of behaviour on a second-by-second basis. Caldwell (2006a) suggests that video can also be a useful retrospective analytical tool for a practitioner in terms of noting significant behaviours overlooked during an interactive session. She also demonstrates that video, focusing on interventions using imitation, can be an effective training tool with those who work with people with autism (Caldwell 2006b). However, the potential benefits increase when engaging in direct work using VIG per se. Trevarthen *et al.* refer to a video (Van Rees and Biemans 1986, cited in Trevarthen *et al.* 1998) which demonstrated that this can be an effective intervention for a family with a child with autism. Video clips showed the child responding to structured communicative play with the mother. Through shared review, the mother was supported in the interpretation of her own actions and the child's responses. In this way, people can gain insight into the child's behaviour and can also consider their own efficacy in their relationship with the child. More recently, Loughran (2010) has explored the positive contribution VIG can make to the siblings of those on the autistic continuum.

Video Feedforward

Finally, Peter Dowrick (1991) has demonstrated the efficacy of self-modelling. Here people watch themselves engaged in adaptive behaviours through the creation of a 'Feedforward' video. A potential future behaviour is identified and deliberately constructed on video from components of an existing repertoire. This is either staged or created by skilful editing to produce a video showing a sequence of actions never before successfully performed in their entirety by the actor. Systematic viewing of these videos without discussion has been found to increase appropriate responses and to produce change in a short period of time for those on the autistic continuum (Buggey 2005; Buggey *et al.* 1999; Dowrick, Kim-Rupnow and Power 2006).

Increasing a sense of belonging
Unlocking communication

In a nursery for children with significant additional support needs staff wished to increase their successful contact with hard-to-reach children. After up to five video feedbacks successful contact with children increased as staff grasped the nature of their role in achieving attunement and the reciprocal nature of intersubjectivity (Gadalla and Phimister 1996). The following description illustrates the intersubjectivity they now recognized.

> The preschool child sat in front of a mirror with a box of hats before them and a hat on their head. The staff member beside them placed a similar hat on their head. The child apparently unaware of the adult took off their hat and put on another. The member of staff followed suit. This caught the child's eye and without expression they briefly looked at the adult in the mirror and changed hats again. Again the member of staff followed suit. The pattern repeated this time with the member of staff naming what was going on e.g. 'You are putting on a hat. I am putting on a hat'. As the turns continued the child looked more directly at the member of staff and eventually watched to see what they would do next. Again the pattern repeated. Then the staff member changed their hat first. The child did not respond. The staff member went back to imitating the child and continuing to name. Then they tried again with their own initiative, taking their hat off and putting it back on again quickly and the child looking at the member of staff, with the hint of a smile, imitated

them. Now they had intersubjectivity i.e. a shared attention, reciprocity and enjoyment of 'playing with hats' and the basis for developing a sense of self. (Carling, Taylor and Forsyth 2002)

Many would have given up before this, seeing their attempts to make contact rejected rather than recognizing that they needed to continue with more imitation. Imitation demonstrates to the child that they are a person in their own right, that what they do has an impact on the world and that this other person understands and will not overwhelm them.

The pattern described above is not an isolated example. Kennedy and Sked (2008) report on a study in which VIG was used alongside an imitative intervention, finding that children with ASD who had previously been unavailable for social interaction became more socially engaged. Case studies of six boys with ASD were undertaken, in which each child was filmed participating with a known teaching auxiliary during five play sessions. In the first session, the adult interacted with the child as normal. In subsequent sessions the adult was encouraged to respond to the child's initiatives using imitation. Each teaching auxiliary also took part in three VIG shared review sessions, focusing on the first four films and considering the balance between the auxiliary's and the child's use of the attunement principles. The effectiveness of this intervention was assessed by tracking changes in interaction over the five play sessions. One minute of film from each play session (4.00–5.00 in a 10-minute play session) was analyzed on a second-by-second basis to show the incidence of aspects of communication relating to the VIG principles: direction of gaze, focus of action, verbal contributions and expressions of pleasure.

Sked (2006) provides a full account of the findings of this study. Key findings are summarized here. In the cases of three of the children who demonstrated reasonable linguistic ability, the adult decreased her verbal contributions immediately following training in imitation, the child gradually made more verbal contributions during the films when imitation was used and as the child's verbal contributions increased, the adult's verbal contributions also gradually began to increase. In the case of another child, who demonstrated lower linguistic ability, progress was seen in his direction of gaze. There was a marked increase over the sessions when imitation was used in his and the auxiliary's gaze towards a shared toy.

Increased experience of imitation over the filming sessions may have stimulated this development of attunement, as demonstrated in other studies of the development of social interaction in children with ASD over repeated imitation sessions (e.g. Nadel and Pezé 1993; O'Neill 2007). However, it is

also possible that the experience of VIG shared review sessions helped the auxiliaries to become more aware of the child's needs and/or the child's increasing development of attunement and that this in turn stimulated a more attuned response from the auxiliaries to the children. VIG shared review gave the opportunity for the auxiliaries to explore the effect of the use of imitation in the specific context of their interaction with these children and to build upon positive features over a period of time. At the end of the study each of the auxiliaries stated that they would consider using imitation as a strategy in working with children with ASD in future. In this way, VIG shared review supported skills development in these members of staff, as well as supporting the development of social interaction and attunement between the adults and children.

Unlocking social understanding and increasing flexibility of thought

VIG has also been used directly with children and young people on the continuum in order to develop their social understanding. This development may increase their responsiveness to another or see their adoption of a new response to particular social demands.

CASE STUDY

An 11-year-old child who attended an autism unit was referred by school staff after parental concerns were expressed regarding difficulties at home between this child and a younger deaf sibling. These difficulties included physical fighting, failure to use British Sign Language (BSL) with their sibling despite knowing it, a refusal to cooperate with the sibling and the use of negative talk about the sibling, using tones of disgust and obvious dislike. Previously, a learning disability nurse had worked with the child to develop better empathy towards their sibling and improve their relationship but without success. VIG aims were agreed on: the child would be more verbally positive towards their sibling and would also, when possible, use BSL. However, at this stage, the child expressed no desire for change.

Having established that the child recognized themselves, they were introduced to VIG and its purpose; there then followed three shared reviews and a final shared review with the parent. As the children often communicated via their parent it was

recommended that no parent would be present during filming in order to promote more direct communication. The contact principles (now revised as the 'principles for attuned interaction and guidance') were introduced using a visual format, a pyramid of drawn symbols symbolizing each of the attunement principles (see Figure 8.1). During shared reviews film was viewed and cubes placed appropriately on the pyramid whenever the child identified a moment of attuned interaction. In order for the principles to be identified the film was often viewed several times and broken down into even smaller clips, with specific questions such as 'Where are your eyes looking?' Language use was minimal and processing time given. After the intervention the parent reported that the child was more helpful towards their sibling and the child had expressed that they missed their sibling during an evening apart. Also staff noticed on the videos subtle positive changes in the child's interaction style and softer, less negative tones used about their sibling in discussions. It seems the visual support of the pyramid and the child's own self-modelling of the principles directly with their sibling aided the child's understanding of their everyday life. At the same time, the parent's changed level of involvement during filming and more positive perception of the interaction taking place after shared review will also have influenced their behaviour off camera.

Lesley Cameron, Autism Unit

This process has been repeated and expanded at the secondary age level to include group work and video shared review conducted by the young person themselves within the enhanced support area of a secondary mainstream school (Learning and Teaching Scotland 2005a). In this school, all the young people in the enhanced support area were on the autistic continuum and enjoyed a range of mainstream experiences according to their needs. The approach was delivered by the principal teacher for the enhanced support area who was training to be a guider. Videoing initially took place in the area with one-to-one shared reviews with each student. Once everyone was familiar with the process, videoing then occurred in a variety of situations both in school and outside school. This ability to video the student successfully transferring social skills was found to be particularly rewarding. The young people engaged in group shared review sessions and ultimately some young people were able to share an individual video of themselves with their peers, inviting them to identify what they did well and pointing this out when necessary. It was reported by staff that focusing

on the client's self-modelled strengths and achievements in shared review had noticeably improved their social skills and behaviour, particularly in the area. There is some suggestion here, then, that the ability to engage in a group shared review process, i.e. seeing and hearing others' opinions within a clear framework (the attunement principles) has additional benefits. However, the benefit of simply over-learning the principles cannot be ruled out and this therefore requires further investigation. Additional variables were changes in staff behaviour as enhanced support area staff and selected mainstream staff also engaged in shared review at the same time.

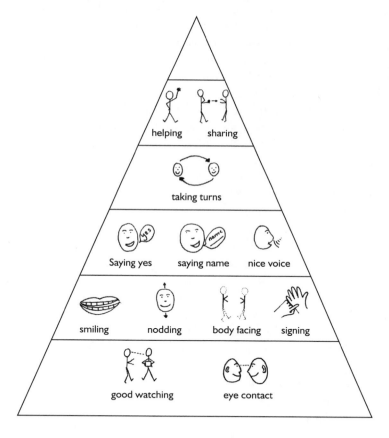

Figure 8.1: Individualized visual pyramid of symbols representing the attunement principles

Another method of increasing social understanding and flexibility of thought is Video Feedforward. Feedforward videos have been used to provide a visual social story or script that helps those on the continuum to adapt

to a situation and eliminate anxiety. For example, in a pre-school setting a young child refused to go out into the playground without their hat, coat and gloves whatever the weather. Having discussed the Feedforward concept with the family, staff created a video of the child going out into the playground on a sunny day without the hat, coat and gloves. This took several days and an eye to continuity with clothing. Individual clips of the child were taken at different times, for example looking at the hot weather symbol in class, walking down the corridor to the door to the playground, looking out of the door at the weather (going out at break time), checking out what was in the toy shed in the playground with this class (playing at break time) and walking back up the corridor. These were then put together. After watching this sequence without comment three times (for approximately five minutes in total) the child thereafter went out into the playground without their hat, coat and gloves when the warm weather symbol was displayed (Viltosz, Fleming and Forsyth 2007). It appears that the use of video allowed this young person to imitate their own actions (self-modelling). Whilst this does not necessarily indicate social understanding or empathy, the implication is that it has created the motivation to copy a set of behaviours and that learning has taken place. The evidence is promising that Feedforward reduces anxiety and embeds new, specific behaviours through the independent viewing of self-modelling.

Feedforward videos can also be co-created with the young person on the autistic continuum where age and ability allows. For example, in preparation for transfer to secondary school a young person was invited to identify areas they would like to be successful in. Short clips of the young person in the secondary context prior to transfer were taken (going into school, being in different classes, in the dinner hall, going from class to class and leaving school). In class behaviour was also stage-managed with the involvement of the young person, for example listening to the teacher, putting up their hand, responding to help, asking for help and undertaking written work. The young person watched the video five times over the holiday and was reported to be calm over that period. In addition, first year was successful, i.e. they regularly attended school, remained on a full timetable, attended mainstream classes for over 70 per cent of the timetable and engaged more in written tasks, something they had found particularly difficult in primary school (Forsyth 2008).

How VIG can support other interventions

It has already been noted that using VIG alongside another intervention (imitation) can augment the effectiveness and understanding of that intervention. There is great potential for further combinations of approaches to enhance the effectiveness of interventions in this way. Parents of young children with autism may take part in the National Autistic Society's Earlybird programme, which helps parents to understand their child's autism and to develop interaction and communication with their child. During the programme, video feedback is used in a group setting, focusing on films of interaction between the parents on the course and their child. A pre-school home visiting teacher involved in delivering Earlybird training noted that parents frequently commented on how helpful they found the video feedback element of the programme and that they would welcome the opportunity to develop this further. This teacher is now intending to offer individual VIG sessions to parents, to follow on from Earlybird training, giving individual parents the opportunity to build upon their skills by looking even more closely and deeply at their interaction with their own child.

VIG can also be used to support the development of a richer picture of the child whose difficulties lie on the autistic continuum when planning, for example, for their inclusion in mainstream education. An educational psychologist worked alongside a highly skilled and experienced nursery team as they developed a behaviour management plan for a young girl. The nursery team had good awareness of the girl's behaviours and were able to employ a wide range of strategies when working with her. However, it was proving difficult to increase the level of the girl's inclusion in group and class activities and there was concern that she was quite isolated. By taking a film of the girl working with staff in the nursery, the educational psychologist was able to look for patterns in the interaction between the girl and the staff and to look for clips showing exceptions to these patterns. These clips were used in VIG shared reviews with the group of nursery staff and they were able to identify the strategies they used in interaction with the girl which supported her inclusion in activities. These strategies were noted and became a core element of a written behaviour management plan which proved highly successful.

Conclusion

Happé (1999) argued that it would be more beneficial to focus on things that people with autism are good at rather than what they are poor at. We have found VIG a flexible and effective tool which has demonstrated the advantages of such an approach.

At the same time VIG straddles the three types of interventions identified by Trevarthen *et al.* (1998): shaping behaviour through the positive reinforcement of the attuned interaction principles; providing structure by their micro-analysis; and focusing reflection upon the quality of social interaction. VIG focuses on the intersubjective experience through developing the capacity to achieve and sustain attuned interactions.

It is this combination of identifying and building on the elements present during successful interactions that is at the core of VIG, thus addressing Happé's proposal to focus on strengths, not deficits. In so doing VIG enhances contact for all those involved and with it a sense of belonging and of future possibilities.

Acknowledgements

Thanks to all participants, their parents and school staff. In particular we would like to acknowledge the contribution of an additional case study by Lesley Cameron, Autism Unit, and the guidance provided by Alex Hall, KTP Associate (Video Interaction Guidance Project), North East Autism Society, on the aetiology of autistic spectrum disorder.

VIG in the Context of Childhood Hearing Impairment
A Tool for Family-Centred Practice

DR DEBORAH JAMES

Two recent UK-wide reviews of children's services within the National Health Service (NHS) (Bercow 2008; Kennedy 2010) show that children's services in the UK need to change and they need to improve. In particular, the NHS needs to learn how to close gaps between the fragments of its own service delivery and across the other services that provide support for families – specifically education and social care but also other community-based services often provided by the charitable sector. One way of closing the gaps between services could be to rethink the role of the family. Instead of being viewed as service users, the family, and the work that they do, could be acknowledged so that they are considered as co-workers within the system.

A re-assignation of roles and responsibilities such as this is not as radical as it may sound. Research from child-focused health, education and social care (Davis and Day 2010; Epstein and Saunders 2000) often upholds a concept of family-as-partner in services. Would family as co-worker present a radical departure from some of the best models of family-centred working in the UK, such as the parent-partnership model from Davis and his colleagues? Perhaps one way to evaluate the size and scope of the suggestions is to consider the practical changes that would have to be made within the public sector workforce. If families were to be successful in the commissioning of their services and in the coordination of those services they would need

to be able to identify their needs and communicate those effectively with others. Their success in this complex communication job relies not only on their own communication but on all the other people within the system being able to see themselves as co-workers, sharing a job and generating new ideas based on the contributions of all the people within it. Equipping the entire workforce, including the families, to work like this would entail skilling them in the art of co-construction.

Public service context for children with hearing impairment

Universal Neonatal Hearing Screening (UNHS) has made the concept of early, inclusive intervention for children with hearing impairment a possibility in the UK. Early intervention is thought to be associated with better outcomes for children with hearing impairment (Yoshinaga-Itano et al. 1998). The importance of early intervention for all children with speech, language and communication needs is underlined in Bercow's review (2008).

UNHS has reduced the average age at which children with hearing impairment are diagnosed (Bamford, Uus and Davis 2005). However, practice in the UK varies widely and ranges from 50 days to over 12 months from screen to hearing aid fitting (Davis 2009, personal communication). For children with more severe forms of hearing impairment a cochlear implant will usually be the intervention of choice. The technology is considered to be more effective in delivering better outcomes than hearing aids for a majority of children (Summerfield, Marshall and Archbold 1997). However, there is wide variation in outcomes after cochlear implantation in the development of speech, language and literacy (Tomblin, Barker and Hubbs 2007). Factors such as the age at which the child receives an implantation and the intelligence quotient of the child have been associated with child outcome (Tobey et al. 2003). However, for different reasons, neither of these factors is particularly amenable to change in the short to medium term. It is not possible to change significantly the general intelligence level of children even with specialist educational input and early intervention. With regard to the age of the child, the timing of implantation varies across the UK with the average age ranging from 18 months to 2 years. Whilst there is a general enthusiasm for earlier implantation, UK cochlear implant services will be stretched to implement and evaluate the new National Institute for Health and Clinical Excellence (NICE) guidelines for bilateral implants for children (NICE 2009). This makes it unlikely that extensive radical reductions in

the age at which implantation occurs (i.e., below 12 months) will occur in the next three years or so. If we are looking for factors that are amenable to change so that we can inform the design of inclusive and effective services for children with hearing impairment then one place we should look is back to the family unit itself.

The diagnosis of childhood hearing impairment is stressful for families (Meadow-Orlans 1994). The most common concern is the child's communication, and families worry about their ability to communicate with their deaf child (Gregory 1995). We also know that families have high expectations of cochlear implant technology prior to the implantation (Kampfe *et al.* 1993; Weisel, Most and Michael 2006). It is likely that many families go through a reasonably extended period during a critical time in their child's development feeling stressed, feeling disempowered as communicators with their child and waiting anxiously for a cochlear implant which they see as holding the key to their child's future success.

In the National Institute of Health Research Child and Family laboratory at the National Biomedical Research Unit in Hearing (NBRUH) we are investigating the impact of parental self-efficacy (Bandura 1986) on the parents' responsiveness to their child (Shin *et al.* 2008). As part of our research programme we explore the concept of parental self-efficacy within a wider investigation on how parents and service providers can work together to develop a shared understanding of the future that the family want to construct. We seek to understand this by exploring the dialogue during the encounters with the family using Video Interaction Guidance (VIG).

Case study

To date, the approach has been used with the families of young hearing-impaired children in a pilot site in Brighton and Hove. Preliminary findings from a number of these families have been disseminated verbally through conference presentation by specialist educational psychologist in hearing impairment Jacqueline Bristow. In this chapter, we describe in detail the impact of VIG on the family of Anne Graham and Steve Graham. We wanted to write about the impact on this family and in particular describe how VIG helped the family to construct their plans for their future wellbeing. The case study is therefore centred around the important outcomes as reported by the family. It starts with Anne's evaluation of her experiences with VIG as told during a semi-structured interview with Claire Falck (fourth named author).

Evan was eight years old at the time this work was undertaken. He is one of triplets, having both a sister and brother. The family, mum, dad and three children, all live together in the north-east of England and Evan attends a special school for children with hearing impairments and additional needs. He has profound hearing impairment and has a cochlear implant.

The family's outcome

The interview was recorded with a video camera and was transcribed verbatim. Researchers Collins and Falck reviewed the interview transcript to identify any particular impact of the intervention reported by Anne. A segment of the interview that appeared to contain an account of a significant change in Anne's thinking about the needs of Evan within the family was identified and then reflexively validated with Anne. This learning is considered to be the outcome of primary importance to the family. The segments where Anne talks about the impact of VIG are given below:

A = Anne (mother)

C = Claire (interviewer)

(.) indicates a short pause; (..) a longer pause; (number) means the pause was long enough to be counted

[] square brackets indicate the time when two speakers were talking at the same time

1	Anne	Why ..it you know, .. he's a complicated child and
2		I think things that have come out of it.. (2.0) I think ..
3		well that the last session that we had was particularly good
4		with Evan because he was getting quite frustrated.. it was
5		more like in the real world I mean you know..there's nothing
6		pre-empted in it it's it's a natural situation…
7		Deborah came at a difficult time that we know is not a good
8		time for Evan and… (2.0) you know he was trying to
9		communicate with me and I didn't really know what he meant
22	A	[coz quite often] you don't know what he's trying to tell you
23	C	yeah
24	A	[um] and where he…you know he's in a hearing family which isn't
25		you know that

27	A	ideal for him I suppose from the point of he's obviously more
28		highly visual than what we are
29	C	yep [yeah]
30	A	and we have to accept that things are are going to be
31		different for him and that we're not going to see things the
32		way he sees things
40	A	looking back...moving forward
41		what I do see happening with Evan in the family is that I do
42		see eventually that we will have to sign all the time
43	C	uuum um
44	A	I think that's going to
45	C	[right]
46	A	[don't] think that's going to happen you know straight away
47	C	right
48	A	but it's something that I seem to be picking up with Evan
49	C	[right]
50	A	[now] that I hadn't picked up before
51	C	right right
52	A	and Evan's in a total communication environment at school
53	C	right
54	A	but he's not actually getting a total communication at home
55	C	right [right]
56	A	so even though mum and dad sign..but we don't actually
57		sign when we're talking to the other children
58	C	um um
59	A	so there are things like that that I think will help Evan (2.0)
60		you know I've.. seen the way when Deborah's been to the
61		house and she's talking to me and she's signing
62	C	[yep]
63	A	[at the] same and I've seen Evan's face light up
64	C	[uuuuum um]
65	A	[so I've seen things that] I hadn't really noticed before
66	C	yeah

76	A	..so I think that's something that's come out of it for us
77		as a family
78	C	um
79	A	and like I said it's not going to happen overnight but
80		it's something that I'm thinking I can see that's what we're
81		going to need to do
82	C	right right right
83	A	..whereas before I wouldn't have noticed that now, whether or
84		not the programme was set out to do it
88	A	it just came as a natural
92	A	..and the videoing.. it was something and the visits it was
93		something that
95	A	made me think aah
96		[ah I think this is something we're going to have to]
97	C	[so this is what you (1.0) so this is
98	A	you know 'cos it seemed to make him (1.0) … (1.0) more
99		included I think

Anne states that what is going to change is they are going to have to sign all the time at home. She talks about the need to sign at three points in this extract from the transcript (lines 42, 80, 96). Her concluding comment is that signing seemed to make Evan more included (line 99). Anne attributes this new way of thinking to the VIG process (lines 48–50). There is a clear theme of 'seeing' emerging from this extract. Anne talks about the visual material that made a difference, i.e. the visits and the video (line 92). She tells of how she saw a positive visual impact of signing on her son, describing how she saw his face light up (line 63). In line 99 she says that it *seemed* to make him more included – the word 'seemed' in the past tense suggesting that she had seen signing as a mechanism for inclusion within the VIG sessions. In addition to these visual mechanisms that Anne names for herself, she also states her son's preference for visually based communication in an appreciative way ('he's obviously more highly visual

than what we are', line 28). This heightening of Evan's particular strength in visual communication compared to their own is followed by the naming of a difference between the way that he sees things and the way the rest of them see things. Anne attributes her new thinking to what she has seen. We also learn that she has seen things differently (in a more metaphorical sense) as a result of the approach.

In addition to the focus on seeing, Anne also makes multiple references to Evan in relation to the family throughout this transcript (lines 24, 41, 57, 77). There is an ease with which she interweaves what she has learnt about Evan with the change she wants to make, which is situated within the family unit. The ultimate uniting of this learning comes in Anne's conclusion that if they sign all the time at home this will help Evan be more included in the family. In this transcript, it is clear that Anne was not aware whether the need to sign was an intended aim of the programme (lines 84–90). She describes this learning as something that came out naturally over the weeks, something that *she* noticed. She attributes this thinking or learning to herself – not to the guider. This is an important point as it speaks for the way in which VIG can help families articulate their own vision for the future. One question that is relevant to how this happened is to ask whether the vision was co-constructed or whether it was, as Anne wondered, always an implicit aim of the 'programme'. This can be explored by looking back at the goal-setting session.

The goals for change

The goals were discussed at a goal-setting session which was held at the school with Deborah, Anne and Penny in attendance. During this session Anne was asked to talk about what was important for her and how she would like to use the video approach to achieve the change that she wanted. The session was recorded, transcribed and entered into the database for future analysis.

The first major theme that arose was that of inclusion in the family. Anne talked about this desire for Evan within the family at the outset of the conversation. In the first instance she said, 'At the end of the day your child's part of the family and you want them to be able to interact with all the family, not just you.' The second main area that Anne talked about was to do with the challenges around the unpredictable nature of Evan's responses to different situations. Anne said that she was finding it difficult to think of lots of different strategies, strategies that may or may not work, so she was avoiding situations. Penny and Anne were both in agreement

about the unpredictable nature of Evan's responses. They both found it hard and they both used avoidance; in Anne's words '…and you tend to avoid situations then…because it's easier'. In summary, Anne wanted Evan more included in the family and she was also concerned about the way in which she was avoiding situations. Together we constructed the goal for using VIG, which was to learn how to deal with difficult situations better. The word cooperation came through in the goal-setting session and Anne was happy to use VIG to find moments of cooperation so that she could see if she could increase the feeling of cooperation between herself and her son, especially when he was being asked to do something that he was not naturally inclined to do.

The VIG process
Chronology of events
The process consisted of the following elements conducted over a period of four months from March 2010 to July 2010. There were three films taken.

Film 1 – Evan at school with Penny (Evan's teacher)

Film 2 – Evan at home doing an enjoyable activity

Film 3 – Evan at home at a time known to be difficult for Anne

Anne nominated the first film to be taken in school with Penny and Evan. The agreed focus for the analysis of the films was to find successful moments of cooperation between Evan and Penny. The first shared review involved Deborah and Penny looking at selected clips from the class film (shared review 1a). The clips from this first film were then shared by Anne at a meeting attended by Anne, Penny and Deborah (shared review 1b). Following this, Anne requested a film at home. Deborah filmed an activity that was likely to be enjoyed by Evan, thus increasing the chances of finding good examples of cooperation, and arranged this for a time when all the family were present. Several clips were edited from this filming session and the shared review took place with Anne and Steve (Evan's father) (shared review 2). Following this Anne asked for the final film to be taken during a time when things were not usually very easy between herself and Evan. The family had been receiving extra support to aid the transition from school to home as it was a time when Evan's behaviour could often be very difficult to manage. The film was taken by Deborah and was reviewed by Deborah and Anne (shared review 3a) and then with Anne, Deborah and Penny (shared review 3b). The interview for evaluation took place about one month after

the final feedback session. Following this the family received all the clips used in the shared review on a memory stick and a photo taken from one of the clips which appeared to be a significant trigger for Anne's learning.

The main learning that Anne talked about during the evaluation interview was her decision to sign all the time at home. As we have already seen, Anne was unsure if the use of signing had been an aim of the programme from the start. It was not, but one simple way that we can explore this from the data is to look at the occurrence of this theme in the interview and the shared reviews. A simple word count shows the following instances of the word sign/signing/signs.

> Initial goal setting with Anne, Deborah and Penny – 3 occurrences
>
> Shared review with Deborah and Penny – 2 occurrences
>
> Shared review with Deborah, Anne and Penny – 11 occurrences
>
> Shared review with Anne, Steve and Deborah – 62 occurrences
>
> Shared review with Anne – 27 occurrences
>
> Shared review with Anne, Penny and Deborah – 7 occurrences
>
> Final evaluation – 16 occurrences

The word count shows that the topic of signing was fully introduced and explored in the shared review with Anne and Steve. A closer look at the entire transcript of the session showed that the topic was first introduced by Steve. He was curious about the signs that he could see Evan using in the video, but he soon went on to connect signing with communication and communication with a feeling of satisfaction.

1	Steve	yeah but it's…good to see that his vocabulary as well
2		just the signs that he's using I think that, that's what it's
3		pleasing to me I think it's great when he puts two or three
4	Deborah	signs
5		[together]
6	S	[signs toge]ther
7	D	yeah
8	S	uh yeah and it's great that you've feel (*sic*) a little sort of
9		sense of satisfaction don't you that…you're
10		communicating with him

Steve goes on to introduce an idea that he has had, which is that there is not enough time being spent on signing at home: 'that's that's one of the biggest things that I find is maybe you don't spend enough time…er…to do a bit more signing with him'. Rapidly he moved on to introduce the idea that signing could be expanded within the family: 'You think well really I think we need to start signing to each other a bit more' and 'we don't sign enough to each other in front of him'. Finally he introduces the concept of inclusion in relation to the topic of signing: 'whereas we need to start thinking right well he's part of the family he's here and he needs to hear what we're saying'. The idea of using signing as a way of including Evan more in the family was present in Steve's discourse during his first VIG shared review.

The transformational learning moment

Whilst Anne did not attribute her learning to Steve in her evaluation interview, she did expand on the topic of signing within the shared review with Steve. During that session she had what felt like a lightbulb moment in which she connected her use of signing with her own goal for change for the VIG intervention. The following extract shows what happened when she was reflecting on the clip that highlighted a moment of social closeness between herself, Evan and John, her other son who is hearing. In the clip Anne and Evan both sign and John is very attentive to Anne as he watches her signing with Evan.

1	A	I don't feel so under pressure now when I'm out with him
2		signing with him but I do know that everybody's looking at you
3		while you do it but.. normally.., I'm normally having
4		to sign because things had gone wrong
8	A	and maybe I should have been signing
9	D	OK
10	A	when things
11	D	OK
20	A	[Yeeah,] I ..think that's when I do tend to, that's when
21		you see a stream of signing from me [then]

22	S	[yeah]
23	A	and then perhaps [maybe]
24	D	[Yes]
25	A	if I'd signed a bit more consistently
26	D	yeh
27	A	before ..before it coming to a situation
28	D	yeh
29	A	then maybe I could [have]
30	D	[yeah ok]
31	A	avoided it or perhaps reduce the [anxiety or]
32	D	[ok ok um]
33	A	Whatever so
34	S	mmm…
35	A	…you know
36	A	I've never really thought about it,
37	S	
38	A	it's only it's just come out there
39	D	um
40	A	and I do know [that]
41	S	[ah]
42	A	really that's when I sign the most

In this extract it is clear that Anne has connected the topic of signing with her own personal goal for the VIG work. The expression of her new idea, that if she used signing more consistently she could reduce anxiety in Evan, was the proposition that we then tested in the final filming session. It was this final session that Anne attributed a lot of change to in her evaluation interview. In this final session we captured a particularly tricky moment, where Evan's behaviour could have become very challenging. During this moment Anne did use sign language, together with her body posture, positioning and general expression of emotion, and the combination of these factors had a noticeably calming impact on Evan, who was able to be moved on from a period of observable intense agitation and to express his own desire for what he wanted next. From behind the camera, the moment where Anne calmed Evan and reduced his anxiety looked like a moment of mastery.

Architects, scaffolders and scientists

In the context of childhood hearing impairment one of the 'choices' the family will face, often on multiple occasions during their child's development (Archbold 2010), will be about the modality through which the family will communicate (predominantly visual, using a sign-based system or predominantly spoken language). We think that using VIG could develop a data-rich approach which could help families explore the choices and evidence the success of their choices with the professionals involved with the family. This type of approach could give families the reflective space that they need to be the architects of their own future. This approach could help to equip the workforce (the paid workforce) with the concepts and tools that they need in order to reassign their role and become scaffolders or efficacy builders whose job it is to help bring the family's vision into being.

One way that VIG could be described as working within families is that it trains parents to be more like scientists, or in other words to become more reflective and analytic in their approach to parenting in their own families. The micro-analysis of behaviour using video clips helps parents develop their own *observational* skills. The use of the principles of attuned interaction and guidance provides a consistent framework that allows the observations to be turned into *data* (observations that can be grouped and ordered). The analytic approach, with the focus on analysing the way that parents create positive moments, encourages parents to *explain* or *model* the reasons for their own successes. A natural consequence of heightened explanatory skills in parents is that they make their own *propositions* for change (something we think worked so well in the case study presented here). This increased confidence in their own ability to explain and predict the functioning of their own family leads to them making their own *recommendations* for the change that they want. One can only imagine that Anne and Steve will now be very effective at marshalling the specific resources they need to enable them to sign all the time. The motivation and energy needed to embed this change within their family unit is likely to be successful because it has been so clearly co-constructed between this pair of architects – Steve and Anne, reflecting and talking together.

The choice I made when thinking about how to share these findings in a way that would develop greater understanding about how VIG works was to let this piece of family work speak for itself. The data has been presented in detail to enable the reader to connect what is seen here with the explanation of VIG as an approach in the earlier chapters in this book and with their own knowledge and experience of family work.

Acknowledgement

The work described in this chapter had several co-workers whose contribution has been and continues to be important in the evolution of Video Interaction Guidance at the NIHR Biomedical Research Unit in Hearing (NBRUH). These co-workers were Evan, his family (in particular his parents, Anne and Steve Graham), Penny Johnson, teacher of the deaf at Northern Counties School, Claire Falck, research associate at NBRUH and Luke Collins, PhD student at NBRUH.

Note: The names of the children in the case study family have been changed to protect their anonymity. The names of the parents, Anne Graham (second named author) and Steve Graham have been retained as has the name of the teacher, Penny Johnson (third named author) with their full agreement.

Video Enhanced Reflective Practice

SANDRA STRATHIE, CALUM STRATHIE AND HILARY KENNEDY

From a single video I have learnt that I should be more aware about continuing conversations that the young person wanted to talk about. For example, the young person wanted to talk about his medication; his body language changed, he appeared to perk up and was more alert, but I didn't notice these signs until we played the video back. Therefore, I missed the young person's feelings and this could have taken a weight off his mind and helped him settle and relax and have a more positive night or next day at school.

Senior Social Care Officer, Young Person's Unit

Introduction and history of video enhanced reflective practice

This chapter aims to introduce the reader to Video Enhanced Reflective Practice (VERP) and the history of its development. The main project described is the delivery of VERP in a residential young people's setting. The chapter ends with a discussion of why VERP is a powerful model for adult learners and celebrates the success of courses so far with an eye to the future.

VERP grew out of the method of VIG as supervisors came to realize the potential of the method for developing other professionals' interpersonal communication and learning. Interpersonal communication is at the core of what most professionals do on a daily basis, whether this is communicating

with a child or chairing a professional meeting. Effective communication is at the heart of all our relationships both at home and in the workplace, and it is the success of these relationships that causes us delight or despair in our daily lives. VIG supervisors also came to see through practice-based evidence that those trained in VIG became more confident as their awareness of their own communication style and that of others increased.

They came to understand that they could, by receiving the initiatives of others, develop the communication in a way that was helpful in leading to satisfying and purposeful discussions and also in managing difficult negotiations and differences of opinion. VIG supervisors also noticed that through their training in VIG they became more observant and reflective and this helped them in other areas of their work, such as assessment and systemic thinking. In other words, they developed many transferable skills that helped them in their working lives and relationships as well as in their personal relationships. VIG supervisors independently, and as a group, began to experiment with the use of short reflective practice courses using the core elements of VIG as the basis for developing and supporting other professionals.

In the early days of VIG in Scotland, Penny Forsyth and Ton Strouken (VIG supervisor, SPIN Netherlands) developed 'Communication for Management', a programme for professional development and reflective practice based on the principles of VIG. VIG supervisors from social work, education and psychology came together to consult with managers from across these departments on their management tasks (e.g. chairing meetings or giving supervision). The managers recorded and micro-analyzed their work, selecting sections where the communication was seen as effective. These were shared in VERP groups and in individual sessions with VIG supervisors. These courses provided an opportunity to deepen respect and understanding of each other's professions and roles through shared reflection on their work.

Two managers who had participated in Communication for Management – the Early Years Partnership manager and the Service Manager for Children and Families – requested that one of the authors (Hilary Kennedy) develop a similar training project for the 300 Early Years staff working in education, social work and independent settings. Again this provided an opportunity for VIG supervisors and staff across services to participate in reflective practice and to share skills and knowledge. This was the start of a seven-year programme in which almost all staff were participants in VERP.

The programme started with a gathering of the city's Early Years staff for a day following the theme 'Addressing the emotional and communication

needs of young children: how to use the contact principles and keep in the yes-cycle!' with the underlying construct of building a more compassionate, nurturing ethos for the parents and young children in the city. Throughout the seven-year roll out, VERP was characterized by education staff working in social work settings and vice versa. The whole day's training and the VERP sessions that followed were evaluated and the results demonstrated a very high degree of staff satisfaction. Staff found that when these principles were actualized (i.e. when staff followed the children's initiatives and ideas wherever possible) the children developed better listening and concentration and their understanding of language improved. At the same time, all Early Years educational psychologists and pre-school home visiting teachers, and some of the nursery teachers and child and family centre staff, began their own training in VIG to continue to support children and families across Dundee. The effect of this roll-out is still apparent in Dundee, where video is used for dynamic assessment, developing nurturing practice, supporting parents at home and sharing good practice.

What is VERP?

Simply put, VERP is reflective practice that is enhanced by the use of video. It aims to improve effective communication in the situation where it naturally occurs by building on the participant's individual and unique style. It is a way of reflecting on clips of successful communication and identifying areas for development, or 'working points' as they have come to be known.

VERP is based on the same core elements as VIG. It involves the video recording of real-life situations and then a 'shared review' of the edited clips in one-to-one or small group meetings with a guider or VIG supervisor, who we will refer to as a facilitator. It is a strengths-based and empowerment-based approach to developing skills in communication, reflection and critical analysis. It also seeks to actualize professional values in practice.

The course participant (care giver) takes a 10-minute video of themselves in an interaction with another person (care seeker), for example communicating with an adult who has a learning disability or supporting a child with developmental needs within a pre-school setting. The care giver views the video using the principles of attuned interaction, and then selects three clips that illustrate moments that are helpful in achieving attuned interaction and that they wish to discuss with the facilitator or group. They may also wish to show or discuss an interaction that presented a challenge to them, for example managing the turns in a group when an emotive subject leads to group members talking over each other.

Care givers then bring their chosen clips to a small group meeting for the 'shared review' session and there follows a viewing of the clips with the facilitator and with the other members of the group with a focus on 'what works'. The care givers benefit from learning from themselves (self-modelling) as well as from the coaching of the facilitator who is also modelling the principles of attuned interaction. They also benefit from the ideas, experience, observations and feedback of the other care givers in the group. This process is repeated two or three times over a few months so that the care givers benefit from having time to refine their communication style between sessions or to address their working points. At the conclusion of the VERP sessions the care givers evaluate and describe to the other course members what they have learned about themselves or about communication, what positive changes they have made to their communication style and how this has benefited the care seekers.

Courses based on the VERP method are typically delivered to groups of about 12 participants. The training groups may be drawn from a wide service area (e.g. Community Care or Children's Services) or can be formed from individual teams (e.g. residential units) where developing a team culture of learning together is seen as beneficial not only to practise skills but also to team cohesion, team confidence and mutual support.

Why is VERP a powerful model for developing adult learners?

> 'The essence of synergy is to value differences – to respect them, to build on strengths, to compensate for weaknesses.' (Covey 1992, p.263)

A telephone survey by the Chartered Institute of Personnel and Development of 750 workers showed that their preferred method of learning was 'on the job', defined in the survey as 'being shown how to do things then practising them' (Sloman 2003). The main principles of adult learning also show that adults wish to be autonomous and self-directed in their learning and that they like to be treated with respect and as equal partners. They come with their own goals for learning and bring with them experience and opinions (Rogers 2007). Therefore, we can take from this that learners enjoy and learn from day-to-day practice and are capable of recognizing their own learning needs.

VERP seeks to work with the adult learners' intrinsic wish to develop their knowledge and skills by increasing motivation to learn through building on strengths (Brown and Rutter 2006). This is done by highlighting moments of successful use of the key principles of attuned interaction. For example, when the care giver is attuned to the care seeker they show this by smiling, nodding, mirroring and verbally or non-verbally indicating that they recognize, understand and receive the care seeker's initiative. The impact on the care seeker is also observed. With successful reception of the care seeker's initiatives it is often observed that this can bring happiness or relief, and can elicit another initiative from the care seeker. This process develops 'reflexivity', where the care giver's observations and thoughts change their actions through observing the impact of their successful attuned behaviour on the care seeker (Payne 1998). The emotional impact of seeing oneself making a difference to the wellbeing of a care seeker with dementia or a profound learning disability is satisfying and affirming for the care giver. The group shares this moment, sees the care and communication skills that led to the successful interaction and understands how a communicative exchange was developed. The use of video recordings of the care giver interacting with a care seeker leads to increased self-awareness, awareness of the care seeker and awareness of the impact of the environment they are in. In other words, the caregiver is learning from their own practice and through reflecting with others in the group.

Reflective practice is developed by the guided and coached discussions about the videos by the facilitator. The group facilitator utilizes the group's diversity and different learning styles to develop a richness of opinion, ideas and problem solving. It shows respect for the care giver's experience and models and actualizes values, such as showing respect, in practice. Development takes place where there is creative cooperation. VERP enhances this group experience of learning through its use of video and of the principles of attuned interaction to build attunement in the group. A shared understanding is developed through appreciation of the different ways in which we each 'think, communicate and relate' (Senge 2006).

VERP promotes the development of analytical and critical awareness skills through reflection on the video recordings of interactions. This involves thinking about and describing an experience. Through VERP the learner can articulate their competence and understanding. It is important for the learner to identify the critical thinking activities that are taking place as this develops an awareness of being able to evaluate how they came to make a particular decision, suggest a course of action or respond to a care seeker in a particular way. VERP entails looking at values, power, risks,

knowledge and experience. The learning from that experience, or from the experience of other members of the group, may lead to change in terms of judgements, practice or communication. Jenny Rogers is in line with most current thinking on adult learning in that she sees learning as 'making connections and seeing patterns, it is about learning to learn' (Rogers 2001).

In today's work environment there is a shift away from viewing professional development as the responsibility of specialist workers or departments to seeing it as core to practice and linked more closely to impact and outcomes for care seekers. It gives more responsibility and accountability to the individual worker for developing their own knowledge and skills. 'The critical moment comes when people realise that this learning organization work is about each one of us. Personal mastery is core' (Senge 2006, p.xvi).

So what are the important aspects of developing adult learners? Rogers (2007) looked at the percentage people retained from various methods of instruction and found that only 5 per cent of a lecture is retained compared with 75 per cent when practice is involved, increasing to 90 per cent when the learners share their knowledge with others taking on the teaching role. In general, the more active the participant, the more learning is retained. With regard to VERP courses there is a mix of lecture (short input), audio-visual micro-analysis and a strong focus on the video clips and group feedback (practice, discussion and reflection). Teaching others is done in a naturalistic way through the group discussion and sharing of experience. It helps us to develop 'competencies in the area of emotional intelligence such as self-awareness, social awareness and empathy' (Goleman 2002). This takes place through seeing the care seeker through other care givers' eyes, reflecting on our own feelings and those of others and 'sensing the learner's concerns, needs and perspective' by witnessing the learning of others in the group (Goleman 2002).

VERP promotes a 'no blame' culture. This is done by focusing on strengths, acknowledging that we all have 'working points' and returning to look at the video for exceptions to those working points. The learner knows that taking risks and testing solutions, experimenting and questioning are all reasonable learner activities, whilst 'remaining accountable to service users', who are with us in the room on video and therefore do not slip from our minds (Knott and Scragg 2007).

Practice example of VERP in a Young People's Unit

This is an example of how VERP has been used to develop a team in a Young People's Unit. Young People's Units (YPUs) typically provide care and accommodation to young people aged 13 to 17 years who are unable to live with their own families and are in need of care and protection.

After initial discussions and agreements for the work to take place the VIG facilitators met separately with the staff (workers and management) and young people. This was done to ensure consent and clarity of purpose for the recording, and to build trust and relationships. The young people and staff were given the opportunity to ask questions and express any fears that they had. All those involved, both staff and young people, understood that VERP was being used to develop workers' awareness of communication and relationships and to develop reflective practice. The young people were involved by making pre- and post-course assessments of the communication skills of each member of staff. Similarly, the staff team had to complete self-assessments on their communication skills, both pre- and post-course.

The involvement of the young people in making this assessment raised a worry for the staff that the young people might use the assessments as an opportunity to criticize individual members of the team. You will see from the evaluation that this did not happen. The young people were also encouraged to choose the situations that they wished to be recorded when interacting with individual staff. There was a highly collaborative emphasis in undertaking this work, with the young people seen as important partners in the process of team development.

The structure of the intervention

Every member of the staffing complement in the unit, including support staff and the unit manager, were invited to take part to ensure that all staff had equal opportunities for reflective practice. Before any recording took place the staff team were introduced to the theory of intersubjectivity and the principles of attuned interaction. They also took part in a short technical workshop focused on the skills of recording and playback.

There then followed three shared review sessions (or reflective practice workshops) held at three- to four-week intervals. In these shared reviews staff would bring short clips from video recordings that they had made of themselves in real-life situations with the young people (e.g. at meal times, in meetings or during informal conversations). The last session involved the

whole staff team coming together to present, share and reflect back on their learning journey with each other and the facilitators.

The main aims of the intervention were to:

- build a whole team/unit approach to learning

- provide consistency and a 'shared understanding' in the team on how to communicate effectively with young people and develop attuned relationships

- build a 'reflecting team' approach to the development of the team

- turn everyday conversations into learning conversations

- bring about cultural change in the way that staff and young people communicate and learn together.

Evaluation

The pre-course and post-course assessments completed both by staff and the young people were based on identical questions so that an exact comparison could be made between how staff assessed themselves and how the young people assessed them at the same points in time. There were 11 scaling questions that were designed to assess communication skills, confidence levels and empathy.

PRE-COURSE

Across all eleven staff that were assessed, the scores by the young people were consistently higher than the self-assessed scores of the staff. In some cases the scores given by the young people were considerably higher, especially where some workers had marked themselves in the lower half of the scale. The relatively low confidence or self-belief indicated by some workers was clearly not recognized by the young people who were perhaps recognizing other strengths and qualities. However, although the young people scored consistently higher, they also followed the pattern of staff scores, that is the lower scores were given to the staff members who scored themselves lower, and the higher scores were given to those who scored themselves higher. It seems that the young people were able to reflect the relative grading of staff scores in their own (more positive) assessments.

What might this tell us? Further, more in-depth research would have to be undertaken to find out what was behind these ratings as well as the differences between the ratings of the staff and those of the young people.

POST-COURSE

In the post-course assessments the results again proved revealing. With only one exception the staff consistently rated themselves higher overall than they had done in the pre-course self-assessment. Yet again, with only two exceptions, the young people also scored the staff higher in the post-course assessment than the staff scored themselves. Seven out of eleven staff scores were higher than their pre-course scores, but even where the scores given by the young people went down slightly from the pre-course scores they were still higher (with one exception) than the self-assessed scores given by staff.

From this we can see that overall the staff had improved their belief and confidence in their own skills of communication with young people. Their lower scores in comparison with those given to them by the young people may reflect what can often be a natural tendency by workers in difficult situations to be self-critical, but this again would have to be researched to establish the thinking behind their scores. Feedback from the manager of the unit indicated that when the scores were reported back to the team they found this both motivating and empowering.

We can also see that overall the young people improved their scores for staff over the course of the training, and consistently gave higher ratings both pre- and post- course. The ratings given by the young people should be viewed within the context of what was going on in the unit in the weeks leading up to the post-course assessment. At that time there had been a prolonged period of crisis and conflict, but this seems not to have had an adverse effect on the ability of the young people to score impartially and fairly. Against this background these results seem even more impressive (Strathie 2009).

In addition to the closed numerical questions, the staff were asked to reflect on the impact, if any, of the VERP course on them as people and workers. The comments below illustrate some of the learning reported.

'One of the other values that my training placed great emphasis on was participation, and this is also a prerequisite of VIG training. For me this can mean helping to empower young people and to identify their needs. These needs have to be met if they are to develop their full potential and grow into participating, contributing adults.'

'VIG training is a core aspect of developing relationships with young people and, as such, for the residential child care worker. It provides participants with support, which enables dialogue to take place. Interactions and effective dialogue encourage a two way process for learning/communication to occur rather than control being "given" to the worker only. It optimized my learning ability

and pulled together strands from different areas of my skills/ knowledge and particularly my value base.'

'Initially the thought of participating filled me with dread. I absolutely hate being filmed or photographed. The course has made me much more aware of initiatives and how I can show the young people clearly that I have picked up on these. I've learnt by doing this I can demonstrate to the young people that I have received them. This in turn makes the young people feel valued and "heard." I am much more responsive to signs and gestures and not only to what is being said. The course has given me greater insight into my own abilities and how I can change elements of an interaction to enhance positive communication. The course has also taught me how to build on my strengths and to support change leading to empowerment. I can use my clips as a microscope and a mirror for a better understanding of what is happening for the young person and why some things don't work as well.'

Service user involvement and ethical use of video

Because VERP-based courses require care givers to record themselves in live practice situations with care seekers there has to be a total reliance on the cooperation and informed consent of the care seekers, or their guardians. This can initially be seen by care givers as a difficult request to make of a care seeker. However, experience has shown that when it is explained to them that they (care seekers) are in the video in order to help the care giver develop their practice or develop their communication, they are usually willing to help. It is natural for the care givers to be apprehensive about their practice being recorded. What is of great importance is for the care seeker to be reassured by the care giver, and for the care giver to be reassured by the facilitator that no video footage will be used to embarrass or criticize either party. It is important to stress that video clips will be chosen by the care giver to show themselves putting the principles of attuned interaction into practice and showing the best of themselves and the care seeker.

VIG facilitators always keep in mind the immense power of the video image and the potential for this to be used in a critical or undermining way. So regardless of whether the subject of the video is a young person in a residential unit, an adult with learning disabilities or a professional care giver, there is respect and sensitivity to the needs and feelings of those involved.

Future innovation

So what continues to make VERP innovative and attractive to organizations? The development of care givers and care seekers interacting and often reflecting together using a shared framework for communication (the principles of attuned interaction) is an empowering approach to shared development and understanding. Video recordings of real-life situations provide material for powerful and empowering visual coaching, practice-based evidence and grounded research. Shared meaning, values and time to reflect with others can build on the strengths of individuals and learning organizations. VERP continues to appeal to care givers and care seekers who wish to develop rich and meaningful working relationships (Strathie, Strathie and Gunn 2009).

In 2009 Dundee City Council Social Work Department was awarded a Care Accolade by the Scottish Social Services Council for Innovative Practice for using VIG and VERP for staff development and working with families. Innovative ways of using VERP continue to this day, with VERP being used in older people's services, child protection work, coaching and developing supervision skills. It continues to attract a range of professionals who are interested in or who have responsibilities for developing adult learners.

The writers acknowledge the foresight and collective aspiration of those who have nurtured new and innovative thinking and practice in VERP to develop a culture of learning in organizations.

Enhancing Teacher and Student Interactions in Higher Education through Video Enhanced Reflective Practice

RUTH CAVE, ANGELA ROGER AND RICHARD YOUNG

Teaching is a special sort of communication. (Cranton 2001, p.73)

Teaching at any level, in any situation, requires that you interact with your audience to establish and build a relationship – usually in Higher Education (HE) an extended one. The quality of this interaction plays a central role in determining not just the effectiveness of the learning that goes on within the taught session (whether a class, tutorial, lecture or laboratory) but also the nature of the relationship. Important consequences arise since the qualities of the interactions and associated relationships have a critical influence on the esteem in which students hold their institution and thus, as Ramsden (2009) suggests, on broader recognition and ultimately finances.

This chapter initially uses theories of learning and interaction to discuss the practice of teaching-as-dialogue, mediated by video. We describe using Video Interaction Guidance (VIG) in two efficient ways to help lecturers/ tutors (hereafter 'teachers') build attuned relationships with their students. Our main innovation, Video Enhanced Reflective Practice (VERP), powerfully assists teachers in HE who are new to teaching as well as those who want to review their teaching or to become more aware of the nature

of their relationship with their students and the profound personal influence they have on it. Further, in situations where a lecturer has sought help to enhance their skills we have used one-to-one VIG to enable a shift in focus from self or lecture content to dialogue and student learning. Finally, we discuss the 'Traject Plan', used to embed the learning into professional development. We discuss our shared learning and some practical issues and encourage the reader to experiment with the approach and to undertake training in VIG.

Background: The problem and a response

Dundee and Newcastle universities, like many others, run professional development programmes for lecturers and other teachers in HE. The first modules in these programmes focus on learning, teaching and assessment. Participants in such programmes frequently take part in microteaching (Perrott 1977) usually using video recording. It is also common for participants to video themselves in a typical teaching session. They may then incorporate their reflections on the recording within an assignment. Video has always been acknowledged to have a useful role, but one that did not have much attention paid to it, partly because of the apprehension involved in looking at one's 'professional self' on video, but perhaps mainly because there was little clear evidence about how best to take or use the recording to promote learning. Furthermore, videotape technology, even when digital, encouraged a linear approach to the review process. So participants filmed themselves teaching and then watched this back in full, usually focusing on the negatives or problems and the content of the session – and paying little attention to the students or to the interaction. They were rarely given guidance on how to view the video or what to look for. On becoming aware of VIG, the authors quickly saw its potential. Training to become guiders helped us realize how effectively video can enable teachers (including ourselves) to become more attuned to their students, and the necessary conditions for this.

VIG IN HE: A SUMMARY

In HE, VIG is an appreciative, respectful intervention focused on the *interaction* between a teacher and their students. The teacher is guided to reflect on video clips of their own *successful* interactions, based on a conviction that the power to change

resides in themselves, their own style and their situation. From (1) basic attuned communication follow successive layers of development: (2) organization of teaching; (3) students' learning; (4) lecturer's professional development; (5) team role/organizational development.

Initially we offered individual course participants one or two standard sessions of observation and guidance. The successes and benefits were clear for those who took up this offer, but the process was time-consuming. With constraints on our availability, we looked for more time-efficient ways to promote learning. We consequently moved to situations where:

- the ownership of the process as well as learning from it has passed more towards the participants

- all participants can benefit from the insights afforded by a video-mediated focus on interaction

- the time input of trained guiders has been reduced to the minimum consistent with effective learning, with more time given where this is justified.

The process we evolved is quicker, deeper and much more effective than reflection from memory, as evidenced by the comments from one lecturer captured on film after his first feedback session:

the workshops give an overview which is all well and good – but you don't actually understand fully, fully (sic) until you've gone through the lecture, and then an analysis with you. It just puts everything into perspective. And it makes sense now: I understand.

To capture such interaction in large groups, using a second camera to record students simultaneously with the teacher is helpful.

VERP in context

From an institutional perspective, a main goal of programmes of professional development in HE is to improve the learning experience of students whom course participants subsequently teach. A rich vein of literature (for a review see Kahn et al. 2006; see also Carson 1996, p.14) suggests that a crucial process lies in enabling teachers to examine their own practice in a way that enhances their students' learning by improving the relationship that they

have with their students. Thus teachers need to be able to hear authentically from their students. In a classic text, Stephen Brookfield tells us that '[t]rusting teachers is often a necessary precondition for students speaking out. This trust only comes with time, as teachers are seen to be consistent, honest and fair.' (Brookfield 1995, p.10). He goes on to say that

> [c]ritically aware teachers…will research how their actions are perceived by their students and will try to understand the meaning and symbolic significance students ascribe to the things teachers say and do… They will come to realize that any authentic collaboration can happen only after they have spent considerable time earning students' trust by acting democratically and respectfully toward them. (Brookfield 1995, p.11)

Many academics worry about exchanges with students in the classroom – notably whether they will be able to answer questions and not appear foolish in front of their audience. Alan Mortiboys suggests that '[w]orking on a good relationship…may prevent…the fear of exchanges with students' (Mortiboys 2002, p.15) and that '[s]ome use of emotional intelligence… would ensure that attention is paid not just to the message but to how it is delivered and received' (Mortiboys 2002, p.15). We agree that what is most significant for student learning is *how* the interaction is managed and *how* the teacher communicates with their students, above what the content of the message is – what Max van Manen discusses as 'pedagogical tact':

> [w]hile the notion of tact is inherently a factor of personal style of individual teachers it is also at the same time inherently an intersubjective, social, and cultural ethical notion. … [T]act can refer both to the intersubjective pedagogical relation between teacher and child (*sic*) as well as to the hermeneutic didactical relation between teacher and curriculum content. (van Manen 1995, p.44)

He contends that the 'intellectualised theory-practice distinction' that often underpins thinking about reflective practice is not a valid epistemology for considering the complex, instantaneous reality of teaching practice: 'The aim of critical reflection is to create doubt and critique of ongoing actions. But it is obviously not possible to act thoughtfully and self-confidently while doubting oneself at the same time' (van Manen 1995, p.50).

The principles of attuned interaction and guidance comprise: attentiveness; encouraging and responding to initiatives; developing

attuned interactions; guiding; and deepening the discussion. Using them, we and teachers share enquiry into their interactions recorded on video to avoid this intellectualization. Teachers' guided access to the 'successful' actions (including non-actions) of themselves on video provides, through neuronal mirroring processes, rapid, effective development of the practical knowledge inherent in their actions. It also enables teachers to integrate this self-knowledge with that gained through observation of others:

> By observing and imitating how the teacher animates the students, walks around the room, uses the blackboard, and so forth, the student teacher learns with his or her body, as it were, how to feel confident in this room, with these students. This 'confidence' is not some kind of affective quality that makes teaching easier, rather this confidence is the active knowledge itself, the tact of knowing what to do or not to do, what to say or not to say. (van Manen 1995, p.47)

The appreciative video process thus affords an opportunity for self-modelling. By viewing their own 'actions' in the light of the attunement principles, teachers can *see* when they are achieving attuned interactions and do not have to rely on feedback from someone else. Dowrick (1999) and Hitchcock, Dowrick and Prater (2003) have shown convincingly the power of such self-modelling.

Looking at video self-evidently necessitates looking at the non-verbal elements of communication as well as the verbal. Much research has been done in this area; see Knapp and Hall (2007), Tubbs and Moss (2008) and Devito (2009). In a section on 'interaction synchrony' Knapp and Hall tell us that 'human beings commonly tend to mimic…behaviours of the people they interact with' (Knapp and Hall 2007, p.245) and cite Dabbs (1969), showing that 'mimicry seems to occur more often when we are other-oriented; for example, when we…feel concerned about others, seek a closer relationship with others' (Knapp and Hall 2007, p.249). This is exactly the kind of relationship that VIG/VERP activates. Knapp and Hall's section on Teacher–Student Messages cites research that has concluded that '[s]ubtle nonverbal influences in the classroom can sometimes have dramatic results' (Knapp and Hall 2007, p.461). What better way of discovering this than on video? Or of seeing the effect on the student audience than on video?

McCluskey (2005) suggests that our natural state is exploratory. We see this readily in the young: babies are naturally curious about the world around them; relaxed children actively seek out new situations and friendships

and seem to soak up knowledge and develop skills quickly. We also see it in adults. Finding out about new things, how to do things differently and studying are all forms of exploration. Lecturers wanting to improve their own teaching are engaging in a form of (self-)exploration with their students, yet McCluskey, in Heard, Lake and McCluskey (2009, pp.5 and 59) informs us that if we are fearful, we cannot explore.

Using video with lecturers in HE to enhance practice requires and promotes a degree of self-awareness often experienced as distinctly uncomfortable (i.e. fearful), especially where a more (self-)judgemental environment pertains. Thus, when viewing video of yourself, unsupported, it is very easy to get stuck in a negative cycle. The fear of humiliation from seeing how bad you are/look/sound is very real. Such unsupported viewing, typically in the presence of others, whom the lecturer/tutor may not yet know and trust, can effectively prevent most exploratory learning from the recorded teaching experience. All this can be ameliorated by a skilled guider-facilitator – for example, in the setting up of the sessions; in informing participants about the nature of the experience and the reasons behind using video; and in guiding the group through the review of the clips each student brings. This level of self-exploration is not readily apparent in traditional feedback on teaching observations. Sessions recorded on video allow for a remarkable depth of perspective on practice, enabling when appropriately facilitated ideal opportunities for what Mortiboys describes as 'a permanent developing' (Mortiboys 2002, p.16) (original underlining). In other words, participants in such programmes (i.e. lecturers) have their memory of their lived experience and an observer's feedback and comments as well as the video to view and re-view.

Video-enhanced learning from classroom teaching and microteaching
Using VERP in classroom teaching

One of us ran a pilot aiming to promote learning, whilst reducing guider time input. Three lecturers agreed to share clips of their teaching and reflect together. Following an introductory session to demonstrate how the film would be used and the principles of attuned interaction, each subsequent session consisted of one participant bringing their own film clips to discuss. After viewing each clip, discussion focused on that individual's practice as viewed, but became more generalized reflection about teaching and learning.

It provided an experiential vehicle of exceptional quality for examining and reflecting on teaching and learning in HE.

One member of this group explained in writing her learning process:

> [For my assignment] I chose to focus upon understanding the emotional dynamics within child protection teaching sessions. It had been my opinion (shared by other teachers) that the learning context can become disrupted by a negative emotional climate constructed by students who exhibited a high level of hostility toward the learning. … My engagement with this module and the paths it has taken me down have led to an understanding that I began my quest…from the wrong starting point – I should have begun with understanding the foundations of my own relationship and thus the nature and origin of my own interactions with these students. … I was privileged and perhaps advantaged by being afforded the opportunity to view the recorded teaching interactions of two other participants. I found these sessions extremely informative and thought provoking. However, I also began to realise the importance of the role of the teacher in the interactions that took place. I had not considered that attention to the affective dimensions of the learning environment were [as] important [as the cognitive aspects]. … However, I saw the solution to this as lying solely within student and not within lecturer. The use of the 'Principles' in the analysis of the recorded teaching interactions of my fellow students began to open the way to my realisation that changing the way I interacted with students might be of more benefit to the 'problem of emotion' I had identified, than attempting to develop a teaching method or technique to 'deal' with problematic students.
>
> I began to see that changing the interpersonal dynamics between myself and students was perhaps the route I should be exploring … [An] observation … from the recorded sessions has been that where I attended to the affective dimensions of my interactions I observed a higher level of positive engagement from students with the learning situation than when I have not. I began to integrate the 'Principles' as a core feature of my interactions with students. [This] has allowed me to facilitate a more positive environment in classroom situations and better communication with students I see one-to-one.

The first time this author used VERP with a group of lecturers, it was hoped that viewing and sharing others' videos would indeed produce this kind of reflection, leading to scaffolding and mediated learning from a shared, rather

than formally facilitated, experience. In the recording of the discussion, the impact on this particular student of showing her teaching video was clearly visible. To then read the words above where this experience is named so explicitly shows VERP coming full circle. We learn from our interactions with the programme participants. The author had testimony from this student of her lived experience and emotions, and the film of the feedback session to look back on. There are also the participant's written words summarizing her reflections on the event; on her classroom practice at other times; on what she has learned from viewing her peers' videos; and on what her peers in the group have said about what they have seen in her video.

Using VERP in microteaching

An even smaller time commitment from trained guiders is required where course participants engage in paired analysis of interactive microteaching episodes. Although here the 'students' are fellow participants this approach ensures that every person identifies the principles of attuned interaction in their own practice and that of a colleague. It also provides a good insight into the potential of the approach for their future development, should they wish it.

TYPICAL ONE DAY SCHEDULE FOR THE FIRST VIDEO ENHANCED ANALYSIS OF A FIVE-MINUTE 'INTERACTIVE TEACHING EPISODE'

Topic	Approx length (minutes)
Tutor introduces session and discusses the principles of attuned interaction; giving and receiving feedback on teaching	25
Participants practise identifying the principles by analyzing prepared video clips of teaching (tutor circulates and assists)	60
Tutor leads a plenary review to check understanding and process	20
Break	

Participants record on video interaction microteaching episodes in groups of six or seven	60
Lunch	
Supported by trained VIG guiders, participants appreciatively analyze their recorded teaching episodes (one guider per six–eight participants)	60
Break	
Each person introduces to their group of six–eight a clip of their *partner* demonstrating one or more principles (one trained guider facilitates each group)	60
Plenary: each group shows one interesting clip to the whole class	30
Final reflections on the day and summary of learning achieved	15

As the group's collective fears are reduced participants gain confidence and start to trust the others. As their knowledge about the process increases, the guider can begin to withdraw. The benefits appear to arise from sharing just one or two films from each participant: the method illustrated includes only one. This approach acknowledges diversity and models student-led independence from the teacher. It promotes student engagement in a social context. As one participant suggested: 'really worthwhile – liked the fact that it was student-led for example, filming/observing: less intimidating'. Another said: 'Facilitator respects all the group and encourages us to value ourselves. [It was] a positive, non-judgmental learning environment.'

We have noticed that once colleagues are aware of what they do well and how to look at themselves in a different way, they are forever seeking not just to maintain this but to improve on it. We are privileged to see how positively and constructively this knowledge and awareness enables our participants to change the learning experiences they create for their own students. We may later be able to see how it in turn affects their students' learning.

Using VIG where a lecturer is seeking help

Lecturers may seek assistance in developing their interactions with students, or may be referred by a manager. In the latter case we have found it essential that the lecturer chooses to come and that any performance management is

maintained quite separate from the VIG. As in other contexts, the teacher's goals may not be expressed in VIG-related terms, so the guider will need to assist.

At first sight, one-to-one VIG may appear time-costly. Yet, where someone otherwise fails their students, an institution can save a great deal against issues of student dissatisfaction, stress, management time and severance/re-appointment costs. Of course, the teacher's personal benefits from successful intervention are also great. A Head of Department saw 'impressive evidence of the effectiveness of [these] video coaching techniques with a senior member of staff'.

We have found the following to be helpful:

- a clear, agreed brief at the start, with Head of Unit commitment

- a limited number of sessions, including perhaps just three observations

- responsibility for learning is clearly understood to be the lecturer's

- a Traject Plan (see examples below) is helpful in extending and embedding learning into longer-term development

- independent evaluation of the intervention.

A lecturer undertaking a series of three guided observations drew the following conclusions. Alongside the video evidence, they demonstrate the powerful impact of engaging in the process. It is relatively easy to pick out the principles of attuned interaction from this participant's independent account.

HOW A LECTURER CAN LEARN FROM THE EXPERIENCE OF VIG

1. You are not aware of the subtle things that you do to communicate to students until you see yourself on video and the guider is able to point out to you that this is a part of engagement!

2. Seeing students' reactions enables you to pick up on these more quickly when you go back into the classroom and alter your style/approach to suit them, thus reaching learning outcomes more effectively.

3. You pick up on the smallest things students do, for example, raising their eyebrows, which in turn allows you as the teacher to comment on the class's reactions and praise or question their attention and engagement.

4. Even in large group teaching (100–300 students) it is possible to communicate to a wide variety of students on many different levels.

5. Being able to reflect on what you agreed with the guider to act on; seeing the results; and reflecting upon them enables the teacher to see the improvements being made.

6. Learning to do short exchanges and getting students to explain why they said what they said or why they consider something to be the case allows them to test their knowledge.

7. If a student answers a question incorrectly, do not automatically think they do not understand – asking them to explain further often enables you to elicit the correct answer.

8. If a student provides the incorrect response to a question it does not mean it is irrelevant. You may be able to incorporate their answer later on in the same class or in a future one. This makes the student less reluctant to attempt to answer another question in the future.

9. If you can use the student's name and repeat it during that session or at a later date, this helps with engagement outside of the classroom as well as in, especially in large multi-cohort groups.

WHAT I PERSONALLY LEARNED FROM VIG

1. Engagement and communication in class is not as straightforward as it first appears.

2. There are many subtle nuances (hand gestures, movement across the room) that can be used in different teaching situations to elicit reaction from students – which encourages interaction.

3. Communication is not just a teacher asking students questions. A teacher's positive body language is important as students sometimes mimic this (e.g. smile) and interact more as they feel more relaxed and less threatened.

4. A teacher's enthusiasm can assist in the engagement process – students are more interested in the topic being taught, which in turn generates student enthusiasm.

5. It is an organic process – the more practice you have using the techniques, the more naturally you incorporate them into your teaching approaches, and thus the more the students expect to contribute in class.

6. Sometimes NOT doing is as effective as doing, i.e. standing still and looking directly at the class without talking communicates that you want them to be attentive and thus are ready to actively 'listen' and engage.

From communication to development: Using a Traject Plan

New attunement in interaction carries other development implications that can be helpfully staged and extended using a Traject Plan. This allows supporting behaviours to be considered at the right time and calls the teacher to think about how their skills can enhance their team and wider organization.

The Plan from a new lecturer illustrates the small steps they took in developing more active learning in lectures. A key moment for them was to become, as a result of seeing video clips of their teaching interactions, sufficiently confident to take the risk of a small change in their practice.

Problems in teaching or communication between a lecturer and their students have an impact outside the classroom. A Traject Plan may be used to develop immediate and longer-term objectives at a range of scales, as the following synthetic example illustrates. Success further down the plan depends on the continuing achievement of the objectives nearer the top. These are themselves motivating, which assists with achieving the more demanding elements of the plan.

Table 11.1: Traject Plan for a new lecturer

Aspects	Current objectives
Basic communication	Attunement with students, reception, turn-taking
Organization and structure of lectures	Building interaction into lectures; making time for students to process information
Students' learning	Involving students actively in lectures; asking for feedback from students
Lecturer's development	Building confidence to allow risk-taking in trying something new
Team development	Telling others about VIG; joint planning for change; feedback to/from others

Table 11.2: Example Traject Plan for a lecturer seeking to develop their teaching skills

Aspects	Example current objectives	Example future objectives
Basic communication	Simple questioning and response from students during lectures	More interaction with students in lectures More attuned responses, such as positively describing student behaviour in class; disclosing own feelings
Organization and structure of lectures	Presentation of material in lectures, such as structure, summaries and using a 'road map' Nature/use of handouts	Use new presentation technology to accommodate students' needs Continued development of handouts, using student consultation
Students' learning	Use a valid test of student understanding that motivates students	Measure students' understanding twice per lecture

Table 11.2: Example Traject Plan for a lecturer seeking to develop their teaching skills *cont*.

Aspects	Example current objectives	Example future objectives
Own professional development	Record own development through VIG and other means.	Apply VIG to other situations, e.g. research presentations Obtain other development, e.g. voice coaching
Academic role/ organizational development	To be respected	Develop a communication strategy including evaluating its success

To show how a Traject Plan may be used to support wider organizational outcomes, we show one of our own. This example indicates the potential for VIG/VERP not only to develop our own practice but also to lead to institutional development such as enhanced student engagement through staged influence.

Table 11.3: Traject Plan for a professional development course leader

Aspects	Current objectives
Basic communication	Initiative and reception, short turns, constructive interruption
Organization and structure of sessions	Focus on positive, focus on principles of attuned interaction, prompting client to speak first, giving turn back
Guider's skill development	Deepening discussion, co-constructing new insights, using film for reception
Professional development	Combining guider and tutor role, developing group-based VERP, deepening understanding through supervision, promoting reflection, theoretical development, research
Team development	Presentations to teaching team, joint development of VERP with teaching colleagues
Institutional development	Provide VERP to all new lecturers; offer VERP on request/referral; develop module on reflective practice with VERP at core

Conclusions

The positive feedback we have gathered from lecturers and their testimony of the developments they have made in their teaching that they attribute to VERP, make a convincing case that VERP is applicable, practical and potentially very valuable in higher education. There is increasing interest in the quality of the HE student experience, for example through the impact of fees and the revision of the Professional Standards Framework in the UK, and worldwide. VERP can efficiently enhance lecturer–student engagement at all levels.

VERP holds a further dimension: that of looking for moments when things are going well. Teachers still have to confront themselves (Wels 2002) but VERP makes it different: a skilled guider-facilitator can scaffold the experience and mediate the learning by using emotional intelligence and VIG guiding skills (and care-giving skills); help to diminish the fear of this self-confrontation; and encourage the participant to return to their natural exploratory state and really see what is happening with video evidence. Just as in any VIG situation, it is the shared reviewing of the clips of positive interaction that is crucial. This is a long way from traditional constructive criticism, yet participants still find in their practice what we might term 'working points'. VERP looks for the solution within the situation. Crucially, the identified moments of vitality supplant the negative focus.

The exceptional power of VIG-related interventions to raise confidence is readily observable among the lecturers we have worked with. Cynicism does not seem to be a problem – the practical nature of the technique provides its own justification. We now aim to develop our theoretical understandings of how and why VIG/VERP works so effectively; to apply the approach in a wider range of more problematic situations; to carry out further work on the impact of VERP for students and the challenges of capturing richer films of interaction in large groups.

PART 3

Connections

Confirming Companionship in Interests, Intentions and Emotions

How VIG Works

COLWYN TREVARTHEN

Introduction

Knowledge of how we share motives and emotions, intentions, hopes and enjoyment of life has been gained from film and video studies of infants in intimate play with people they know best. Important steps before language give us a new appreciation of the nature of friendship and the value of meaning created and shared with friends. The research has used photography and sound recordings to direct attention to spontaneous initiatives and preferences of the learner, to expressions of emotions and to the coordination of actions.

In the 1980s clinical methods were developed in the Netherlands to use videos of spontaneous encounters between family members in their homes to highlight and give value to small positive events that indicate latent strengths in relationships, which it was felt might be encouraged to improve attachments, communication and learning. The method, developed by Harrie Biemans and originally called SPIN (for the Dutch 'Stichting Promotie Intensieve Thuisbehandeling Nederland' or 'Association for the Promotion of Intensive Home Training in the Netherlands'), has been developed in many countries as Video Home Training or Video Interaction Guidance (VIG), and it has been applied widely – to improve teachers'

communication with pupils in schools, to assist shared experience with people with special educational needs, such as autism, and to strengthen working groups of many kinds. The research on conversations with infants gives scientific evidence on how video feedback works.

Movements that communicate before and besides speech

Video and sound recording with micro-analysis of natural and experimental engagements with infants, following methods pioneered by researchers in animal ethology, has transformed our theory of communication without words (Bråten 2009; Reddy 2008; Stern 2010; Trevarthen 1977, 1979a). The findings have been used to improve methods of therapy for disorders of relating and cooperating (House and Portuges 2005; Meares 2004; Ryle and Kerr 2002; Stern *et al.* 1998).

The science of human communication has a long and complex history. Education in the conventions of social life in civilized and industrial societies has, since ancient times, often undervalued the powers of natural sympathy; in particular, it has doubted that infants can have or communicate states of mind, as Giannis Kugiumutzakis has recorded with reference to how ancient Greek philosophers viewed infants' imitative powers and the role of emotions in learning with others (Kugiumutzakis 1998).

Charles Darwin, in *The Expressions of Emotion in Man and Animals*, used the then very new art of photography to show how facial expressions and gestures are used by infants and actors in similar ways to show their feelings (Darwin 1872). He commissioned portraits, including those of mentally disturbed people, and collected pictures of other races to prove the universal features of emotional expression. He distinguished complex human emotions, including anxiety, grief, despair, joy, love, devotion, meditation, sulkiness, determination, hatred, contempt, disgust, guilt, pride, patience, astonishment, horror, shame and modesty. Most of these have a highly personal, moral or relationship-regulating function. They do not just express feelings of physiological state, or simple 'primary emotions' of a single self-conscious individual, and they have no rational explanation. They are intuitive 'relational emotions' (Stern 1993), which demonstrate imagination for the hopes of living with another person or in a family or community. They seek intimate recognition by others.

But Darwin's pictures are motionless and often posed by actors – they are moments in communication caught by a camera. A deeper insight into

his theory, and why he was willing to give rich interpretation to the motives of the expressions, is given to us by his sensitive reflections on the real-life situations where the movements could grant powerful meaning to the emotions. Especially informative are his 'Biographical sketch of an infant', based on affectionate entries by himself and his wife Emma in a diary of observations on their children (Darwin 1877), and the poignant essay he wrote about his own feelings after his beloved daughter, Annie, died (Conrad 2004).

An important change in research on the earliest stages of human communication came in the 1960s with the development of sensitive methods that, by recording 'instrumental' actions of the infants to choose their experiences, proved the abilities of even newborns to perceive different sights and sounds, and especially human expressions, and to identify the mother from her face and from her voice (Trevarthen, Murray and Hubley 1981). Then clear proof came from the studies of films that young infants could engage with affectionate speech and take part in conversational games by exciting and reacting to the emotive responses of a partner. At the end of the 1970s three landmark books announced the new findings; these cleared the way for a study of how language and other conventions of culture are learned within a sensitive and creative communication by the precisely regulated rhythmic timing of inarticulate but delicately modulated vocal sounds, facial expressions and gestures (Bullowa 1979; Lock 1978; Schaffer 1977).

Mary Catherine Bateson described a film she studied of a dialogue between a mother and her nine-week-old in these words:

> The study of timing and sequencing showed that certainly the mother and probably the infant, in addition to conforming in general to a regular pattern, were acting to sustain it or to restore it when it faltered, waiting for the expected vocalization from the other and then after a pause resuming vocalization, as if to elicit a response that had not been forthcoming. These interactions were characterized by a sort of delighted, ritualized courtesy and more or less sustained attention and mutual gaze. Many of the vocalizations were of types not described in the acoustic literature on infancy, since they were very brief and faint, and yet were crucial parts of the jointly sustained performances. (Bateson 1979, p.65)

A newborn infant, in the first day, imitates tongue protrusion, and another about one hour after birth tries to imitate hand movements.

Laura at home in Edinburgh at three months, with her family, chats with her mother Kay. Her three-year-old sister wants to talk with her too. Father proudly watches them.

Leanne at five months enjoys her mother's recitation of 'Round and Round the Garden', with actions. Emma at six months, as she sits on her father's knee, is proud she knows 'Clappa-Clappa-Handies' when her mother asks her to show it.

Basilie, a one-year-old in Edinburgh, reads her book as her mother reads the telephone bill. They both know what reading is. In Lagos, Adegbenro, another one-year-old, is proud of his rattle and after asking someone to hand it to him, he shows it to everybody.

Figure 12.1: Stages in the development of infant sociability in the first year

By 1980 it was established that a child is born with a human mind adapted for learning by intimate sharing of impulses and feelings with other human minds (Trevarthen 1979a, 1979b, 1980). In Edinburgh my group was beginning systematic recordings of the age-related changes in mother–infant communication through the first year (Figure 12.1), and, in collaboration

with Alistair Mundy-Castle, we made comparisons of what we found in Scottish subjects with developments of babies in the very different culture of Lagos in Nigeria (Mundy-Castle 1980; Trevarthen 1998). There were important differences, but there were also clear universals in how mothers understood their infants' expressions and shared their interests and feelings, explaining their own ideas and those of their culture and making them easy to learn.

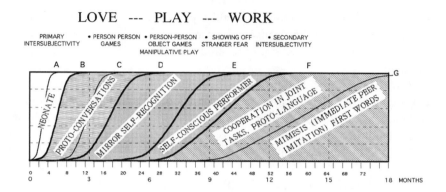

Figure 12.2: Chart of developments in self-awareness and communication in the first year, related to key developments in motor regulation and perception. (See Trevarthen and Aitken 2003 for sources)

While we were charting the key phases, summarized in Figure 12.2, Saskia van Rees visited and introduced me to the work of Harrie Biemans and his new kind of therapy that supported positive moments in engagements between people who were finding communication difficult. Saskia and Harrie thought the observations of infants, and the stages of their development in cooperative communication, could give support to the method of SPIN. I have since benefited from our collaboration, especially from the beautiful video studies Saskia has made of birth, communication with newborn infants in the intensive care unit, ways of assisting communication with children who have developmental disabilities, and Video Home Training. (See Body Language Foundation of the Netherlands, Stichting Lichaamstaal www.stichtinglichaamstaal.nl)

One idea that grew from discussions with Harrie and Saskia was that the course of Video Home Training might parallel or reproduce the

sequence of stages in communication with an infant – from 'courteous' proto-conversations of the early weeks, through the fun of games in the middle of the first year to studious cooperation in tasks at the end of the year, preparing the way for mastery of conventions of object use and for language. I remember we summarized the sequence as *Love* comes before *Play*, which prepares for *Work*. In other words, a stage of intimate, trusting and affectionate communication must be in place before the teasing creativity of games may enrich and bring confidence and joy to the relationship, and then attentive cooperation in performing tasks and solving challenging problems together may confirm friendship. I compare this to a hierarchy of different language functions, with increasing informative authority and decreasing concern for feelings of relationship: *Intimate, Inventive, Informative, Instructive.*

I will review the findings from research with infants to clarify how development, regulated within relationships by core motives and emotions common to all human beings, is vital to wellbeing and the growth of understanding.

Love: Relating to known persons with affection and trust in intimate dialogues

The experiments of the 1960s changed beliefs about the beginnings of human experience. They proved infants could see people with discrimination and were seeking certain appearances and making social associations. Hanuš Papoušek (H. Papoušek 1967; M. Papoušek 2007) demonstrated that infants a few days old had an 'appetite' for controlling experience by moving in a purposeful way, and they showed emotional appraisals 'of a human kind' depending on the consequence – pleasure at success and annoyance at failure. Studies of listening, by measuring purposeful orientations of head and eyes to attend to sounds, proved that the infant's hearing was discriminating and that it enabled a delicate appreciation of the quality of human vocal sounds. Babies were proved to have learned to identify their mother's voice and certain acoustic or prosodic features of her language before birth, and they showed a preference for her particular voice immediately after birth (Busnel *et al.* 1992; DeCasper and Spence 1986). The care of newborns, including those born prematurely, was transformed by the work of Brazelton and his associates who used demonstrations of the infant's capacities for self-regulation, selective orientation to events in the nearby world and emotional response to people as feedback to facilitate the parent's care and to boost

their confidence and joy in company with their baby (Als 1995; Brazelton 1979; Brazelton and Nugent 1995).

Then a controversy was generated by claims that newborn infants could imitate sounds, face expressions and gestures of adults. Freud, Piaget and Skinner had all denied this was possible. But by the 1970s there was clear proof that responses to certain human signs were both controlled by emotion and imitated (Nadel and Butterworth 1999; Reddy *et al.* 1997; Uzgiris 1991). Kugiumtzakis (1998) demonstrated that the acts of imitation were accompanied by expressions of effort to imitate 'correctly' and pleasure at accomplishing the goal. Emese Nagy confirmed that neonatal imitations are not merely copies of actions, but bids to establish a dialogue (Nagy 2011; Nagy and Molnár 2004). She distinguished 'imitations', where the infant copied an act demonstrated by the experimenter, from 'provocations' or 'initiations' where, after the experimenter had paused and watched the infant expectantly, the baby repeated the act with attention to the experimenter, clearly wanting a reply. Nagy showed, moreover, that the infant's heart accelerated just before an imitation and that it slowed just before the infant initiated a provocation and paid attention to the response. The baby was taking an active part in a dialogue and was doing so with emotion, as Kugiumutzakis had said. Earlier, Uzgiris (1991) had maintained that imitation by infants serves a social motive.

By 1979 I was convinced we had evidence for a state of primary intersubjectivity that enabled infant and adult to cooperate in a precisely regulated exchange of their changing individual interests and feelings (Trevarthen 1979a, 1979b, 1998). It was clear that both the baby and the mother were emotionally involved in a single evolving process, or 'composition'. A loving mother's voice when she addresses her infant was shown to have controlled timing and prosodic or musical features that transcended the special features peculiar to her language, and that 'attune' precisely with her infant's expressions, supporting them with 'intuitive parenting' (Papoušek 1996; Papoušek and Papoušek 1987; Stern *et al.* 1985). These parenting behaviours are clearly adapted to meet and confirm the intelligent sensibility of the young infant. In them the 'musicality' of movements that convey the dynamic flow of human thoughts and feelings is made especially clear and responsive (Malloch and Trevarthen 2010a, 2010b) (Figure 12.3). Experiments that varied the appropriateness, temporal contingency and affective tone of the mother's responses to the infant's expressions of interest and pleasure, or those of the infant to the mother's efforts to communicate, proved that the actions and feelings were expectant of a certain synchrony and quality of sympathetic human response, in the

mother for the infant and vice versa (Murray and Trevarthen 1985, 1986; Papoušek and Papoušek 1977; Reddy et al. 1997; Tronick et al. 1978).

In New York Daniel Stern and Beatrice Beebe and their colleagues adapted 'conversational analysis', the approach of researchers who had been making a micro-examination of adult conversations from film, to study games between mothers and infants (Beebe et al. 1985, 2000; Stern 2000; Stern et al. 1975, 1985). They found the same integrated patterns of body movement, facial expression, vocalizations and gestures with self-synchrony of actions within each subject and inter-synchrony of timing between them. Stern gave special value to the dynamics of movement in games and has developed a theory known as 'Forms of Vitality' to give an account of the rich variety of controlled ways of moving that animate all human communication and the dramatic arts, and that support all forms of therapy (Stern 2010). The intentionality of infants was accepted and integrated into a theory of early intersubjective communication and the growth of shared understanding by John Newson (1979), who with his wife Elizabeth pioneered a longitudinal study of how parents support their children's learning in early years by intimate communication (Newson and Newson 1974).

The research on early infancy has shown that there are personal capacities in infants from birth that are developed during gestation. By two months the baby and a person in the role of a parent can share a story that opens the baby's powers of learning to the imitation and co-creation of special rituals of knowing and acting, making narratives of changing expectation, excitement and satisfaction (Gratier and Trevarthen 2008). However, this is just the first phase of human relating and expanding knowledge. In the following months there are developments in the infant's strength, wit and self-awareness that lead a parent-companion into more lively games and more acute manifestations of pleasure or displeasure.

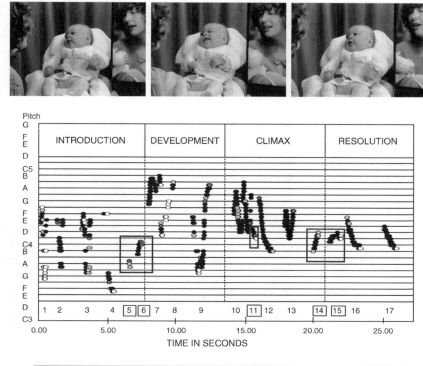

Figure 12.3: Malloch's analysis of a proto-conversation between six-week-old Laura and her mother. (See Malloch and Trevarthen 2010b)

Play: Making fun and showing off in ritual forms of art

All who have made close observations week by week of how infants show their purposes and feelings in the first year have noted 'periods of rapid change' when the abilities of the body, awareness, emotional regulations and preferred interests undergo development, changing both active exploration

of the world and communication with other persons (Trevarthen and Aitken 2003). After three months the head, trunk and arms gain power to support themselves against gravity and the infant has new interest in objects at a greater distance from the body. Objects are tracked with head and eyes, and the hands reach out to manipulate them. This increase in self-awareness seems to compete with interest in communication. Mothers notice that their infants often do not seem to want to join in intimate chats as before, and this causes them to change their strategy for attracting the infant's attention. They become more playful, and the infant responds happily. We called this the beginning of the 'Period of Games' (Trevarthen and Hubley 1978). Companions discover the baby enjoys being invited to take part in action songs, sharing in melodies that are similar in different cultures with different languages. Baby songs are rhythmic and melodic, like intuitive motherese, but they have a more extensive narrative/dramatic form, being composed of rhyming phrases grouped in repetitive verses or stanzas lasting tens of seconds. The infants join in with harmonious sounds at particular points in the poetry, and if actions are requested they comply with enjoyment.

The appreciation of stories in body movement is accompanied by a growing sense of fun in interplay with others to make narratives into jokes, teasing their intentions and experiences. At first, when the infant is around four months, the games involve the mother or other playmate acting in a comical imitative way, then increasingly the infant's growing interest in objects causes the things to which they give attention to be used as 'bait' for the game. Infants of around six months of age can take pleasure in giving and taking objects and throwing or hitting them in teasing ways (Hubley and Trevarthen 1979; Reddy 2008). By six months the behaviours of the infants become self-conscious displays of pride in compliance with a ritual action song, such as 'Clappa-Clappa-Handies', of laughter with surprises, and of coyness or shame if another person's appraisal appears too attentive, negative or uncomprehending. Reddy has observed the beginnings of this social self-other awareness in displays of shyness, as when the child catches sight of themselves in a mirror, from as early as ten weeks (Reddy 1991, 2008; Reddy *et al.* 1997). She shows that there is an acute other awareness long before any evidence of a 'theory of mind', or any learned ability to infer and talk about other persons' thoughts and feelings.

Awareness of how others appraise one's expressions of will, interest and feelings is essential for discovering what they intend and believe, and for gaining shared meaning or 'common sense' with them. The 'moral' emotions, especially pride and shame, are demonstrated by infants in the first year. All our endeavours and ambitions in society are regulated by feelings

about how others give their regard, which Scheff (1988) calls 'deference emotions'. Adam Smith in his *Theory of Moral Sentiments* (1759) defined the conscience as an impartial observer who passes judgement on one's actions. In other words, he describes the moral self as divided into two persons and concludes this is essential for sympathetic awareness of other persons:

> ... it is only by consulting this judge within, that we can ever see what relates to ourselves in its proper shape and dimensions; or that we can ever make any proper comparison between our own interests and those of other people. (Smith 1759, p.213)

Evidently we are born with this doubleness of self, able to sense how another may regard what we do and how we feel, and we are ready for what may be called a 'co-conscience' in habitual social dealings with other persons and their wishes.

None of this self-other awareness has to be defined or explained by rational rules of conduct. It is founded on motives and emotions felt within the self, and shared in what Stein Bråten (2009) calls 'felt immediacy' with others; he extends the evidence for sympathetic feelings of relatedness in infants to include 'helping' or 'altruistic' actions of caring for another's difficulties or distress. Showing off, being funny and teasing test the limits of others' enjoyment and tolerance of opposition or surprise (Reddy 1991, 2008). Provocation with a sly expression of pleasure, as well as confusion when another's responses are inappropriate, may occasionally be seen even in newborn infants (Nagy 2011). These ways of life with others show impressive development in the games mothers play with infants in the middle period of the first year, and by eight months an infant can be a very successful clown capable of clever mimicry or teasing to share a joke with a willing, or, one hopes admiring, audience (Hubley and Trevarthen 1979; Reddy 1991, 2008; Trevarthen 1990).

In spite of this clever self-other awareness, however, a baby under nine months of age is unlikely to show 'joint attention' to a task that requires sharing of the practical use of objects, outside the performance of a game. The infant appears incapable of combining self-interest in using an object with attention to another's different purpose. Thus the baby will not follow directives to do something new. This changes at around nine months, as Penelope Hubley discovered, leading to what we named secondary intersubjectivity or person-person-object awareness in cooperative awareness (Hubley and Trevarthen 1979; Trevarthen and Hubley 1978).

Sharing tasks and meanings

After moving to Oxford in 1968, Jerome Bruner, who had been concentrating his research on intentions and development of concepts of things at Harvard, became more concerned with the antecedents of language, and he and his collaborators described the development of 'joint attention' (Bruner 1977). This has since become a topic of major importance in infant psychology and identified as the beginning of cultural learning (Tomasello 1999). Hubley and I were interested in the interpersonal 'mutual attention' from which we saw a capacity to divide responsibility for joint task performance developing. Infants, we found, changed at around 40 weeks after birth, wanting to comply with their mother's wishes and taking instructions in how to manipulate objects. They started to combine their cognitive mastery of objects with their understanding of their mother's interest. For us it was important that this ability grew within an established companionship of fun in games where the 'artistic' action rather than the object and its 'technical' uses was paramount. They began to share projects directed by the mother *indicating*, not demonstrating, what the infant should do, and the infants were proud to comply. Our observations were in agreement with the findings of the linguist Michael Halliday, who described the development, when his son was nine months old, of 'acts of meaning' in a 'proto-language' made up of pointing to objects and events combined with vocal expression of his interpersonal feelings (Halliday 1975). At this age games involving objects become more 'business like', more concentrated 'cognitively' and methodical or, as Halliday puts it, more 'mathetic', and at the same time they begin to be shared with a familiar companion.

Halliday understands language as growing from interpersonal or social acts. It is not just a way of passing on information, and not just a consequence of mastery of grammatical rules or the product of a 'language instinct'. Children acquire language because it serves certain purposes or functions for them in a community. He identifies seven functions that language has for children in their early years. Four, which he calls *instrumental* (to express needs), *regulatory* (to instruct others what to do), *interactional* (to make contact and express affection) and *personal* (to state how the child's self is) are intersubjective. The other three are related to the shared world: *heuristic* (to gain knowledge about the world), *imaginative* (to tell stories and jokes, which obviously relate to *interactional* and *personal* uses) and *representational* (to convey facts and information).

Language, a common sense made of descriptions of the world, can grow only within intimate relationships and a presumption of trust and shared

curiosity. Working relationships, though they may become technically, politically and legally complex, and seemingly ruled by dispassionate procedures and reasons, are based on intimate friendships. As Jerome Bruner insists, they, and language, depend upon the innate ability of human beings for sharing creative and moving stories (Bruner 1990).

Conclusions: Steps in VIG recall the journey of infancy

The responses that VIG seeks to encourage in a client viewing their videos are exactly those by which an affectionate mother supports a chat with her young infant, plays games and finds tasks that build confidence and cooperation as the baby becomes more active and willing to share purposes with her. She reflects her infant's mood and will, not only with respect and care for distress and anxiety, but also with attunement to any positive sign of pleasure in her company. She offers respect and wants to empower the baby, guiding from worries and concerns to enlivening fun and hopes for a better future.

For a young baby the future and its goals are present, or very near, but they come from an adventurous vitality within that is anticipating experience; surprisingly early mother and infant are sharing habitual stories of their life together, building them in trust and with pleasure. Adult relationships and those between parents and older children also use these principles of attunement and an imaginative story-making that grows in time and space and becomes 'transcendent' (Donaldson 1992). They are the natural ways human minds build creativity and cooperation in intimate friendships. Awareness of these motives requires sensitivity for 'micro elements of interaction', as Hilary Kennedy says – for the timing and courtesy of steps in the dance; often they can be perceived only with a patient and respectful attention to signs of strength that avoids detached causal explanations or formal diagnosis of problems.

When there is discord or 'mis-attunement' there has to be a step back to sense small signs of how things can go better. Infants feel disconnection, and withdraw when a mother is made distant and unresponsive by depression or worry. But they are quick to respond positively when there is a moment of recognition and support from her. That is how, as Selma Fraiberg (1980) found, an infant can be a co-therapist. She demonstrated that severely mentally ill mothers could benefit greatly from assistance in responding to their infants and 'developmental guidance' that alerted them

to the responses that could be expected when communication and care were directed to meet the infants' needs for company.

I think the work on infant development and the changing relationship with a happy parent gives us information that complements the notion of affective maternal attachment for infant care and state regulation. Mothers and infants need fun. They enjoy testing the limits of one another's 'attunement', making the harmonies hilarious. They make dramatic narrations of intimacy like those that, when developed as musical art and theatre, can generate powerful attachments in a community, as Ellen Dissanayake says in *Art and Intimacy* (Dissanayake 2000). Mothers and infants also become involved in serious *creativity*, or intentionality, with affective appraisal of projects and goals in rhythmically patterned time, and *cooperation* in engagements of purposes and feelings to do practical tasks. Cooperation generates mutual approval and the making of shared meaning, with more awareness than an individual can accomplish. The one-year-old's zone of proximal development (Vygotsky 1967) is a region of learning how to act with skill and how to share it. The parent accompanying and composing or improvising the achievement works with a comrade. I am sure successful Video Interaction Guidance will be aiming for this too, after the difficulties of primary intersubjective attunement and trust are recovered. Dan Hughes (2006) finds this is so in his caring work with the relationships between severely traumatized youngsters and their foster parents. They are guided to intend together and to share rewarding plans.

Babies are born intentional persons, wanting goals and wanting to do by moving body and mind; asserting a wish and purpose. The will, however, is always tinged with apprehension, a fear for the cost, effort and possible pain. Giving help requires first deliberate empathy for this, leading to genuine positive sympathy in achievement and pleasure of accomplishment.

VIG and Attachment
Theory, Practice and Research

JENNY JARVIS AND NELLEKE POLDERMAN

This chapter brings together two very different but complementary discussions of the contribution that Video Interaction Guidance (VIG) brings to the achievement of secure attachment in infancy. Jenny Jarvis, a counselling psychologist working in child and adolescent mental health and children centres, uses the vehicle of a hypothetical case study, drawing on her experience in using VIG with many vulnerable parents and children, to give a highly detailed account of the way that the processes of the first VIG cycle can work to promote attunement with the child. Nelleke Polderman works in the Netherlands and explains Basic Trust, an approach to attachment problems that is very similar to VIG.

The relationship between attachment and intersubjectivity, parent sensitivity, mindfulness, mentalization and attunement become clear in this careful work by the two authors. Each makes a significant but different contribution to what VIG can bring to attachment concerns. Jenny takes the reader through the first meeting, filming, shared review and supervision. The details of how to go about this first cycle will be useful to the experienced and novice guider alike. She also shows how hope is inspired in both the parent and the guider and how goals are negotiated. A particular contribution of the discussion of Basic Trust by Nelleke Polderman is an explanation of the importance of naming, an aspect of VIG easily forgotten in the interest in attunment principles. She quotes an evaluation of Basic Trust, and both sections reference other evaluations of the contribution of VIG to parent sensitivity (Kennedy, Landor and Todd 2010; see also Chapter 4).

Part 1 VIG and Attachment

JENNY JARVIS

Introduction

Attachment behaviours involve the intention of the baby or child to remain in close proximity to a reliable and responsive care giver for comfort. This is in response to internal or external stress, in order to regain emotional and physical equilibrium. The baby or child can thereby begin to learn comfortably about themselves in relation to others and the world around them. However, when that care giver cannot provide a reliable or consistent secure base the infant adapts his strategies and redoubles his efforts in a further attempt at proximity. If these strategies continue to be ineffective in bringing physical, emotional and psychological support from the care giver, many aspects of the child's cognitive functioning and personality are compromised.

Video Interaction Guidance (VIG) has been shown to be effective in promoting sensitivity and also changing attachment classifications (Gorski and Minnis in prep.; Kennedy, Landor and Todd 2010; Robertson and Kennedy 2009). The first part of this chapter will explore the key concepts of intersubjectivity, mentalization and empowerment in relation to VIG as an intervention where attachment issues are central. This will be demonstrated by a fictional case study describing the VIG process and illustrating the proposal that

> VIG is a sensitivity-focused intervention where the underlying theory of 'intersubjectivity' permeates the method at every level, from the selection of clips of attuned interaction, and the therapeutic learning process in the shared review, to the supervision of guiders delivering the intervention. (Kennedy *et al.* 2010, p.59)

I will now introduce the hypothetical case study, which is followed by an exploration of the theoretical proposition that VIG promotes intersubjective capacity, mentalizing function and empowerment. I will then return to illustrate this proposition with a detailed analysis of the case study.

CASE STUDY

A teenage mother (Kirsty) who finds it difficult to settle her crying baby (Adam) is referred to a children's centre for support. Her health visitor has told her that there is a family support worker who uses video and that this will help. She believes that the worker will film her crying baby and see how impossible it is to calm him. She may also believe that the 'professional' will have more advice on stopping babies from crying, and she is fearful that unless someone does something to help her, she could shake or hit the baby to stop him from crying. Sometimes she wants to run away or leave him with her mother, Yvonne. Kirsty has not mentioned this to the health visitor or her mother because she thinks that social care will remove her baby and she knows Yvonne thinks she's a bad parent. On the rare moments when Adam sleeps, she has also thought that he has something wrong with him that requires medical investigation. She has a glimmer of hope that the video will demonstrate this to the worker, thereby increasing her chances of receiving a medical opinion with an ally. At the back of her mind somewhere is a feeling of hopelessness and alienation from her baby, and resentment that he has disrupted her life.

The family support worker training in VIG (Louise) has received a referral from the health visitor highlighting an 'attachment disorder' between the mother and baby. She may have been told that Kirsty often leaves Adam in his cot when he is crying and that in the parent and baby group she spends more time talking to the other parents than focusing on her baby. Louise's training enables her to articulate a considered understanding of the process whereby the baby cries because the mother is poor at settling him, and she may also take the perspective that the baby's constant state of dysregulation is interfering with his development. She has concerns about Adam's safety and recognizes that she might have to monitor this. At the back of her mind somewhere is a feeling of hopelessness and alienation from Kirsty – a good example of transference! – and the thought that the baby should be looked after by his grandmother, Yvonne.

Theoretical underpinnings

There are several important theories that underpin attachment.

Attachment and intersubjectivity

Theories of intersubjectivity were derived from parent–infant observation and video research into the minutiae of complex interactional cycles that make up the relationship between a baby and the baby's care givers; these theories extend our knowledge of attachment (Brazelton, Koslowski and Main 1974; Murray and Trevarthen 1985; Stern 2004; Trevarthen 1979a). Intersubjectivity is defined as the common ground where mother and baby share an understanding, a 'harmonious interpenetrating mix up' (Balint 1968, p.66), or when 'two people see and feel roughly the same mental landscape for a moment at least' (Stern 2004, p.75). It is believed to be hardwired into the brain at birth (Trevarthen 1979a; Trevarthen 1998; Trevarthen and Hubley 1978). It is thought to be an intuitive recognition of one another's impulses and intentions, which is 'immediate, unrational, unverbalized, conceptless and atheoretical' (Beebe 2005, p.35).

Stern discusses the two-way relationship between attachment and intersubjectivity, proposing that '[a]ttachment keeps people close so that intersubjectivity can develop or deepen, and intersubjectivity creates conditions that are conducive to forming attachments' (Stern 2004, p.102).

Sensitive parenting requires a moment-by-moment attunement with the baby's needs, emotions and intentions, without feeling overwhelmed. Most parents occasionally experience a sense of feeling inundated by a young baby's presence, yet for parents who have experienced abuse and neglect in childhood, their baby's distress may activate dysfunctional representations or schemas of parenting. Their subsequent reactions may become governed by their own emotions as a consequence, rendering them unavailable to their infant.

This understanding is central to our work in VIG when we are helping parents to work through their own problematic past and see their child for who the child really is. In doing so, with the help of the video and skilled collaborative review, they can not only see their child but also see themselves without the projections and transferences that informed their behaviour towards the child.

The importance of mentalization

Therapeutic approaches that promote mentalization, which encompasses 'mind mindedness' (attunement to others) and mindfulness (attunement to oneself) within a safe relationship are therefore thought to be helpful in increasing sensitivity.

Attachment and mentalization processes are seen to be 'loosely coupled' (Fonagy and Bateman 2006, p.420). Support for this comes from the finding that securely attached children have good mentalization abilities (Fonagy *et al.* 1997) and also that the degree to which a parent is able to reflect enhances the quality of attachment (Meins *et al.* 2002, 2003) and reduces the need for the baby or child to monitor the parent for signs of danger (Fonagy *et al.* 1991).

Individuals whose attachment relationships have not provided them with a secure base, and whose ability to make supportive adult relationships in the present and with their own children is seriously compromised, require therapeutic relationships as described here:

> …psychotherapy has the potential to recreate an interactional matrix of attachments in which mentalization develops and flourishes. The therapist's mentalizing in a way that fosters the patient's mentalizing is seen as a critical facet of the therapeutic relationship and the essence of the mechanism of change. The crux of the value of psychotherapy is the experience of another human being's having the patient's mind in mind…the aim of therapy is not insight but the recovery of mentalization: achieving representational coherence and integration for intentional states… (Fonagy and Bateson 2006, p.215)

How VIG promotes intersubjective capacity, mentalizing function and empowerment

Video is an effective tool that has also been used within psychotherapy to enable care givers to increase intersubjectivity and attunement within the therapeutic encounter (see Beebe 2005; McCluskey 2005). VIG has highly developed strategies with sound theoretical constructs for promoting sensitivity in a therapeutic relationship (Kennedy *et al.* 2010). These strategies are not simply behavioural elements to be applied sequentially, but have within them the very essence of intersubjective understanding and mentalization. In addition, VIG provides an opportunity for overwhelming emotions to be received. This supports emotional regulation, where meta-cognitions can begin to reframe the present moment, loosening the associations to the past and re-processing representational schema.

VIG, like many effective interventions, regards partnership and collaboration as necessary factors in early intervention programmes (see Barlow and Svanberg 2009 for details). However, unlike most early

intervention and video feedback methods, but essential to any therapeutic process, the main focus in VIG training is the quality of partnership and collaboration.

The process of attuned interaction between the parent and guider enables both to develop through the stages of mentalizing: from 'acting and reacting' with its 'rigid and stereotypical thinking and high emotional arousal' to 'awareness of reacting'; 'reflective and flexible thinking' to 'empathy and realistic attunement'; and ultimately towards 'symbolic, imaginative and interpretive thinking about self and other' (Munich 2006, p.145). It is quicker to access thoughts about self and other when watching the video and discussing the extracts shown. The video becomes a witnessed present reality rather than a remembered past, and is therefore not tied to attitudinal or affective processing-over-time, as with other talking therapies. The ability of the guider to activate meta-cognitions in the parent about what is witnessed on video promotes this shift and is thought to be one of the factors responsible for increasing the sensitivity of the parent. The reflective conversation of the guider and supervisor is an essential part of this change process, helping to find new possibilities for change that can be explored together through following the principles of attuned interaction.

Discussions that draw close attention to successful interaction often allow a greater degree of honesty about difficulty and allow parents to build on their own strengths. Parents who have experienced abuse in their childhood are likely to find seeing negative interactions, or hearing professionals' views about what they should do, a trigger towards helplessness. Parents may withdraw or disengage from services when they feel powerless and the moment of hope may be lost.

Looking in more detail at the therapeutic encounter within VIG we will pay particular attention to what constitutes attuned interaction between parent and child, and between guider and parent. It is also acknowledged that the relationship between the guider and supervisor must contain the same elements of attuned responsiveness and promote mentalization. It is believed that sensitive attunement within each level can affect intersubjectivity at all other levels.

Analyzing the case study

We can see that the perspectives of Kirsty and Louise differ greatly. There are implicit assumptions and expectations that are likely to remain unspoken. There are hopes, but for different outcomes. There are also feelings of hopelessness, concern and anxiety in both. Is there a meeting point for these

two individuals? It is not yet the place in which to start using the video, but it is a place to start work engaging this mother in possibilities through VIG.

The first meeting – therapeutic engagement

The initial meeting with the parent gives the most significant chance of beginning the partnership process; it is a time in which the implicit may become explicit, in which expectations may become realistic, in which the therapeutic arena of safety and containment can begin to help emotional regulation and in which hope for change can be shared by both parties. This stance encourages mutual and *collaborative* exploration and is fundamental in helping both partners arrive at *new meaning*.

At the start of the initial meeting with the guider, Louise, the first thing Kirsty becomes aware of is her non-verbal signals. The experience is felt implicitly. The mother may begin to feel that she is being held in the mind of the guider by signals such as a *friendly expression, attentiveness, providing space* and *waiting for the initiatives* of the mother. Louise must receive Kirsty's initiative that there is something wrong with Adam. Receiving rather than acting and reacting allows the guider time to become aware of her own thoughts and feelings in relation to this statement before she makes her own initiative.

Emotional regulation within VIG

We might hypothesize that when Adam cries, an implicit memory is re-activated in which her own mother reacted in an aversive way to Kirsty's needs. This may not necessarily be a conscious memory but is likely to have brought with it associated negative beliefs and assumptions about crying, emotional expression and her ability to provide comfort. We can begin to speculate now that hearing her own baby crying would immediately bring Kirsty into a state of emotional dysregulation. Theories of innate intersubjectivity (Trevarthen 1998) also allow us to speculate that the baby might be responding to feelings that his mother has about him. If the mother does become distressed when discussing her worries during the initial meeting or shared review, there is the chance for the guider to be truly empathic with marked mirroring – a contingent intersubjective experience which signals attunement and which Fonagy believes to be a significant feature for the construction of representations of self-states (Fonagy and Bateman 2006).

In this way the guider remains sensitive to Kirsty's feelings but not overwhelmed by them. She might tentatively name them to enable Kirsty to move into 'awareness of reacting', which Munich suggests 'pushes the pause button' (Munich 2006, p.145) and therefore allows the possibility of acknowledging feelings and regulating distress.

At this point in their first meeting, the guider might be beginning to understand how upsetting it is for the mother, but there is still no shared goal, no starting point for filming. At some stage Kirsty might ask the guider for her own opinion about Adam's crying, and this might be a cue for Louise to remain curious and suggest making the first film so that they can look together for moments where Adam is soothed and ascertain exactly what it is that Kirsty has done to soothe him. *Judging the amount of support required* at all stages of the dialogue is complex and requires continual monitoring as to whether there is reception of the guider's initiative or not, and the level of emotional response.

Within this first meeting there must be negotiation to reach a *shared goal* before agreeing to film. Often parents themselves wish for the bad or difficult situations to be the subject of the video. It may take time and trust to shift into wanting to find ways for things to improve. Within VIG practice, it is particularly important to demonstrate effective, rather than ineffective, parenting strategies. It is thought to be counter-productive to use ineffective sequences, because the parent often has a fixed belief about their inability to parent, which could be compounded were these sections to be shown. The shared goal must relate to areas of intersubjectivity within the dyad, i.e. the attuned responsiveness of the parent and the contingent behaviour of the child.

The first film and the importance of editing

Kirsty and the guider Louise have reached agreement that it might be helpful for her to see a moment when Adam changed from crying to a calmer state, and to look together to see what conditions had contributed to this. The guider must edit the clips to show moments where the parent *follows the initiatives* of the baby with a successful outcome.

> Louise has edited one clip where Kirsty picked up a crying Adam from his cot whereby he immediately quietened, one clip where his fretfulness is arrested when he glimpses his mother smiling at him, and he smiles in response, and a third clip where he finally settles on Kirsty's shoulder and begins to look around with curiosity.

The first shared review

Although parents may have experienced a high degree of distress when being filmed, as in the case of Kirsty when trying to soothe her crying baby, the same degree of emotion is not present when watching the film. The film already creates a meta-perspective. Distinguishing between her own and her baby's state of mind is easier as her feelings in watching the film are likely to be more moderate than those she experiences when she is with him. The guider's role is to show micro-moments, rewind, show again, use slow motion and so on, and to provide the parent with an opportunity to experience herself tuning into her baby's needs.

Unexpectedly, Kirsty brings Adam to the shared review as she has been unable to find childcare for him. The baby sits on her lap and shows some interest in the video and in Louise, the guider. The task for the guider is also to allow space for the relationship in the room as well as discussing the film. Louise shows Kirsty the first clip and pauses, allowing the mother to assimilate what she has seen. The mother smiles as she notices that Adam stopped crying when she picked him up. She states that 'usually he carries on crying when I pick him up'. She tells Louise that she wishes it were that easy normally and mentions that last week when she picked him up he cried more vigorously, so she put him down and left him to cry. Louise can see that Kirsty has smiled at the video example and therefore deduces that she is not as upset when watching the film as when being videoed. Louise also hears that this is an exception to a 'usual' pattern between Kirsty and Adam, and begins to understand the feelings of hopelessness and distress and her wish for more success in soothing her baby. At this stage the guider might choose to look more closely by replaying the first clip and asking about the non-verbal signals or tone of voice that Kirsty used. Further scrutiny reveals that Kirsty's facial expression showed marked mirroring and that she had *named* her baby's feelings in a gentle way. Following this Kirsty reflects that in the example she gave from the previous week when Adam cried she had been angry and shouted at him before she picked him up.

It is the guider's role to help the parent think about successful moments rather than dwelling on moments of hopelessness, and to allow the parent to ascertain which contingencies produce an attunement. Showing these exceptions to the usual ineffective sequence begins to challenge Kirsty's conceptualization of herself as an ineffective parent and Adam as a child with problems. Kirsty begins to understand that how she is with her baby

makes a difference to his internal state. She is left with a clear image of herself tuning in to Adam's feelings sensitively and can then begin to restructure an event in the past. Further clips can be shown and discussed along the same theme, focusing on the feelings, wishes and thoughts of the mother and also asking Kirsty to mentalize about what Adam might be feeling. In this way Kirsty's original dysregulated past-influenced internal state is less constrained by the dominant implicit messages from her past, and her attention is more available in the present relationship. There is a shift as hopelessness is replaced by hope for improvement. It is this process that allows for internal representations of self and others to become gradually reconstructed.

The first supervision

Reviewing the video footage of the shared review and discussing it with the supervisor is an essential part of the method and is particularly important during training. Three fields of intersubjectivity can be reflected upon: the relationship between the parent and baby, the parent and guider, and the guider and supervisor. All these dimensions are associated with the success of the work. It is possible for trainee guiders to become derailed from the theoretical stance of VIG by powerful feelings about parents and children that have been activated during the shared review. Inevitably there will be implicit resonances from the guider's own childhood and assumptions about parenting. Looking with the supervisor at film of shared review enables the guider to ascertain whether they are maintaining a respectful and curious attitude towards the parents, gauging whether they have successfully understood the parents' emotional state and whether their own understanding and current affect is in tune.

> Louise brings a selected clip showing a moment demonstrating her own marked mirroring towards Kirsty. She pauses the film where they establish eye contact at the point where Kirsty was expressing her wish that calming Adam was as easy as the example shown on film. The supervisor asks Louise to look closely at what happens next, focusing particularly on how the guider receives the mother's initiative. The next few milliseconds of film are reviewed frame by frame. Louise notices that she and the mother move synchronously and that her own facial expression shows empathy. Louise recalls that she felt she understood how difficult Adam's crying was for Kirsty at this point and reflects that she also felt hopeful that Kirsty wanted things to change. In reviewing

the subsequent few milliseconds of video, Louise notices that directly following this, Kirsty looked down at her baby, opening her eyes wider, and that this was mirrored by the baby. Louise remarks to the supervisor that she hadn't noticed this moment of intersubjectivity during the shared review and believes there to be an association between her own attunement with Kirsty and the contingent interaction between the mother and baby.

Reflections

Whilst this fictional example shows only the beginning of the VIG process, it is hoped that in so doing it has demonstrated the processes of 'transitional relatedness' slowed down to moments of significance. It is usual for all parties when watching film in this way to be surprised by the richness and by the many ideas that can be generated in dialogue between two people, creating opportunities for positive change in communication and promoting deeper understanding between them. In addition, parents become active agents in improving their interactions with their child, building closer and more harmonious relationships as confidence improves.

Part 2 The Basic Trust Method: An Attachment-based Specialized Form of VIG

NELLEKE POLDERMAN WITH M.G. KELLAERT-KNOL AND
G.J.J.M. STAMS

Introduction

It is crucial in child rearing to provide a sense of basic trust so that the child can experience security in their relationship with their care giver, which is a necessary condition for healthy cognitive, social and personality development (Bowlby 1988; Fearon *et al.* 2010; Stams, Juffer and Van IJzendoorn 2002; Bakermans-Kranenburg, Van IJzendoorn and Juffer 2003, 2005; Van IJzendoorn, Schuengel and Bakermans-Kranenburg 1999). Failure to foster a sense of basic trust in children by means of sensitive parenting can result in insecure child–parent attachment relationships (De Wolff and Van IJzendoorn 1997; Van IJzendoorn and De Wolff 1997), which have been shown to be associated with both internalizing problems (Brumariu and Kerns 2010; Colonnesi *et al.* in press) and externalizing problems (Fearon *et al.* 2010). Recent research shows that insecure attachment is associated not only with parental insensitivity but also with a lack of mentalizing ability – the ability to understand that other people have an internal world with feelings, thoughts and desires (Allen and Fonagy 2006; Fonagy *et al.* 2002; Fonagy and Target 1997).

The Basic Trust Method (Polderman 1998), a specialized form of Video Interaction Guidance (VIG) (Dekker and Biemans 1994), is one of the few attachment-based interventions focusing on the more clinical patterns of insecure and disorganized attachment in children from 0 to 18 years. It focuses on strengthening the sensitivity and the mentalizing abilities of the parents (Ainsworth, Bell and Stayton 1974; De Wolff and Van IJzendoorn 1997; Goldsmith and Alansky 1987; Van IJzendoorn and De Wolff 1997). Basic Trust uses a specialized form of VIG (Dekker and Biemans 1994). The intervention comprises an average of eight training sessions. It has been applied in supporting parents, teachers at schools, teenage mothers in care, foster parents, adoptive parents and professionals in residential care.

The use of VIG in the Basic Trust method is different from regular VIG in a number of ways. First, it teaches parents to 'name' the behaviours, feelings, wishes, intentions and thoughts of the child. Second, it uses psycho-education about attachment. Like VIG in the UK it places special

emphasis on the guider's communication skills. This is because 'good enough' (Bettelheim 1987) sensitivity is not sufficient in the treatment of attachment difficulties. According to Stovall and Dozier (2000, pp.153–154) 'foster parents may need to be not only sensitive but therapeutic as well for a secure attachment to form with late-placed infants'. The guider–parent relation parallels these special demands, in that the guider also needs to be 'therapeutic' to form a secure bond with the parents and help them to develop in their relationship with their child.

Naming

Parents are asked to attend explicitly to their child's behaviours and signals by 'naming' the child's behaviours, feelings, wishes, intentions and thoughts according to a set of well-specified criteria. First, 'naming' consists of *you*-statements, such as 'you're painting the flowers yellow', ensuring that the child's behaviours and mental states are named rather than those of the parents (not: 'I see you painting the flowers yellow'). Second, 'naming' is concerned with the child's behaviours and mental states in the *here and now*, enabling the child to become conscious of their experiences, which is thought to enable adequate self-regulation (Schore and Schore 2008). Third, 'naming' includes a *detailed* description of the child's behaviours, feelings, wishes, intentions and thoughts (not 'you are playing', but 'you like to play with your doll'), which makes sure that the parent's communications are clear, concrete and geared to the child's perception of their environment. Fourth, 'naming' should be declarative and *neutral* (not containing an evaluation, such as a compliment), which is thought to communicate acceptance of the child's self as a person. Therefore, fifth, 'naming' does not include a *question*. A question 'forces' the child to attune to the parent and not vice versa. Finally, naming should also be *supported non-verbally* by eye contact, friendly intonation and facial expressions that mirror the child's mood.

According to Polderman (1998), 'naming' is the most important interaction principle in promoting attachment security. Frequent naming, performed in this specific way, is thought to reinforce the parents' sensitivity and responsiveness, providing them with the tools they need to attune to their child. As the child feels 'seen', they are able to develop a secure attachment to the person who 'sees' them. The child also learns to recognize their own feelings and intentions and therefore those of others. Consequently, 'naming' promotes the process of 'mentalizing' (Allen and Fonagy 2006; Fonagy *et al.* 2002; Fonagy and Target 1997).

The child's mentalizing is further strengthened by a so-called 'second step' (Bateman and Fonagy 2004), in which the parents are also taught to name their own thoughts and feelings. They are instructed to do so in the next sentence, right after the 'naming' ('You like your cookie. I like mine too'). Parents' additional naming of their own wishes can also be used in situations where the child shows undesirable behaviour. In this way they can guide the child to more appropriate behaviour.

Parents are also provided with specific advice for dealing with their child's attachment difficulties in daily life, which are meant to make the child feel safe, and not rejected.

Psycho-education

In the Basic Trust Method parents' goals are the starting point. They normally want to have a positive interaction with their child and to help to reduce the child's symptoms. Psycho-education can help them understand the meaning of their child's symptoms from an attachment perspective (see Dozier et al. 2006).

Parents learn that the child's symptoms relate to a lack of 'basic trust' (Erikson and Erikson 1997). The word 'attachment' is rarely used, because parents seldom recognize 'attachment problems' but they do recognize feelings of insecurity in their child. Negative child behaviour that is mentioned by parents and observed on video recordings is discussed with the parents from the perspective of basic trust and fear of losing the parents. Parents often feel rejected by their child. Relabelling the rejection as fear of losing the parent, and trying to manage that fear, stresses the important role of parents in the development of their child. Mostly this interpretation offers parents a new way of looking at their child. Consequently their feelings of guilt and inadequacy will vanish. Parents become highly motivated to cooperate and see how they can help the child. For these reasons this is vital in the process of aiding traumatized children.

Communication between the guider and the parent

By helping parents discover effective parenting strategies and by an intensive use of interaction principles in communication with the parents, a trusting working alliance is developed. Jenny Jarvis described the importance of this working alliance in Part 1 of this chapter, especially with parents whose own attachment was insecure.

Guiders using the Basic Trust Method apply these interaction principles more precisely than usual. They consistently receive the parents' ideas and take turns with them to develop their ideas. They often name parents' intentions, feelings or thoughts 'here and now' while watching the video recording, while also naming their own mental state. Parents feel seen, and this helps to increase their mentalizing capacity. In turn the parent may be able to really 'look' at the child and become aware of the child's internal mental states.

Evaluation of the basic trust method

The Basic Trust method has been used for over 15 years in clinical practice. Its efficacy was measured in a pilot study ($n = 10$ children) in a sample of foster children (from two to five years old). It shows a significant and large improvement in maternal sensitivity ($d^2 = 1.20$) and a decrease of attachment insecurity ($d = 0.80$), but no reduction in psychopathology.

Another study ($n = 20$ families, both fathers and mothers) (Stams *et al.* 2010) evaluated the Basic Trust intervention in a pre-post test design without a control group in adoptive and foster families with children aged two to five years old who were referred for attachment problems and psychopathology. There were large and positive differences ($d = 0.85$) between pre- and post-test in child–mother attachment relationships. The scores on disorganized attachment changed from the clinical to the non-clinical range ($d = 0.82$ mothers/$d = 0.87$ fathers). While the sensitivity of the parents did not increase, overall psychopathology decreased ($d = 0.34$) as did behaviour problems ($d = 0.67$) (a change from borderline clinical to the non-clinical range), and prosocial behaviour improved ($d = 0.42$). These effects are small-to-medium. Further research is required, but these results are very promising.

2 The conventions formulated by Cohen (1988) were used for interpreting the effect sizes. Effect sizes around $d = 0.20$ were considered as small, effect sizes around $d = 0.50$ as medium and effect sizes around $d = 0.80$ as large.

Video Feedforward

Towards a Preferred Future

MIRIAM LANDOR AND CALUM STRATHIE

Introduction

The concept of positive self-modelling, which is an essential element of Video Interaction Guidance (VIG), is also the basis of a method known as Video Feedforward (VFF) (Dowrick 1991, 1999). VFF is an intervention that promotes behavioural change, as clients are shown skilfully edited video images of themselves succeeding in tasks or situations they find difficult, thus providing the opportunity to self-model. It is called 'Feedforward' because it involves showing the client 'created' future images of themselves achieving their goal, to differentiate it from the 'feedback' of images of their past achievement, as in VIG. VFF has a long history based on the pioneering work of Professor Peter Dowrick in New Zealand and the USA.

VFF and VIG

Whilst VFF and VIG have many aspects in common, and guiders often segue between the two approaches, nevertheless there are critical differences. VFF emphasizes learning from the future; VIG enables learning from the past and reflecting in the moment. The following model gives a simple visual reminder of the relationship between VFF and VIG; it can be seen from this that the empowering aspect of VFF is the link between the client and the video, whereas the empowering aspect of VIG is the relationship between the guider and the client.

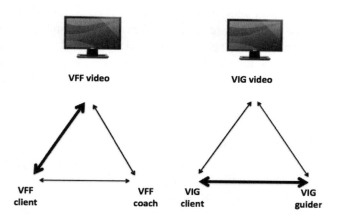

Figure 14.1: Model of VFF and VIG showing critical differences in emphasis

As the model demonstrates, the components of VFF and VIG are similar but the emphasis has shifted.

How does Video Feedforward work?
How can we see ourselves in the future?

The practitioner needs to think like a film director as well as like a change agent. The main skill of the VFF coach is to plan, record and edit a series of images of the client undertaking an activity or dealing with a situation in which they have typically been unsuccessful in the past. VFF takes existing component behaviours and reconfigures them into 'new' or future skills. Where possible the client is fully involved in planning with the VFF coach throughout the process, to give ownership and increased feelings of self-efficacy. The activity is first broken down into different elements and a storyboard created. Each scene is planned to give an element of successful performance, either through hidden supports (e.g. physical assistance, verbal prompting, coached rehearsal) that are later edited out, or through adapting parts of the context or environment to make it easier to achieve the desired behaviour. Through skilful editing the successful elements are then 'spliced' together to form a short (two- to three-minute) video showing 'perfect'

accomplishment of the task. The client then watches the video daily for a week or so, thus becoming their own, and most powerful, role model.

The method works because it gives clients the opportunity to self-model successful behaviours, strategies and physical actions and to view themselves actually performing these achievements. In addition it works because it is a natural way of learning according to what we now know of brain processes (Dowrick 2011).

Who is VFF used with?

VFF has been used successfully in countless situations: with people who are having to make difficult transitions in their lives, such as teenagers with disabilities preparing for adulthood (Dowrick, Tallman and Connor 2005) or with children with autism, for example to train verbal responding (Buggey *et al.* 1999). It is often used to help improve skills and behaviours, such as reading fluency (Dowrick, Kim-Rupnow and Power 2006) and sporting performance (Dowrick 1989). It can also be used with people who need to be more confident in different situations, for example vulnerable people learning to say no to unwanted advances (Dowrick 1991), and it can be used in language development (Whitlow and Buggey 2004). Of course, this method can only work if the desired change is possible, that is, if 'component skills (which are in the repertoire) are put together to appear as new skills, or (existing) skills are put into a new/challenging context' (Dowrick 2009). It probably works best if the client can conceptualize the change and is motivated; however, even if the client is developmentally or cognitively unable to cooperate in this way, VFF can be very successful. In fact there are almost endless possibilities for client groups and situations where change can be achieved using VFF.

Before beginning VFF

VIG guiders and other change agents may wish to know how to determine whether VFF is an appropriate intervention in any given case. Through analyzing many reports of practitioners using VFF with a wide range of clients, such as those illustrated in the case studies below, the first author proposes a set of pre-VFF criteria. Of course, a negative response to any of these criteria does not necessarily mean that VFF is unsuitable, but rather that that issue needs to be resolved before you start.

PRE FEEDFORWARD CHECKLIST

- [] Self-recognition: is the client able to recognize themselves on video?

- [] Motivation: will the client find it intrinsically rewarding to change the behaviour?

- [] Distraction: is the client able to block out background distracters on video (visual and/or auditory details)?

- [] Observable behaviour: can the 'goal for change' be expressed as an observable behaviour? Is it within the Zone of Proximal Development (that is, are the components all existing behaviours/skills)? Can all the elements be video-recorded successfully using hidden supports or different contexts, to give the 'perfect' final performance after editing?

- [] Client capacity: for those who are cognitively able, does the client understand the process?

- [] VFF coach capacity/resources: is the VFF coach able to take and edit video and burn a DVD?

- [] Viewing capacity: is there someone (adult/key worker) who can watch the video with the client and give sensitive encouragement? (More important for children than for adults)

- [] Ethics: Have the necessary permission and DVD release forms been signed?

Some case illustrations

At the most basic level VFF can be very effective in one-off situations. The first case study was chosen to illustrate a piece of work that was undertaken to address a single issue: a job interview.

CASE STUDY 1 (CALUM STRATHIE)

Adult with mild learning difficulties, Andy (name changed to protect client identity)

Andy was referred by the Supported Employment Team for adults with learning disabilities. He had been offered an interview at a facility where he had already had some work experience and

where he was keen to gain permanent employment. However, he had little experience of interviews, lacked self-esteem and was anxious about what to do or say in such a situation. Hence a referral was made with his consent.

The first step was to establish with Andy that he understood clearly how VFF might help him to achieve his goals, i.e. to gain some confidence and relieve anxieties about going for a job interview. We agreed to stage an interview based on the kind of questions he would be asked and to record this on video camera. He understood that this would give him an opportunity to 'rehearse' for the real interview and that he would have ownership of the completed recording. It was emphasized that the finished recording would show only successful elements of the interview, not any mistakes.

Setting up the interview

The plan was to have Andy experience all the people he might encounter and the questions he would be asked. He was then able to think about the information he would need in order to respond confidently to the questions. He was *asked* – not *told* – how he would present himself. A simple storyboard was then formulated to help him appreciate the significance of the main elements of the 'story'.

The 'interview' was conducted as a series of short takes for each question, allowing for a second take when Andy forgot what he wanted to say. This 'stop/start' approach allowed for a final rehearsal of each answer before the camera recorded.

The main elements, or parts of elements, where Andy was successfully dealing with the situation or engaging well with others – such as being friendly, confident and polite, making good eye contact, talking clearly – were then captured from the master tape as individual clips. These were then spliced together into a seamless and continuous interview and saved onto a DVD which Andy viewed every day in the lead-up to his interview.

Evaluation

More than a year later a semi-structured interview gave Andy an opportunity to discuss what impact VFF had had on him. Although he had not been offered the job in that instance he was able to recall the reasons for making the video, the things that he learned from it, the positive feelings he had when viewing himself and the benefits he had gained. He seemed to have an understanding of the

process and how it had helped him, to the extent that he would like to do it again before his next interview.

This case study is a good example of the respectful collaboration between client and professional which VFF makes possible, and highlights the importance of the resultant growth in feelings of self-efficacy.

VFF is also effective in 'messier' situations where there are complex inter-related factors to contend with. A series of VFF interventions may then be necessary in order to build up successful component skills and behaviours. The following case study illustrates such a process:

CASE STUDY 2 (FIONA BROWN)

Primary school pupil, Barbara (name changed to protect client identity)

Barbara is a ten-year-old child who was referred to the Outreach Teaching Service for support with her challenging behaviours in school. She has attachment disorder and pica, and the resulting behaviours affect her safety and learning and also that of her classmates.

VFF was suggested after various strategies to reduce Barbara's disruptive behaviours had been used with limited success throughout her school career. The school's primary objective was to include her more fully in class. As this was a wide remit, individual behaviours were isolated and a series of videos created.

The first of the series focused on the most easily adapted behaviour, 'good sitting'. Barbara used to swing violently on her chair and 'windmill' her arms and legs around, endangering herself and her classmates. She was told that a video would be made showing her sitting well and 'good sitting' behaviours were discussed. She was filmed in several different school settings and the footage was edited into a two-minute film, spliced with images of clocks showing different times, giving the impression that she could sustain appropriate sitting throughout the school day. After the intervention, Barbara's class teacher noted that she sat on her chair for significant portions of her lessons.

The second behaviour targeted was 'safe walking'. Barbara had enjoyed the process of making the first video, so was keen to be even more involved with the second, storyboarding it with adult support. This film showed her walking appropriately around the school by herself, with a partner and with her class. Again, the class

teacher noted significant improvements in this area, which was very encouraging as it showed excellent 'client as collaborator' progress.

The most challenging of Barbara's behaviours, and the most difficult to tackle in a VFF context, was related to her pica. This impeded her inclusion in class as she frequently ate rubbers, glue sticks, blu-tack and other stationery items, often taking these from her peers. However, this was the issue that she chose to tackle for her next film and, with teacher support, she came up with ways that it could be dealt with in the video. She chose three scenarios where she would usually eat non-food items, storyboarded them, scripted some self-talk and then directed most of the filming (we would like to add a reminder here – this is a ten-year-old!). In each scene, she put the non-food item (glue stick/rubber/blu-tack) towards her mouth, stopped herself and made a comment to camera such as 'yuck – I'm not going to eat this' before disposing of the item. Barbara continued to make good progress following this intervention.

Using VFF as a series proved exceptionally useful for many reasons: it successfully addressed a deep-seated behaviour; it allowed the previous behaviours to be revisited; and, most importantly, it allowed a child who presented with consistently challenging behaviours to show herself in a positive light, demonstrating not one but several appropriate behaviours. In addition, it has given staff working with this pupil a useful tool that can be used to tackle other behaviours in the future.

It is often the case that VIG guiders who are familiar with Feedforward techniques switch between the two methods. In the next case study the VFF came about through VIG work, and the VFF film was subsequently micro-analyzed in a shared review session using the VIG approach.

CASE STUDY 3 (SHIONA ALEXANDER)

Primary school pupil, Carla (name changed to protect client identity)

Carla was a ten-year-old girl who had been referred to the Psychological Service. She was having difficulties attending her small rural school.

From a discussion with Carla's head teacher and mother it was clear her mother was concerned that her relationship with her daughter was suffering as a result of the arguments about Carla

not attending school. It was agreed to film Carla and her mother together at home. At the shared review of this film Carla's mother could see many examples of attunement and she felt reassured that she still had a strong relationship with her daughter. She also felt comforted that she was doing all she could to support Carla's attendance at school.

This VIG intervention allowed Carla and her mother to feel supported, and a more trusting relationship developed between the guider and family. Carla confided that she was very concerned that her mother would come to harm when she was not with her and that the head teacher would be angry because of her non-attendance. A Feedforward film was planned together so that Carla could repeatedly view film of her mother being well while she was at school and of the head teacher being calm and not angry.

Carla filmed herself going into school and talking to the head teacher. This was staged at a time when no other pupils were around so that success was as likely as possible. Any anxious or hesitant moments were edited out. While this was happening a film was made of her mother outside school which would reinforce that her mother was well and happy even when Carla was not present. In the final Feedforward film the transitions between clips of Carla in school and of her mother outside were captioned 'meanwhile' to emphasize that the clips were concurrent.

The next VIG shared review session of the Feedforward film was critical in helping Carla identify that although she was anxious just outside the school door she felt much better a few moments later when she was in school. This helped to reduce the challenge to just a few steps and she clearly felt more optimistic once she realized this. When in school, Carla saw herself as happy and fairly relaxed. She was also able to see how well she and the head teacher got on together in moments of very positive interaction. Most importantly she recognized how well her mother was even when they were separated.

Carla was asked to watch the Feedforward film every weekday morning immediately before setting off for school for two weeks. Other fortuitous factors were also involved but within two weeks of watching the Feedforward film Carla returned to school on a reduced timetable. Soon she was attending full time.

This case study illustrates how VFF and VIG can be sensitively combined to bring about a successful outcome.

The research project
The background
This small-scale research project developed from a Feedforward Interest Group, formed by the first author to give ongoing support to those practitioners in her local authority who were using Feedforward with their child clients. In addition, data was included from a case study by the second author who used Feedforward with an adult client. The group benefited from the support of a Psychological Service Research Assistant. The aim was to identify factors that either contribute or throw up barriers to the success of the Feedforward approach.

The project
Case studies included nine children, aged 6–13 years, male and female, who attended different schools, and one adult. They were carried out by five VFF coaches (a senior nursery nurse in an autism unit, a LAC outreach teacher, an ADHD outreach teacher, an educational psychologist and a VIG development officer from another authority). There were a range of reasons for referral, including disruptive behaviour, a negative attitude to homework and a lack of self-confidence. The target behaviours followed on from them, for example, not calling out, following a good homework routine and being more confident with strategies to help learning or with interview skills.

Information leaflets, consent forms and evaluation sheets were sent to participating children, parents and school staff. The participants were for the most part helped to plan their Feedforward video in small steps or scenes, using a storyboard, in order that video clips or photographs could be taken for each scene. There was one exception where the child was not involved in the planning; this was a child with autistic spectrum disorder who had high levels of anxiety. The VFF coach then edited the visual images. In some cases the storyboard was made into a photo story, rather than a video, because of a lack of resources. The client then viewed the video or photo story several times over the next week, with children being accompanied by a key worker or other significant adult.

Comments from the evaluation forms and from the adult's post-intervention interview were collated and analyzed using thematic analysis (Braun and Clarke 2006), in order to determine factors that contributed, or that threw up barriers, to the success of the Feedforward approach.

Results and conclusions

Thematic analysis of the data found seven main themes that led to success and five that were barriers (see Landor *et al.* 2009 for a full report of the project). Evaluation showed mainly positive responses from all involved and a desire to use the approach again in future. It engaged the child/client and other significant adults (parents and school staff) in a positive cycle and engendered self-efficacy. A range of factors contributed to the successful outcomes: the popularity of using video cameras; the empowerment brought about by collaborating in planning the storyboards; the pleasure in viewing successful future images of themselves; and the encouragement it gave to parents and staff.

To be successful, VFF requires careful planning, sufficient time, effective IT skills and resources, positive attitudes and good communication between those involved. Individualized and appropriate evaluation methods should also be considered at the planning stage. Practitioners are advised not to embark on it if there are overwhelmingly negative attitudes around, too much else going on for the client or client's family or too little time available for creating and watching the video.

It was concluded that the VFF method is simple, inspiring and one of the most powerful approaches in a practitioner's toolkit for bringing about change.

Review of research literature and psychological theories

Research literature

According to Dowrick's seminal conceptual review (Dowrick 1999), the origins of video self-modelling can be traced back to the late 1960s. Creer and Miklich (1970, cited in Dowrick 1999) were inspired by Albert Bandura's (1969) book *Principles of Behaviour Modification* to video-record a boy who was hospitalized with asthma role-playing effective social skills; results showed that the role-playing had no positive effect on his behaviour but viewing the videotape did. Coincidentally, throughout the 1970s Hosford (1980) used a similar method of 'self as model' in adult behavioural counselling, following the growing literature on observational learning. Dowrick developed the notion of creating future images of success in a wide range of contexts, such as extending the attention span of an impulsive four-year-old (Dowrick and Raeburn 1977), encouraging two children with selective mutism to speak at school (Dowrick and Hood

1978) and improving the swimming performance of children with spina bifida (Dowrick and Dove 1980).

Dowrick (1991) discriminates between two kinds of video self-modelling, Positive Self Review (PSR) and Feedforward. PSR uses video-recorded incidents of exceptional superior performance, which is in the client's current repertoire but is rarely achieved, to increase the frequency of achievement, whereas Feedforward targets behaviours that have not been achieved previously. Dowrick reports that Feedforward produces much greater behavioural change (Dowrick 1999).

Since these early beginnings, further meta-analyses of video self-modelling (VSM) in a range of contexts have been carried out. For example, Hitchcock, Dowrick and Prater (2003) reviewed VSM interventions in school-based settings, and found the following results over a range of studies (including classroom behaviour, language responses, peer relationships, adaptive behaviours, mathematical skills and reading fluency):

- Children of all ages have achieved successful outcomes with VSM.

- VSM can be used with an array of behaviours and academic skills.

- The effects are usually immediate and dramatic.

- VSM is time- and cost-effective compared to other instructional methods.

- The skills learned are maintained.

- Social validity has been documented.

- It can be combined with other interventions.

Bellini and Akullian (2007) carried out a meta-analysis of video modelling/video self-modelling interventions for children and adolescents with autism spectrum disorders. Again, VSM was found to be effective in improving student outcomes, and also in terms of generalization across settings and maintenance. 'The results suggest that video modeling and VSM intervention strategies meet criteria for designation as an evidence-based practice.' (Bellini and Akullian 2007, p.264)

Psychological theories
There are a number of key psychological theories underpinning self-modelling in general and Feedforward in particular.

Bandura's (1977) Social Learning Theory provided the original impetus for video self-modelling. He emphasized 'the ability to learn by observing a model or receiving instructions without experiencing the behaviour firsthand' (Hitchcock *et al.* 2003, p.36). Seeing oneself perform successfully provides the ultimate in role models (Bellini and Akullian 2007), gives clear information on how best to perform skills and strengthens belief in one's capacity; these are the essential elements of self-efficacy, which is a major influence on generalization and maintenance of the learned behaviour (Dowrick 1991, 1999).

Another key theory is the sociocultural view of learning. Vygotsky's model (1978) of the zone of proximal development (ZPD) describes learning as the journey, which is scaffolded through the guidance of a more skilled person, between what can be achieved only with maximum support through to consistent and independent achievement. This is in harmony with Dowrick's (1999) view of self-modelling as learning from images of one's own future 'skilled' behaviour or success (Hitchcock *et al.* 2003), and the whole of the VFF process is positioned within the ZPD.

Skinner's (1953) Operant Behaviour Theory is also applicable to VFF; indeed, in his Notebooks (1980) he advocated using videos of positive performance (hitting home runs) rather than the negative feedback of failures (striking out) in order to improve the performance of baseball players (cited in Dowrick 1999). It is also consistent with Seligman's (1991) theory of learned optimism and with cognitive behavioural theory (e.g. Beck 1976).

Recently, Dowrick (2011) has articulated self-modelling, conceived as learning from the future, as a learning theory in its own right – bringing together behavioural and neuro-cognitive evidence.

VFF and VIG: Common roots and critical differences

Common to both VIG and VFF is the initial engagement and goal setting with the client (or in some cases the adult/parent/carer acting on behalf of the client). Collaboration is manifest from the very start through effective communication skills that can be developed through VIG training (i.e. naming, receiving, checking for understanding), leading to a trusting and respectful relationship in which goals for change can be identified. These skills can be of particular importance when several people are expressing views that are not necessarily in accord with each other – for example, the teacher feels that child needs to conform to school rules in order to avoid

disruption, while the child and parent feel that the child is unfairly labelled or made a scapegoat. The challenge then is how the VIG guider/VFF coach makes use of the principles of effective communication to help achieve a shared understanding and shared goal. In such a scenario there is an inbuilt power imbalance – the school has power over the child and the parent. So if both the school and the family are to be viewed as clients (or care seekers) there requires to be a skilled balancing act on the part of the guider/coach in achieving a collaborative partnership with both while also helping both reach a shared understanding.

In VIG the initial goals provide the 'steer' or direction throughout the reflective process in which new goals or 'working points' can be identified. In VFF the goals serve as the focus during the storyboarding and pre-production phase, and these can be revisited if a post intervention review is appropriate.

Table 4.1 notes the key features of VFF and VIG and describes what they have in common and where they diverge, may help when deciding whether VFF or VIG is most appropriate to use.

Conclusion

Often a care seeker comes to a guider asking for help with changing the behaviour of a third person such as their child, pupil or client. The skilled guider will determine whether the presenting problem will be more effectively managed as a difficulty with individual skills, abilities or behaviours (which, however, may impact on the interpersonal relationship) – i.e. through VFF – or primarily as a difficulty with the interpersonal relationship – i.e. through VIG. In our experience the skills developed through VIG (receiving, naming, checking for understanding, scaffolding, etc.) can make a significant contribution to the effectiveness of VFF in the early engagement and goal-setting stages. However, as VFF is predominantly a visual intervention, it can be most effective (and in fact is sometimes the only possible intervention) where clients are unable to engage with the practitioner, for example those with autism or significant communication difficulties. VFF is an invaluable additional tool in the guider's toolkit; it is also a powerful stand-alone approach for those practitioners who are not VIG-trained.

Table 14.1: Key features of VFF and VIG

Key Features	VFF	VIG
1. Positive self-modelling through video	Yes	Yes
2. Change: client can conceptualize change and wants change	Usually, but not necessarily; change must be of benefit to client, but goal may be set by significant other if client is cognitively unable to collaborate	Yes – care-seeker needs to be able to conceptualize and to verbalize own desire for change
3. The goal of the change	Client's behaviour	Interaction skills / relationship with other (but this may be reframed from initial request for changing behaviour of other)
4. Observable behaviours	Yes, the key outcome. Changing these is the goal of VFF	Yes, but these are used as 'indicators' of elements of successful interaction (attunement principles)
5. Viewing video with other person (VFF Coach/VIG guider/ key adult)	Usually yes with children, through encouragement/ reinforcement whilst watching, but not vital	Yes, through shared review session in a therapeutic relationship
6. Training required	Minimal – single session of training plus peer support advocated. No formal accreditation system as yet	Usually 1.5–2 years – training days and three-phase supervision model. Formal accreditation system

Acknowledgements

Thanks to all participants, their parents and school staff. In particular we would like to acknowledge the contribution of additional case studies by Fiona Brown, Trainee Educational Psychologist, Dundee University and Shiona Alexander, Psychological Service, Highland Regional Council, and of research assistance by Lyndsay Wood, West Lothian Council Psychological Service.

Reflecting on VIG Practice from a Relational Systemic Perspective

CAROLE S. CHASLE

> Understanding the shadow cast by the other in the space between seems to be an apt metaphor for intersubjectivity (Benjamin 1998, p.xii).

As an educational psychologist (EP) and Video Interaction Guidance (VIG) practitioner the interactions I have with clients in a range of contexts and for differing purposes are messy and complex; as part of my doctoral thesis I wanted to be able to reflect and analyze this complexity. Bruner (1996) says that: 'The next chapter in psychology...is about intersubjectivity – how people come to know what others have in mind and how they adjust accordingly' (Bruner 1996, p.161). It is therefore my belief that focusing on theories related to 'intersubjectivity' would allow me to be reflexively aware of my own personal experience and critically aware of the social and cultural discursive influences on my practice and on my relations with others. This chapter will give a brief overview of the theoretical base I have used to support my reflections and will then discuss this in the context of my work with a VIG client.

A model of reflexivity

The model I chose to inform reflection on my practice is based on the pivotal construct of 'intersubjectivity' and draws primarily from relational psychoanalysis, with influence from the fields of infant and attachment

research. 'What these approaches share is the belief that the human mind is interactive rather than monadic' (Benjamin 1990b, p.1).

My aims for a theory of reflexivity based on this convergence of perspectives are that it will inform and support my interactions and relationships with clients and that it will give me a set of 'tools' to help me to analyze more thoroughly and sensitively what is happening in an interaction, between a client and myself and between clients (adults and children). These aims follow directly from the VIG model of working, which focuses on the quality of the moment-to-moment communication, not only between clients but also between the client and the therapist, using the basic communication principles drawn from the work of Trevarthen (1979). This level of analysis goes some way towards meeting my aims; however, human relations are complex and dynamic, and I am interested in the *meaning* behind much of what we do and say. Therefore I believe that the theories supporting relational psychoanalysis, and in particular the work of Mitchell (2000), will help me to understand in more depth my own and others' actions and interactions.

Modes of relating within relational psychoanalysis

Relational psychoanalysis challenges many of the central tenets of traditional psychoanalysis (Mills 2005) with a shift in emphasis away from Freud's biological drives, providing '…an alternative perspective which considers relations with others, not drives, as the basic stuff of mental life' (Mitchell 1988, p.2). The focus is instead on the interpersonal process, with meaning emerging through co-created knowledge rather than offered as expert opinion through interpretation and advice to others. This view of intersubjectivity fits well with my philosophy and approach to EP practice.

Mitchell (1988) was a key theorist and practitioner in the field of relational psychoanalysis, and he described its central feature as the idea that humans are foremost defined by their relationships; to appreciate truly a person's experience is to understand the interpersonal contexts in which that person lives. In his work, Mitchell (1988) offers an 'interactional hierarchy' or framework that allows exploration of different dimensions of relationality. Mitchell described his four modes as:

Mode one: Non-reflective behaviour

Mode two: Affective permeability

Mode three: Self-other configurations

Mode four: Intersubjectivity

Mitchell's framework provides a clear relation between the concepts of subjectivity and intersubjectivity which he describes as an '...endless Mobius strip in which internal and external are perpetually regenerating and transforming themselves and each other' (Mitchell 2000, p.57). However, it does not address the broader social/cultural influence on relationships and I have therefore added a fifth mode, which I have called 'situated'.

MODE ONE: NON-REFLECTIVE BEHAVIOUR

This mode of interaction has been demonstrated by contemporary infant researchers such as Trevarthen (1979a) and is analogous to VIG's 'principles of attuned interaction and guidance'. Stern (2004) also described this mode of interaction when he used a phenomenological approach to explore what he calls 'present moments'. These 'present moments' are described as short episodes of untold emotional narratives that take place during an interaction, which is mentally grasped as it is still unfolding through non-symbolic and non-verbal processes.

The Boston Change Process Study Group (BCPSG) (2007) also describe this mode of relating as the most profound level of human experience. They argue that '...physiological and then social/behavioural regulation is carried out between the infant and its caregiver, and represented and remembered by the infant' (BCPSG 2007, p.2).

The representations of these early dyadic exchanges continue throughout life and guide the moment-to-moment exchanges that occur in any interaction. 'All the things that are the stuff of the interactive flow, such as gestures, vocalisations, silences and rhythms, constitute this moment-to-moment exchange, which we refer to as the local level' (BCPSG 2007, p.2).

MODE TWO: AFFECTIVE PERMEABILITY

Mitchell's mode two domain of relating is concerned with a fundamental, boundaryless, affective level of experience. Mitchell is quite clear in his description of this mode that what we are concerned with is the contagious nature of affects, which throughout life are evoked interpersonally through dense resonances between people. Mitchell draws on Bowlby's work to speculate from a developmental perspective that:

> ...the residue of attachment experiences both early on and through later life includes not simply cognitive working models of the interpersonal world, but affective states of undifferentiated connection with attachment figures, organised around both

positive affects, like euphoria or soothing calm, and negative affects, like depression anxiety or terror. (Mitchell 2000, p.90)

This mode of relational knowing links to the concepts traditionally known in psychoanalytic literature as transference, counter transference and projective identification. Relational psychoanalysts, uneasy with these terms, have offered alternatives such as 'self-other confusions' (Auerbach and Blatt 2001).

MODE THREE: SELF-OTHER CONFIGURATIONS

Mitchell draws on the theories of the 'object-relations' school of psychoanalysis and in particular the work of Fairbairn (1952) to elaborate this mode. The 'object-relations' school of thought encompasses any approach that focuses on relationships between the developing self and the 'objects' (mental representations of people) with whom it comes into contact. Within this mode of relating interpersonal experiences are organized into configurations entailing self in relation to others. 'On this symbolic level of organization co-constructed interactions are sorted out and tagged, consciously or unconsciously, according to the person involved' (Mitchell 2000, p.62).

The quality of relationships available to the developing self during the formative period of early life is crucial. These early relationships are understood to lay down the basic psychic structures and internalization that provide the template for later life. From this perspective it makes no sense psychologically to consider the self except in relation to others.

Mitchell is keen to locate this mode of interacting within the context of his overall framework to avoid any reductionism. He says that the sense of oneself as populated with presences of early significant objects does not have to be accounted for solely in terms of some discrete, intentional defensive process, but rather we can assume that a baby begins life fully embedded in a presymbolic relational matrix (mode one), and that the baby experiences powerful emotional experiences (mode two) that transcend the cognitive boundaries of self and others.

MODE FOUR: INTERSUBJECTIVITY

Mitchell's mode four of relating addresses the fundamental tension that 'being fully human (in Western culture) entails being recognised as a "subject" by another human subject' (Mitchell 2000, p.64).

Thus, it requires us to consider the concept of a person who is a complex agent with both self-reflective intentionality and dependency, relating to a living responsive other. Mitchell draws on relationally oriented psychoanalysts to expand his theorizing on this aspect of the intersubjective dimension of relationality; one such theorist is Benjamin (1990a, 1990b, 1998). A central theme in Benjamin's work is the notion of recognition. 'Recognition is that response from the other which makes meaningful the feelings, intentions and actions of the self. It allows the self to realise its agency and authorship in a tangible way' (Benjamin 1990a, p.12).

This notion of recognition can often escape notice, appearing as it does in terms of validation, appreciation, acknowledgement and so on, but essentially it is about the self searching for affirmation of the self through the other. From this the idea of 'mutual recognition' becomes crucial to the intersubjective view, as it implies that we also in turn have a need to recognize the other. Benjamin (1990a) says that this need for recognition contains a fundamental paradox, as at the very moment of realizing one's own independence, we are dependent upon another to recognize it. Benjamin also highlights the potential for conflict as '...the desire to remain attuned can be converted into submission to the other's will' (Benjamin 1990a, p.37). Therefore, without a balance between recognition of other and assertion of self, domination can enter a relationship.

MODE FIVE: SITUATED

Within this mode I am concerned to emphasize that our relational knowing is always 'situated' or 'located' by culturally and historically specific accounts. This is a position taken by post-structuralists, who highlight the implications of language as a producer of the social and cultural world and who also focus on disclosing the implications of cultural and social discourse (Jessup and Rogerson 2004).

Reflecting on intersubjectivity within this mode does not mean finding a correct standpoint, but it does mean understanding how we come to stand where we are. 'We are always already embedded in a particular set of perspectives, operating from within certain positions when we try to understand ourselves and others' (Parker 1999, p.3).

The position or heuristic approach I am seeking in mode five could, therefore, be said to be one of deconstruction, where:

> A deconstruction is a process of critical reading and unravelling of terms, loaded terms and tension between terms that construct how we read our place in culture and in our relationships and

how we think about who we are and what it might be possible for us to be (Parker 1999, p.6).

The position I take in mode five allows me to take that extra reflexive step, whereby EP practice and the theories underpinning my work are not treated as 'forms of truth', but rather as narratives of Western cultural thought; a step that places criticality at the heart of ethical expert practice.

I will now present my reflections on my practice using this model of reflexivity. After some consideration I have decided not to indicate when each mode is implicated in my reflections as the complexity of the interactions and the analysis involves using all the modes interchangeably throughout.

Reflecting on a case

Like practitioners before me I was drawn to the elegant simplicity of the technique of Video Interaction Guidance, but, as Beaufortová says, there is more to it than this: 'We realised that it was not just about learning to analyse pictures, it was about how to work with people, how to be with them and how to accept them' (Beaufortová 2001, p.37).

This was very much the case in my work with Alice and her family. I was asked to become involved with Alice, a mother of four children, by a children's centre worker. Alice was finding managing and relating to her children challenging, and prior to my involvement she had the benefit of a number of interventions at the children's centre, including attending a 12-week parenting programme. These interventions had helped Alice to develop her confidence in terms of managing her children's behaviour; however, she continued to find it difficult to relate to Gavin, aged nine years, her third child by her first partner. Alice was particularly finding it hard to deal with her very negative feelings towards Gavin, and spoke openly about him going into care. The children's centre workers were at a loss as to how to support her further in her relationship with Gavin, and thus referred her case to my service.

My VIG work with Alice provided a unique 'cameo' of an intense piece of work with a client and an opportunity to apply my reflective model to my work. The following focuses on three elements of my analysis of this work.

Ethics and incongruence

During the course of my work with Alice there were times when I found myself questioning my practice from an ethical perspective, and asking *Is*

VIG all a lie? I found it very difficult at the start of the intervention to find moments of positive interaction between Alice and Gavin as the dominant pattern of relating was very negative and painful to watch. Only through perseverance and very careful editing was I able to capture momentary exchanges (initially on stills) that showed elements of positive interaction – for example, photographs of Alice sitting beside Gavin watching him drawing, or of Alice reaching out to take a toy that Gavin is offering her and looking towards his face. However, for her these were powerful images and the word she frequently used to describe her reaction to seeing them was 'shocked'. These images challenged Alice's concepts about her relationship with her child:

> Alice: I was quite um shocked that obviously it's not as bad [yeah th..] oh I can't see (.) to me it seems bad but obviously this is telling me different [yeah yeah] I'm not as (.) it's not as bad as it is (.) obviously I can respond to him and er\

What Alice was seeing in the videos and photographs was incongruent with how she was experiencing her interactions with Gavin; however, these small episodes began to challenge her notion that she was a 'bad mother' who could not respond to her son.

> Alice: …obviously I am doing something right but I don't feel like I'm doing it right

Stern's (2004) description of how viewing a static image such as a photograph captures an action or 'story' in midstream, or at a decisive moment, is helpful when I think about the change process for Alice. Stern suggests that the viewer provides, in imagination, the action leading up to the decisive moment and the resolving action: 'an imaginary temporal contour is added while one watches a static image, it becomes a small emotional narrative' (Stern 2004, p.68). It is arguable that over time the images that Alice and I shared and discussed helped her to story an alternative narrative about herself and Gavin.

On reflection, I can therefore feel reassured that the VIG process was not 'lying'; rather, in a sense it parallels a solution-focused approach where the aim is to find exceptions from which to build towards a solution. In terms of how this process positioned Alice, it could be said that I was offering her a choice in how she interacted with Gavin. I was illuminating for her those positive moments and helping her to analyze what she was doing at these times and how Gavin was responding to her. I was also helping her to

reflect on her thoughts and feelings when she saw these positive moments and in a sense offering her an opportunity to behave differently. It could be said that I was empowering Alice, in that I was positioning her as an active agent in 'storying' her future relationship with Gavin, particularly when she said:

> Alice: It's given me confidence that I'm not a bad mother…

However, I wish to be cautious about framing my relationship with Alice in this way, for:

> Even the word 'empowerment' betrays something of the position of expert who thinks that they have been able to move an enlightened step beyond 'helping' people but cannot give up the idea that it is possible to bend down to lift someone less than themselves up a step. (Parker 1999, p.9)

I prefer then to think that my curious stance about the moments of positive interaction between Alice and Gavin provided a catalyst for change, and in this respect I am taking an ethical attitude and following Foucault's interpretation of the word 'curiosity':

> It evokes 'care'; it evokes the care one takes of what exists and what might exist; a sharpened sense of reality, but one that is never immobilised before it; a readiness to find what surrounds us strange and odd; a certain determination to throw off familiar ways of thought and to look at the same things in a different way (Foucault 1988, cited in Cooper and Blair 2002, p.526).

Foucault's concerns were related to hierarchies and systems in society, but I find his interpretation of the word 'curious' very relevant to my current endeavour, and to how I worked optimistically with those fragile moments of positive interaction between Alice and Gavin.

Staying with the 'personal'

Alice found it hard to make eye contact with myself and her son Gavin. As VIG works with the principles of attuned interaction and guidance (e.g. receiving other's initiations through open body language and facial expression including eye contact), this came up in our discussions around the clips. After a few sessions Alice explained what this avoidance of meeting eye gaze meant for her:

Alice: …its like when I'm talking to anybody its like aaaah I don't like looking them in the face it's it's that looking and people looking back at you sort of thing and thinking is my face is it perfect sort of thing do you know what I mean it's just that image when you come across what are they thinking about you and that I thought God I don't like and I do have trouble talking to people face to face basically um and that I have got that issue so it's not just with children it's with everybody.

For Alice then this avoidance of eye gaze was linked to a complex web of thoughts and feelings that influenced her 'implicit processing'. 'Implicit processing consists of the representing of the relational transactions that begin at birth and continue throughout life. Such implicit processing guides the moment-to-moment exchanges that occur in any interaction' (BCPSG 2007, p.2).

It was in this context that I initially found myself wondering whether Alice had some form of social interaction or communication difficulty. On reflection this line of thinking is best understood as growing out of the interplay between our two different subjective worlds. As professional and client our worlds met: Alice's was one of problems with relating and painful experiences of being parented herself, which impacted on how she related and felt about herself. My professional world, on the other hand, was one of assessment and intervention, of special educational needs and conditions that impact on people's lives, sometimes leading to diagnoses which may or may not be helpful. Thus it was that during the course of my work with Alice the discourses of my world led me to question whether certain aspects of Alice's pattern of relating, for example her avoidance of eye contact and her dislike of close physical contact with her family members, would in some other context have meant that she would have been considered for an assessment of a diagnosis of autism. However, by not allowing myself to dwell on this 'medicalized' version of Alice, I was able to resist it limiting or diminishing my knowledge of her and our relationship, and also a growth in my self-knowledge, for as Benjamin says '…intersubjectivity theory postulates that the other must be recognised as another subject in order for the self to fully experience his or her subjectivity in the other's presence' (Benjamin 1990b, p.2).

Benjamin's (1990a, 1990b, 1998) intersubjectivity theory is essentially developmental and is concerned with an infant's separation from a care giver, in order to recognize the other as a unique human being. La Mothe (2007), however, discusses this concept in relation to adult life and suggests that

where power and domination take precedence recognition and the personal relationship are absent. From a professional perspective the power contained within a 'medicalised discourse' of diagnosis and categorizing belies a depersonalized epistemology, which whilst carrying some recognition of the other negates the personal. It also negates the potential to understand fully the meaning behind implicit forms of relating, and as the BCPSG say '...defensive strategies are likely to constitute one component of a much broader interpersonal arrangement that has endured over a significant period of the person's life' (BCPSG 2007, p.10).

Thus, if I had continued to think of Alice in terms of her behaviour having features of autism I would have negated the meaning that her avoidance of eye contact had for her. I think I have always tried to see and relate to the individual beyond a diagnosis, but the opportunity to reflect on this aspect of my work with Alice has powerfully reinforced this position for me. As Yalom says diagnosis threatens '...the human, the spontaneous, the creative and uncertain nature of the therapeutic venture' (Yalom 2001, p.5).

MY DEFENDED SELF

My work with Alice raised a number of anxieties for me; it was a complex case and I was using a new methodology to attempt to bring about change, a methodology that involved using technology and opening my practice to close external scrutiny through the supervision process. My reflections on my work with Alice helped me to understand the effects of my defences against anxiety on my actions and on the 'intersubjective matrix' that Alice and I formed: '...one of the obstacles in shaping a spontaneous and authentic response to fulfil a moment of meeting is the anxiety experienced by the therapist' (Stern 2004, p.169).

Stern (2004) also says that there is a tendency in moments of anxiety to fall back and hide behind 'technical moves'. What then was my 'technical' response? To help me to understand my response I have found some aspects of Hollway and Jefferson's (2000) research with 'defended subjects' helpful, and in particular their notion of an anxious defended subject being simultaneously psychic and social. However, I am interested in the transactional level of relating rather than unconscious processes, the transactional level of moment-to-moment verbal and non-verbal exchanges, which the BCPSG (2007) suggest are influenced by both current and past emotional experiences. 'This level of enactive representation...encodes the most profound aspect of human experience including elements of conflict, defences and affective resistance' (BCPSG 2007, p.767).

The following excerpt is a short section of what I consider to be a defensive response on my part:

> Carole: …can I tell you what I see Gavin doing here [uh] umm I see him as you said fully engrossed in this activity showing really good concentration and attention … he was showing really good planning and thinking skills he was problem solving he was looking at shapes seeing which shapes are going to fit … so lots *of really* important cognitive process [mmm] going on here in terms of the kinds of things that schools are trying to teach children they are the kind of process skills I guess that um are so important for children to take forward into all aspects of learning…

This monologue shows a very different style of interacting from when Alice and I are attuned to one another. I have taken a very long conversational turn and my style of speaking has changed from slow and tentative to fast and fluent, with very few pauses and a strong emphasis on words such as 'really', which is giving the message: 'this cannot be disputed'. I have also resorted to 'technical discourse', to 'teacher speak', with terms like 'cognitive processes' and 'process skills' to make my point. This is a notion taken up by Hollway and Jefferson (2000) when they say: 'The idea of a defended subject shows how subjects invest in discourses when these offer positions which provide protections against anxiety and therefore supports to identity' (Hollway and Jefferson 2000, p.23).

Is it possible that I was protecting my professional identity which was feeling somewhat under threat from an accumulation of anxiety, and that I was doing this by adopting an expert model and 'telling' Alice, rather than supporting her understanding in a co-constructive way? I am happy to say that this was the worst example of what I have come to think of as 'defended teacher speak', and as I relaxed into the VIG process and my relationship with Alice, my anxieties and defensive responses lessened. The 'expert model' is not a model of EP practice that I aspire to, but I am left wondering whether I have retreated to this position in other circumstances where I have felt defensive. The impact of my monologue on Alice was one of disempowerment and defensiveness on her part, as evidenced by her comment soon after:

> Alice: …I thought well I know I should be doing that really sort of thing and I just thought are they wanting me to do that? or thing but obviously this is like day to day thing sort of thing

I, presumably, was the '*they*', the expert who knew the right way to do things, and the expert who does not know about '*day to day*' sorts of thing. However, by revealing to myself the impact of my defensive response on my client, I hope I am developing the skills of a different type of 'expert', one who more readily fulfils the criteria of expertise set by Billington when he says: '…as professionals it is our responsibility to attend ethically to our side of our relationship with clients by being "experts" in the effects and consequences of our work' (Billington 2006, p.73).

Final thoughts

My use of video analysis and a relational systemic framework to study and reflect on the meanings contained within verbal and non-verbal actions and reactions has been illuminating to me, both personally and in my practice as an EP. I am incredibly humbled as I reflect on the experience of working with Alice and the trust she placed in our relationship. I also learnt an enormous amount about myself and the process of interacting which continues to fascinate me and from which I continue to draw strength. My reflections have also prompted me to consider that although I have been trained as a scientist/practitioner, I also need to take account of the aesthetics of professional practice, the art of relating. This leads me to conclude that for me, EP practice is as much an aesthetic endeavour as it is scientific.

My practice to date has also reflected the position that no one psychological paradigm will serve to explain the complexity of human relating and behaviour. This position has been strengthened for me by focusing on *meaning* and incorporating relational psychoanalytic theory into my set of analytic tools for thinking and reflecting.

Narrative Therapy and VIG

Windows on Preferred Identities

DENISE MCCARTAN AND LIZ TODD

Video Interaction Guidance (VIG) uses the shared review of short video clips of successful interaction to promote change in relationships, whilst narrative therapy assists people, through conversation, in a rediscovery of preferred meanings for their lives. Both are relational approaches to change about which there is increasing interest amongst practitioners including how they may be used together. In this chapter we reflect on how we use two different approaches in our work with people in the context of children's services. This reflection takes a critical perspective on the way we understand professional practice. We draw on a case study of such practice and explore the ways that we are using VIG and narrative practices together to enhance the opportunities for and experience of re-authoring for those involved.

Whilst a detailed examination of each approach is beyond the scope of this chapter and is discussed elsewhere (Freedman and Coombs 1996; Monk *et al.* 1996; White 2007; see also Chapter 1), we provide a brief outline below of what each entails.

VIG and narrative therapy: An overview

VIG uses shared review of short clips of interaction between people bringing a concern to engage in a collaborative conversation about specific aspects of the interaction. As Kennedy explains, 'VIG works by reviewing micro-moments of video clips of clients' own successful communication, based

on the premise that attuned responses to the initiatives of others are the building blocks of an attuned interaction pattern' (see Chapter 1).

In contrast, narrative aims to contribute to the re-authoring of people's lives. The re-authoring process offered in a narrative approach names the problem as the problem thus separating personal identity conclusions from negative experiences. The naming of unhelpful practices and movement away from 'thin descriptions', which support a problematic version of a person and obscure other possible versions or possibilities, becomes more likely. Preferred stories of people's experience and identity are allowed to emerge and are 'thickened' through opportunities for them to be more richly described and experienced (Monk *et al.* 1996; Morgan 2000; White 2007). For example, one of Michael White's (an originator, with David Epston, of narrative therapy) celebrated examples, talking about his work with Tom in using externalizing language to unravel the influence of 'encopresis' on his life, is related by David Epston (2011):

> In a straightforward externalization encopresis was renamed 'Sneaky Poo'. Encopresis is a medical diagnostic term; in itself there is nothing wrong with it. However, the grammar that we use in speaking with and about young people has certain effects. To say that 'Tom is encopretic' is to imply something about his identity. To say that 'Tom's problem is that he soils his pants' is accurate, but it may be adding shame to an already humiliating situation. To say that 'Sneaky Poo has been stinking up Tom's life by sneaking out in his pants' is a more gamesome way to describe Tom's relationship with the problem of soiling. It is more likely to invite Tom's participation in the discussion of his problem. It can also evoke a more sportive stance for Tom vis-à-vis the problem, as we can now talk about how 'Tom can outsneak Sneaky Poo and stop it from sneaking out on him'. Tom no longer has to be a different kind of person from the one he understands himself to be. In fact, revising his relation with such a problem as 'Sneaky Poo' may very well confirm him as being just the right kind of person for the job at hand – 'outsneaking Sneaky Poo'. (Epston 2011)

Here we look first at how we think about practice and about the integration of therapies, before using a case example from our work to take us into a discussion about the ways that the ideas and processes of VIG and narrative might be used together.

Practice as disassembled tools – or a political event?

It is tempting to think of the different practices drawn upon in the course of professional work in terms of tools, or separate actions that can be taken apart and used at different times. We might refer to these tools and actions as skills and competencies, models that are dominant in professional training and registration (Freidson 1994). Whilst using VIG and narrative will require proficiencies, the conceptualization of practice in terms of those skills and competencies seems to us a form of reductionism. It conjures more or less fixed interpersonal and internal elements that are somehow taken out and brought to bear on problems. Problems consequently seem cast as the concrete entities of people's identities. There seems to be little room for people's own agency in knowing themselves or in addressing their own problems. This also seems to ignore the constructed and interpreted realities that we inhabit. Instead, we suggest that Eraut's (2000) understanding of competence in terms of context and situation takes us to a more political understanding of practice. In addition we need to draw on Foucault's (1979; 1984) notion of modern power, which shows the potential of professional practice to contribute to the policing of normality and therefore the construction of thin (problem-saturated) identity stories (Monk *et al.* 1996; White and Epston 1990). Working with people and their problems is therefore more likely to be a political event and so requires a response that is more focused on ethics and values than choosing from a smorgasbord of disassembled tools to fix people's problems. It is from this perspective that we look at using VIG and narrative therapy in working with people's concerns.

We wondered if literature on combining different therapeutic approaches might help in our thinking of how to go about using narrative therapy and VIG. Much of this is outcome research comparing the effectiveness of different therapies (often involving cognitive behavioural therapy (CBT)) on a range of measures (Beckerman and Corbett 2010; Benns-Coppin 2008; Leichsenring 2001), but there is also other literature looking more at process (Field *et al.* 2009). However, outcome research by definition pays little attention to the process of intervention used, let alone the intervention as a socio-political practice. Indeed in the UK's National Health Service context the 'discourse of "evidence-based practice" requir(-ing) specification, manualization and strict adherence to models (Layard 2006)' (Wallis, Burns and Capdevila 2010) mitigates against giving attention to the process of combining approaches, whatever they are. In Benns-Coppin's

(2008) exploration of the use of CBT and psychodynamic psychotherapy he raises the concern that narrow medical protocols may lead to 'an homogenization of treatment, loss of invaluable skills and understanding from other treatment approaches, and loss to the patient who may be best cared for by a combination of treatments and approaches' (p.262). This chapter, therefore, proposes to exhort practitioners to engage in a reflective, ethical development of skills and understanding in the political process of engaging with clients.

We are educational psychologists, one working in a local authority educational psychology service, the other working in a university setting contracting time to various services (i.e. speech therapy, child and adolescent mental health service, educational psychology). We have both found VIG and narrative to have strong resonances and to be effective ways to work with people's concerns. Both approaches by definition seem to resist the pick-and-mix approach to practice by entailing a more integrated approach to working with people that draws on a range of theoretical ideas and modes of thought. We think of the way that we work with people, that draws *both* on narrative and VIG, as (to quote Wallis, Burns and Capdevila 2010, writing about practitioner views of using narrative therapy, p.10) 'a social justice, political and ethical stance to therapy; a "re-authoring" approach'. The way we use narrative is informed by and influenced by VIG, and vice versa. Given the boundaried nature of most therapies, and the theoretical distinctiveness of narrative and VIG, such an approach might appear unlikely. However, some central assumptions and practices of VIG and narrative resonate; indeed, we suggest, they build upon and develop the strengths and capacity of the other. First we will describe a case study from our work before discussing the way that we think this work is enhanced by narrative and VIG.

In the case study, narrative was used to inform a VIG-based intervention with a parent, teacher and primary-aged boy around concerns about behaviour in class. This was the focus of doctoral thesis research (McCartan 2009). All the people involved reportedly experienced the therapies as useful and change was appreciated. The case description is in the first person to emphasize the personal nature of observations, and it is Denise McCartan (author) who is speaking. In the examples of practice provided in this chapter, the names of those with whom we worked are anonymized.

Case study: VIG and narrative-based work with a school concern

The aim of my work with a primary school child, Jack, his mother Jane Thomas and his class teacher Mrs Adams, was to explore the possibilities of using a video intervention based on the principles of VIG and narrative for the development of collaborative relationships between parents and teachers in a situation where there was a perceived problem with pupil behaviour.

What emerged over a period of four months was an intervention in which actions and questions were strongly aligned to VIG. However, it seems impossible to separate the two in some ways, as narrative ideas were used to inform my reflections and thinking about how to enable change and how to interpret what happened in the sessions. I did not use narrative practices in my questions to Jack, Jane or Mrs Adams, and so would not refer to this work as using narrative therapy. I would, however, describe this work as informed by the principles and ideas of narrative. The timings of the different interactions, filmings, shared reviews and supervisions are shown in Figure 16.1.

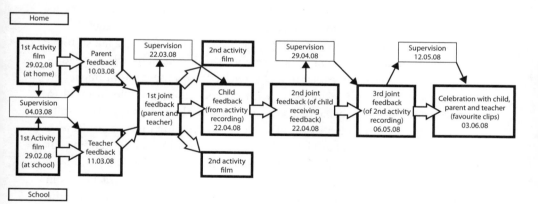

Figure 16.1: Different aspects of the case study, a VIG-based process involving a school situation

Over the period of four months, two films were taken of Jack in each of the situations of his home and the class, interacting (respectively) with his mother and his teacher. Shared review meetings happened with the teacher and parent both alone and together, and I also met with Jack to enable a

shared review conversation to take place with him about the first videos taken of him in home and school. I took videos to regular supervision meetings with Liz Todd (author). Jane Thomas and Mrs Adams were interviewed before and after this piece of work about their perspectives on the situation for Jack at school and their views of the VIG process. Detailed systematic analysis of all video feedback sessions and interviews led to the generation of themes that were used to create thematic 'process' maps (McCartan 2009) to show the way in which collaboration between Jane and Mrs Adams developed in relation to the video intervention. The maps tracked the way in which change occurred across the intervention in relation to the content of the communication. They showed what was shared, and changes in the interaction and relationship between those involved as the intervention progressed.

VIG and narrative working in tandem

Whilst my work with Jack, his mother and his teacher was very much a process using the practices of VIG, the theoretical ideas of narrative were influential in my thinking about change. I used narrative ideas and post-structuralist understandings of behaviour and change in my decisions as to how to deepen conversations in the shared review meetings. 'Thin' descriptions (i.e. 'craves attention'; 'he thinks everyone is against him'; 'naughty'; and 'mood swings') underpinned the dominant narratives relating to Jack in the problem situation and suggested ways these might impact on his sense of self and relationship with others. I therefore had in mind to deconstruct ideas of behaviour and change so Jack could stand more fully within his preferred identity (or identities). I was hoping to make available to both Jack's mother and teacher and to Jack himself richer understandings of him, rather than the totalizing labels used of him. I thought a lot about how to move away, within the conversation with his mother and teacher, from assumptions of Jack as 'at fault'. I did not use narrative questions (such as the practices of externalization and re-authoring) in my work in this situation. However, narrative ideas very much helped to direct my responses and the language I used in deepening the discussion in shared review meetings.

The dominant 'within child' narrative identified at the start of the intervention seemed to have the potential to isolate and marginalize Jack within the contexts of school and home in which it was shared, as it became perceived as part of his identity and he was defined, for example, as 'manipulative' and 'naughty':

Parent: ...But we couldn't go out as a whole family because he wouldn't have all the attention and he wouldn't like it (Interview 1, pp.10, 26)

Parent: ...He's kind of...I don't know whether I should say this either...labelled I think as...as being... '[child] is naughty' by other children (Interview 1, pp.12, 35)

Parent: ...he says 'I hate myself and no one likes me' (2nd joint feedback session, 22.04.08, 41:54)

Over the course of the intervention, a clear sense of collaborative working developed between Jane, Mrs Adams and myself (the educational psychologist) that had not been there at the start, and Jack's behaviour in class improved. The ways that Jack was described and his actions were understood changed over the course of the intervention from predominantly negative descriptions, with identity labels such as 'attention-seeking', to a wider range of positive understandings such as 'willing to engage and more willing to understand'; 'he can do it'; 'his heart is in the right place'; 'he's really chuffed'; and 'it's within his grasp'. What seemed to be central to this process was the way that VIG and narrative worked in tandem to promote change.

A key aspect of the VIG process involved providing the opportunity for people to reflect upon, and give and receive feedback on, their own successful interactions, and in particular on the principles of attunement that, in VIG, account for success in interactions. I found that the way this was used to appreciate and notice what was going well within the interactions provided a stock of unique outcomes, which challenged the focus on negative perceptions and beliefs expressed at the start of the intervention. Adopting a different lens with a focus upon what was happening between people enabled alternative narratives to begin to emerge. Such narratives were ones that more richly described Jack and the relationship between Jack, Jane and Mrs Adams. This seemed to begin to address some of the power differentials that were apparent at the start of the intervention and to promote a sense of hope.

The exemplification of the principles of attuned interaction and guidance within the shared review sessions, which is an integral part of the VIG process, promoted increased attunement between those involved and enabled a deepening of discussion in an atmosphere of trust and openness in which unique outcomes could be further explored. This allowed multiple possible interpretations and realities to be acknowledged, discussed and reflected

upon, providing an alternative to the well-trodden 'taken for granted' path to constructing meaning and experience, that of developing hypotheses that might be causal or of classifying a person's experience (O'Neill unpublished notes 2011). In this respect, the shared review sessions were seen to provide an 'interactive space', where those involved were able to share alternative narratives and to have witnessed and validated preferred personal narratives. This also helped to develop a greater awareness in those involved, including myself, of the ways in which they made sense of and perceived their lived experience and of an increased selection of available possibilities.

> Parent: See it's eye opening because I thought I was bad, I...I thought I was...wasn't doing a very good job [as a parent], but obviously I am you know...(1st individual feedback, 10.03.08, 31min:18)

Thick (or rich) descriptions provide a space for people's individual thoughts, views, beliefs and hopes and involve the exploration of the fine detail of the story lines of a person's life (Morgan 2000). In deepening discussion within shared review, I found opportunities were presented for those involved to visit, revisit and pause particular moments of interaction, providing an opportunity to begin to tell and retell preferred stories of their history and identity, interwoven with the lives of others to produce a 'thick description', that is, one that is 'elaborately presented and multi-storied' (Goldenberg and Goldenberg 2008, p.368).

> Parent: ...It made me think of her differently you know... [teacher] really helped me throughout this, she's really helped me...like in the sense that I know she knows [child] now, you know. She was...she didn't just have it in for him, all the time... she knew what I knew about him

Integrating VIG and narrative

In the case discussion Denise used the ideas but not the practices of narrative to enrich the practice of VIG. It was VIG – but it was not narrative therapy. This is an example of the way in which we take a narrative approach to VIG, and a VIG approach to narrative, whilst maintaining the integrity and ethics of each. In the following discussion we will try to explain how we find this not only possible but enhancing of our practice, given that these are distinctive ways of working.

We start first with VIG, in order to consider how narrative might inform the practices of VIG. People come to VIG with a wide range of concerns that are addressed through the co-construction of goals focused on videos of interactions. VIG is understood to produce change in relationships as interaction is enhanced by developing attunement in the shared review, using the video as an object of secondary intersubjectivity (see Chapter 3 and Chapter 12). VIG is characterized in the idea, informing the whole VIG process, that communication develops through primary and secondary intersubjectivity. There is a focus on the quality of the interaction and on the principles of attunement, to support this change.

One of the opportunities for narrative to inform VIG is the idea of preferred futures. VIG initially supports people in bringing about change in interactions. The VIG process, through the collaborative review of clips of effective interaction, is understood to engage clients actively in a process of change towards realizing their own hopes for a preferred future in their relationships. If used in this way, as an idea, it is not narrative therapy, but it is VIG informed and enhanced by narrative ideas.

Similarly, the narrative understanding of identity as storied also seems to be meaningful for the practice of VIG. There may well be, however, differences in how being storied is understood. Michael White applies 'Bruner's idea of storying to therapy (White and Epston 1990), and distinguishes between our experiences of events, sequences, time or plot (landscape of action) and the meanings or interpretations that are made (landscape of consciousness/identity) through reflecting on these events' (Wallis, Burns and Capdevila 2010, p.3). Narrative talks more of bearing witness to people's stories whilst VIG might refer to reception of the stories (see Chapter 1).

However, narrative therapy can indeed be used within VIG cycles of review. The purpose of narrative questioning is initially to *unravel* problems and their influences so that the storyteller and listener may appreciate and develop some shared understanding of the story's plot and its effect on a person's life. The naming of unhelpful practices becomes more likely and the discovery and use of alternative and more useful responses is more possible. Such questioning can take place in the shared review of clips. Indeed, the clips can provide the stimulus for such narrative conversations. There are many possible opportunities in the shared review meetings for *unravelling* and *re-authoring* conversations. Liz, working with a family, started with an initial VIG film, micro-analysis and shared review. She used narrative therapy (to enable unravelling and re-authoring) in the first shared review and in all subsequent sessions. When Natasha's mother Alee saw the start

of the video, the picture of her sitting playing paper-and-pencil games with Natasha, she commented, 'I wish I was calm like that all the time.' Both Alee and Natasha named 'closeness' and 'fun' as aspects they noticed and together with Liz they noticed the micro-aspects of communication that contributed to these. What Alee and Natasha reported to be a usual lack of eye contact was contrasted with the eye contact observed in the video. Such initiatives on the part of Alee and Natasha can be the opening for narrative re-authoring questions such as: Was it different when you did/ thought that? Is that unusual? How is it unusual? What made that difference possible? What is this different from? What do you think about the different occurrence? Such questions are entirely consistent with VIG and might be considered to be conceptualized in VIG in terms of 'deepening the discussion' (see Chapter 1).

There are some VIG processes that are always used in narrative therapy – and these are the practices that are central to forming a relationship. The principles of attunement (see Chapter 1), the aspects of effective communication in terms of eye contact, naming, turn-taking, reception and so on – are central for the development of any relationship. Both authors have found attention to these principles has enhanced narrative conversations.

There are two areas that seem common to both VIG and narrative; one is the interest in noticing exceptions and the other the practice of scaffolding. We will consider each in turn, before looking at some more conceptual and political issues in using narrative and VIG together. Whilst we have no interest in pulling VIG or narrative apart to use bits of one with bits of the other, we do have an interest in understanding whether practices that are similarly named are indeed used in the same way in each approach. And if they are understood differently, we are interested in learning from that difference. Taking unique outcomes first, also referred to as exceptions, these are understood in VIG and narrative as those things that stand in contrast or outside of what might be predicted with the problems that are experienced. However, VIG seems to assume a more realistic approach in understanding exceptions as behaviours, more or less concrete entities, that show that the preferred future is already happening. In narrative, which takes a more post-structuralist approach, exceptions provide points of 'entry to alternative story-lines of people's lives that, at the outset of these conversations, are barely visible' (White 2007, p.61). This seems to relate to conceptual differences between narrative and VIG, to which we will return after looking at scaffolding.

Scaffolding is a central practice and concept in both VIG and narrative. Indeed, it seems to draw this time on the same theoretical basis, the ideas of

Bruner and Vygotsky in sociocultural psychology (Daniels 1993). However, there still seems to us to be a different quality to its use in both narrative and VIG. And we might suggest that this different quality is likely to relate to the different underlying theoretical basis of each. In both, scaffolding refers to the role of the practitioner in trying to ask a question that takes just enough of a step forward into the zone of proximal development of the person bringing the concern (Daniels 1996). Careful reception of the person by the practitioner is needed, as it is the responses to the question that give feedback to the practitioner about the accuracy of the step taken. In VIG this is spoken about in terms of activating, or asking more direct questions, or compensating, when information or thoughts are given. Participants mediate each other's learning by 'referencing' or looking to each other to give meaning to their shared experiences in video shared review and supervision sessions (see Chapter 1). Alternatively, in narrative, therapists scaffold their questions to assist people in a different kind of concept development. The purpose of such questions is so that people can move in their understandings of themselves from the 'known and familiar', the 'thin stories' of people's identities, for example 'I am short-tempered' to 'what is possible to know' (preferred identities), i.e. 'I want my child to know me as a loving parent' (White 2007; White and Epston 1990).

The theoretical differences between narrative and VIG have never seemed far away in this retelling of our practice. Such differences appear at the same time potential hazards in claiming we can combine VIG and narrative but also opportunities for the development of our thinking and practice. In contrast to the ideas of intersubjectivity that are the basis for practices in VIG, narrative is influenced by areas of thinking including post-structuralism, socio-cultural psychology, Foucault's (1979; 1984) modern power, Derrida's deconstructionism, Deleuze's idea of difference (Colebrook 2002) and Bruner's ideas of storying (Wallis, Burns and Capdevila 2010, p.3) to name a few. In the narrative process of unravelling or externalizing and then re-authoring, meaning that was contributed from societal and cultural discourses but that is not in line with the values and intentions of a person is deconstructed and reconsidered (O'Neill, personal communication and notes 2011). Alternative and preferred stories of people's lives are systematically thickened by being more richly described. A number of practices contribute to this, such as remembering and outsider witness (Russell and Carey 2004). This is a relational therapy, with 'relational' having several meanings. For example, the therapist takes a particular position in relation to the problem in that the 'problem is the problem', and 'the person is not the problem'. The externalizing practices enable the person to explore their relationship

with the problem and the therapist takes a particular, decentred position in relation to the person bringing the concern, in that they are considered to be the primary authors of their life; it is they who are doing the meaning making and this is reflected in narrative conversations. Whilst VIG describes itself as relationship-based, with meaning co-constructed in therapeutic situations, we find the narrative idea of therapy as relational helpful in our VIG practice, which has us thinking in more post-structuralist terms and about our own position in respect to the problem and to the person. This also enables us to sit in a place of curiosity.

Such ideas of power, story and positioning are, for us, entirely consistent with VIG and sit comfortably in our own practice, but they may be more of a challenge to others. In VIG practice an awareness of the influence of the sociocultural context is integral to shared review meetings and the ways in which practitioners go about deepening discussions. Contextual under-standings also inform the development of the Traject Plan (see Chapter 1), which focuses on structural and systemic aspects of the VIG intervention. Post-structural understandings seem to enhance shared reviews, as suggested in the challenging of assumptions of normality and of totalizing identity statements (i.e. attention-seeking, naughty, etc.) that seemed to happen in Denise's work with Jane, Jack and Mrs Adams in the earlier case discussion. Indeed we would go further and suggest that the antidote provided by narrative practices to the objectifying processes of complex everyday life (White 2007) is mirrored in the use of video in VIG. The video can, or might always, provide externalization, and the shared review of micro-principles a kind of externalization. It could also be suggested that separation from the problem in VIG is implicit to the extent that the focus is on interaction and attunement.

Concluding thoughts

Narrative therapy and VIG are distinct approaches to working with people. We have explored ways that the ideas and practices of one can enhance the other. Narrative therapy can be used throughout VIG cycles of review. VIG's principles of attunement will inform the communication in narrative and can only, we suggest, enhance interaction. On the other hand, both have separate theoretical ideas that inform them and distinctive practices, histories and training that have caused us many times to pause and reflect. Maybe this is a Deleuzian moment of difference that (to end on a narrative idea) takes us further from the 'known and familiar' into what is 'possible to know' (Carey, Walther and Russell 2009).

Mindfulness, Attunement and VIG
Being Fully Present whilst Communicating

HENK VERMEULEN, JACQUELINE BRISTOW AND MIRIAM LANDOR

Introduction

Mindfulness and Video Interaction Guidance (VIG) have many key concepts in common, such as openness, attunement and being present in the here and now. In this chapter we will discuss the common neurobiological roots and explain why we recommend mindfulness practice for VIG practitioners.

Mindfulness

Mindfulness originates from Buddhist traditions and is often combined with modern therapeutic techniques for increasing attention. It is an approach in which one cultivates a state of mind with the focus on the *present moment without judging*. Langer (in Snyder and Lopez 2007) describes mindfulness as a flexible state of mind, an openness to novelty, a process of actively drawing novel distinctions. When mindful, we become sensitive to context and perspective.

By meditating one can gradually become mindful. Siegel (2007) presents research which has found that mindfulness practice affects synaptic connections in specific parts of the prefrontal areas of the brain and that regular meditators have increased brain tissue in these areas. These findings led Siegel to conclude that a 'mindfulness trait' can be developed by the frequent practice of a mindfulness state. Several studies examining the effects of mindfulness meditation show positive gains in empathy and stress management (Snyder and Lopez 2007).

Why the care giver should develop mindfulness

It is important for the care giver to develop mindfulness with respect to their child. In *Why Love Matters* Sue Gerhardt (2004) describes neuroscientific evidence regarding the importance of high-quality early interactions. She describes how from birth on, the nervous system of the young child is shaped by care giver–infant interactions, especially the prefrontal, orbitofrontal cortex and anterior cingulate brain areas, which are relevant for emotional regulation, social functioning and communication (Gerhardt 2004).

Attachment theory (Bowlby 1979) led to insights that the quality of attachment during early childhood has strong implications for later capacities to bond with others. Mothers' 'mind-mindedness' (that is, their verbal attributions to their babies of mental states) has been found to be an important predictor of later secure infant attachment, along with parenting reflectivity (Rosenblum *et al.* 2008). Fonagy and Bateman (2006) use the concept of the *attachment system* to refer to brain areas activated while communicating with others. An adult who had a childhood with an unpredictable mother may develop an attachment system that predisposes them to feel unsafe and anxious when they are interacting with other people. It is therefore essential for the guider to develop a mindful attitude, especially when working with such clients.

How VIG can support the care giver

VIG is an intervention for enhancing communication skills and relationships between people. In VIG the guider has two main interrelated tasks. The first is to micro-analyze the client's communication patterns on video, with the aim of moving from the 'no-cycle' to the 'yes-cycle' (Hundeide 1991, p.62). The second is to lead the communication between self and clients in a way that supports their goals. In psychotherapy this is called 'the task of creating an effective working relationship between therapist and client'. Studies have shown that the quality of the client–therapist relationship – and not the technique that is used – is the second largest predictive factor of therapy outcome, after client factors (Lambert and Bergin 1994; Lambert and Simon 2008).

Through practising these tasks, guiders become able to observe an unfolding interaction as *present moments that succeed each other in the here and now*. (For theoretical background and the practical implications of the present moment concept, see Stern 2004.) In fact in VIG the guider, through the micro-analysis, seems essentially to create a 'virtual present moment' with the client. Our aim in this chapter is to deepen our insights regarding this

fundamental aspect of VIG practice: that is, focusing and staying fully aware in present moments as professional communicators, observing, evaluating and changing basic communication patterns by striving for an atmosphere of respect, openness and approval. This is essential for supporting clients to reach their goals. Ultimately guiders 'practise what they preach' by observing what is happening in the here and now between self and client. This is referred to explicitly in the fourth of 'seven steps in a learning conversation': 'Reception of the client's response: *mindful response to your own feelings*, then respond with own thoughts or question building on client's response' (see Chapter 1).

Thus an essential aspect of VIG guiding is being present in the here and now. We will show that such awareness and self-reflection can be strongly facilitated by mindfulness training. Mindfulness and VIG share the same philosophy: paying attention in the here and now in a non-judgemental way. Because of this we believe that each can strengthen the other.

The guider who wants to be attentive in the present moment during VIG will need a mindful attitude to both their own and their client's internal state. When a guider is able to recognize and silently name what is going on for themselves internally there is a parallel process where they become able to name and/or explore what is happening externally, between them and the client, and the impact that this is having. This facilitates the client's own internal and external mindfulness. We will now explain how mindfulness training can be significant for developing and cultivating this attitude.

Mindfulness: What is it and how does it relate to VIG?

How one of the authors (Vermeulen) came across mindfulness

It was not until I (Vermeulen) read Daniel Siegel's groundbreaking book *The Mindful Brain* (Siegel 2007), that I recognized the striking resemblance between mindfulness training and VIG activities, and the beneficial possibilities for integrating them. In his book Siegel records his insights that mindful awareness, attending to the richness of our here-and-now experiences, enhances our physiology, our mental functions and our personal relationships. Siegel is a psychiatrist who has worked for many years with clients with severe mental problems and with families with parent–child relationship difficulties. He is also a mindfulness expert and practitioner. Siegel made the connection that practising mindfulness leads to neurological

changes in the areas that affect social and emotional functioning (Siegel 2007).

Siegel stressed that mindfulness should primarily be seen as a healthy relationship with oneself. This is a prerequisite for communicating in a respectful way with other people. Siegel states that interpersonal 'attunement', defined as focusing attention on the internal world of another, harnesses neural circuitry to 'feel felt' by each other. This state is crucial if people in relationships are to feel vibrant and alive, understood and at peace. Moreover, research has shown that attuned relationships promote resilience and longevity (Siegel 2007). Siegel presents neurobiological evidence to underpin his statement that mindful awareness is a form of intrapersonal attunement, promoting neural circuitry to 'feel felt' by oneself, or in other words to be empathic towards oneself. A key concept in Siegel's book is the process of neural integration that takes place in the brain when a person is attuned to another person or to themselves (when in a mindful state). Neural integration involves the 'synaptic linkage of physically and functionally distinct regions into a working whole' (p.334). The prefrontal regions especially play a vital coordinating role in this process. In other words, when there is both intrapersonal and interpersonal attunement neural integration takes place. Siegel calls the effects of 'feeling felt' experiences and their neurological correlates, the neural integration processes, 'balanced self-regulation'. Flexibility, self-understanding and feeling connected in the world are the most characteristic psychological phenomena that result from this.

Siegel is particularly interested in what he calls interpersonal neurobiology, i.e. the brain processes that take place when people are interacting with each other. His insights are therefore especially relevant for VIG practitioners, whose task is to support interactions between people. He states that in both intra- and interpersonal attunement the same brain areas are active, which together he calls the *resonance circuit*. By examining the neural dimensions of intra- and interpersonal functioning and their relation to mindfulness, he began to understand why and how mindfulness creates the reported improvements in immune functioning, in an inner sense of wellbeing and – of especial relevance for guiders – in rewarding interpersonal relationships.

Developing mindfulness

The effects and impacts of mindfulness must be experienced rather than intellectually understood. The only way to experience the positive benefits of mindfulness is by practising it. This is the same as with VIG. With both

the real learning comes from reflecting (observing without judging) upon internal experiences, rather than from the different process of trying to work through intellect alone. For a detailed overview of mindfulness, how it can be practised and its applications in therapy, see Eifert and Forsyth (2005); Kabat-Zinn (1990); Segal, Williams and Teasdale (2002); Williams *et al.* (2007); also *Acceptance and Commitment Therapy (ACT)*, a programme explicitly built on mindfulness insights for clients with mood and anxiety disorders (Hayes and Smith 2005; Hayes, Strosahl and Wilson 1999).

From a mindfulness perspective, the human mind has two modes: a *doing mode* and a *being mode* (see, for example, Hayes and Smith 2005). The doing mode is active when thinking. Thinking can be described as 'being in your thoughts', rather than being fully aware of what is happening in reality in the here and now. Thoughts take you with them into illusions of being in the past or future, and let you make judgements about reality. In contrast, the being mode is active when experiencing. Here you are fully aware of what is happening from moment to moment in the here and now. The being mode can alternatively be described as the not doing mode. The goal of mindfulness practice is to strengthen your mind in being able to concentrate fully on the here and now in a non-judgemental way (being). In VIG the guider creates a 'virtual present moment' with the client or trainee through the micro-analysis which can be re-experienced almost as 'in the present'. They engage in the now, at this micro-moment or freeze-frame, with joint attention. This often feels like a key turning point for the client or trainee. Through the micro-moment it has been possible to slow right down, to share and reflect upon what both see and upon their experience of shared attention while looking at the clip. A trainee guider knows the attunement principles intellectually. However, only by experiencing this 'observation and reflection in the now', in this environment that has been created, can they learn how to be it (rather than do it). This has led to dramatic changes in their approach, which come from an inner-based learning or understanding.

Here and now

In principle Siegel (2007) distinguishes three dimensions of reality to focus on during mindfulness practice:

1. phenomena in the external world that enter your mind via your senses (e.g. visual and auditory stimuli)

2. physical phenomena (e.g. physical sensations like heartbeats, pain, breathing)

3. mental phenomena (e.g. thoughts, emotions, judgements, fantasies, memories, images)

During mindfulness practice one concentrates in the here and now to observe the phenomena that appear in reality, from moment to moment. The main difficulty here is to remain in a mindful state and to observe your mental phenomena rather than becoming fused with them because you are distracted. Every time your thoughts distract you, the mindful state is lost. The purpose of mindfulness is to become more aware of the tendencies of your brain to distract you from moment to moment and to strengthen the discipline to return to your mindful state. These tasks require concentration, a capacity that will increase with frequent mindfulness practice. As was said earlier, as this capacity increases with practice there will be parallel neurobiological development in the prefrontal cortex regions.

Breathing space and body scan procedures (Kabat-Zinn 1990) are elementary exercises to practise and cultivate mindfulness by bringing your focus of attention (back) to the here and now. By concentrating on the process of breathing in/breathing out and subsequently on your physical sensations it becomes possible to 'step out of your thoughts' and 'observe' them as mental phenomena that just come and go. These exercises can be of benefit to those involved in training and delivering VIG.

Non-judging

Mindfulness is not merely a method for training concentration. It is also a practice of *non-judging*. Several experts in therapeutic relationships stress the importance of a non-judgemental attitude in the context of psychotherapy (Bien 2008; Hick 2008; Walsh 2008; Wilson and Sandoz 2008). This is especially relevant for guiders.

While meditating one observes everything that enters the mind, both external and internal events. Moreover, one tries to keep an attitude of non-judging these passing events and even showing interest and curiosity. By judging we mean activities like interpreting, rationalizing, evaluating, criticizing or trying to understand.

Guiders are trained to operationalize their attitude of showing respect, openness and approval towards their clients' initiatives through their responses to them. This attitude is congruent with the aim of mindfulness: observing reality in the here and now in an open, non-judgemental way; that is, in an attuned rather than a discordant way. VIG sequences of successful interactions are also attuned. Another aspect of mindfulness supporting VIG is about cultivating respect, openness and approval towards oneself.

Receiving negative feelings by welcoming and accepting them

Frequent mindfulness practice, or meditating, cultivates the attitude of accepting reality as it is, without wanting to change it while it unfolds from moment to moment. This refers to stimuli and events from the outside world, external reality (which enter the mind by our senses), as well as to stimuli and events from our internal reality, i.e. bodily sensations and mental phenomena. There is no real difference between observing internal and external stimuli, because external events entering an organism via its senses are translated into electrical and biochemical stimuli, ultimately resulting in a subjective experience.

Let us give an example. It is a well-known phenomenon that meditating will produce uncomfortable feelings in the body after a time because of sitting in the same position without moving. The most common reactions of the body and mind to these uncomfortable feelings are to respond automatically by relieving the discomfort. The body and mind evaluates these feelings instinctively as 'bad' so they must be dispersed by changing position. From a biological perspective these reactions serve as a function to protect the body. The person who is meditating, however, does not conform to these automatic reactions. The task is primarily to observe these evaluating-protesting impulses in the body and mind and then, by not reacting to them, to keep a non-judgemental and friendly attitude. In other words the meditator chooses to accept these feelings of discomfort by, paradoxically, observing and investigating them with interest and curiosity.

By frequently practising these meditating tasks the person develops an attitude best described as being open and non-judgemental to physical and mental phenomena (that is, states develop into a trait (Siegel 2007)). In this way awareness of these phenomena and the ability to recognize and resist automatic reactions will be strengthened, enabling one to respond according to one's long-term purpose rather than short-term relief.

Practising mindfulness while meditating deals with emotional as well as with physical discomfort. Emotions can be understood to have cognitive and bodily components. Hayes states in his relational frame theory – which originated from the paradigm of functional contextualism – that emotions are mainly judged as negative because they are fused with language, the building blocks of our thoughts (Hayes *et al.* 1999). Hayes *et al.* speak of defusing our experiences (e.g. emotions) from language (thoughts) in order to free ourselves from the negativism of emotional experiences. These defusing activities are exactly the processes that mindfulness promotes. For

example, an anxious person may be overwhelmed by negative cognitions (e.g. negative thoughts, mental representations of fearful events) while at the same time experiencing strong physical sensations like a racing heartbeat, stressed muscles and sweaty palms (expressions of the evolutionary flight response).

People with emotional disturbances can benefit from mindfulness by learning to deal with their negative emotions in a more effective way and by defusing them through distinguishing thought and feelings from each other. Concentrating with an investigative and friendly attitude on the physical phenomena that accompany your emotions is the best way to do this (Eifert and Forsyth 2005; Kabat-Zinn 1990; Williams *et al.* 2007). These activities can be described as staying with the bodily expressions of your negative emotions in a mindful way and observing how they change from moment to moment. In this way, people with anxiety problems, for example, can, step by step, learn to focus on the bodily manifestations of their feelings with an accepting attitude, then the intensity of their feelings will diminish. The mindful guider will model this process for their clients.

Barriers to effective guiding – transference and counter transference

So it can be said that an important effect of mindfulness practice is the capacity to welcome and accept your own inner feelings and thoughts rather than ignoring or rejecting them. In this way a person develops a greater awareness of their thoughts and feelings while interacting with another person. Self-awareness and an attitude of open acceptance towards your own inner mental and bodily reactions is a prerequisite for regulating them in an effective way. This is especially relevant for professional communicators such as guiders, whose task it is to develop successful dialogues with their clients through adhering to the attunement principles. Mindfulness supports the VIG guider to be more aware of their own intentions during the interaction, such as an urge to interrupt with their own agenda, instead of receiving their client's initiative and clearing space in their mind for their client's views.

Mindfulness also supports the effective regulation of inner feelings through intrapersonal attunement. A guider who is more open and ready to attune to the client is a better vessel for co-regulation with the client through the physical and biological entrainment (where the internal rhythm of an organism synchronizes with the rhythm of an external system) of interpersonal attunement. Goleman (2007) describes the two-way influence

between people who are attuned in terms of a kind of entrainment, both physiological and emotional – a person's physiological synchronization with the other's internal patterns such as sweat responses, breathing patterns and rhythms and also an emotional resonance where the person picks up the other's feelings without conscious awareness, through the amygdala circuitry of the emotional brain. He calls this transfer of emotional feelings during interactions 'emotional contagion', which can be either positive or negative in effect (Goleman 2007, p.16). A guider who is 'intrapersonally attuned' and at one with themselves has greater potential for being part of Goleman's (2007) 'positive contagion' effect in the client's search for greater wellbeing.

It is not always easy for a guider to maintain an open and respectful attitude to the client's initiatives and responses when they have emotional and social difficulties or poor attachment systems. Such clients may react in ways that impact negatively on the affects of the guider, such as feeling offended, incompetent, slighted, used or (over)responsible. Such negative emotions can complicate the guider's task of responding respectfully and helpfully, and emotional arousal can conflict with rational thinking. In these situations the guider needs to respond in a complementary way by supporting the development and goals of the client, instead of reacting in a symmetrical way, for example by defending themselves, reacting with verbal aggression or taking over the client's responsibilities. The psychoanalytic concepts of transference and counter transference are used to understand and deal with these obstacles in psychotherapy. These concepts refer to the tendencies of both clients (transference) and therapists (counter transference) to react in the here and now in a biased way towards a person. The biases are caused by projecting expectations onto the intentions of the other in the here and now, which originate from their own personal history, especially regarding their own attachment figures.

We think that guiders can benefit from mindfulness in dealing with these transference and counter transference effects. Mindfulness meditation provides a tool for guiders to help them develop greater capacity to regulate their own negative affects (because of the cultivation of self-awareness, combined with an internal attitude of openness and accepting emotional discomfort).

In this way, guiders are better able to deal with any negative feelings that are triggered by the behaviour of clients with emotional and social difficulties. We think that accepting and respecting one's own feelings and thoughts rather than rejecting or hiding them are prerequisites for

responding in a respectful and understanding way to the person who elicited those feelings and thoughts.

Moreover, we think that these clients can benefit immensely from experiencing opportunities to interact with someone who is able to regulate their own (especially negative) reactive emotions and who can still act in a way that fits the standard for positive interaction, as described by the attunement principles. People with poor attachment systems are provided with new relational experiences that may help to modify their internal models of self-other relationships (Safran and Reading 2008).

When working with clients with emotional difficulties who are used to triggering negative affect, it is important to cultivate an open attitude, awareness and acceptance towards your own feelings and thoughts. It is also important to develop the self-discipline not to respond automatically to them for short-term relief, but rather to respond with long-term purpose. These mindful qualities on the part of the guider facilitate their continuing to communicate according to the attunement principles. The result is that the client feels respected as a person and the relationship with the guider deepens, thus facilitating more opportunities to explore new ways of dealing with emotions and conflicts.

Conclusion

In this chapter we have shown that mindfulness and attuned interaction are strongly related to each other, even at the neurobiological level. We believe this correlation has the potential for positive outcomes in the process of helping those with social and emotional difficulties, especially those with difficult histories in early childhood. Crucial are empirical findings, offered by Siegel, that the number of synaptic connections in prefrontal brain areas increases as a result of frequent mindfulness practice. This is important since we know from research evidence (e.g. Gerhardt 2004) that adverse early parent–child interactions have negative consequences on the developing brain of the child. Prefrontal areas play a dominant role in the process of *neural integration* by coordinating the *resonance circuit* (i.e. the process that is active when attuning to oneself, while meditating and/or while mindfully interacting with another person). The resonance circuit can be understood as the neurobiological correlate of the *attachment system*.

As a consequence of these insights we make the following propositions. The first is that poor attachment systems (and as a consequence the resonance circuits) can be modified by mindfulness practice. In other words, learning to attune to oneself by mindfulness practice can be seen as a first step for

learning to attune to someone else. This suggests greater opportunities for help and repair, even for those clients with severe adverse childhood histories and related consequences for their early brain development.

The second proposition is that clients with poor attachment systems can benefit from guiders who practise mindfulness. This is because of their increased capacity to regulate successfully their own inner negative responses in reaction to the disruptive behaviour of clients with poor attachment systems. As a result, the guider can respond in a way that will give the client an experience of a successful interaction, which can offer the client new opportunities to deal with people in everyday life.

The third proposition relates to the potential of VIG to improve the clients' communication skills by helping them to learn to concentrate on the present moment while interacting. Every time a client, supported by the guider and videotape, is concentrating on an initiative of their interaction partner, they are at the same time creating neural integration in their brain. In other words their resonance circuit is activated. So from an attachment point of view, it is proposed that their attachment system is developing and repairing because of the increase of synaptic connections in the prefrontal brain areas, which makes it more possible to regulate inner experiences and attunement.

The final proposition is that the practice of mindfulness is a tool that can help the guider prepare their mind and body to be in a good state to work with the client in terms of emotional resonance and the emotional environment they will be creating. Through helping the guider be more aware of their own intentions, mindfulness can enable them to become a more receptive guider. It can also help them to develop greater space in their mind for working with both clients and trainees.

Beyond Therapy
Supporting a Culture of Relational Democracy

WILMA BARROW AND LIZ TODD

Introduction

The previous chapters have offered detailed consideration of the theoretical basis, the efficacy and a range of applications of Video Interaction Guidance (VIG). VIG began as an intervention to support interpersonal communication and relationships within families. Practice has developed and it is now used in many different settings, such as residential child care establishments, mental health agencies and schools. In this final chapter we will reflect more widely on the potential applications of VIG. Specifically, we will consider whether VIG might be considered as a tool to support democratic practice at both an interpersonal and a community level. We will use a dialogic lens through which to view this issue. The way in which we understand dialogism and the implications of this for democratic practice will be considered. We will offer some critical consideration of the helpfulness of this perspective when applied to institutions and agencies with statutory functions and hierarchical structures, such as schools and children's services. Finally, examples of the ways in which VIG might be used to support the development of practices that are moving in a more democratic direction will be offered. Before attempting to tackle the questions that lie at the heart of this chapter we will outline the ways in which both democracy and dialogism are defined in this chapter.

Towards a definition of democracy and dialogic communication

The definition of democracy that will underpin this chapter is not the dominant concept of majority rule where minority voices can be silenced. Rather, the definition we are using is reflected in forms of communication that are genuinely reciprocal, where all parties are receptive to the voices of others and the communication is not closed down by an expert or dominant voice providing the 'last word'. The process of such communication, we argue, offers the potential for change to all voices involved. Chasle (see Chapter 15) provides an example of such communication at the level of a therapeutic relationship in which the dominance of the voice of the expert was deliberately eschewed and the perspectives of both service user and guider were enabled to shift. This definition of democracy is of particular interest to us as VIG practitioners given that VIG has developed to support reciprocal communication.

Moving to the wider political context, Arnett and Arneson (1999) argue that there is a need to create 'democratic community by encouraging independent voices to work together as interdependent voices' (p.14). Their notion of the importance of these voices within civic space echoes Habermas' (1987) notion of a democracy that widens participation beyond the political institutions and across social and cultural institutions, organizations and communities. Within this model, the voices of all, not just those of the powerful, are heard. Within the children's rights literature there has been significant emphasis on dialogue as an important means to children's participation in decision-making (Deakin Crick *et al.* 2004; Fattore and Turnbull 2005; Fielding 2004; Hill *et al.* 2004; Todd 2007). Deakin Crick *et al.* (2004), in their review of citizenship education in schools, argue that dialogue is crucial in order to help children develop the skills required to enable them to participate as citizens in adult life.

The nature of the dialogue, however, is crucial if it is to be democratic and the ways in which it is conceptualized are important. Arnett and Arneson (1999) argue that where there is no genuine reception of the other confrontation of difference can lead to marginalization, alienation, aggression and violence. For them, there is a vital need to 'keep a conversation going' (p.297). This particular phrase is crucial to their vision of a global democratic culture and ethos. Our aim in this chapter is to consider the application of this principle to smaller, localized communities and to interpersonal relationships. From this perspective, a democratic conversation is one that is jointly owned and always ongoing, and democratic practices are those that

support and facilitate such conversations. Such conversations were observed in the UK student occupation of Newcastle University in 2010 over higher education funding changes, as countless interactions over the day as well as a massive evening meeting (where 'jazz hands' denoted agreement with a speaker) negotiated action, identity and engagement in the jobs of living and protesting together (Offredo 2010).

This concept of the neverending conversation is reflected in dialogic thinking which can be traced to Bakhtin and his circle (Holquist 1990). Bakhtin developed the concept of 'dialogic space' in which different perspectives are held together in tension and do not reach resolution. Through this ongoing tension, insight and creativity are sparked (Wegerif 2007). Dialogism has developed as a theoretical perspective within and beyond psychology (Markova 2003; Salgado and Hermans 2005). It is difficult to refer to dialogism as one theoretical perspective. Grossen (2010) suggests that it is a paradigm based on some shared assumptions but that it represents a range of conflicting and differing theoretical developments and application. A key distinctive of a dialogical approach, however, is that meaning is not determined by gesture or word, nor does it reside in the mind of the individual to be unlocked by the skill of the other. Rather, meaning is negotiated between those in interaction in this notion of 'dialogic space' (Markova 2003). A dialogic perspective holds that self and other/s exist in an interdependent relationship. The individual self is defined as being-in-relationship. The confrontation between self and other is also seen in the notion of the internal dialogue and the heterogeneity of voice (Markova *et al.* 2007). From this perspective, each of us is multivoiced and our internal dialogues echo those taking place within society (Gillespie *et al.* 2008). A further feature of a dialogic perspective that is of profound significance to our discussion is that it is not goal-directed. It is clear therefore why this perspective fits with a notion of democracy as a neverending conversation. When a conversation is moving towards an agreed goal then what is there to say when that goal is achieved? Instead, a dialogic perspective sees the confrontation of self and other/s as an ongoing and dynamic process which is fraught yet transformative (Markova 2003). From this position the precise nature of the transformation that takes place in the space between persons in dialogue cannot be predicted.

In a similar argument to Markova's, Van der Riet (2008) discusses the role of dialogic process, which she views as key to transformation, in participatory research. She employs the concepts of empathic and distanciated perspectives to explain how participatory work can lead to change. Like Markova's, it is the holding of these two perspectives in tension that is key to Van der Riet's

understanding of the transformative potential of participatory approaches. There are clear links here to any collaborative approach that aims to operate democratically by taking diversity and power differentials seriously. An empathic perspective comes from accessing an 'insider' account of a situation. Accessing this perspective relies on intersubjective processes between the researchers and the participants. In developing an empathic perspective the researcher or practitioner needs to understand the community and groups they are working with from their perspective, using their cultural symbols and language. An empathic, insider perspective is receptive and uncritical. A distanciated perspective, on the other hand, is an outsider perspective that moves beyond the frame of reference of the participants, possibly drawing on the expertise or knowledge of the researcher. Here the researcher needs to step outside and avoid being subsumed by the culture of the participants. It is through this confrontation with 'otherness' that the participants are able to develop fresh insights on their situation. The use of visual methods is argued by Van der Riet (2008) to illustrate the interplay between the insider and outsider perspectives. They provide a shared reference point and discussion around the visual artefact is less threatening as questions can be directed to it rather than to individual participants. Furthermore, she argues that for these reasons the use of visual representations has the potential to provide the space for dialogue. It is clear that this is an approach to dialogue that takes difference seriously and might well fit with Arnett and Arneson's understanding of democratic practice. We will consider how this might enable us to conceptualize VIG as an approach that draws on the interplay of empathic and distanciated perspectives and thus offers potential to those seeking to support democratic practices. Before looking at this in more detail we will briefly consider the ways in which self is conceptualized and the relevance of this to the particular understanding of democracy that we are employing here.

Democracy and the self: Interdependent voices

The concept of interdependent voices rests upon particular philosophical assumptions that view self not as a single entity, but as self in relation to others in an interdependent relationship. This underpins Arnett and Arneson's (1999) contention that 'we need those who know that it is not just "me" but "us" – self and other – that make the intentional connection of life meaningful' (p.297). This ontological principle lies at the heart of

their notion of democratic relationship. It is important to recognize that the implications of philosophical assumptions about the configuration of the self reach well beyond academia and are of profound importance to the question of how to generate and maintain democratic relationships and practices at all levels (Sampson 2008).

Previous approaches to the helping relationship have claimed a democratic basis. Rogers' person-centred therapy, for example, optimistically (and, for its time, radically) hoped that the emphasis on the authority of the individual, rather than that of the therapist, would provide the basis for a more democratic culture. For Rogers, the authority and empowerment of the individual self were key to therapeutic, educational and even societal transformation (Holdstock 1993).

This focus on the individual self has been the subject of critique and in particular of questions over the relevance of Rogers' approach to a contemporary culture characterized by diverse voices. Brazier (1994) contends that Rogers' understanding of self leads to a loss of focus on the other and the risk of narcissism. In addition to weakening Rogers' claims to altruism, the charge of individualism ultimately contradicts his democratic political ideal (Sampson 1985). This reflects a wider critique of the emphasis on the individual self within Western psychology (see, for example, Cushman 1990; Sampson 1985; Sampson 1989; Spence 1985). These arguments focus on the individualistic notions of the self underpinning dominating models of Western psychology (e.g. behaviourist, psychodynamic, humanistic, cognitive) and offer a scathing political critique of the impact of psychology (e.g. Burman 2008). Sampson (2008) even suggests that 'the science that studies the individual and the society within which those studies are conducted have developed a very cosy relationship' (p.42).

Whilst it can be argued that democracy in the last two centuries has been advanced through a culture of individual rights emerging from individualistic perspectives, there is also concern that an individualistic approach assumes humanity to be a 'job lot' and is in danger of ignoring the diversity of needs and interests. It is this that led Sampson (1985) and others to argue that a dominantly individualistic view of the self flies in the face of democratic values.

The rising prominence of the work of eastern European psychologists in the sociocultural tradition within psychology has further challenged an individualistic emphasis in psychology by seeing all learning as social in origin. Their theoretical work, particularly that of Vygotsky (Daniels 1996), emphasizes the role of the other in human development and challenges

the notion of the autonomous, imperialistic self. In the last 40 years the empirical work of Trevarthen (see Chapter 12) and others, who have been of such significance to the development of VIG, has demonstrated the innate capacity of the human mind to communicate with others. The idea of the bounded autonomous individual is difficult to support in the face of the breadth of these developments.

Alternative theoretical approaches that rest on relational understandings of the self have become prominent in recent years. Sampson (2008) describes a range of theoretical perspectives that reject the individualistic Western idea of self and instead focus on the fundamental significance of language as an indication of the interdependence of the individual and others. This he refers to as the 'dialogic turn', which he suggests has led to an emphasis on a dialogic, relational self where the boundary between self and other(s) is fluid and meaning is constructed in the space between, as discussed above. The self here is defined through dialogue with others and is not bounded and autonomous. As we have seen, from a dialogic perspective utterances contain multiple and diverse voices. These reflect diversity both between and within selves. There is therefore no monological or authoritative 'last word'.

We can now see the link to the vision of a democratic community where the conversation between diverse people and groups is ongoing and the voice of 'otherness' is neither alienated nor silenced. For Sampson, a monologic understanding of human nature cannot provide a basis for democratic practice as it offers 'a singular perspective for negotiating the diversity of human experience' (p.176). The potential of dialogic thinking for Arnett and Arneson's (1999) democratic vision reaches beyond mutuality or intersubjective agreement. Markova (2003) draws on Bakhtin to argue that the gap in a two-way communication should never be completely closed. It is in this space, she contends, that there is potential for something new to emerge through the sparks of tension between self and otherness. An emphasis on mutuality, empathy and intersubjectivity is not, according to this perspective, enough to account for new insights. These can only come through a confrontation between self and otherness and in dialogue. This dialogue should lead to an ongoing and dynamic tension as opposed to fusion and stability. Without this there is no possibility of challenge or critique in the interpersonal or community context (Markova 2003). This approach is critical of Buber's notion of the I-thou encounter which has its focus on intersubjectivity and mutuality alone. These ideas may be of significant interest to VIG practitioners as they consider their stance

in relation to intersubjectivity, and how they account for change in the communicative relationship.

It is clear that philosophical assumptions about the self are of fundamental importance to the question of how to support democratic practice. An approach to democracy that assumes the possibility of ongoing and transformative discussion between diverse voices requires an understanding of the self in relation with other(s). This does not imply collectivism, which equally closes down diverse voices through a process of fusion. Rather, it involves the understanding of that notion of creative tension which Markova portrays in her discussion of the dialogical self.

While we recognize the potential of this perspective we also recognize that there are some limitations to applying this perspective to support an understanding of democratic practice within the contexts in which many of us as VIG guiders operate. These will be outlined next before we consider VIG's potential in supporting practice which is moving in a democratic direction.

How might applying a dialogic perspective to VIG support democratic practice?

The structures within which many of us practise VIG are characterized by complex hierarchies and layers of policy. Doria, Strathie and Strathie (see Chapter 6) provide a helpful discussion of how they work through some of these issues, including the need to shut down the conversation when abusive behaviour is being observed, in their discussion on using VIG as social work practitioners. Other contexts offer similar challenges. A classroom, for example, is not an autonomous community of practice. The views of school managers, parents and quality assurance bodies, for example, impinge on curricular and pedagogic decisions. This leads us to contend that although a dialogic model of ongoing open and transformative conversation is one that offers a vision to work towards there is a need to maintain critical reflexivity in working out this democratic vision in the complex contexts within which we practise.

Even where processes might allow individuals an opportunity to enter dialogue with professionals, for example in a school review or a transition planning meeting, it is not always easy for individuals to take up these opportunities and become critically engaged in the sort of dialogue we have been discussing. There may be some links here to Foucault's notion of modern power whereby discourses about what is 'normal' or what is

'success' become the normalizing 'truths' by which individuals then evaluate themselves and their lives (Walther and Carey 2009). Even having the opportunity to speak may not be enough for some people whose narratives are built on their evaluation of themselves against these dominant societal norms. These narratives may be carried into contexts like school meetings by individuals who subsequently feel that they cannot readily contribute to the dialogue. White's practice of externalization attempts to interrupt these narratives by 'employing the practices of objectification of the problem against the cultural practices of objectification of people' (White 2007).

Having recognized these difficulties, however, it is our contention that there are aspects of dialogic thinking that can help frame our work and enable us to operate more democratically. In particular, we would argue that Van der Riet's (2008) notion of the interplay of empathic and distanciated perspectives and the use of visual techniques as a means to support the process of distanciation are particularly helpful. There are obvious parallels between these processes and VIG. The empathic perspective can be accessed in VIG through the intersubjective process of attunement between guider and service user and the reception of the service user by the guider using the principles of attuned interaction and guidance. Given the prominence of reception in the attunement principles the key question might be to what extent VIG can support the development of a distanciated perspective. It is here that the use of the video is of vital importance. Van der Riet argues that visualization is a catalyst for distanciation. This is particularly interesting in relation to research in VIG where some researchers are reporting that the video is being regarded by service users as offering an outsider's view on their situation which they find helpful. The distanciated perspective can be further supported during the dialogue taking place within the shared review process as the guider introduces the 'otherness' of the attunement principles in the discussion. Finally, in participatory research there is a need for researchers to ensure that steps are taken to reduce power differentials between researchers and participants. Again, parallels can be found in VIG through the shared review process and the emphasis on guiding and not leading the work. Although the video is not produced collaboratively, the identification of clips by service users can facilitate collaboration between service user and guider. The VIG model, we would suggest, also reduces this power gap between service users and guiders through the requirement that guiders are videoed during their feedback for a supervision process that mirrors the shared review.

Suggested applications of VIG which might support democratic practice

The following suggestions are not novel but they represent work that is taking place in geographical pockets in the UK and which may merit wider exploration.

How professionals work together

When VIG has been used with a range of professionals working together, usually with parents and one or more children to focus on a concern such as classroom behaviour, learning or communication, the process of looking together for attunement in video clips seems to encourage different ways of working. Is it the 'difference' of video, the 'power of the visual image to create a crucially important context for growth' (Sluckin 1998) or the culturally unusual process of watching oneself that cuts across other professional expert discourses? The use of VIG in such a context allows the confrontation of different voices and for questions to be directed at the screen rather than at the parent or any individual professional. It allows all to work together in partnership, often showing professionals the positive aspects of the child's relationships at home which can be significant in the development of a partnership between parent and teacher (e.g. McCartan 2009).

Pupil participation

VIG has been used to support communication within classrooms (Kaye, Forsyth and Simpson 2000). It may be possible to extend this work towards supporting pupil participation within the school and the wider community. As discussed above, the role and importance of dialogue between adults and children is being increasingly emphasized within the children's rights literature. If that dialogue is to be democratic and potentially transformative it is required to be genuinely dialogic (Barrow 2010). There may be ways of supporting such work through for example, the use of Philosophy for Children within the classroom. VIG can be used with teachers as they work with children or with groups of children supporting them in the development of democratic dialogue. This has been employed in one school where Philosophy for Children was introduced as a means of enhancing pupil participation in the classroom. Each philosophy lesson was videoed and followed by a shared review between the teacher and educational

psychologist. These reviews supported the teacher in developing her skills in facilitating the children's talk. The findings suggest that the use of video was extremely important to the teacher's reflection on lessons. In particular the video appeared to support a distanciated perspective and often led the teacher to view the lesson quite differently from her initial subjective judgement and also helped her to identify aspects of her own talk that she wanted to change. This process led to the teacher recognizing the journey of change in classroom talk as one that she was sharing with the children. Her perception of the children's abilities shifted as she saw them engaging with one another and with herself in ways that were both critical and respectful. Interviews with children at the end of the process indicated that they had appreciated the opportunity to express their own opinions without fear and that they had understood the need to listen to others as well, and that this had helped their own thinking (Edwards and D'Arcy 2004).

Restorative practices

VIG can be used to support restorative practices within schools or communities in a range of ways. Restorative practice can be argued to be democratic in that it operates on a relational notion of justice. Many adults in schools are now trained in restorative practices. There is a recognition that these approaches need to be embedded within a school culture rather than implemented through an instrumental approach to training (Macready 2009). It is here that VIG might be used to support school staff in the development of the communication skills used in restorative conversations. It can also be used with young people to develop their skills as peer mediators. Finally, given the closer links with communities afforded by new configurations of services, there are possibilities of using VIG to support wider community-based restorative projects.

Parent groups

The ideas, cycles and tools of VIG, in our view, enable democratic processes to be embedded in parent groups to provide a no less effective alternative to the plethora of parenting programmes. This is a potentially sensitive area as many parents will have seen less democratic approaches to the use of video in working with parents within the popular media. The shared reflection on video clips of the lived experience of the parents taking part in VIG, rather than pre-prepared videos for a particular purpose, is an indication already of support for more democratic processes in parent work.

The process of making video clips to use in shared review were quickly adopted over a series of three meetings by a group of parents who came together in a primary school one afternoon each week for a programme of activities that were put together by staff and parents. This work was based on mutuality, with parents and teachers seeing themselves as offering mutual support. Trevarthen's notion of the need for a communicative space (Trevarthen 2001), illustrated by a video of a very young infant taking turns in communicating with their father, was convincing of the notion of reception and attunement. The parents directed problem-solving when technology failed, choosing to act as a group on the shared review of clips of the interaction between two parents and their children at home. Whilst carefully structured parenting programmes that aim to develop particular skills no doubt achieve much skill development, there is no substitute for the agency of directing the goals and processes of one's own group and the skill development within such a group. Whilst VIG involves expertise and a theoretical understanding of the underpinnings of reciprocal interaction, it is possible to extend its use in this more democratic way, where parents are not 'objectified' as problems but have their role valued both in the process of running the group and in the process of sharing feedback on the video clips.

Conclusion

This chapter began with the question of the potential of VIG as a tool to support democratic practice at an interpersonal and community level. Arnett and Arneson's (1999) notion of democracy as a neverending conversation between diverse persons has been used as a template for democratic practice. The significance of a dialogic understanding of the person and the possibilities this offers in supporting democratic practice have been critically considered. Finally, we have argued that Van der Riet's (2008) dialogic notion of the transformative tensions between an empathic and a distanciated perspective supported by visual techniques, which characterize participatory research, can provide a helpful way of viewing VIG. We would suggest that VIG is not in itself a 'democratic intervention'. Rather, it is the ways in which we conceptualize both its use and those involved in its use (both guiders and service users) that will influence the extent to which VIG can be used to support the development of more democratic practice in the contexts within which we work. We accept that the focus in VIG on relationship, as opposed to the individual within the relationship, is relevant to the understanding of democratic practice emphasized in this

chapter. Some of the assumptions underpinning dialogic approaches can provide a useful perspective from which to view VIG and to understand and explain transformation. These also allow a basis on which to critique our own practice when it veers towards a monologic use of the attunement principles or emphasizes our own professional expertise in ways that fail to give space to the other within the shared review (see Chapter 15).

Although we have acknowledged that there are limits to dialogism as a basis for practice in the contexts within which we work, we suggest that understanding VIG from this perspective allows us to consider how it might be applied to support practices that are moving further towards our definition of democracy. It is possible to argue that VIG is a tool that can support democratic practice at an interpersonal level. It is also possible to view it as a tool to support other existing democratic practices at a group or community level. It is here that its application might prove helpful with the challenges and opportunities presented by new models of localized service delivery. As communication is at the heart of delivery of all forms of service there is an enormous breadth of potential application. The current shift within the UK towards locality-based integrated children's services, for example, represents new challenges and opportunities. The challenge of developing a shared culture of relationships between workers (Booker 2005) and between workers and service users is significant. There are, however, opportunities to work in and with communities in new ways (Davis and Cahill 2006; Todd 2010). Democratic participation, with genuine dialogue and confrontation with difference, if applied to the concerns and goals of children's services, may, we suggest, have much to offer. Even where the operation of VIG might be impractical its underpinning communication principles have much to offer those seeking to consider the relational ethos of team or agency. It has been argued that there are distinctive features of VIG that are congruent with a democratic approach to relationship and that it therefore has potential to contribute positively to supporting such practices within this emerging context of service delivery. These distinctive features include a core emphasis on supporting the development of relationships as opposed to individual selves within relationship, the use of the video as a visual tool and the process of shared review with the emphasis on guiding or facilitating as opposed to leading the process. As communication and dialogue are involved in all aspects of service delivery within and beyond children's services, there is enormous potential here for VIG.

Glossary

Accreditation	An assessment of a **trainee guider**'s competencies at the end of each phase of training by an accrediting supervisor.
Activation	A process by which the **guider**/supervisor encourages **initiatives** from and active participation/lead by the client/ **trainee guider**, using open-ended questions in order to elicit what they already know.
Attuned naming	A type of **reception (receiving)** where the **care giver** describes in a friendly tone what the **care seeker** is doing, thinking or feeling.
Attuned response	A response to an **initiative** showing sensitivity and positive acceptance and which keeps the interaction moving in or towards the **yes-cycle**.
Attunement	Describing a harmonious and responsive relationship where both partners share positive emotion within a **communicative dance**.
AVIGuk	Organization which promotes and develops VIG in the UK and provides quality assurance for the method www. videointeractionguidance.net.
Care giver	An adult, e.g. a parent, teacher, care worker, therapist or **guider**, responding to the **care seeker**'s initiatives in an **attuned** way.
Care seeker	An infant, child or client seeking a secure attachment response.
Co-construction of meanings	The means by which the **guider** and the client offer, receive, exchange and develop their ideas and opinions and enlarge their shared understanding within an **attuned** relationship.

Communica-tive dance	Reciprocal and positive interaction between individuals having the features of music and dance in their timing and rhythm.
Compensation	The process by which the **guider**/supervisor guides, leads or offers opinions and suggestions to the client/**trainee guider** in order to provide information they are currently lacking.
Contract	An explicit agreement (verbal and/or written) as to the purpose and desired outcomes hoped for by the client or supervisee. May include information about the number of sessions, ownership of the video, etc.
Core principles for attuned interaction and guidance	Core elements of communication on which **VIG** is based, comprising being attentive; encouraging **initiatives**; receiving **initiatives**; developing **attuned** interactions; guiding; and deepening the discussion.
Edited clips	Video clips micro-edited by the **guider** to demonstrate interaction which is 'better than usual' for **shared review**, usually lasting anything from a few seconds to just under a minute.
Follow	The **care giver** responds to the **care seeker**'s **initiative** and concerns, allowing the **care seeker** to lead the interaction and supporting it. This often leads to **attunement**.
Guider	A professional qualified to deliver **VIG**.
Helping question	A statement of what the client hopes **VIG** will help them achieve.
Initiative	A communication (non-verbal and/or verbal) which begins an interaction or introduces a new 'topic' into the interaction.
Mediated learning	Feuerstein's concept of the child's learning being facilitated by an adult who is **attuned** to the child's level of understanding and who can judge the amount and kind of help that the child needs to be successful.
Mentalization	The ability to understand the mental state of oneself and others which underlies overt behaviour.
Micro-analysis of interaction	Breaking down sequences of interaction into very small elements, each lasting only seconds, in order to understand their impact on the communication.

Mindfulness	Originating from Buddhist traditions, mindfulness refers to paying attention in the here and now to experience, thoughts and feelings in a non-judgemental and curious way.
Mind-mindedness	The ability to accurately infer others' mental states.
No-cycle	A pattern of interaction where negative/discordant communications and emotions are initiated, exchanged and perpetuated.
Primary inter-subjectivity	Basic face-to-face communication between two people where emotions are expressed and perceived in a two-way dialogue.
Reception/receiving	A communication (non-verbal and/or verbal) that acknowledges and positively accepts an **initiative**, showing it has been understood.
Reflective alliance	A partnership between the **care giver** and **care seeker** where each person works with the other to reflect on and develop new insights into the **care seeker**'s relationships with significant others.
Scaffolding	Bruner's concept of how skilled individuals provide structure and assistance to 'scaffold' or assist novices' learning.
Secondary intersubjectivity	More sophisticated communication between two people where they share their attention to each other with attention to a third subject, such as a toy or task.
Self-modelling	Learning from observing oneself demonstrating on video the desirable behaviour.
Sensitivity	The **care giver**'s ability to perceive the **care seeker**'s signals accurately and to respond to them promptly and appropriately.
Seven steps (to creating an effective working relationship between guider and client)	A seven-step cyclical model describing how a **guider** might flexibly use **activation** and **compensation** and the video clips during a **shared review**. Step 7 is achieved when the level of discussion is deepened and new learning, feelings and narratives emerge.

Shared review	The process of the **guider** and client spending time together watching and discussing the video clips and reflecting together on their significance (previously called 'feedback').
Social con-structionism	An approach that challenges the notion of one 'objective reality', showing how individuals in conversation with others co-construct and re-construct past, present and future events through ongoing reflection and dialogue.
Space in one's mind	Being able to hold in mind an awareness of how the other might be thinking and feeling. In its earliest form, e.g. in the premature infant, it refers to the innate ability to communicate with another through a natural turn-taking pattern of **initiatives** and pauses (Trevarthen).
Still/freeze frame	A static or still shot from the video to emphasize a salient positive moment of interaction.
Trainee guider	A person who can deliver VIG under supervision following initial training.
Traject Plan	Originally translated as 'treatment plan', a plan now used to consider the structural/systemic aspects of the intervention.
Turning points	A moment at which an interaction shifts into a new dynamic; for example, when a parent softens their tone and the child leans in for physical contact.
Video	Short (unedited) video taken of the client and the other person interacting. Video is taken to have both people in the frame simultaneously.
Video Enhanced Reflective Practice (VERP)	A variation of **VIG** to support individuals or groups to reflect on and develop their communication, teaching or therapeutic skills with clients through **shared review** and reflection on edited video clips of their day-to-day practice. VERP is often delivered in a short-course format comprising one or two days of initial training followed by three to six half-day supervision sessions.
Video Feedforward (VFF)	Video Feedforward is an intervention that promotes behavioural change, as clients are shown skilfully edited video images of themselves succeeding in tasks or situations they find difficult, thus providing the opportunity to self-model. It is called 'Feedforward' because it involves showing the client 'created' future images of themselves achieving, to differentiate it from the 'feedback' of images of their past achievement as in **VIG**

Video Home Training (VHT)	VIG used in the home context in the Netherlands.
Video Interaction Guidance (VIG)	An intervention to help clients move from discordant to **attuned** communication by supporting them to reflect through dialogue on the micro-analysis of video clips of their own successful interactions.
VIGuk	Organization which promotes and develops **VIG** in the UK and provides quality assurance for the method. Sometimes used to describe the method **VIG** in the UK.
Working points	Areas identified by the client or **trainee guider** during the **shared review** or supervision as ones that they would like to work on improving.
Yes-cycle	A pattern of interaction where positive/attuned communications and emotions are initiated, exchanged and maintained.
Zone of proximal development (ZPD)	The level at which the learner is currently functioning and from where they can have their learning supported and extended slightly by the right kind of help; the distance between what a learner can achieve given maximum support and what they can achieve independently; all teaching and learning takes place within the learner's ZPD.

References

Adams, R., Dominelli, L. and Payne, M. (eds) (2002) *Social Work: Themes, Issues and Critical Debates.* Basingstoke: Palgrave.

Ainsworth, M.D.S., Bell, S.M. and Stayton, D.J. (1974) 'Infant-mother Attachment in Social Development: Socialization as a Product of Reciprocal Responsiveness to Signals.' In M.P.M. Richards (ed.) *The Integration of a Child into a Social World* London: Cambridge University Press, 99–135.

Alexander, R. (2004) *Towards Dialogic Teaching: Rethinking Classroom Talk.* Cambridge, MA: Dialogos.

Allen, G.J. and Fonagy, P. (2006) *Handbook of Mentalization-Based Treatment.* Chichester: John Wiley and Sons.

Als, H. (1995) 'The Preterm Infant: A Model For the Study of Fetal Brain Expectation.' In J.-P. Lecanuet, W.P. Fifer, N.A. Krasnegor and W.P. Smotherman (eds) *Fetal Development: A Psychobiological Perspective.* Hillsdale, NJ and Hove: Erlbaum, 439–471.

Archbold, S. (2010) 'Deaf Education: Changed by Cochlear Implantation?' PhD dissertation Nijmegen Medical Centre, Radboud University Nijmegen, Nijmegen.

Argyris, C. and Schön, D. (1974) *Theory in Practice.* San Francisco, CA: Jossey-Bass.

Arnett, R.C. and Arneson, P. (1999) *Dialogic Civility in a Cynical Age: Community, Hope and Interpersonal Relationships.* New York, NY: State University of New York.

Auerbach, J. and Blatt, S. (2001) 'Self-reflexivity, intersubjectivity, and therapeutic change.' *Psychoanalytic Psychology 18,* 3, 427–450.

Bakermans-Kranenburg, M.J., Juffer, F. and Van IJzendoorn, M.H. (1998) 'Interventions with video feedback and attachment discussions: Does type of maternal insecurity make a difference?' *Infant Mental Health Journal 19,* 202–219.

Bakermans-Kranenburg, M.J., Van Ijzendoorn, M.H. and Juffer, F. (2003) 'Less is more: Meta-analyses of sensitivity and attachment interventions in early childhood.' *Psychological Bulletin 129,* 2, 195–215.

Bakermans-Kranenburg, M.J., Van IJzendoorn, M.H. and Juffer, F. (2005) 'Disorganized infant attachment and preventive interventions: A review and meta-analysis.' *Infant Mental Health Journal 26,* 3, 191–216.

Balint, M. (1968) *The Basic Fault.* London: Tavistock Publications.

Bamford, J., Uus, K. and Davis, A. (2005) 'Screening for hearing loss in childhood: issues, evidence and current approaches in the UK.' *Journal of Medical Screening 12,* 3, 119–124.

Bandura, A. (1969) *Principles of Behavior Modification.* New York, NY: Holt, Rinehart and Winston. Cited in P.W. Dowrick (1999) 'A review of self-modeling and related interventions.' *Applied and Preventive Psychology 8*, 23–39.

Bandura, A. (1977) *Social Learning Theory.* Englewood Cliffs, NJ: Prentice Hall.

Bandura, A. (1986) *Social Foundations of Thought and Action: A Social Cognitive Theory.* Englewood Cliffs, NJ: Prentice Hall.

Bandura, A. (2000) 'Health Promotion from the Perspective of Social Cognitive Theory.' In P. Norman, C. Abraham and M. Conner (2000) *Understanding and Changing Health Behaviour; From Health Beliefs to Self-Regulation.* Amsterdam: Harwood.

Barlow, J. and Schrader McMillan, A. (2010) *Safeguarding Children from Emotional Maltreatment. What Works.* London: Jessica Kingsley Publishers.

Barlow, J. and Svanberg, P.O. (2009) *Keeping the Baby in Mind: Infant Mental Health in Practice.* Hove: Routledge.

Baron-Cohen, S. (1995) *Mindblindness: An Essay on Autism and Theory of Mind.* Cambridge: MIT Press.

Barrow, W. (2010) 'Dialogic, participation and the potential for Philosophy for Children.' *Thinking Skills and Creativity 5*, 2, 61–69.

Bateman, A. and Fonagy, P. (2004) *Psychotherapy for Borderline Personality Disorder.* Oxford: Oxford University Press.

Bateson, M.C. (1979) 'The Epigenesis of Conversational Interaction: A Personal Account of Research Development.' In M. Bullowa (ed.) *Before Speech: The Beginning of Human Communication.* Cambridge: Cambridge University Press, 63–77.

BBC Breakfast (2011) 'The Happiness Challenge: Can a few simple daily actions make us happier?' Action for Happiness and Headspace, 24–28 January.

Beaufortová, K. (2001) *Seven Years of VTI (Video Training in Interaction) in the Czech Republic – Doing, Reflecting and Learning.* International Conference Papers, 2001. Available at http://tiny.cc/beau01, accessed on 5 July 2011.

Beck, A.T. (1976) *Cognitive Theory Therapy and the Emotional Disorders.* New York, NY: International Universities Press. Cited in P.W. Dowrick (1999) 'A review of self-modeling and related interventions.' *Applied and Preventive Psychology 8*, 23–39.

Beckerman, N.L. and Corbett, L. (2010) 'Mindfulness and cognitive therapy in depression relapse prevention: A case study.' *Clinical Social Work Journal 38*, 2, 217–225.

Beebe, B. (2005) 'Faces-in-Relation: Forms of Intersubjectivity in an Adult Treatment of Early Trauma.' In B. Beebe, S. Knoblauch, J. Rustin and D. Sorter (2005) (eds) *Forms of Intersubjectivity in Infant Research and Adult Treatment.* New York, NY: Other Press.

Beebe, B., Jaffe, J., Feldstein, S., Mays, K. and Alson, D. (1985) 'Inter-Personal Timing: The Application of an Adult Dialogue Model to Mother-Infant Vocal and Kinesic Interactions.' In F.M. Field and N. Fox (eds) *Social Perception in Infants.* Norwood, NJ: Ablex, 217–248.

Beebe, B., Jaffe, J., Lachmann, F.M., Feldstein, S., Crown, C. and Jasnow, J. (2000) 'Systems models in development and psychoanalysis: The case of vocal rhythm coordination and attachment.' *Infant Mental Health Journal 21*, 99–122.

Bellini, S. and Akullian, J. (2007) 'A meta-analysis of video modeling and video self-modeling interventions for children and adolescents with autism spectrum disorders.' *Exceptional Children 73*, 264–287.

Benjamin, J. (1988) *The Bonds of Love: Psychoanalysis, Feminism, and the Problems of Domination.* New York, NY: Pantheon.

Benjamin, J. (1990a) *The Bonds of Love: Psychoanalysis, Feminism, and the Problem of Domination.* London: Virago.

Benjamin, J. (1990b) 'An outline of intersubjectivity: The development of recognition.' *Psychoanalytic Psychology 7,* 33–46.

Benjamin, J. (1998) *Shadow of the Other: Intersubjectivity and Gender in Psychoanalysis.* New York, NY: Routledge.

Benns-Coppin, L. (2008) 'Understanding, respecting and integrating difference in therapeutic practice.' *Psycholanalytic Psychotherapy 22,* 4, 262–284.

Benoit, D., Madigan, S., Lecce, S., Shea, B. and Goldberg, S. (2001) 'A typical maternal behavior toward feeding-disordered infants before and after intervention.' *Infant Mental Health Journal 22,* 6, 611–626.

Bercow, J. (2008) *Bercow Review of Services for Children and Young People (0-19) with Speech, Language and Communication Needs.* DCSF Publications, Crown Copyright 2008.

Berger, J. (2008 [1972]) *Ways of Seeing.* London: BBC and Penguin Books.

Berger, M.M. (1978) *Videotape Techniques in Psychiatric Training and Treatment* (rev. edn). New York, NY: Brunner/Mazel Publishers.

Bettelheim, B. (1987) *A Good Enough Parent.* New York, NY: Vintage Books.

Biemans, H. (1990) 'Video Home Training: Theory Method and Organisation of SPIN.' In J. Kool (ed.) International Seminar for Innovative Institutions. Ryswijk: Ministry of Welfare, Health and Culture.

Bien, T. (2008) 'The Four Immeasurable Minds. Preparing to Be Present in Psychotherapy.' In S.F. Hick and T. Bien (eds) *Mindfulness and the Therapeutic Relationship.* New York, NY: The Guilford Press.

Billington, T. (2006) 'Psychodynamic theories and the "science of relationships" (Bion): A rich resource for professional practice in children's services.' *Educational and Child Psychology 23,* 4, 72–79.

Biringen, Z., Robinson, J.L. and Emde, R.N. (2000) 'Appendix B: The Emotional Availability Scales (3rd edn: An Abridged Infancy/Early Childhood Version)' *Attachment and Human Development 2,* 256–270.

Black, P. and Wiliam, D. (1998) 'Assessment and classroom learning.' *Assessment in Education 5,* 1, 7–71.

Body Language Foundation (2011) Available at www.stichtinglichaamstaal.nl, accessed on 2 February 2011.

Bogdashina, O. (2005) *Communication Issues in Autism and Asperger Syndrome: Do We Speak the Same Language?* London: Jessica Kingsley Publishers.

Booker, R. (2005) 'Integrated children's services – implications for the profession.' *Educational and Child Psychology 22,* 4, 127–142.

Boston Change Process Study Group (BCPSG) (2007) 'The foundational level of psychodynamic meaning: Implicit process in relation to conflict, defense and the dynamic unconscious.' *International Journal of Psychoanalysis 88,* 1–16.

Bouma, J., Rancher, A.V., Sanderman, R. and Van Sonderen, E. (1995) *Het Meten van Symptomen van Depressie van de CES-D: Een Handleiding* [Measuring Depression Symptoms using the CES-D: A Manual]. Groningen: Noordelijk Centrum voor Gezondheidsvraagstukken, Rijksuniversiteit Groningen.

Bowlby, J. (1969) *Attachment and Loss. Volume 1: Attachment.* New York, NY: Basic Books.

Bowlby, J. (1971) *Attachment and Loss. Volume 1: Attachment.* Harmondsworth: Penguin Books.

Bowlby, J. (1979) *The Making and Breaking of Affectional Bonds.* London: Tavistock.

Bowlby, J. (1988) *A Secure Base: Parent-Child Attachment and Healthy Human Development.* London: Routledge.

Bråten, S. (2009) *The Intersubjective Mirror in Infant Learning and Evolution of Speech.* Amsterdam and Philadelphia, PA: John Benjamins Publishing Company.

Braun, V. and Clarke, V. (2006) 'Using thematic analysis in psychology.' *Qualitative Research in Psychology 3,* 77–101.

Brazelton, T.B. (1979) 'Evidence of Communication During Neonatal Behavioural Assessment.' In M. Bullowa (ed.) *Before Speech: The Beginning of Human Communication.* London: Cambridge University Press, 79–88.

Brazelton, T.B., Koslowski, B. and Main, M. (1974) 'The Origins of Reciprocity: The Early Mother-Infant Interaction.' In M. Lewis and L.A. Rosenblum (eds) *The Effect of the Infant on its Care Giver, Vol. 1.* New York, NY: Wiley, 49–76.

Brazelton, T.B. and J.K. Nugent (1995) *Neonatal Behavioural Assessment Scale* (3rd edn) London: MacKeith Press.

Brazier, D. (1994) 'The Necessary Condition is Love.' In D. Brazier (ed.) *Beyond Carl Rogers: Towards a Psychotherapy for the 21st Century.* London: Constable

Brookfield, S. (1995) *Becoming a Critically Reflective Teacher.* Hoboken, NJ: Jossey-Bass.

Brown, K. and Kennedy, H. (2011) 'Learning through conversation: exploring and extending teacher and children's involvement in classroom talk.' *School Psychology International,* 32, 4, 377–396.

Brown, K. and Rutter L. (2006) *Critical Thinking for Social Work.* Exeter: Learning Matters.

Brumariu, L.E. and Kerns, K.A. (2010) 'Parent–child attachment and internalizing symptoms in childhood and adolescence: A review of empirical findings and future directions.' *Development and Psychopathology,* 22, 177–203.

Bruner, J. (1977) 'Early Social Interaction and Language Acquisition.' In H.R. Schaffer (ed.) *Studies in Mother-Infant Interaction.* New York, NY: Academic Press, 271–289.

Bruner, J. (1983) *Child's Talk: Learning to Use Language.* Oxford: Oxford University Press.

Bruner, J. (1996) *The Culture of Education.* Cambridge, MA: Harvard University Press.

Bruner, J.S. (1968) *Process of Cognitive Growth: Infancy (Heinz Werner Lectures)* Worcester, MA: Clark University Press.

Bruner, J.S. (1990) *Acts of Meaning.* Cambridge, MA: Harvard University Press.

Buggey, T. (2005) 'Video self-modeling applications with students with autism spectrum disorder in a small private school setting.' *Focus on Autism and Other Developmental Disabilities 20,* 52–63.

Buggey, T., Toombs, K., Gardener, P. and Cervetti, M. (1999) 'Training responding behaviours in students with autism: using videotaped self-modeling.' *Journal of Positive Behaviour Interventions 1,* 4, 205–214.

Bullowa, M. (ed.) (1979) *Before Speech: The Beginning of Human Communication.* Cambridge: Cambridge University Press.

Burman, E. (2008) *Deconstructing Developmental Psychology* (2nd edn). London: Routledge.

Burr, V. (1995) *Social Constructionism.* London: Routledge.

Busnel, M.-C., Granier-Deberre, C. and Lecanuet, J.P. (1992) 'Fetal audition.' *Annals of the New York Academy of Sciences, 662,* 1, 118–134.

Calder, M.C. and Hackett, S. (2003) *Assessment in Child Care.* Lyme Regis, Dorset: Russell House Publishing.

Caldwell, P. (2006a) *Finding you Finding Me: Using Intensive Interaction to Get in Touch with People Whose Severe Learning Disabilities are Combined with Autistic Spectrum Disorder.* London: Jessica Kingsley Publishers.

Caldwell, P. (2006b) 'Speaking the other's language: imitation as a gateway to relationship.' *Infant and Child Development 15,* 275–282.

Carey, M., Walther, S. and Russell, S. (2009) 'The absent but implicit: a map to support therapeutic enquiry.' *Family Process 48,* 3, 319–331.

Carling, Y., Taylor, M. and Forsyth, P. (2002) 'A local authority perspective: from there to here and beyond.' Presentation at Scottish National Autistic Society Inaugural Conference, Edinburgh.

Carrington, G. (2004) 'Supervision as a reciprocal learning process.' *Educational Psychology in Practice 20,* 1, 31–42.

Carroll, M. (1996) *Counselling Supervision: Theory, Skills and Practice.* London: Cassell.

Carson, B.H. (1996) 'Thirty years of stories: the professor's place in student memories.' *Change 28,* 6, 10–17.

Cassibba, R., Van IJzendoorn, M.H., Coppola, G., Bruno, S. *et al.* (2008) 'Supporting Families with Preterm Children and Children Suffering from Dermatitis.' In F. Juffer, M.J. Bakermans-Kranenburg and M.H. Van IJzendoorn (eds) *Promoting Positive Parenting: An Attachment-based Intervention.* Hillsdale, NJ: Lawrence Erlbaum Associates, 91–110.

Cassidy, J. (1999) 'The Nature of the Child's Ties.' In J. Cassidy and P.R. Shaver (eds) *Handbook of Attachment: Theory, Research, and Clinical Applications.* New York, NY: The Guilford Press, 3–20.

Cicchetti, D. and Curtis, W.J. (2005) 'An event-related potential study of the processing of affective facial expressions in young children who experienced maltreatment during the first year of life.' *Development and Psychopathology,* 17, 641–677.

Claxton, G. (2006) 'Mindfulness, learning and the brain.' *Journal of Rational-Emotive and Cognitive Therapy 23,* 4, 301–314.

Cohen, J. (1988) *Statistical Power Analysis for the Behavorial Sciences* (2nd edn). Hillsdale, NJ: Lawrence Erlbaum.

Colebrook, C. (2002) *Gilles Deleuze.* London: Routledge.

Colonnesi, C., Draijer, E.M., Stams, G.J.J.M., Van der Bruggen, C.O., Noom, M.J. and Bogels, S.M. (in press) 'The relation between insecure attachment and anxiety during childhood and adolescence: A meta-analytic review.' *Journal of Clinical Child and Adolescent Psychology.*

Confucius, 479BC–221BC, The Analects, VII.1

Conrad, R. (2004) '"As if she defied the world in her joyousness": rereading Darwin on emotion and emotional development.' *Human Development 47,* 1, 40–65.

Cooper, M. and Blair, C. (2002) 'Foucault's ethics.' *Qualitative Inquiry 8,* 511–531.

Covey, S. (1992) *Principle-Centred Leadership.* London: Simon and Schuster.

Covey, S.R. (1999) *The 7 Habits of Highly Effective Families.* London: Simon and Schuster.

Cranton, P. (2001) *Becoming an Authentic Teacher in Higher Education.* Malabar, FL: Krieger Publishing Company.

Creer, T.L. and Miklich, D.R. (1970) 'The application of self-modeling procedure to modify inappropriate behaviour: A preliminary report.' *Behaviour Research and Therapy* 8, 91–92. Cited in P.W. Dowrick (1999) 'A review of self-modeling and related interventions.' *Applied and Preventive Psychology 8,* 23–39.

Crittenden, P. (2009) 'Briefing paper: Patricia Crittenden's dynamic maturational model of attachment (DMM).' *Attachment: New Directions in Psychotherapy and Relational Psychoanalysis 3,* 2, 206–213.

Crittenden, P.M. (2000) 'A Dynamic-Maturational Exploration of the Meaning of Security and Adaptation: Empirical, Cultural and Theoretical Considerations.' In P.M. Crittenden and A.H. Claussen (eds) *The Organisation of Attachment Relationships: Maturation, Culture and Context.* Cambridge: Cambridge University Press.

Cummings, C., Dyson, A. and Todd, L. (2011) *Beyond the School Gates: Can Full Service and Extended Schools Overcome Disadvantage?* London: Routledge.

Cushman, P. (1990) 'Why the self is empty. Towards a historically situated psychology.' *American Psychologist 45,* 599–611.

Dabbs, J.M. (1969) 'Similarity of gestures and interpersonal influence.' *Proceedings of the annual convention of the American Psychological Association 77,* 4 , 337–338.

Dallos, R. (2010) *Attachment Narrative Therapy. Integrating Narrative, Systemic and Attachment Therapies.* Maidenhead, Berkshire: Open University Press.

Daniels, H. (1993) *Charting the Agenda. Educational Activity after Vygotsky.* London: Routledge.

Daniels, H. (1996) *An Introduction to Vygotsky.* London: Routledge.

Darwin, C. (1872) *The Expression of Emotion in Man and Animals.* London: Methuen.

Darwin, C. (1877) 'A biographical sketch of an infant.' *Mind 2,* 285–294.

DataPrev (2011) *Mental Health Prevention Focusing on Parenting.* DataPrev. Available at www.dataprevproject.net/Parenting_and_Early_Years, accessed on 3 January 2011.

Davis, A. (2009) (personal communication, 28 September 2009) Professor. Director UNHS.

Davis, B. and Cahill, S. (2006) 'Challenging expectations for every child through innovation, regeneration and reinvention.' *Educational and Child Psychology 23,* 1, 80–91.

Davis, H. (2009) 'The Family Partnership Model: Understanding the Processes of Prevention and Early Intervention.' In J. Barlow and P.O. Svanberg (2009) *Keeping the Baby in Mind.* London and New York, NY: Routledge.

Davis, H. and Day, C. (2010) *Working in Partnership: The Family Partnership Model* London: Pearson.

DCSF (Department for Children, Schools and Families) (2008) *Commissioning Resources from Strategy to Delivery. Key Variables Affecting the Implementation of Parenting Strategies.* Available at www.dcsf.gov.uk/everychildmatters/strategy/parents/pip/PIPrkstrategytodelivery /PIPstrategytodelivery/, accessed on 14 September 2010.

De Jong, P. and Kimberg, I. (2002) *Interviewing for Solutions* (2nd edn). Pacific Grove, CA: Brooks/Cole.

De Wolff, M.S. and Van IJzendoorn, M.H. (1997) 'Sensitivity and attachment: A meta-analysis on parental antecedents of infant attachment.' *Child Development, 68,* 571–591.

Deakin Crick, R., Coates, M., Taylor, M. and Ritchie, S. (2004) *A Systematic Review of the Impact of Citizenship Education on the Provision of Schooling.* Research Evidence in Education Library. London: Evidence for Policy and Practice Coordinating Centre Department for Education and Skills. Available at http://eppi.ioe.ac.uk/cms/Default.aspx?tabid=127, accessed on 21 May 2010.

DeCasper, A.J. and Spence, M.J. (1986) 'Prenatal maternal speech influences newborns' perception of speech sounds.' *Infant Behavior and Development 9*, 133–150.

Degroat, J.S. (2003) 'Parental stress and emotion attributions as correlates of maternal positive affect and sensitivity during interaction with young children.' *Dissertation Abstracts International. Section B: The Sciences and Engineering*, 64, 2383.

Dekker, J., Hoogland, M., Eliëns, M. and van der Giessen, J. (2004) *Video-interactiebegeleiding* [Video interaction guidance]. Houten: Bohn Stafleu Van Loghum.

Dekker, T. and Biemans, H.M.B. (1994) *Video-hometraining in gezinnen* [Video home training in families]. Houten/Zaventhem: Bohn Stafleu Van Loghum.

Den Otter, M. (ed.) (2009) *De School Video Interactie Begeleider (The School Video Interaction Coach)*. Antwerp-Apeldoorn, the Netherlands: Fontys OSO and Uitgevers Garant

Department of Health (1995) Child Protection: Messages From Research. London: HMSO.

Devito, J.A. (2009) *The Interpersonal Communication Book* (12th edn). Upper Saddle River, NJ: Pearson Education.

Dissanayake, E. (2000) *Art and Intimacy: How the Arts Began*. Seattle and London: University of Washington Press.

Donaldson, M. (1992) *Human Minds: An Exploration*. London: Allen Lane/Penguin Books.

Doria, M.V., Kennedy, H., Strathie, C., Strathie, S. and Adams, M. (2009) *How Does Video Interaction Guidance Work? Explanations for the Success of VIG as a Therapeutic Tool in Family Work*. Available at http://tiny.cc/dor11, accessed on 5 July 2011.

Doria, M.V., Kennedy, H., Strathie, C., Strathie, S. and Adams, M. (2011) *Explanations for the Success of Video Interaction Guidance (VIG) as a Therapeutic Tool in Family Work*. Available at http://tiny.cc/dorken09, accessed on 5 July 2011.

Dowrick, P.W. (1989) 'Video Training Strategies for Beginners, Champions, and Injured Athletes.' In A.A. Turner (ed.) *Arctic Sports Medicine: Proceedings of the American College of Sports Medicine Conference 1–9*. New York, NY: University of Alaska Press.

Dowrick, P.W. (1991) *Practical Guide to Using Video in the Behavioral Sciences*. New York, NY: Wiley.

Dowrick, P.W. (1999) 'A review of self modeling and related interventions.' *Applied and Preventive Psychology 8*, 1, 23–39.

Dowrick, P.W. (2009) Personal communication (email) to Miriam Landor, 12 May 2009.

Dowrick, P.W. (2011) 'Self model theory: Learning from the future.' Invited article, WIREs Cognitive Science.

Dowrick. P.W. and Dove, C. (1980) 'The use of self-modeling to improve the swimming performance of spina bifida children.' *Journal of Applied Behavior Analysis* 13, 51–56. Cited in P.W. Dowrick (1999) 'A review of self-modeling and related interventions.'.

Dowrick, P.W. and Hood, M. (1978) 'Transfer of Talking Behaviours Across Settings using Faked Films.' In E.L. Glynn and S.S. McNaughton (eds) *Proceedings of New Zealand Conference for Research in Applied Behaviour Analysis*. Auckland, NZ: Auckland University Press. Cited in P.W. Dowrick (1999) 'A review of self-modeling and related interventions.' *Applied and Preventive Psychology* 8, 23–39.

Dowrick, P.W., Kim-Rupnow, W.S. and Power, J.P. (2006) 'Video feedforward for reading.' *Journal of Special Education 39*, 4 194–207.

Dowrick, P.W. and Raeburn, J.M. (1977) 'Video-editing and medication to produce a therapeutic self-model.' *Journal of Consulting and Clinical Psychology 7*, 1, 25–37. Cited in P.W. Dowrick (1999) 'A review of self-modeling and related interventions.' *Applied and Preventive Psychology* 8, 23–39.

Dowrick, P.W., Tallman, B.I. and Connor, M.E. (2005) 'Constructing better futures via video.' *Journal of Prevention and Intervention in the Community 29*, 1/2, 131–144.

Dozier, M., Peloso, E., Lindheim, O., Gordon, M.K. *et al.* (2006) 'Developing evidence-based interventions for foster children: An example of a randomized clinical trial with infants and toddlers.' *Journal of Social Issues 62*, 4, 765–783.

Dunn, L., Dunn, L.M., Whetton, C. and Burley, J. (2005) *British Picture Vocabulary Scale* (2nd edn). London: GL Assessment.

Dunsmuir, S., Brown, E., Iyadurai, S. and Monsen, J. (2009) 'Evidence-based practice and evaluation: from insight to impact.' *Educational Psychology in Practice 25*, 1, 53–70.

Dunsmuir, S. and Leadbetter, J. (2010) *Professional Supervision: Guidelines for Practice for Educational Psychologists.* Leicester: BPS.

Dweck, C.S. (2000) *Self-theories: Their Role in Motivation, Personality and Development.* Philadelphia, PA: Psychology Press.

Dweck, C.S. (2006) *Mindset: The New Psychology of Success.* New York, NY: Ballatine.

Edwards, A. and D'Arcy, C. (2004) 'Relational agency and disposition in sociocultural accounts of learning to teach.' *Education Review 56*, 2, 147–155.

Egeland, B., Weinfield, N.S., Bosquet, M. and Cheng, V.K. (2000) 'Remembering, Repeating, and Working Through: Lessons from Attachment-based Interventions.' In J.D. Osofsky and H.E. Fitzgerald (eds) *WAIMH Handbook of Infant Mental Health, vol. 4.* New York, NY: John Wiley and Sons, 38–89.

Eifert, G.H. and Forsyth, J.P. (2005) *Acceptance and Commitment Therapy for Anxiety Disorders. A Practitioner's Treatment Guide to Using Mindfulness, Acceptance and Values-Based Behaviour Change Strategies.* Oakland, CA: New Harbinger Publications.

Eliëns, M. (2005) *Baby's in beeld: Video-hometraining en video-interactiebegeleiding bij kwetsbare baby's* [Babies in the picture: Video home training and video interaction guidance with vulnerable babies]. Amsterdam: SWP.

Eliëns, M. (2010) *Babies in the picture; Video home training and video interaction guidance with vulnerable babies* (1st tanslated edn). Amsterdam: SWP.

Eliëns, M. and Prinsen, B. (2008) *Handleiding kortdurende video-hometraining in gezinnen met jonge kinderen: Voor professionals in de jeugdgezondheidszorg* [Manual on the short version of video interaction guidance for families with young children: For professionals in preventive child healthcare]. Santpoort-Noord: AIT.

Emde, R.N. (1983) 'The prerepresentational self and its affective core.' *Psychoanalytic Study of the Child* 38, 165–192.

Epstein, J.L. and Saunders, M.G. (2000) 'Connecting Home, School, and Community: New Directions for Social Research.' In M.T. Hallinan (ed.) *Handbook of the Sociology of Education.* New York: Kluwer Academic/Plenum Publishers, 285–306.

Epston, D. (2011) *About Narrative Therapy with Children.* Available at www.narrativeapproaches. com/narrative%20papers%20folder/narrative_therapy.htm, accessed on 6 February 2011.

Eraut, M. (2000) 'Non-formal learning and tacit knowledge in professional work.' *British Education Research Journal 70*, 1, 113–136.

Erikson, E. and Erikson, J.M. (1997) *The Life Cycle Completed.* New York, NY: W.W. Norton.

Fairbairn, W.R.D. (1952) *An Object Relations Theory of Personality.* New York, NY: Basic Books.

Falender, C.A. and Shafranske, E.P. (2004) *Clinical Supervision: A Competency-based Approach.* Washington, DC: American Psychological Association.

Fattore, T. and Turnbull, N. (2005) 'Theorizing Representation of and Engagement with Children: The Political Dimension of Child-orientated Communication.' In J. Mason and T. Fattore (eds) *Children Taken Seriously: In Theory, Policy and Practice.* London and Philadelphia, PA: Jessica Kingsley Publishers, 46–57.

Fearon, R.P., Bakermans-Kranenburg, M.J., Marinus, H., van IJzendoorn, M.H., Lapsley, A. and Roisman, G.I. (2010) 'The significance of insecure attachment and disorganization in the development of children's externalizing behaviour: a meta-analytic study.' *Child Development 81*, 435–456.

Festinger, L. (1957) *A Theory of Cognitive Dissonance.* Stanford, CA: Stanford University Press.

Feuerstein, R. and Feuerstein, S. (1991) 'Mediated Learning Experience: A Theoretical Review.' In R. Feuerstein, P.S. Klein and A.J. Tannenbaum (eds) *Mediated Learning Experience (MLE): Theoretical, Psychosocial, and Learning Implications.* London: Freund, 3–51.

Field, T., Deeds, O., Diego, M., Hernandez-Reif, M. *et al.* (2009) 'Benefits of combining massage therapy with group interpersonal psychotherapy in prenatally depressed women.' *Journal of Bodywork and Movement Therapies 13*, 4, 297–303.

Fielding, M. (2004) 'Transformative approaches to student voice: theoretical underpinnings, recalcitrant realities.' *British Education Research Journal 30*, 2, 295–311.

Figueira, J. (2007) 'The effects of video self-modelling on the compliance rates of high school students with developmental disabilities.' Masters thesis submitted to the faculty of Brigham Young University, August 2007.

Findlay, K. (2006) 'The mirror, the magnifying glass and the map. An action research approach to raising educational psychologist's awareness of supervision skills.' MSc dissertation, University of Dundee. Available at http://tiny.cc/fin06, accessed 5 July 2011.

Fonagy, P. (2009) *Trauma and the Neuroscience of Attachment: Intersubjectivity via Contingent Marked Mirroring.* VIG IRC, University of Dundee. Available at http://tiny.cc/fon09, accessed on 5 July 2011.

Fonagy, P. and Bateman, A.W. (2006) 'Mechanisms of change in mentalization-based treatment of BPD.' *Journal of Clinical Psychology 62*, 4, 411–430.

Fonagy, P., Gergely, G., Jurist, E.L. and Target, M. (2002) *Affect Regulation, Mentalization, and the Development of the Self.* New York, NY: Other Press.

Fonagy, P., Gergely, G. and Target, M. (2007) 'The parent–infant dyad and the construction of the subjective self.' *Journal of Child Psychology and Psychiatry 48*, 3/4, 288–328.

Fonagy, P., Steele, H., Steele, M. and Holder, J. (1997) 'Attachment and theory of mind: Overlapping constructs?' *Association for Child Psychology and Psychiatry Occasional Papers 14*, 31–40.

Fonagy, P., Steele, M., Steele, H., Moran, G.S. and Higgitt, A. (1991) 'The capacity for understanding mental states: the reflective self in parent and child and its significance for security of attachment.' *Infant Mental Health Journal 12*, 201–218.

Fonagy, P. and Target, M. (1997) 'Attachment and reflective function: Their role in self organisation.' *Development and Psychopathology 9*, 679–700.

Forrester, D., Kershaw, S., Moss, H. and Hughes, L. (2008) 'Communication skills in child protection: how do social workers talk to parents?' *Child and Family Social Work 13*, 1, 41–51.

Forsyth, H., Kennedy, H. and Simpson, R. (1996) 'Video interaction guidance in schools – we've looked at life from both sides now.' (unpublished papers) Dundee: Dundee Educational Psychology Service.

Forsyth, P. (2008) 'Video feedforward.' Presentation. Dundee VIG Network Meeting (March 2008) Educational Developmental Service, Dundee.

Forsyth, P. and Thurston, A. (2007) 'Video enhanced reflective practice and communication.' Presentation at Royal College of Nursing, International Nursing Research Conference, Dundee.

Forsythe, K. (2010) 'Promoting strengths and empowering classroom assistants.' PhD thesis, Queens University, Belfast. Available at http://tiny.cc/for10, accessed on 5 July 2011.

Foucault, M. (1979) *Discipline and Punish: The Birth of the Prison.* London: Penguin Books.

Foucault, M. (1984) *The History of Sexuality.* London: Penguin Books.

Fraiberg, S. (1977) *Insights from the Blind.* London: Souvenir.

Fraiberg, S. (1980) *Clinical Studies in Infant Mental Health: The First Year of Life.* London: Tavistock.

Freedman, J. and Coombs, G. (1996) *Narrative Therapy. The Social Construction of Preferred Realities.* London: W.W. Norton.

Freidson, E. (1994) *Professionalism Reborn: Theory, Prophecy and Policy* London: Polity Press.

Freud, S. (1940) 'An Outline of Psycho-Analysis.' In R.N. Emde (1983) 'The prerepresentational self and its affective core.' *Psychoanalytic Study of the Child, 38,* 165–192.

Frith, U. (2003) *Autism: Explaining the Enigma* (2nd edn). Oxford: Blackwell Publishing.

Fruggeri, L. (2005) 'Different Levels of Analysis in the Supervisory Process.' In D. Campbell and B. Mason (eds) *Perspectives on Supervision* (3rd edn). London: Karnac.

Fukkink, R.G. (2008) 'Video feedback in widescreen: A meta-analysis of family programs.' *Clinical Psychology Review 28*, 6, 904–916.

Fukkink, R. and Tavecchio, L. (2010) 'Effects of video interaction guidance on early childhood teachers.' *Teaching and Teacher Education 26*, 8, 1652–1659.

Fukkink, R., Trienekens, N. and Kramer, L. (2011) 'Video feedback in education and training: putting learning in the picture.' *Educational Psychology Review 23*, 1, 45–63.

Gadalla, Y. and Phimister, E. (1996) 'After two bites of the cherry: video interaction guidance in the Frances Wright Pre-school Centre.' SPIN*VIP In Schools Conference paper. Tayside Educational Psychology Service.

Gallese, V., Fadiga, L., Fogassi, L. and Rizzolatti, G. (1996) 'Action recognition in the premotor cortex.' *Brain*, 119, 593–609.

Gallese, V., Keysers, C. and Rizzolatti, G. (2004) 'A unifying view of the basis of social cognition.' *Trends in Cognitive Sciences 8*, 396–403.

Gavine, D. and Simpson, R. (2006) *Enhancing Practice in Formative Assessment by Means of Video-Feedback.* VIG IRC, University of Dundee. Available at http://tiny.cc/gavsim06, accessed on 7 July 2011.

Gergen, K.J. (2001) *Social Construction in Context.* London: Sage.

Gerhardt, S. (2004) *Why Love Matters: How Affection Shapes a Baby's Brain.* London: Routledge.

Gillespie, A., Cornish, F., Aveling, E. and Zittoun, T. (2008) 'Conflicting community commitments: analysis of a British woman's World War II diaries.' *Journal of Community Psychology 36*, 1, 35–52.

Goldenberg, H. and Goldenberg, I. (2008) *Family Therapy: An Overview* (7th edn). Belmouth, CA: Thomson Brooks Cole.

Goldsmith, H.H. and Alansky, J.A. (1987) 'Maternal and infant temperamental predictors of attachment: A meta-analytic review.' *Journal of Consulting and Clinical Psychology, 55*, 805–816.

Goleman, D. (2002) *Primal Leadership: Realizing the Power of Emotional Intelligence.* Boston, MA: Harvard Business School Press.

Goleman, D. (2007 [2006]) *Social Intelligence: The New Science of Human Relations.* London: Arrow Books, Random House Group Ltd.

Gorski, C. and Minnis, M. (in prep.) 'Feeding forward to a miracle day – a pilot study of a video intervention in Reactive Attachment Disorder'. Available from charlotta.gorski@ggc.scot.nhs.uk.

Gratier, M. and Trevarthen, C. (2008) 'Musical narrative and motives for culture in mother-infant vocal interaction.' *Journal of Consciousness Studies 15*, 10/11, 122–158.

Greenberg, M.T. (1999) 'Attachment and Psychopathology in Childhood.' In J. Cassidy and P.R. Shaver (eds) *Handbook of Attachment: Theory, Research, and Clinical Applications.* New York, NY: The Guilford Press, 469–496.

Gregory, S. (1995) *Deaf Children and their Families.* Cambridge: Cambridge University Press.

Grossen, M. (2010) 'Interaction analysis and psychology.' *Integrative Psychological and Behavioural Science 44*, 1, 1–22.

Habermas, J. (1987) *The Theory of Communicative Action. Volume Two: System and Lifeworld.* Cambridge: Polity Press.

Hadjikhani, N., Joseph, R.M., Snyner, J. and Tager-Flusberg, H. (2006) 'Anatomical differences in the mirror neuron system and social cognition network in autism.' *Cerebral Cortex 16*, 9, 1276–1282.

Häggman-Laitila, A., Pietilä, A.-M., Friis, L. and Vehviläinen-Julkunen, K. (2003) 'Video home training as a method of supporting family life control.' *Journal of Clinical Nursing,* 12, 93–106.

Häggman-Laitila, A., Seppänen, R., Vehviläinen-Julkunen, K. and Pietilä, A.-M. (2010) 'Benefits of video home training on families' health and interaction: evaluation based on follow-up visits.' *Journal of Clinical Nursing,* 19, 3504–3515.

Halliday, M.A.K. (1975) *Learning How to Mean: Explorations in the Development of Language.* London: Edward Arnold.

Hammond, S.A. (1996) *The Thin Book of Appreciative Inquiry* Bend, OR: Thin Book Publishing Company.

Happé, F. (1999) 'Understanding assets and deficits in autism: why success is more interesting than failure.' *Psychologist 12*, 11, 540–547.

Hattie, J. (1999) 'Influences on student learning.' University of Auckland. Available at www.education.auckland.ac.nz/uoa/home/about/staff/j.hattie/hattie-papers-download/influences, accessed on 1 February 2011.

Hattie, J. (2009) *Visible Learning.* Oxford: Routledge.

Hattie, J. and Timperley, H. (2007) 'The power of feedback.' *Review of Educational Research 77*, 1, 81–112.

Hawkins, P. and Shohet, R. (2000) *Supervision in the Helping Professions* (2nd edn). Buckingham: Open University Press.

Hayes, S.C. and Smith, S. (2005) *Get Out of Your Mind and Into Your Life. The New Acceptance and Commitment Therapy.* Oakland, CA: New Harbinger Publications.

Hayes, S.C., Strosahl, K.D. and Wilson, K.G. (1999) *Acceptance and Commitment Therapy: An Experiential Approach to Behavior Change.* New York, NY: The Guilford Press.

Heard, D., Lake, B. and McCluskey, U. (2009) *Attachment Therapy with Adolescents: Theory and Practice Post Bowlby.* London: Karnac Books.

Hedges, F. (2005) *An Introduction to Systemic Therapy for Individuals.* London: Palgrave Macmillan.

Hewett, D. and Nind, M. (1992) 'Returning to the Basics: A Curriculum at Harperbury Hospital School.' In T. Booth, W. Swann, M. Masterton and P. Potts (eds) *Curricula for Diversity in Education.* London: Routledge.

Hewitt, J. (2009) 'Video Interaction Guidance: A training tool for classroom assistants working in mainstream classrooms.' Submitted in part-fulfilment of the Doctorate in Educational, Child and Adolescent Psychology. Belfast: Queen's University.

Hewson, J. (2001) 'Integrative Supervision: Art and Science.' In M. Carroll and M. Tholstrup (eds) *Integrative Approaches to Supervision.* London: Jessica Kingsley Publishers.

Hick, S.F. (2008) 'Cultivating Therapeutic Relationships.' In S.F. Hick and T. Bien (eds) *Mindfulness and the Therapeutic Relationship.* New York, NY: The Guilford Press.

Hill, M., Davis, J., Prout, A. and Tidsall, K. (2004) 'Moving the participation agenda forward.' *Children and Society, 18,* 77–96.

Hitchcock, C.H., Dowrick, P.W. and Prater, M.A. (2003) 'Video self-modeling intervention in school-based settings – A review.' *Remedial and Special Education 24,* 1, 36–45, 56.

HMIe (2009) *Video Interaction Guidance.* Dundee Educational Psychology Service. Available at www.journeytoexcellence.org.uk/videos/dundeecity.asp, accessed on 12 March 2010.

Hobson, P. (2002) *The Cradle of Thought.* Oxford: Macmillan.

Holdstock, L. (1993) 'Can we afford not to revision the person-centred concept of self?' In D. Brazier (ed.) *Beyond Carl Rogers: Towards a psychotherapy for the 21st Century.* London: Constable.

Hollway, W. and Jefferson, T. (2000) *Doing Qualitative Research Differently.* London: Sage.

Holquist, M. (1990) *Dialogism: Bakhtin and his World.* London: Routledge.

Hosford, R.E. (1980) 'Self-as-a-model: A cognitive, social learning technique.' *Counseling Psychology 9,* 1, 45–62. Cited in P.W. Dowrick (1999) 'A review of self-modeling and related interventions.' *Applied and Preventive Psychology 8,* 23–39.

Hoskins, G. (1999) Digging up the roots of violence (1999) Wavetrust.org www.wavetrust. org/key-publications/articles/digging-roots-violence-1999

House, J. and Portuges, S. (2005) 'Relational knowing, memory, symbolization, and language: Commentary on the Boston Change Process Study Group.' *Journal of the American Psychoanalytic Association 53,* 3, 731–744.

Howe, D. (2005) *Child Abuse and Neglect, Attachment, Development and Intervention.* Basingstoke: Palgrave Macmillan.

Hubley, P. and Trevarthen, C. (1979) 'Sharing a Task in Infancy.' In I. Uzgiris (ed.) *Social Interaction During Infancy (New Directions for Child Development 4),* 57–80. San Francisco, CA: Jossey-Bass.

Hughes, D. (2006) *Building the Bonds of Attachment: Awakening Love in Deeply Traumatized Children* (2nd edn). Lanham, MD: Rowman and Littlefield.

Hundeide, K. (1991) *Helping Disadvantaged Children* London: Jessica Kingsley Publishers.

Hynd, S. and Khan, S. (2004) 'Identity and the experience of postnatal depression: the use of Video Interaction Guidance.' *Journal of Psychiatric and Mental Health Nursing 11*, 738–741.

Iacoboni, M. (2008) *Mirroring People: The New Science of how we Connect with Others.* New York: Farrar, Straus and Giroux.

Iacoboni, M., Woods, R.P., Brass, M., Bekkering, H., Mazziotta, J.C. and Rizzolatti, G. (1999) 'Cortical mechanisms of human imitation.' *Science 286*, 2526–2528.

Inskipp, F. and Proctor, B. (2001) *Making the Most of Supervision* (2nd edn). London: Cascade.

James, D., Graham, A., Johnson, P., Falck, C. and Collins, L. (2011 submitted for publication) Video Interaction Guidance in the context of childhood hearing impairment: A tool for family-centred practice.

Jansen, R.J.A.H. and Wels, P.M.A. (1998) 'The effects of video home training in families with a hyperactive child.' Association for Child Psychology and Psychiatry, occasional papers, 15, 63–73.

Janssens, J.M.A.M. and Kemper, A.A.M. (1996) 'Effects of video hometraining on parental communication and a child's behavorial problems.' *International Journal 2*, 137–148.

Jessup, H. and Rogerson, S. (2004) 'Postmodernism and the Teaching and Practice of Interpersonal Skills.' In M. Robb, S. Barrett, C. Komaromy and A. Rogers (eds) *Communication, Relationships and Care: A Reader.* London: Routledge.

Juffer, F., Bakermans-Kranenburg, M.J. and Van IJzendoorn, M.H. (2008) *Promoting Positive Parenting: An Attachment-Based Intervention.* Hillsdale, NJ: Lawrence Erlbaum Associates.

Juffer, F., Bakermans-Kranenburg, M.J. and Van IJzendoorn, M.H. (2005a) 'Enhancing children's socio-emotional development: A review of intervention studies.' In D.M. Teti (ed.), *Handbook of Research Methods in Developmental Psychology.* Oxford: Blackwell Publishers, 213–232.

Juffer, F., Bakermans-Kranenburg, M.J. and Van IJzendoorn, M.H. (2005b) 'The importance of parenting in the development of disorganized attachment: evidence from a preventive intervention study in adoptive families.' *Journal of Child Psychology and Psychiatry 46*, 3, 263–274.

Juffer, F., Hoksbergen, R.A.C., Riksen-Walraven, J.M. and Kohnstamm, G.A. (1997) 'Early intervention in adoptive families: Supporting maternal sensitive responsiveness, infant-mother attachment, and infant competence.' *Journal of Child Psychology and Psychiatry 38*, 8, 1039–1050.

Kabat-Zinn, J. (1990) *Full Catastrophe Living: Using the Wisdom of your Body and Mind to Face Stress, Pain and Illness.* New York, NY: Dell.

Kadushin, A. (1976) *Supervision in Social Work* (3rd edn). New York, NY: Columbia University Press.

Kahn, P.E., Young, R., Grace, S., Pilkington, R., Rush, L., Tomkinson, C.B. and Willis, I. (2006) *The Role and Effectiveness of Reflective Practices in Programmes for New Academic Staff: A Grounded Practitioner Review of the Research Literature.* York: Higher Education Academy. Available at www.heacademy.ac.uk/www.heacademy.ac.uk/assets/York/documents/ourwork/archive/reflective_practice_full_report.pdf, accessed on 5 July 2011.

Kalinauskiene, L., Cekuoliene, D., Van IJzendoorn, M.H., Bakermans-Kranenburg, M.J., Juffer, F. and Kusakovskaja, I. (2009) 'Supporting insensitive mothers: The Vilnius randomized control trial of video-feedback intervention to promote maternal sensitivity and infant attachment security.' *Child: Care, Health and Development* 35, 613–623.

Kampfe, C.M., Harrison, M., Orringer, T., Ludington, J., McDonald-Bell, C. and Pillsbury, H.C. III. (1993) 'Parental expectations as a factor in evaluating children for the multichannel cochlear implant.' *American Annals of the Deaf* 138, 297–303.

Kang, M.J. (2006) 'Quality of mother-child interaction assessed by the Emotional Availability Scale: Associations with maternal psychological well-being, child behaviour problems and child cognitive functioning,' *Dissertation Abstracts International. Section B: The Sciences and Engineering*, 66.

Karremans, J.C. and Van Lange, P.A.M. (2008) 'Forgiveness in personal relationships: its malleability and powerful consequences.' *European Review of Social Psychology 19*, 202–241.

Kaye, K. (1977) 'Toward the origin of dialogue.' In H.R. Schaffer (ed.) *Studies in Mother-infant Interaction*, London: Academic Press.

Kaye, G., Forsyth, P. and Simpson, R. (2000) 'Effective interaction in the classroom-towards a new viewpoint.' *Educational and Child Psychology 17*, 4, 69–90.

Kemper, A. (2004) 'Intensieve vormen van thuisbehandeling; Doelgroep, werkwijze en uitkomsten' [Intensive forms of home treatment; Target group, method and outcomes]. NIJmegen: n.p.

Kennedy, H. (2001) *Can a Sure Start Intervention Show Measurable Gains?* Poster presentation, University of Dundee International Research conference. Available at http://tiny.cc/kenn01, accessed on 5 July 2011.

Kennedy, H. (2008) *Why Does VIG Work?* 2008 BPS European Coaching Psychology Conference. Available at http://intranet.spinlink.eu/files/get/6478?hlandf=Hilary+coaching+conf+dec+2008.pdf, accessed on 3 February 2011.

Kennedy, H., Landor, M. and Todd, L. (2010) 'Video Interaction Guidance as a method to promote secure attachment.' *Educational and Child Psychology 27*, 3, 59–72.

Kennedy, H. and Sked, H. (2008) 'Video Interaction Guidance: a Bridge to Better Interactions with Individuals with Communication Impairments.' In M.S. Zeedyk (ed.) *Promoting Social Interaction for Individuals with Communicative Impairments: Making Contact.* London: Jessica Kingsley Publishers.

Kennedy, I. (2010) *Getting it Right for Children and Young People: Overcoming Cultural Barriers in the NHS so as to Meet their Needs.* Department of Health (ed.), Crown Copyright.

Klein Velderman, M. (2005) *The Leiden VIPP and VIPP-R Study: Evaluation of a Short-term Preventive Attachment-based Intervention in Infancy.* Leiden: Mostert and Van Onderen.

Klein Velderman, M., Bakermans-Kranenburg, M.J., Juffer, F., Van IJzendoorn, M.H. *et al.* (2006) 'Preventing preschool externalizing behavior problems through video-feedback.' *Infant Mental Health Journal 27*, 5, 466–493.

Klein Velderman, M., Juffer, F., Bakermans-Kranenburg, M.J. and Van IJzendoorn, M.H. (2008) 'A Case Study and Process Evaluation of Video Feedback to Promote Positive Parenting Alone and with Representational Attachment Discussions.' In F. Juffer, M.J. Bakermans-Kranenburg and M.H. Van IJzendoorn (eds) *Promoting Positive Parenting: An Attachment-based Intervention.* Hillsdale, NJ: Lawrence Erlbaum Associates, 23–36.

Klein Velderman, M., Pannebakker, F.D., Fukkink, R.G., De Wolff, M.S. *et al.* (2011). *De effectiviteit van kortdurende video-hometraining in de jeugdgezondheidszorg: Resultaten van een studie in gezinnen met overmatige spanning als gevolg van een excessief huilende baby.* [The effects of short-term VIG in preventive child healthcare: Results of a study in families with worries about excessive infant crying.] Leiden: TNO, Department of Child Health.

Knapp, M.L. and Hall, J.A. (2007) *Nonverbal Communication in Human Interaction* (7th edn). Belmont, CA: Thomson Wadsworth.

Knott, C. and Scragg, T. (2007) *Reflective Practice in Social Work.* Exeter: Learning Matters.

Knowles, W. and Masidlover, M. (1982) The Derbyshire Language Scheme. Language test published by Derbyshire County Council.

Kugiumutzakis, G. (1993) 'Intersubjective Vocal Imitation in Early Mother-infant Interaction.' In J. Nadel and L. Camaioni (eds) *New Perspectives in Early Communicative Development.* London: Routledge.

Kugiumutzakis, G. (1998) 'Neonatal Imitation in the Intersubjective Companion Space.' In S. Bråten (ed.) *Intersubjective Communication and Emotion in Early Ontogeny.* Cambridge: Cambridge University Press, 63–88.

Lambert, M.J. (1992) 'Implications of Outcome Research for Psychotherapy Integration.' In J.C. Norcross and M.R. Goldfried (eds) *Handbook of Psychotherapy Integration.* New York, NY: Basic Books, 94–129.

Lambert, M.J. and Bergin, A. (1994) 'The Effectiveness of Psychotherapy.' In S. Garfield and A. Bergin (eds) *Handbook of Psychotherapy and Behaviour Change.* New York, NY: Wiley, 143–189.

Lambert, M.J. and Ogles, B.M. (2004) 'The Efficacy and Effectiveness of Psychotherapy.' In M.J. Lambert (ed.) *Bergin and Garfield's Handbook of Psychotherapy and Behavior Change* (5th edn). New York, NY: Wiley, 139–193.

Lambert, M.J. and Simon, W. (2008) 'The Therapeutic Relationship. Central and Essential in Psychotherapy Outcome.' In S.F. Hick and T. Bien (eds) *Mindfulness and the Therapeutic Relationship.* New York, NY: The Guilford Press.

La Mothe, R. (2007) 'Beyond intersubjectivity: personalisation and community.' *Psychoanalytic Psychology 24,* 2, 271–288.

Landor, M., Brown, F., Cameron, L., Wood, L. and Strathie, C. (2009) *Video FeedForward for Change – Transitions to a Preferred Future.* Available at http://tiny.cc/lanstr09, accessed on 5 July 2010.

Langer, E. (2002) 'Well-being: Mindfulness Versus Positive Evaluation.' In C.R. Snyder and S.J. Lopez (eds) (2007) *The Handbook of Positive Psychology.* New York, NY: Oxford University Press.

Landry, S.H., Smith, K.E. and Swank, P.R. (2006) 'Responsive parenting: Establishing early foundations for social, communication, and independent problem-solving skills.' *Developmental Psychology 42,* 627–642.

Lantz, J. (2005) 'Using self-modeling to increase the pro-social behaviour of children with autism and their siblings.' *Dissertation Abstracts International 66,* 2.

Layard, R. (2006) 'The case for psychological treatment centres.' *British Medical Journal 332,* 1023–1032.

Learning and Teaching Scotland (2005a) *Video Interaction Guidance: Putting the Focus on the Reflective Practitioner.* Available at www.google.co.uk/search?sourceid=navclient&ie=UTF-8&rlz=1T4ADBR_enGB327GB329&q=Video+Interaction+Guidance+%28V.I.G.%29%3a+putting+the+focus+on+the+reflective+practitioner, accessed on 3 February 2011.

Learning and Teaching Scotland (2005b) *Harris Academy Dundee: Work with a Group: Supporting Youngsters who have Autistic Spectrum Disorder.* Dundee City Education Department. Inclusive Education website.

Leddick, G.R. and Bernard, J.M. (1980) 'The history of supervision: A critical review.' *Counselor Education and Supervision 19,* 3, 186–196.

Leichsenring, F. (2001) 'Comparative effects of short-term psychodynamic psychotherapy and cognitive-behavioral therapy in depression: A meta-analytic approach.' *Clinical Psychology Review 21,* 3, 401–419.

Lennon, L. (2003) *Using Video Interaction Guidance With a Special Educational Needs Auxiliary to Promote Development of a Visually Impaired Child in Transition from Nursery to Primary One: A Child Case Study.* University of Dundee. Available at http://tiny.cc/lenn03, accessed on 5 July 2011.

Lennon, L. and Philp, S. (2003) *Adapting Video Interaction Guidance as a Tool for Training Auxiliary Staff Within Schools: Evaluation of a Pilot Project.* Available at http://tiny.cc/lenn03, accessed on 5 July 2011.

Lester, B.M., Boukydis, C.F.Z., Garcia-Coll, C.T., Holl, W.T. and Peucker, M. (1992) 'Infantile colic: Cry characteristics, maternal perception of cry, and temperament.' *Infant Behaviour and Development 15,* 15–26.

Lishman, J. (ed.) (2007 [1991]) *Handbook for Practice Learning in Social Work and Social Care.* London: Jessica Kingsley Publishers.

Lock, A. (ed.) (1978) *Action, Gesture and Symbol: The Emergence of Language.* London, New York and San Francisco, CA: Academic Press.

Locke, A. and Beech, M. (1991) *Teaching Talking Kennedy* (2001) Windsor: NFER-Nelson.

Loughran, I. (2010) 'VIG with siblings on the autistic continuum.' Doctorate in educational psychology thesis, Queens University, Belfast. Available at http://tiny.cc.lough10, accessed on 5 July 2011.

Lunt, I. and Sayeed, Z. (1995) 'Support for educational psychologists in their first year of professional practice: induction and supervision arrangement for newly qualified educational psychologists.' *Educational and Child Psychology 12,* 2, 25–30.

Macready, T. (2009) 'Learning social responsibility in schools: a restorative practice.' *Educational Psychology in Practice 25,* 3, 211–220.

Magill-Evans, J., Harrison, M.J., Benzies, K., Gierl, M. and Kimak, C. (2007) 'Effects of parenting education on first-time fathers' skills in interaction with their infants.' *Fathering 5,* 42–57.

Malloch, S. and Trevarthen, C. (eds) (2010a) *Communicative Musicality: Exploring the Basis of Human Companionship.* Oxford: Oxford University Press.

Malloch, S. and Trevarthen, C. (2010b) 'Musicality: Communicating the Vitality and Interests of Life.' In S. Malloch and C. Trevarthen (eds) *Communicative Musicality: Exploring the Basis of Human Companionship.* Oxford: Oxford University Press, 1–11.

Markova, I. (2003) 'Constitution of the self: intersubjectivity and dialogicality.' *Culture and Psychology 9,* 3, 249–259.

Markova, I., Linell, P., Grossen, M. and Orvig, A.S. (2007) *Dialogue in Focus Groups: Exploring Socially Shared Knowledge.* London and Oakville: Equinox.

Marvin, R.S. and Britner, P.A. (1999) 'Normative Development: The Ontogeny of Attachment.' In J. Cassidy and P.R. Shaver (eds), *Handbook of Attachment: Theory, Research, and Clinical Applications.* New York, NY: The Guilford Press, pp. 44–67.

McCartan, D. (2009) *Using Video to Promote the Development of a Collaborative Approach between Parents and Teachers around Pupil Behaviour.* (Doctoral dissertation) Newcastle: Newcastle University.

McCluskey, U. (2005) *To Be Met as a Person: The Dynamics of Attachment in Professional Encounters.* London: Karnac.

McDaniel, S., Weber, T. and McKeever, J. (1983) 'Multiple theoretical approaches to supervision: Choices in family therapy training.' *Family Process 22*, 491–500.

McDonough, S.C. (2000) 'Interaction Guidance: Understanding and Treating Early Relationship.' In C.H. Zeanah (ed.) *Handbook of Infant Mental Health.* New York, NY: The Guilford Press.

McDonough, S.C. (2005) 'Interaction Guidance: Promoting and Nurturing the Caregiving Relationship.' In A. Sameroff, S. McDonough and K. Rosenblum (eds) *Treating Parent-Infant Relationship Problems: Strategies for Intervention.* New York and London: The Guilford Press.

McMillan, A. (2004) 'Using Video Interactive Guidance (VIG) to support staff development in the pre-school sector.' Unpublished MSc dissertation, University of Dundee.

Meadow-Orlans, K.P. (1994) 'Sources of stress for mothers and fathers of deaf and hard of hearing infants.' *American Annals of the Deaf 140*, 352–357.

Meadows, S. (1996) *Parenting Behaviour and Children's Cognitive Development.* Hove: Psychology Press.

Meares, R. (2004) 'The conversational model: an outline.' *American Journal of Psychotherapy 58*, 1, 51–66.

Meins, E., Fernyhough, C., Wainright, R., Clark-Carter, D., Das Gupta, M. and Fradley, E. (2003) 'Pathways to understanding mind: construct validity and predictive validity of maternal mind-mindedness.' *Child Development 74*, 1194–1211.

Meins, E., Fernyhough, C., Wainright, R., Das Gupta, M., Fradley, E. and Tuckey, M. (2002) 'Maternal mind-mindedness and attachment security as predictors of theory of mind understanding.' *Child Development 73*, 1715–1726.

Meltzoff, A. and Gopnick, A. (1993) 'The role of imitation in understanding and developing a theory of mind.' In S. Baron-Cohen, H. Tager-Flusberg and D. Cohen (2005) (eds) *Understanding Other Minds: Perspectives from Developmental Cognitive Neuroscience* (2nd edn). New York, NY: Oxford University Press.

Mendelsohn, A.L., Dreyer, B.P., Flynn, V., Tomopoulos, S. *et al.* (2005) 'Use of videotaped interactions during pediatric well-child care to promote child development: A randomized, controlled trial.' *Journal of Developmental and Behavioural Pediatrics 26*, 34–41.

Mills, J. (2005) 'A critique of relational psychoanalysis.' *Psychoanalytic Psychology 22*, 2, 155–188.

Milne, D. (2007) 'An empirical definition of clinical supervision.' *British Journal of Clinical Psychology 46*, 4, 449–459.

Minnis, H. (2010) Personal communication, 5 September.

Mitchell, S. (1988) 'The intrapsychic and the interpersonal: different theories, different domains, or historical artefacts.' *Psychoanalytic Inquiry 8*, 472–496.

Mitchell, S. (2000) *Relationality. From Attachment to Intersubjectivity.* Hillsdale, NJ: Analytic Press.

Monk, G., Winslade, J., Crocket, K. and Epston, D. (1996) *Narrative Therapy in Practice. The Archaeology of Hope.* San Francisco, CA: Jossey-Bass.

Moran, G., Pederson, D.R. and Krupka, A. (2005) 'Maternal unresolved attachment status impedes the effectiveness of interventions with adolescent mothers.' *Infant Mental Health Journal 26*, 231–249.

Morgan, A. (2000) *What is Narrative Therapy? An Easy-to-read Introduction.* Adelaide: Dulwich Centre Publications.

Mortiboys, A. (2002) *The Emotionally Intelligent Lecturer.* Birmingham: SEDA Publications.

Mundy-Castle, A. (1980) 'Perception and Communication in Infancy: A Cross-cultural Study.' In D. Olson (ed.) *The Social Foundations of Language and Thought: Essays in Honor of J. S. Bruner.* New York, NY: W.W. Norton, 231–253.

Munich, R.L. (2006) 'Integrating Mentalization-based Treatment.' In J.G. Allen and P. Fonagy (eds) *Handbook of Mentalization-Based Treatment.* Chichester: John Wiley and Sons Ltd., 143–182.

Murphy, J.J. (2008) *Solution-focused Counseling in Schools.* VISTAS 2008 ONLINE. Available at http://counselingoutfitters.com/vistas/vistas08/Murphy.htm, accessed on 31 January 2011.

Murray, L. (1998) 'Experimental Perturbations of Mother-Infant Communication.' In S. Braten (ed.) *Intersubjective Communication and Emotion in Early Ontogeny.* Cambridge: Cambridge University Press.

Murray, L. and Trevarthen, C. (1985) 'Emotional Regulation of Interactions Between Two Month Olds and Their Mothers.' In T.M. Field and N.A. Fox (eds) *Social Perspectives in Infants.* Norwood, NJ: Ablex, 177–197.

Murray, L. and Trevarthen, C. (1986) 'The infant's role in mother-infant communication.' *Journal of Child Language 13*, 15–29.

Nadel, J. and Butterworth, G. (eds) (1999) *Imitation in Infancy.* Cambridge: Cambridge University Press.

Nadel, J. and Camaioni, L. (eds) (1993) *New Perspectives in Early Communicative Development.* London: Routledge.

Nadel, J., Carchon, I., Kervella, C., Marcelli, D. and Reserbat-Plantey, D. (1999) 'Expectancies for social contingency in 2-month-olds.' *Developmental Science 2*, 2, 164–173.

Nadel, J. and Pezé, A. (1993) 'What Makes Immediate Imitation Communicative in Toddlers and Autistic Children?' In J. Nadel and L. Camaioni (eds) *New Perspectives in Early Communicative Development.* London: Routledge.

Nagy, E. (ed.) (2011) 'The Newborn Infant: A missing stage in developmental psychology.' *Infant and Child Development 20*, 1, 3–19.

Nagy, E. and Molnár, P. (2004) 'Homo imitans or homo provocans? Human imprinting model of neonatal imitation.' *Infant Behaviour and Development 27*, 1, 54–63.

Neilson, G. (1962) *Studies in Self-confrontation.* Copenhagen: Munksgaard.

Newson, J. (1979) 'The Growth of Shared Understandings Between Infant and Caregiver.' In M. Bullowa (ed.) *Before Speech: The Beginning of Human Communication.* Cambridge: Cambridge University Press, 207–222.

Newson, J. and Newson, E. (1974) 'Cultural Aspects of Childrearing in an English-Speaking World.' In M.P.M. Richards (ed.) *The Integration of a Child into a Social World.* Cambridge: Cambridge University Press, 53–82.

NICE (2009) 'Cochlear Implants for Children and Adults with Severe to Profound Deafness.'

Nolan, A. (1999) 'Supervision for educational psychologists: how are we doing?' *Education and Psychology in Practice 15,* 2, 98–107.

NSPCC (2010) *The National Society for the Prevention of Cruelty to Children (NSPCC) Evidence to the Independent Review of the Delivery of Early Interventions Intended to Fulfil Potential and Reduce Dysfunction in the Lives of Children and Young People.* November 2010. Available at www.nspcc.org.uk/Inform/policyandpublicaffairs/consultations/responses2010_wda70544.html, accessed on 29 January 2011.

Offredo, J. (2010) *The Next Page / They Say They Want a REVOLUTION: Inside Today's British Student Uprising.* Post-gazette, 19 December 2010. Available at www.post-gazette.com/pg/10353/1111596-109.stm#ixzz1D2kuw3Pbo, accessed on 5 February 2011.

Ofsted (2010) *Report on Riverside Children's Centre, Lowestoft.* Available at www.ofsted.gov.uk/oxedu_reports/download/(id)/125827/(as)/22519_362552.pdf, accessed on 2 February 2011.

O'Kane, C. (2000) 'Development of Participatory Techniques.' In P. Christensen and A. James (eds) *Research with Children: Perspectives and Practices.* London: Routledge Falmer, 136–159.

O'Neill, M.B. (2007) 'Imitation as an intervention for children with autistic spectrum disorder and their parents/carers.' PhD thesis, University of Dundee.

O'Neill, M. (2011) Personal communication and notes.

Pain, R. and Francis, P. (2003) 'Reflections on participatory research.' *Area 35,* 1, 46–54.

Papoušek, H. (1967) 'Experimental Studies of Appetitional Behaviour in Human Newborns and Infants.' In H.W. Stevenson, E.H. Hess and H.L. Rheingold (eds) *Early Behaviour: Comparative and Developmental Approaches.* New York, NY: John Wiley, 249–277.

Papoušek, H. and Papoušek, M. (1977) 'Mothering and Cognitive Head Start: Psychobiological Considerations.' In H.R. Schaffer (ed.) *Studies in Mother-Infant Interaction: The Loch Lomond Symposium.* London: Academic Press, 63–85.

Papoušek, H. and Papoušek, M. (1987) 'Intuitive Parenting: A Dialectic Counterpart to the Infant's Integrative Competence.' In J.D. Osofsky (ed.) *Handbook of Infant Development* (2nd edn). New York, NY: Wiley, 669–720.

Papoušek, H. and Papoušek, M. (1997) 'Fragile Aspects of Early Social Interaction.' In L. Murray and P.J. Cooper (eds) *Postpartum Depression and Child Development.* London: Academic Press, 63–85.

Papoušek, M. (1995) 'Origins of Reciprocity and Mutuality in Prelinguistic Parent-Infant "Dialogues".' In I. Markova, C. Graunmann and K. Foppa (eds) *Mutualities in Dialogue.* Cambridge: Cambridge University Press.

Papoušek, M. (1996) 'Intuitive Parenting: A Hidden Source of Musical Stimulation in Infancy.' In I. Deliège and J. Sloboda (eds) *Musical Beginnings: Origins and Development of Musical Competence.* Oxford: Oxford University Press, 88–112.

Papoušek, M. (2007) 'Communication in early infancy: an arena of intersubjective learning.' *Infant Behavior and Development 30,* 258–266.

Parker, I. (1999) 'Deconstruction and Psychotherapy.' In I. Parker (ed.) *Deconstructing Psychotherapy.* London: Sage.

Parker, I. (2003) 'Jacques Lacan, barred psychologist.' *Theory and Psychology 13*, 1, 95–115.

Payne, M. (1998) 'Social Work Theories and Reflective Practice.' In R. Adams, L. Dominelli and M. Payne (eds) *Social Work, Themes, Issues and Critical Debates* Basingstoke: Palgrave Macmillan.

Pease, T. (2006) *The Science of SPIN.* VIG IRC, University of Dundee. Available at http://tiny.cc/pea06, accessed on 5 July 2011.

Perrott, E. (1977) *Microteaching in Higher Education: Research, Development and Practice.* Guildford: SRHE.

Polderman, N. (1998) 'Hechtingsstoornis, beginnen bij het begin' [Attachment disorder: begin at the beginning]. *Tijdschrift voor Orthopedagogiek 10*, 422–433.

Polderman, N. (2007) Attachment and Video Interaction Guidance. Basic Trust. Available at www.basictrust.com, accessed 2 February 2011.

Powell, M., Leyden, G. and Osborne, E. (1990) 'A curriculum for training in supervision.' *Educational and Child Psychology 7*, 3, 44–51.

Raiha, H., Lehtonen, L., Huhtala, V., Saleva, K. and Korvenranta, H. (2002) 'Excessively crying infant in the family: Mother-infant, father-infant and mother-father interaction.' *Child: Care, Health and Development 28*, 419–429.

Ramsden, P. (2009) *The Future of Higher Education Teaching and the Student Experience.* Commissioned contribution to UK Government review of Higher Education. Available at http://webarchive.nationalarchives.gov.uk/tna/+/http://www.bis.gov.uk/wp-content/uploads/2009/10/HE-Teaching-Student-Experience.pdf/, accessed on 12 January 2011.

Rautenbach, R. (2010) 'From nurture group to nurturing community: exploring processes and evaluating outcomes when nurturing principles are consistent between nurture group, home and school.' Submitted as PhD thesis, University of Exeter. Available at http://tiny.cc/rau10, accessed 5 July 2011.

Ravenette, T. (1999) *Personal Construct Theory in Educational Psychology: A Practitioner's View* London: Whurr Publishers Ltd.

Reddy, V. (1991) 'Playing With Others' Expectations; Teasing and Mucking About in the First Year.' In A. Whiten (ed.) *Natural Theories of Mind: Evolution, Development and Simulation of Everyday Mindreading.* Oxford: Blackwell, 143–158.

Reddy, V. (2008) *How Infants Know Minds.* Cambridge, MA: Harvard University Press.

Reddy, V., Hay, D., Murray, L. and Trevarthen, C. (1997) 'Communication in Infancy: Mutual Regulation of Affect and Attention.' In G. Bremner, A. Slater and G. Butterworth (eds) *Infant Development: Recent Advances.* Hove: Psychology Press, 247–274.

Reijneveld, S.A., Van der Wal, M.F., Brugman, E., Hira Sing, R. and Verloove-Vanhorick, S.P. (2004) 'Infant crying and abuse.' *Lancet 364*, 1342.

Rizzolatti, G. and Craighero, L. (2004) 'The mirror neurone system.' *Annual Review of Neuroscience 27*, 169–192.

Rizzolatti, G., Fadiga, L., Gallese, V. and Fogassi, L. (1996) 'Premotor cortex and the recognition of motor actions.' *Cognitive Brain Research 3*, 131–141.

Robb, L., Simpson, R. and Forsyth, P. (2003) 'Teacherese: How Qualities of Teacher Talk Support Learning.' Paper presented at the European Early Childhood Education Research Association Conference. Glasgow: University of Strathclyde.

Robertson, M. and Kennedy, H. (2009) *Relationship-Based Intervention for High Risk families and their babies: Video Interaction Guidance – an International Perspective.* Seminar Association Infant Mental Health, Tavistock, London, 12 December 2009. http://intranet.spinlink. eu/files/get/6513?hl&f=Robertson%2C+M+and+Kennedy%2C+H.+2009+VIG+ Tavistock+pres..pdf

Roffey, S., Tew, M. and Dunsmuir, S. (2010) 'Guest Editorial. In school relationships and their outcomes.' *Educational & Child Psychology 27*, 1, 6–8.

Rogers, J. (2007) *Adults Learning.* Maidenhead: Open University Press, McGraw-Hill Education.

Rogers, C. (1979) *Carl Rogers on Personal Power.* New York, NY: Delacorte.

Rogers, C.R. (1990) *On Becoming a Person, A Therapist's View of Psychotherapy.* London: Constable and Company Ltd.

Rogers, J. (2001) *Adults Learning.* Buckingham: Open University Press.

Rogers, S.J. and Ozonoff, S. (2005) 'Annotation: What do we know about sensory dysfunction in autism? A critical review of the empirical evidence.' *Journal of Child Psychology and Psychiatry 46*, 12, 1255–1268.

Rogers, S.J. and Pennington, B.F. (1991) 'A theoretical approach to the deficits in infantile autism.' *Development and Psychopathology*, 3, 137–162.

Rogoff, B. (1990) *Apprenticeship in Thinking: Cognitive Development in Social Context.* New York, NY: Oxford University Press.

Rogoff, B., Paradise, R., Arauz, R.M., Correa-Chávez, M. and Angelillo, C. (2003) 'Firsthand learning through intent participation.' *Annual Review of Psychology 54*, 175–203.

Rosenblum, K.L., McDonough, S.C., Sameroff, A.J. and Muzik, M. (2008) 'Reflection in thought and action: maternal parenting / reactivity predicts mind-mindedness comments and interactive behaviour.' *Infant Mental Health Journal 29*, 4, 362–376.

Russell, S. and Carey, M. (eds) (2004) *Narrative Therapy. Responding to your Questions.* Adelaide: Dulwich Centre Publications.

Russell-Chapin, L. (2007) 'Supervision: An Essential for Professional Development.' In J. Gregoire and C.M. Jungers (eds) *The Counselor's Companion: What Every Beginning Counselor Needs to Know.* Mahwah NJ: Lawrence Erlbaum Associates.

Ryle, A. and Kerr, I.B. (2002) *Introducing Cognitive Analytic Therapy: Principles and Practice.* Chichester and New York, NY: John Wiley and Sons.

Safran, J.D. and Reading, R. (2008) 'Mindfulness, Metacommunication and Affect Regulation in Psychoanalytic Treatment.' In S.F. Hick and T. Bien (eds) *Mindfulness and the Therapeutic Relationship.* New York, NY: The Guilford Press.

Salgado, J. and Hermans, H. (2005) 'The return of subjectivity: from a multiplicity of selves to the dialogical self.' *E-Journal of Applied Psychology (Clinical section) 1*, 1, 3–13.

Sampson, E. (1985) 'The de-centralization of identity: towards a revised concept of personal and social order.' *American Psychologist 40*, 11, 1203–1211.

Sampson, E. (1989) 'The challenge of social change for psychology: globalization and psychology's theory of the person.' *American Psychologist 44*, 6, 914–921.

Sampson, E. (2008) *Celebrating the Other: A Dialogic Account of Human Nature.* Chagrin Falls, OH: Taos Institute.

Sander, L. (2008) In G. Amadei and I. Bianchi (eds) *Living Systems, Evolving Consciousness, and the Emerging Person: A Selection of Papers from the Lifework of Louis Sander.* New York, NY: The Analytic Press.

Satir, V., Stachowiak, J. and Taschman, H.A. (1989) *Helping Families Change.* Northvale, NJ: Jason Aronson Inc.

Savage, E. (2005) 'The use of Video Interaction Guidance to improve behaviour, communication and relationships in families with children with emotional and behavioural difficulties.' Thesis submitted in part fulfilment of MSc degree, Queens University, Belfast.

Scaife, J. (2009) *Supervision in Clinical Practice; A Practitioner's Guide.* London: Routledge.

Schaffer, H. (ed.) (1971) *The Origins of Human Social Relations.* New York, NY: Academic Press.

Schaffer, H.R. (ed.) (1977) *Studies of Mother-Infant Interaction: The Loch Lomond Symposium.* London: Academic Press.

Scheff, T.J. (1988) 'Shame and conformity: the deference-emotion system.' *Sociological Review 53,* 395–406.

Schore, A. (1994) *Affect Dysregulation and the Origin of the Self.* Hillsdale, NJ: Lawrence Erlbaum Associates.

Schore, J.R. and Schore, A.N. (2008) 'Modern attachment theory: The central role of affect regulation in development and treatment.' *Clinical Social Work Journal 36,* 9–20.

Segal, Z.V., Williams, J.M.G. and Teasdale, J.D. (2002) *Mindfully-Based Cognitive Therapy for Depression: A New Approach to Preventing Relapse.* New York, NY: The Guilford Press.

Seifer, R., Clark, G.N. and Sameroff, A.J. (1991) 'Positive effects of interaction coaching on infants with developmental disabilities and their mothers.' *American Journal of Mental Retardation 96,* 1–11.

Seligman, M.E.P. (1991) *Learned Optimism.* New York: Knopf. Cited in P.W. Dowrick (1999) 'A review of self-modeling and related interventions.' *Applied and Preventive Psychology 8,* 23–39.

Seligman, M.E.P. (2002) *Authentic Happiness.* New York, NY: Free Press.

Seligman, S. (2009) 'Anchoring intersubjective models in recent advances in developmental psychology, cognitive neuroscience and parenting studies: introduction to papers by Trevarthen, Gallese, and Ammaniti and Trentini.' *Psychoanalytic Dialogues 19,* 503–506.

Senge, P.M. (2006) *The Fifth Discipline: The Art and Practice of the Learning Organisation.* New York, NY: Random Books.

Sharry, J., Guerin, S., Griffin, C. and Drum, M. (2005) 'An evaluation of the parents plus early years programme: a video-based early years intervention for parents of pre-school children with behavioural and developmental difficulties.' *Clinical and Child Psychology and Psychiatry 10,* 3, 319–336.

Shin, H., Park, Y.-J., Ryu, H. and Seomun, G.-A. (2008) 'Maternal sensitivity: a concept analysis.' *Journal of Advanced Nursing 64,* 304–314.

Short, K. (2010) 'An exploration of the use of video in interaction-focused interventions for children with Autism Spectrum Condition and their parents: A systematic review of literature.' PhD thesis in Applied Educational Psychology, Newcastle University.

Shutz-Bozbach, S., Mancini, B., Aglioti, S.M. and Haggard P. (2006) 'Self and other in the human motor system.' *Current Biology 16,* 1830–1834.

Sibbing, M.H.M., Kat, C.N., Grootenhuis, M.A. and Last, B.F. (2005) 'Positief effect van video-interactiebegeleiding in het kinderziekenhuis' [Positive effects of video interaction guidance in the children's hospital]. *Tijdschrift Kindergeneeskunde 73,* 6, 209–214.

Siegel, D.J. (2007) *The Mindful Brain. Reflection and Attunement in the Cultivation of Well-being.* New York, NY: Norton.

Šilhánová, K. (2008) 'VTI a Supervize.' In Z. Havrdová and M. Hajný (eds) *Praktická supervize.* Prague: Galén.

Simpson, R. (1999) 'The Traject Plan: systemic dimesnsion to VIG.' Available at http://tiny.cc/sim99, accessed 5 July 2011.

Simpson, R. (2003) What is going on here? Unpublished paper Dundee City Council. Available at http://tiny.cc/sim03, accessed 5 July 2001.

Simpson, R., Forsyth, P. and Kennedy, H. (1995) 'An evaluation of video interaction analysis in family and teaching situations.' Professional Development Initiatives SED/Regional Psychological Services. Available at http://tiny.cc/simforken, accessed 5 July 2011.

Sked, H. (2006) 'Learning their language: a comparative study of social interactions between children with autism and adults, using imitation and video interaction guidance as interventions.' Thesis submitted in part fulfilment of an MSc in Educational Psychology, University of Dundee.

Skinner, B.F. (1953) *Science and Human Behavior.* New York: MacMillan. Cited in P.W. Dowrick (1999) 'A review of self-modeling and related interventions.' *Applied and Preventive Psychology, 8,* 23–39.

Skinner, B.F. (1980) *Notebooks, B.F. Skinner.* Englewood Cliffs, NJ: Prentice-Hall.

Sloman, M. (2003) *Focus on the Learner.* The Change Agenda: Chartered Institute of Personnel and Development. Available at www.cipd.co.uk, accessed on 23 January 2010.

Sluckin, A. (1995) 'Bonding failure: I don't know this baby, she's nothing to do with me.' *Clinical Child Psychology and Psychiatry 3,* 1, 11–24.

Sluckin, A. (1998) 'Bonding Failure: "I don't know this baby…she's nothing to do with me".' *Clinical Child Psychology.*

Smith, A. (1759) *Theory of Moral Sentiments.* Edinburgh: Kincaid and Bell.

Snyder, C.R. and Lopez, S.J. (2007) *Positive Psychology. The Scientific and Practical Explorations of Human Strengths.* London: Sage.

Spence, J.T. (1985) 'Achievement American style: the rewards and costs of individualism.' *American Psychologist 40,* 12 827–836.

Stams, G.J.J.M., Juffer, F. and Van IJzendoorn, M.H. (2002) 'Maternal sensitivity, infant attachment, and temperament predict adjustment in middle childhood: The case of adopted children and their biologically unrelated parents.' *Developmental Psychology 38,* 806–821.

Stams, G.J.J.M., Noom, M.J., Colonnesi, C., Asscher, J.J. *et al.* (2010) 'The efficacy of Basic Trust. An observational pilot study into the efficacy of the Basic Trust Method.' Submitted for publication.

Stein, A., Woolley, H., Senior, R., Hertzmann, L. *et al.* (2006) 'Treating disturbances in the relationship between mother with bulimic eating disorders and their infants: A randomized, controlled trial of video feedback.' *American Journal of Psychiatry 163,* 899–906.

Stern, D. (1971) 'A micro-analysis of mother-infant interaction: behaviour regulating social contact between a mother and her 3 1/2 month twins.' *Journal of the American Academy of Child Psychiatry 19,* 501–517.

Stern, D. (1997) *The First Relationship: Infant and Mother.* London: Fontana/Open Books.

Stern, D.N. (1985) *The Interpersonal World of the Infant.* New York, NY: Basic Books.

Stern, D.N. (1993) 'The Role of Feelings for an Interpersonal Self.' In U. Neisser (ed.) *The Perceived Self: Ecological and Interpersonal Sources of Self-Knowledge.* New York, NY: Cambridge University Press, 205–215.

Stern, D.N. (2000) *The Interpersonal World of the Infant: A View from Psychoanalysis and Development Psychology* (2nd edn). New York, NY: Basic Books.

Stern, D.N. (2004) *The Present Moment in Psychotherapy and Everyday Life.* New York, NY: W.W. Norton and Company.

Stern, D.N. (2010) *Forms of Vitality: Exploring Dynamic Experience in Psychology, the Arts, Psychotherapy and Development.* Oxford: Oxford University Press.

Stern, D.N., Hofer, L., Haft, W. and Dore, J. (1985) 'Affect Attunement: The Sharing of Feeling States Between Mother and Infant By Means of Inter-Modal Fluency.' In T.M. Field and N.A. Fox (eds) *Social Perception in Infants.* Norwood, NJ: Ablex, 249–268.

Stern, D.N., Jaffe, J., Beebe, B. and Bennett, S.L. (1975) 'Vocalization in unison and alternation: two modes of communication within the mother-infant dyad.' *Annals of the New York Academy of Science 263*, 89–100.

Stern, D.N., Sander, L.W., Nahum, J.P., Harrison, A.M. *et al.* (1998) 'Non-interpretive mechanisms in psychoanalytic therapy: the something more than interpretation.' *International Journal of Psychoanalysis 79*, 908–921.

Stewart-Brown, S. and Schrader McMillan, A. (2010) 'Promoting the Mental Health of Children and Parents, Evidence and Outcomes, Home and Community Based Parenting Support Programmes and Interventions, Report of Workpackage 2 of The Dataprev Project.' Warwick Research active portal http://wrap.warwick.ac.uk, accessed 12 June 2011.

Stoltenberg, C.D. and Delworth, U. (1987) *Supervising Counsellors and Therapists.* San Francisco, CA: Jossey-Bass.

Stone, D., Patton, B. and Heen, S. (1999) *Difficult Conversations: How to Discuss what Matters Most.* Harmondsworth: Penguin.

Stout, G.F. (1903/1915) *The Groundwork of Psychology.* London: New Tutorial Press.

Stovall, K.C. and Dozier, M. (2000) 'The development of attachment in new relationships: Single subject analyses for 10 foster infants.' *Development and Psychopathology 12*, 133–156.

Strathie, C. (2009) *The Art of Effective Communication: A Pilot Course in Video Enhanced Reflective Practice for Staff in a Residential Setting for Young People.* Available at www.goodenoughcaring.com/JournalArticle.aspx?cpid=111, accessed on 23 January 2011.

Strathie, C. and Kennedy, H. (2008) 'Parents who misuse drugs or drug users who have children?' *Today's Children are Tomorrow's Parents.* University of Timisoara 22, 30–39. Available at http://tiny.cc/strken08

Strathie, C., Strathie, S. and Gunn, H. (2009) 'Video Interaction Guidance, intervention, training and research.' (Unpublished submission paper.) Dundee City Council.

Summerfield, A.Q., Marshall, D.H. and Archbold, S. (1997) 'Cost-effectiveness considerations in pediatric cochlear implantation.' *The American Journal of Otology 18*, 1, 166–168.

Svanberg, P.O. (2009) 'Promoting a Secure Attachment Through Early Screening and Interventions.' In J. Barlow and P.O. Svanberg (2009) *Keeping the Baby in Mind: Infant Mental Health in Practice.* London and New York: Routledge.

Talay-Ongan, A. and Wood, K. (2000) 'Unusual sensory sensitivities in autism: A possible crossroads.' *International Journal of Disability, Development and Education 47*, 2, 201–212.

Thomson, C., MacDougall, L., McFarlane, M. and Bryson, M. (2005) 'Using Video Interaction Guidance to assist student teachers' and teacher educators' reflections on their interactions with learners and bring about change in practice.' Presentation at British Educational Research Association Conference, University of Glamorgan.

Tobey, E.A., Geers, A.E., Brenner, C., Altuna, D. and Gabbert, G. (2003) 'Factors associated with development of speech production skills in children implanted by age five.' *Ear and Hearing 24*, 36–45.

Todd, L. (2007) *Partnerships for Inclusive Education: A Critical Approach to Collaborative Working.* London: Routledge.

Todd, L. (2010) 'Multi-Agency Working And Children And Young People With Disabilities: From "What Works" To "Active Becoming".' In D. Ruebain and S. Haines (eds) *Education, Disability and Social Policy.* London: Policy Press.

Tomasello, M. (1999) *The Cultural Origins of Human Cognition.* Cambridge, MA: Harvard University Press.

Tomblin, J.B., Barker, B.A. and Hubbs, S. (2007) 'Developmental constraints on language development in children with cochlear implants.' *International Journal of Audiology 46*, 512–523.

Torrance, H. and Pryor, J. (1998) *Investigating Formative Assessment. Teaching, Learning and Assessment in the Classroom.* Maidenhead, Berkshire: Open University Press.

Trevarthen, C. (1977) 'Descriptive Analyses of Infant Communication Behavior.' In H. R. Schaffer (ed.) *Studies in Mother-Infant Interaction: The Loch Lomond Symposium.* London: Academic Press, 227–270.

Trevarthen, C. (1974) 'Conversations with a two month old', *New Scientists*, 2 May 1974, 230–5.

Trevarthen, C. (1979a) 'Communication and Cooperation in Early Infancy. A Description of Primary Intersubjectivity.' In M. Bullowa (ed.) *Before Speech: The Beginning of Human Communication.* London: Cambridge University Press, 321–347.

Trevarthen, C. (1979b) 'Instincts for Human Understanding and for Cultural Cooperation: Their Development in Infancy.' In M. von Cranach, K. Foppa, W. Lepenies and D. Ploog (eds) *Human Ethology.* Cambridge: Cambridge University Press, 530–571.

Trevarthen, C. (1980) 'The Foundations of Intersubjectivity: Development of Interpersonal and Cooperative Understanding of Infants.' In D. Olson (ed.) *The Social Foundations of Language and Thought: Essays in Honor of J.S. Bruner.* New York, NY: W.W. Norton, 316–342.

Trevarthen, C. (1990) 'Signs Before Speech.' In T.A. Sebeok and J. Umiker-Sebeok (eds) *The Semiotic Web, 1989.* Berlin, New York and Amsterdam: Mouton de Gruyter, 689–755.

Trevarthen, C. (1998) 'The Concept and Foundations of Infant Intersubjectivity.' In S. Braten (ed.) *Intersubjective Communication and Emotion in Early Ontogeny.* Cambridge: Cambridge University Press.

Trevarthen, C. (2001) 'Intrinsic motives for companionship in understanding: their origin, development, and significance for infant mental health.' *Infant Mental Health Journal 22*, 1/2, 95–131.

Trevarthen, C. (2004) *Learning about Ourselves from Children: Why a Growing Human Brain Needs Interesting Companions.* Clinical Centre for Child Development, University of Hokkaido Annual Report, 26, 9–44. Available at http://hdl.handle.net/2115/25359, accessed on 15 October 2010.

Trevarthen, C. (2009) 'The intersubjective psychobiology of human meaning: Learning of culture depends on interest for co-operative practical work – and affection for the joyful art of good company.' *Psychoanalytic Dialogues 19*, 507–518.

Trevarthen, C. and Aitken, K.J. (2001) 'Infant intersubjectivity: research, theory, and clinical application.' *Journal of Child Psychology and Psychiatry 42*, 1, 3–48.

Trevarthen, C. and Aitken, K.J. (2003) 'Regulation of Brain Development and Age-Related Changes In Infants' Motives: The Developmental Function of "Regressive" Periods.' In M. Heimann (ed.) *Regression Periods in Human Infancy*. Mahwah, NJ: Erlbaum, 107–184.

Trevarthen, C., Aitken, K., Papoudi, D. and Robarts, J. (1998) *Children with Autism: Diagnosis and Interventions to Meet Their Needs* (2nd edn). London: Jessica Kingsley Publishers.

Trevarthen, C. and Hubley, P. (1978) 'Secondary Intersubjectivity: Confidence, Confiding and Acts of Meaning in the First Year.' In A. Lock (ed.) *Action, Gesture and Symbol: The Emergence of Language*. London, New York and San Francisco, CA: Academic Press, 183–229.

Trevarthen, C., Murray, L. and Hubley, P. (1981) 'Psychology of Infants.' In J. Davis and J. Dobbing (eds) *Scientific Foundations of Clinical Paediatrics* (2nd edn). London: W. Heinemann Medical Books, 235–250.

Tronick, E.Z., Als, H., Adamson, L., Wise, S. and Brazelton, T.B. (1978) 'The infant's response to entrapment between contradictory messages in face-to face interaction.' *Journal of the American Academy of Child Psychiatry 17*, 1, 1–13.

Tubbs, S.L. and Moss, S. (2008) *Human Communication* (11th edn). New York, NY: McGraw-Hill, Inc.

Tucker, J. (2006) 'Using video to enhance the learning in a first attempt at "Watch, Wait and Wonder".' *Infant Observation 9*, 2, 125–138.

Uzgiris, I.C. (1991) 'The Social Context of Infant Imitation.' In M. Lewis and S. Feinman (eds), *Social Influences and Socialization in Infancy*. New York, NY: Plenum Press, 215–251.

Van der Riet, M. (2008) 'Participatory research and the philosophy of social science: beyond the moral imperative.' *Qualitative Inquiry 14*, 546–564.

Van der Zeeuw, C. and Eliëns, M. (2009) 'Drie jaar Baby Extra: Een terugblik op wat bereikt is' [Three years of Baby Extra: A review on what has been achieved]. Available at www.babyextra.nl/nieuws.html, accessed on 23 August 2010.

Van IJzendoorn, M.H. (1995) 'Adult attachment representations, parental responsiveness, and infant attachment: A meta-analysis on the predictive validity of the Adult Attachment Interview.' *Psychological Bulletin 117*, 387–403.

Van IJzendoorn, M.H., Juffer, F. and Duyvesteyn, M.G.C. (1995) 'Breaking the intergenerational cycle of insecure attachment: a review of the effects of attachment-based interventions on maternal sensitivity and infant security.' *Journal of Child Psychology and Psychiatry 36*, 2, 225–248.

Van IJzendoorn, M.H., Schuengel, C. and Bakermans-Kranenburg, M.J. (1999) 'Disorganized attachment in early childhood: Meta-analysis of precursors concomitants, and sequelae.' *Development and Psychopathology 11*, 225–249.

Van IJzendoorn, M.H. and De Wolff, M.S. (1997) 'In search of the absent father – meta-analyses of infant-father attachment: a rejoinder to our discussants.' *Child Development 68*, 604–609.

van Manen, M. (1995) 'On the epistemology of reflective practice.' *Teachers and Teaching: Theory and Practice 1*, 1, 33–50.

Van Rees, S. and Biemans, H. (1986) *Open-closed-open: An Autistic Girl at Home.* Video by Stichting Lichaamstaal,Scheyvenhofweg 12, 6093PR Heythuysen, The Netherlands.

van Sleuwen, B.E., L'Hoir, M.P., Engelberts, A.C., Busscher, W.B. *et al.* (2006) 'Comparison of behaviour modification with and without swaddling as interventions for excessive crying.' *The Journal of Pediatrics 149*, 512–517.

Vermeulen, P. (2001) *Autistic Thinking – This is the Title.* London: Jessica Kingsley Publishers.

VEROC Conferences (2011) *Video Enhanced Reflection on Communication.* Video Interaction Guidance International Conference Papers University of Dundee. Available at www.dundee.ac.uk/eswce/research/centres/veroc/conference/, accessed on 31 January 2011.

Viltosz, M., Fleming, B. and Forsyth, P. (2007) Feedforward. Presentation: Dundee VIG Network Half Day (May) Educational Development Service. Dundee.

Vogelvang, B. (1993) *Video-hometraining 'Plus' en het Project aan Huis; Verheldering van twee methodieken voor intensieve pedagogische thuisbehandeling* [Video Home Training 'Plus' and the 'Project aan Huis': A Clarification of Two Methods for Intensive Pedagogical Home Treatment]. Enschede: CopyPrint 2000.

Vygotsky, L. (1978) 'Interaction between Learning and Development.' In M. Cole, V. John-Steiner, S. Scribner and E. Souberman (eds) *Mind in Society: The Development of Higher Psychological Processes* Cambridge, MA: Harvard University Press, 79–91. Cited in C.H. Hitchcock, P.W. Dowrick and M.A. Prater (2003) 'Video self-modeling interventions in school-based settings: a review.' *Remedial and Special Education 24*, 36–56.

Vygotsky, L.S. (1962 [1934]) *Thought and Language.* Cambridge, MA: MIT Press.

Vygotsky, L.S. (1967) 'Play and its role in the mental development of the child.' *Soviet Psychology 5*, 3, 6–18.

Wallis, J., Burns, J. and Capdevila, R. (2010) 'What is narrative therapy and what is it not? The usefulness of Q methodology to explore accounts of White and Epston's (1990) approach to narrative therapy.' *Clinical Psychology and Psychotherapy.* Available at http://onlinelibrary.wiley.com/doi/10.1002/cpp.723/abstract, accessed 5 July 2011.

Walmsley, L. (2010) 'VIG in schools with children as clients.' Personal communication, 18 August 2010.

Walsh, R.A. (2008) 'Mindfulness and Empathy. A Hermeneutic Circle.' In S.F. Hick and T. Bien (eds) *Mindfulness and the Therapeutic Relationship.* New York, NY: The Guilford Press.

Walther, S. and Carey, M. (2009) 'Narrative therapy, difference and possibility: inviting new becomings.' *Context* (October) 3–8.

Watzlawick, P. (1964) *An Anthology of Human Communication.* Palo Alto, CA: Science and Behaviour Books.

Wegerif, R. (2007) *Dialogic Education and Technology: Expanding the Space of Learning.* New York, NY: Springer.

Weiner, A., Kuppermintz, H. and Guttmann, D. (1994) 'Video Home Training (the Orion Project): A short-term preventive and treatment intervention for families with young children.' *Family Process 33*, 441–453.

Weisel, A., Most, T. and Michael, R. (2006) 'Mothers' stress and expectations as a function of time since child's cochlear implantation.' *Journal of Deaf Studies and Deaf Education, 12*, 1, 55–64.

Wels, P.M.A. (2002) *Helping with a Camera: The Use of Video for Family Intervention.* Nijmegen: Nijmegen University Press.

Wels, P.M.A. (2004) *Helping with a Camera: The Use of Video for Family Intervention* (2nd edn). Nijmegen: Nijmegen University Press.

Wels, P.M.A., Jansen, R.J.A.H. and Pelders, G.E.J.M. (1994) 'Videohometraining bIJ hyperactiviteit van het kind' [Video home training for hyperactive children]. *TIJdschrift voor Orthopedagogiek 33*, 363–379.

White, M. (2007) *Maps of Narrative Practice*. London: Norton.

White, M. and Epston, D. (1990) *Narrative Means to Therapeutic Ends*. London: W.W. Norton.

Whitlow, C.K. and Buggey, T. (2004) 'Video self-modelling: an effective intervention for a preschooler with language delays.' *Journal of Research in Special Educational Needs 3*, 1. Available at www3.interscience.wiley.com/cgi-bin/fulltext/120188050/main. html,ftx_abs, accessed on 15 July 2009.

Wijnroks, L. (1994) *Dimensions of Mother-Infant Interaction and the Development of Social and Cognitive Competence in Preterm Infants*. Groningen: Stichting Kinderstudies.

Williams, M., Teasdale, J., Segal, Z. and Kabat-Zinn, J. (2007) *The Mindful Way Through Depression: Freeing Yourself from Chronic Unhappiness*. New York, NY: The Guilford Press.

Wilson, K.G. and Sandoz, E.K. (2008) 'Mindfulness, Values and Therapeutic Relationship in Acceptance and Commitment Therapy.' In S.F. Hick and T. Bien (eds) *Mindfulness and the Therapeutic Relationship*. New York, NY: The Guilford Press.

Wing, L. (1996) *The Autistic Spectrum: A Guide for Parents and Professionals*. London: Constable.

Wing, L. and Gould, J. (1979) 'Severe impairments of social interaction and associated abnormalities in children: epidemiology and classification.' *Journal of Autism and Developmental Disorders 9*, 1, 11–29.

Wittgenstein, L. (1953) *Philosophical Investigations* (trans. G.E.M Anscombe). Oxford: Basil Blackwell.

Wolf, N., Gales, M., Shane, E. and Shane, M. (2001) 'The developmental trajectory from amodal perception to empathy and communication: the role of mirror neurons in this process.' *Psychoanalytic Inquiry 21*, 1, 94–112.

Wood, D., Bruner, J.S. and Ross, G. (1976) 'The role of tutoring in problem-solving.' *Journal of Child Psychology and Psychiatry 17*, 89–100.

Woolley, H., Hertzmann, L. and Stein, A. (2008) 'Video-feedback intervention with mothers with postnatal eating disorders and their infants.' In F. Juffer, M.J. Bakermans-Kranenburg and M.H. Van IJzendoorn (eds) *Promoting Positive Parenting: An Attachment-Based Intervention*. Hillsdale, NJ: Lawrence Erlbaum Associates, 111–138.

Wosket, V. and Page, S. (2001) 'The Cyclical Model of Supervision. A Container for Creativity and Chaos.' In M. Carroll and M. Tholstrup (eds) *Integrative Approaches to Supervision*. London: Jessica Kingsley Publishers.

Yalom, I. (2001) *The Gift of Therapy. Reflections on being a Therapist*. London: Piatcus Books.

Yoshinaga-Itano, C., Sedey, A.L., Coulter, D.K. and Mehl, A.L. (1998) 'Language of early and later-identified children with hearing loss.' *Pediatrics 102*, 1161–1171.

Zeedyk, M.S. (2006) 'From intersubjectivity to subjectivity: The transformative roles of emotional intimacy and imitation.' *Infant and Child Development 15*, 321–344.

Ziegenhain, U., Derksen, B. and Dreisörner, R. (2004) 'Frühe Förderung von Resilienz bei jungen Müttern und ihren Säuglingen' [Early promotion of resilience in young mothers and their infants]. *Kindheit und Entwicklung 13*, 226–234.

The Contributors

Wilma Barrow is an Academic and Professional Tutor on the DAPPEdPsy at Newcastle University and an educational psychologist with Scottish Borders Council. She has an interest in dialogic theory and the ways in which VIG can be used to support the development of dialogic approaches within and beyond the classroom.

Jacqueline Bristow is a freelance chartered educational psychologist in Sussex, involved with VIG since 2001. She is a VIG guider, supervisor and trainer. Jacqueline is interested in the role of entrainment and embodiment in relation to attunement and the VIG process. She works on enabling clients to reconnect with lost pathways.

Ruth Cave is a lecturer at the University of Dundee. She first came across VIG in 2006 and has worked closely ever since with her co-authors Dr Angela Rogers and Dr Richard Young to bring VIG, its principles and benefits to the university classroom. She is particularly proud of the group work she has undertaken with lecturers in HE.

Carole S. Chasle is a Senior Educational Psychologist for Derbyshire County Council, where she has worked since 2004. Carole's interest and training in VIG began in 2007 and she is now a qualified guider and training to be a supervisor. In 2010 Carole completed her doctorate at Sheffield University and her final thesis involved analyzing and reflecting in depth on a VIG case.

Jenny Cross is a freelance chartered educational psychologist living in Brighton. Jenny trained as a VIG supervisor in 2000 and has mainly used VIG in her work with young disabled children and their parents and with staff in children's centres. She is currently working as a trainer, supervisor and researcher in VIG with particular interest in promoting parental sensitivity to infants deemed to be at risk of neglect.

Maria V. Doria, PhD is a chartered psychologist who works both in clinical practice and in research in the areas of interpersonal relationships and psychotherapy, including VIG. She is currently a post-doctoral researcher at the University of Lisbon (Portugal) and honorary research fellow at University of East Anglia (UK) being a *Fundação para a Ciência e Tecnologia* (FCT) Research Scholar since 2001.

Penny Forsyth, is a senior educational psychologist with Dundee City Council, and a member of the multi-agency team that leads Dundee's VIG Network. She co-founded the VEROC centre at Dundee University and has contributed to organizing four international conferences in Dundee. Penny has extensive experience in the use of VIG including international work, research and the introduction of the approach to the initial training of health professionals and social workers.

Ruben Fukkink, PhD is a researcher at the University of Amsterdam. He has published two meta-analytic reviews of effects of video feedback in the context of parental support and professional training. He is currently involved in an experimental study into video feedback for childcare teachers.

David Gavine is former Principal Educational Psychologist for Dundee City Council and former tutor in educational psychology at Dundee University. A VIG practitioner and supervisor for more than a decade, he was one of the founders of the Centre for Video Enhanced Reflection on Communication (VERoC) at Dundee University.

Deborah James, PhD is the lead scientist for the child and family programme of work at the National Institute of Health Research Biomedical Research Unit in Hearing. She is a speech and language therapist and has a PhD in psychology from the Institute of Child Health, University College London. She works with a range of children and adults with complex communication needs and is using VIG to understand how we can design and deliver person-centred and family-centred services in health, education and social care settings.

Jenny Jarvis is a chartered counselling psychologist using VIG with families in Lowestoft Child and Adolescent Mental Health Service since her initial training with Hilary Kennedy in 1998. She leads a project in South Lowestoft Children's Centres, focusing on the relationship between parents and babies using VIG and is involved in VIG training and supervising professionals in Health, Social Care and Children's Centres.

Miriam Landor is a VIG guider, supervisor and trainer. She is also a chartered educational psychologist with West Lothian Council and is currently seconded as an associate tutor to Dundee University's Masters programme in educational psychology. She has a strong interest in encouraging writing for publication.

Hilary Kennedy is a freelance chartered educational psychologist who trained in VIG in the Netherlands in 1993–5 while developing VIG training in Scotland with Raymond Simpson. She has worked as a VIG practitioner in Tayside, supervisor throughout the UK and trainer in Europe and the USA. She co-founded the VEROC centre at Dundee University and was involved in organizing four international conferences in Dundee.

Mariska Klein Velderman, PhD is researcher/project leader at TNO Quality of Life, the Netherlands. She has published internationally on various pedagogic and public health topics. Her PhD (2005) evaluated two attachment-based preventive video feedback interventions. Main focuses of her work are attachment and sensitive parenting, child maltreatment, risk behaviours, early interventions, and children of divorce.

Denise McCarten has worked for Stockton-on-Tees Educational Psychology Service. Since qualifying as a Doctor of Applied Educational Psychology in 2009 from Newcastle University Denise continues to develop her specialism and practice in VIG with the aim of bringing about positive change in complex situations, in her work with children, families and schools.

Nelleke Polderman is a psychologist and founder and director of Basic Trust, www.basictrust.com, a Dutch national organization of psychologists. The core method is Video Interaction Guidance (VIG). She developed a special form of VIG where insecure attachment (or deficits in basic trust) is concerned, called the Basic Trust method.

Dr Angela Roger is a Senior Lecturer in Education at the University of Dundee and Programme Director for the Postgraduate Certificate in Teaching in Higher Education which prepares new lecturers for their roles. She began using VIG for coaching in 2006 and was accredited as a guider in 2009.

Dr Michelle Sancho is a senior educational psychologist in West Berkshire where she leads developments in VIG. She is involved in VIG training and supervision on the doctoral initial training programme for educational psychologists at UCL and supervises a range of professionals. She has presented at national and international conferences.

Kateřina Šilhánová is a social worker trained in VIG by Dutch SPIN organization and is currently a freelance lecturer and supervisor. As a co-founder, and since 1996 also a leader, of the National Centre for VIG in the Czech Republic, she has been involved in many projects implementing this approach in education, social and health care services in her own and also in other post-communist countries. Invited to UK by Hilary Kennedy, Kateřina regularly participates in VIG training courses and accreditations of VIG practitioners.

Heather Sked is an educational psychologist with The Highland Council and is a VIG guider and supervisor. Heather developed an interest in using VIG to help improve communication with children with autism while studying for the MSc in Educational Psychology and focused on this in her dissertation.

Calum Strathie is a VIG supervisor, trainer and family practitioner. Working in Learning and Workforce Development Calum delivers and develops VIG and VERP training across the range of social work activity as well undertaking direct family work. Former Children and Families Manager Calum is a member of Dundee VIG Network who won Best Innovative Training Programme National Award.

Sandra Strathie is a social worker, VIG supervisor, trainer, consultant and former teaching fellow. She has developed VIG/VERP projects across the UK in health and social work settings, including child protection, family centres, young people's services and community care. She is also a member of the Dundee VIG Network., who won Best Innovative Training Programme National Award.

Liz Todd is Professor of Educational Inclusion at Newcastle University. She is interested in non-professional led approaches to change for individuals and communities, in particular using VIG and narrative practices. Her main research is in extended schools. Her 2007 book 'Partnerships for Inclusion' was short-listed for the NASEN/TES Inclusive education award.

Colwyn Trevarthen is Professor (Emeritus) of Child Psychology and Psychobiology at the University of Edinburgh. He studies brain development, infant communication, child learning, and emotional health. With musician Stephen Malloch he has developed a theory of the 'Communicative Musicality' of expression in movement, and its importance in therapy and education.

Henk Vermeulen, MSc is a developmental psychologist who belonged to the SPIN group which started to develop the VIG method in the 1980s in the Netherlands. He is currently employed as a clinical psychologist at Max Ernst GGZ, a mental health centre for adults and families. His main interest lies in the concept of *the present moment*, the starting point for therapeutic change.

Dr Richard Young is Professional Development Manager at Newcastle University, working to develop the practice of academics, especially their engagement with students. He leads the Certificate in Advanced Studies in Academic Practice and has used VIG and VERP in Higher Education with British, Nigerian and many other participants since 2007.

Subject Index

Author Index